BOHEMIANS

THE GLAMOROUS OUTCASTS

ELIZABETH WILSON

Rutgers University Press
New Brunswick, New Jersey

First published in the United States 2000
by Rutgers University Press, New Brunswick, New Jersey

First published in Great Britain 2000
by I.B.Tauris, Victoria House, Bloomsbury Square, London

Library of Congress Cataloging-in-Publication Data

Wilson, Elizabeth, 1936–
 Bohemians : the glamorous outcasts / Elizabeth Wilson.
 p. cm.
 Includes bibliographical references and index.
 ISBN 0-8135-2894-1 (cloth : alk. paper) – ISBN 0-8135-2895-x (pbk. : alk. paper)
 1. Bohemianism in art. 2. Arts, Modern–19th century. 3. Arts, Modern–
20th century. 4. Bohemianism–History–19th century. 5. Bohemianism–
20th century I. Title: Half title: Bohemia. II. Title.

NX650.B64 W55 2000
306.4'7–dc21

 00-039029

Printed and bound in Great Britain

BOHEMIANS

CONTENTS

LIST OF ILLUSTRATIONS

ACKNOWLEDGEMENTS

Different versions of Chapters 10, 11 and 14 appeared in, respectively, *Fashion Theory*, vol. 2, no. 3, September, 1998, *Theory Culture and Society*, special issue on Love and Eroticism, vol. 15, nos. 3–4, 1998, and *International Journal of Cultural Studies*, 1999, vol. 1, no. 2.

Very special thanks to Faith Evans and Sarah Grimes for all their help and support. Thanks also to Philippa Brewster for her enthusiasm and to Susan Lawson and Steve Tribe at I.B.Tauris.

Every effort has been made to trace the copyright holders of the illustrations reproduced in this book. The publishers would be glad to hear from any copyright holders they have not been able to contact and to print due acknowledgement in the next edition.

Degenerates are not always criminals, anarchists and pronounced lunatics; they are often authors and artists.
Max Nordau: *Degeneration*

The General, speaking, one felt, with authority, always insisted that, if you bring off adequate preservation of your personal myth, nothing much else in life matters. It is not what happens to people that is significant, but what they think happens to them.

Anthony Powell: *Books Do Furnish A Room*

A man can become as addicted to reading as to any other intoxicant ... You reach for a book as you do for a drink, to escape the depressing banality of newspaper headlines, to wash away the disgusting aftertaste of the medicines served up in the hospital known as contemporary civilization. And there's nothing so good as a potent brew of well aged pathos, preferably distilled in verse. At once you feel cleansed and ennobled. The trouble is that you don't stick to the select vintages for very long. And in reading as in drinking you incline to mix the cocktail stiffer and stiffer; you are looking for self assurance and a general absolution.

Walter Mehring: *The Lost Library*

CHAPTER ONE

INTRODUCTION

I wanted to smoke Gauloises, drink black coffee and talk about absurdity and maquillage with wicked women and doomed young men ... I wasn't interested in happiness, I was looking for the Holy Grail.
Marianne Faithfull: Faithfull.

'Who *were* the bohemians?' 'Who were the *real* bohemians?' Whenever I mentioned my work on bohemians these questions came back at me. They were purely rhetorical, since those who asked them were confident they already had the answer. Yet although the definitions offered were many and various, all were unsatisfactory, for our clichéd idea of the rebel artist turns out to be a Frankenstein's monster of a figure, patched up from competing and incompatible characteristics.

In 1850 Henry Murger, the first writer to popularize them, described the bohemians as 'water drinkers,' artists too poor and too dedicated to their work to dissolve their problems in alcohol.[1] But when in 1995 the novelist Beryl Bainbridge was told that her part of London, Camden Town, was 'the nearest thing London has to Bohemia,' she was quite indignant: 'bohemian means getting drunk together all the time, but everyone round here works bloody hard.'[2]

Between these two there have been hundreds of attempts to capture the essence of the elusive bohemian. Sometimes s/he is successful, but a self-destroyer – Jackson Pollock, for example. Sometimes, like Modigliani, he dies in poverty, still unrecognized, famous only posthumously. On the other hand he is just as likely to be a would-be genius without talent, frittering his life away in the company of other seedy failures, or, like Oscar Wilde, putting his genius into his life and only his talent into his work. The bohemian is both a genius and a phoney, a debauchee and a puritan, a workaholic and a wastrel, his identity always dependent on its opposite. Sometimes the bohemian (good) is contrasted with the bourgeois (bad); at others it is the artist (good) who is set against the bohemian (bad); or again

it might be the 'true' bohemian (good) who is opposed to the phoney bohemian (bad).[3] To complicate matters further, there is 'no action or gesture capable of being identified as bohemian that cannot also be – or has not been – undertaken outside of [sic] Bohemia.'[4]

The attempt to define Bohemia and the bohemians is therefore complex and frustrating. It is complex because the adjective 'bohemian' has been stretched to cover so many different and sometimes opposed ways of life and such a remarkable assortment of groups, communities and individuals. It is frustrating because definitions of the bohemian have been so contradictory, yet each is tenaciously defended. In fact, the recurring questions – 'but who *were* the bohemians?,' 'who were the *real* bohemians?' – are the cultural equivalent of a neurotic compulsion, which both disguises and hints at another and different problem behind the questions actually asked. For it is not the identity of the bohemian, some set of clearly defined characteristics, that should interest us, but rather the reasons for his emergence. The repeated questions express the ambivalence of an audience that has been complicit in the creation of a stereotype and therefore resists its deconstruction. The questions disavow the very ambivalence to which they simultaneously gesture. A better question might therefore be: 'when and why did this particular idea of *what an artist is* emerge?'

'There were no Baudelaires in Babylon,' wrote the Beat poet, Kenneth Rexroth[5] – in ancient Babylonian culture there was no place for bohemians. Equally in medieval and Renaissance Europe, the figure of the dissident artist-rebel – of whom Charles Baudelaire was to be an archetypal example – would have been neither tolerated nor understood. The artist might be a humble artisan or an established master, but he was normally bound closely into the world for which he worked. Art was not yet, or not typically, oppositional; on the contrary, the artist was the servant of society rather than its critic.

The dominant Renaissance view of the artist had been of a well-adjusted individual. It is true that there had been an alternative, based on the platonic idea of eccentric, melancholy genius,[6] which had conceived of the artist as a man 'who refused to accept conventions, who belonged, in the eyes of the public, to a class of his own and eventually developed into what is now generally called the bohemian.'[7] It is also the case that there were individual artists and writers in medieval and Renaissance society who led disordered lives – François Villon, Caravaggio, Christopher Marlowe. These, however, were untypical; while Diderot's fictional character, 'Rameau's nephew,' sometimes thought of as an early bohemian, was an isolated eccentric. The fully fledged nineteenth-century bohemians, on the other hand, belonged to an identifiable subculture. Bohemia is the name for the attempt by nineteenth- and twentieth-century artists, writers, intellectuals and radicals to create an alternative world within Western society (and possibly elsewhere[8]). Despite the exaggerated individualism of its citizens, Bohemia was a collective enterprise; the bohemians created and participated in a social milieu created

against the dominant culture, as the artist made a startling transformation from paid ideologue to violent critic of society in the unfamiliar world of 'modernity.'

Since that time, the early nineteenth century, the bohemian has been the hero – and anti-hero – of the story the West has wanted to hear about its artists, a story of genius, glamour, outlawry and doom. The figure and his audience are inseparable. As soon as the bohemian appeared on the urban stage there were eager consumers of stories of glamorous and sordid individuals, men and women of genius and eccentricity, who lived exciting lives and challenged the conventions. The vicissitudes of the bohemian way of life, its excesses, its triumphs, its failures and its aura of grim seriousness incongruously expressed in performance and pose, have always been good copy.

Yet Bohemia is more than a series of stories about unusual individuals. The figure of the bohemian personifies the ambivalent role of art in industrial society; and Bohemia is a cultural *Myth* about art in modernity, a myth that seeks to reconcile Art to industrial capitalism, to create for it a role in consumer society. The bohemian is above all an idea, the personification of a myth.

Roland Barthes[9] has suggested that in modern society a myth arises as the imaginary solution of a problem or conflict the society cannot solve, its function to reconcile impossibilities. It is an ideological statement that papers over the cracks of a conflict that, because it is unresolved and unresolvable, must be disguised and hidden. The myth of the bohemian represents an imaginary solution to the *problem* of art in industrial Western societies. It seeks to resolve the role of art as both inside and outside commerce and consumption, and to reconcile the economic uncertainty of the artistic calling with ideas of the artist's genius and superiority.

The myth of the bohemian had its roots in the economic and political upheavals at the end of the eighteenth century. As they undermined the traditional order, these upheavals generated both a yearning for the past and a thirst for yet more change, to create a kind of chronic crisis at every level: the economic, the political, the artistic and the personal. The bohemian is a complex personification of the cultural moment of this crisis. Emerging in the early nineteenth century as a distinct actor upon the urban stage, he dramatized these difficulties in his person, transforming them into a way of life. He was not simply a creative individual; he created and performed an identity which rapidly became a stereotype.

The bohemian myth – the idea of the artist as a different *sort of person* from his fellow human beings – is founded on the idea of the Artist as Genius developed by the Romantic movement in the wake of the industrial and French revolutions. The romantic genius is the artist against society. He or she embodies dissidence, opposition, criticism of the status quo; these may be expressed politically, aesthetically or in the artist's behaviour and lifestyle. Components of the myth are transgression, excess, sexual outrage, eccentric behaviour, outrageous appearance, nostalgia and poverty – although wealth

MAP 3

Scale: 1 inch equals 174 yards

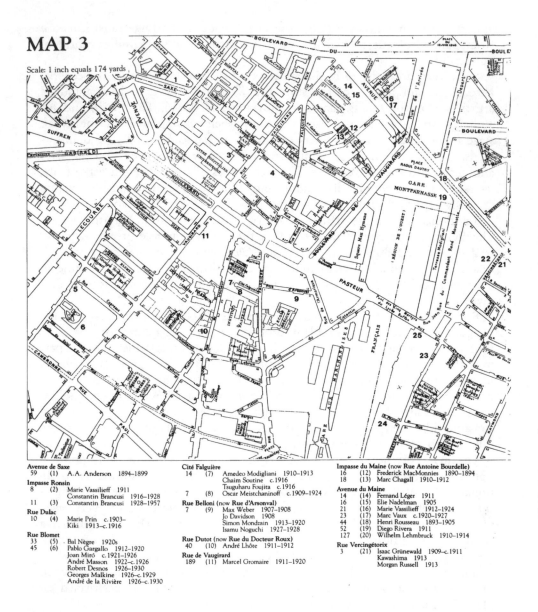

Avenue de Saxe
59 (1) A.A. Anderson 1894–1899

Impasse Ronsin
8 (2) Marie Vassilieff 1911
 Constantin Brancusi 1916–1928
11 (3) Constantin Brancusi 1928–1957

Rue Dulac
10 (4) Marie Prin c.1903–
 Kiki 1913–c.1916

Rue Blomet
33 (5) Bal Nègre 1920s
45 (6) Pablo Gargallo 1912–1920
 Joan Miró c.1921–1926
 André Masson 1922–c.1926
 Robert Desnos 1926–1930
 Georges Malkine 1926–c.1929
 André de la Rivière 1926–c.1930

Cité Falguière
14 (7) Amedeo Modigliani 1910–1913
 Chaim Soutine c.1916
 Tsuguharu Foujita c.1916
7 (8) Oscar Meistchaninoff c.1909–1924

Rue Belloni (now Rue d'Arsonval)
7 (9) Max Weber 1907–1908
 Jo Davidson 1908
 Simon Mondzain 1913–1920
 Isamu Noguchi 1927–1928

Rue Dutot (now Rue du Docteur Roux)
40 (10) André Lhôte 1911–1912

Rue de Vaugirard
189 (11) Marcel Gromaire 1911–1920

Impasse du Maine (now Rue Antoine Bourdelle)
16 (12) Frederick MacMonnies 1890–1894
18 (13) Marc Chagall 1910–1912

Avenue du Maine
14 (14) Fernand Léger 1911
16 (15) Elie Nadelman 1905
21 (16) Marie Vassilieff 1912–1924
23 (17) Marc Vaux c.1920–1927
44 (18) Henri Rousseau 1893–1905
52 (19) Diego Rivera 1911
127 (20) Wilhelm Lehmbruck 1910–1914

Rue Vercingétorix
3 (21) Isaac Grünewald 1909–c.1911
 Kawashima 1913
 Morgan Russell 1913

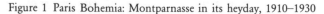

Figure 1 Paris Bohemia: Montparnasse in its heyday, 1910–1930

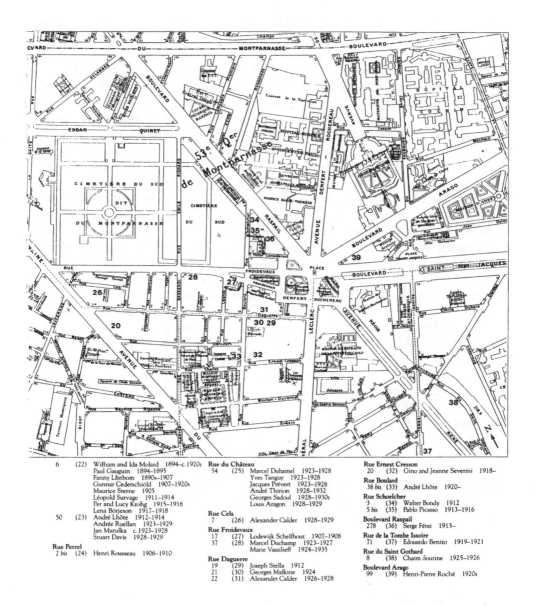

6 (22) William and Ida Molard 1894–c. 1920s
Paul Gauguin 1894–1895
Fanny Låstbom 1890s–1907
Gunnar Cederschiöld 1907–1920s
Maurice Sterne 1905
Léopold Survage 1911–1914
Lena Börjeson 1917–1918

50 (23) André Lhôte 1912–1914
Andrée Ruellan 1923–1929
Jan Matulka c. 1923–1928
Stuart Davis 1928–1929

Rue Perrel
2 bis (24) Henri Rousseau 1906–1910

Rue du Château
54 (25) Marcel Duhamel 1923–1928
Yves Tanguy 1923–1928
Jacques Prévert 1923–1928
André Thirion 1928–1932
Georges Sadoul 1928–1930s
Louis Aragon 1928–1929

Rue Cels
7 (26) Alexander Calder 1928–1929

Rue Froidevaux
17 (27) Lodewijk Schelfhout 1907–1908
37 (28) Marcel Duchamp 1923–1927
Marie Vassilieff 1924–1935

Rue Daguerre
19 (29) Joseph Stella 1912
21 (30) Georges Malkine 1924
22 (31) Alexander Calder 1926–1928

Rue Ernest Cresson
20 (32) Gino and Jeanne Severini 1918–

Rue Boulard
38 bis (33) André Lhôte 1920–

Rue Schoelcher
·3 (34) Walter Bondy 1912
5 bis (35) Pablo Picasso 1913–1916

Boulevard Raspail
278 (36) Serge Férat 1913–

Rue de la Tombe Issoire
71 (37) Edouardo Benito 1919–1921

Rue du Saint Gothard
8 (38) Chaim Soutine 1925–1926

Boulevard Arago
99 (39) Henri-Pierre Roché 1920s

could contribute to the legend provided the bohemian treated it with contempt, flinging money around instead of investing it with bourgeois caution.

The raw material for this identity was provided by the many creative individuals who lived out the role, but this in itself did not suffice for the creation of a myth. Bohemia as a recognized concept – a way of life encompassing certain forms of behaviour and a particular set of attitudes towards the practice of art – came into existence only when writers began to describe it and painters to depict it. From the start this was a myth created in literature and art, often when these artists fixed their own transient circumstances as permanent or archetypal examples of how an artist *ought* to live.

Bohemia, therefore, could never be separated from its literary and visual representation. Once these representations existed, new generations could build on them, so that the bohemian myth was self-perpetuating, the bohemian an icon that became more and more encrusted with additions based on successive artistic lives, both famous and obscure, as memoirs, novels and autobiographies recorded the myth, and recycled and amplified anecdote, legend and stereotype. Memoir and anecdotal reminiscence were, in fact, the typical bohemian forms of 'evidence', often unreliable in an empirical sense, valuable primarily as sources of a legend.

The first bohemians pictured themselves as embattled geniuses defending Art against a vulgar bourgeoisie. Yet paradoxically the bohemian myth was embedded in and reliant on the popular, the 'legend' disseminated through mass entertainment. Created initially in journalism, on the stage and in salon painting, it was later amplified in fiction, biography, popular music, film, television and even cyberspace.

The word 'legend' is itself a warning signal of the problems inherent in the identity. It implies a larger-than-life figure, a genius among Lilliputians, yet at the same time it is a good-humoured, but tongue-in-cheek word, an affectionate smile at the endearing eccentricities of 'colourful characters,' subtly inviting demolition of the very heroes it appears to celebrate. At the same time it hints that the 'legend' *is* a fiction, concealing a more truthful, hidden 'reality', the 'real' individual behind the myth.

Suzanne Valadon, for example, was one of the few women artists of her period, the early twentieth century, whose importance has been posthumously recognized, yet this recognition seems inseparable from her unconventional life. A recent biographer, Johanna Brade, summarising the Valadon 'legend,' suggests that 'some poverty and a bit of melodrama' were two of its components. Also essential was the picturesque setting of Montmartre in the time of Toulouse Lautrec – with can-can dancers, bawdy songs, prostitutes, and painters who scoured the underworld for their subject matter:

At its centre, the star: the temperamental, life-loving Valadon, her husband André Utter, younger by twenty one years, and her alcoholic son, the painter Utrillo. A woman who made the leap from artist's model to artist;

a woman of untrammelled sensual vitality, a woman who knew how to dramatize herself, in short a shining example of the Parisian artist-bohemian. That is the Valadon myth.[10]

– Trilby, Mimi and Marguerite Gautier rolled into one. Johanna Brade complains of the clichés endlessly recycled, and the 'mystification' of collapsing life into art. She, by contrast, aims to find and describe the 'real' Valadon. Yet this assumed opposition between 'reality' and 'legend' reinforces the very myth that the search for the 'real' seeks to deconstruct. Efforts to separate the two merely amplify or revise the legend, rather than demolishing it, since to search for, and claim to describe the 'real,' more usually results in the setting up of just another fiction – the infinite regress of multiple identity.

This fruitless search for the 'real' distracts from the questions that should be asked: why is there a 'legend' in the first place; what longings in the consumers of the myth, the 'bourgeois' audience, led them to create, or at the least collude in, this representation of the artist; what collective desire is being addressed by the myth of the bohemian. What, in other words, has caused the erotic chemistry, the mutual attraction-repulsion between bohemian and bourgeois? For this is a long-standing love–hate relationship between Western industrialized society and the culture it has produced. 'Unending and involved is the flux of attraction and repulsion between those two opposite characters, bohemian and bourgeois, constantly irritating and enchanting, missing and desiring each other ... Eros floats between them, disguised as envy or scorn or admiration' wrote Klaus Mann[11] in the 1920s. And, like all love–hate relationships, that of conventional society and its bohemian countercultures was unstable and obsessive, involving contradictory beliefs and impossible ideas.

The bohemian myth revolves around a central problem of authenticity. The ability of mass production to create new forms of art and to replace the craftsperson with the machine raised doubts as to the role of both art and artist. The necessity for the painter's skill, for example, became less obvious when photography could record a likeness or a landscape so much more quickly and easily. Culture was becoming a commodity and society demanded that artists should bow to the laws of the expanding market. In attempting to negotiate this unfamiliar situation, artists engaged in increasingly challenging experiments. Modernist art and the works of an intransigent avant-garde were intended to reinforce the line of demarcation between art and mere entertainment, and to re-emphasize the superiority of art. Unfortunately they often failed to do so, for the lay public found such experiments increasingly baffling, were liable to dismiss them as deliberate jokes or outright insults, and felt less and less confident in distinguishing good from bad art, the authentic from the pretentious. In the mid-nineteenth century the critic John Ruskin raged at Whistler's paintings, considering them a slap in the face, and by the 1920s audiences of thousands

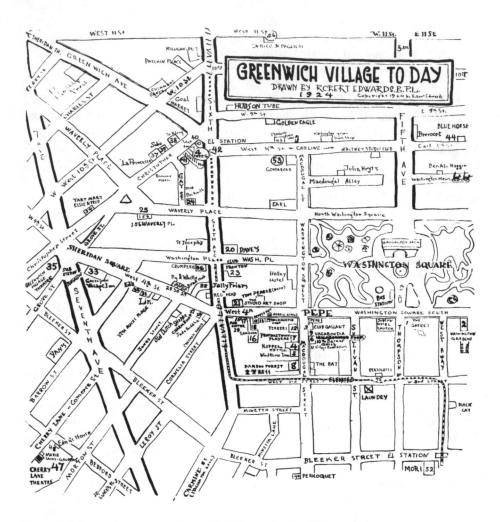

Figure 2 Bohemia in America: Greenwich Village after World War I

had to be forcibly prevented from tearing the German Dadaists limb from limb, enraged by their incomprehensible performances and their all too readily understood praise of Bolshevism. Artists in their turn despised an audience they felt to be vulgar and lacking in taste. Thus the relationship between artist and audience was fundamentally altered, characterized by mutual suspicion and contempt, even as, by a further contradictory twist, successful artists were rewarded with riches and celebrity on a scale hardly seen before.

The figure of the bohemian acts out the way in which the artist was caught up in the uncertainties modernity produced. By living, dressing and behaving not only differently from the surrounding social culture but in a manner

calculated to shock and outrage his or her audience, the bohemian drama-
tized his/her love–hate relationship with the society that had given birth to
him/her. The bohemian stereotype seeks to conceal, but inadvertently exposes
the uncertainty at its core, for it characterizes the artist simultaneously as an
authentic and dedicated creator, and as a poseur. He or she is both heroic
enemy of the bourgeois philistine and inauthentic café idler, both representa-
tive of society's highest values and a pretentious fake. It is this 'impossibility'
that elicits the question – in fact unanswerable: who really were the bohe-
mians?

One of the most striking expressions of the impossibility of the bohe-
mian is the persistent nostalgia that surrounds the bohemian way of life.
'Bohemia is always yesterday' wrote Malcolm Cowley[12] of Greenwich Village
in the 1920s. Successive generations of bohemians elegiacally recalled a
golden age of authenticity, when Bohemia had been untainted by com-
mercialism and tourists. Bohemians always believed that they were the last
of the *real* bohemians, and that Bohemia had been killed, either by the
rapacious commercialism of contemporary entertainment, which had
destroyed real art, or because Bohemia had been too successful in eroding
bourgeois morality: 'There was as much freedom in [Greenwich] Village as
before; but since it was equalled and even surpassed by [the suburbs], where
was the defiance and the revolt against convention which once infused
Bohemia?'[13]

The contradictory belief that Bohemia is on the one hand dead and on
the other that it is everywhere is puzzling. It is true that the bohemian
appeared at a particular point in the development of industrial capitalism,
as a response to changes in the way in which art was produced. It is true
that the nostalgia central to the myth fixes the bohemian as an historical
figure, who has more or less disappeared along with the circumstances that
created him or her. It is also the case that bohemian nostalgia is partly a
lament for lost youth, since it was above all the young who flocked to
Bohemia. Yet if bohemian values have really penetrated mainstream society
to a degree unthinkable a hundred years ago, their tenacity, and the popu-
larity of behaviour, attitudes and tastes once considered completely beyond
the pale, raise issues more profound than the identity of the 'real'
bohemian, his/her demise or transformation. Are we all bohemians now,
and if so, why?

The thematic method chosen to explore this question will result in
glimpses of many bohemian lives rather than a full account of any – but
many bohemian stories *are* fragmentary and incomplete. A thematic account,
moreover, interrogates the nostalgia that a chronological narrative is liable to
reinforce. In addition it gives the flavour of the patchwork of strange and
colourful lives that went to make up the bohemian subculture, creating a
unique theatrical spectacle. Bohemia was a stage, a multiple performance, its
leading players brightly lit yet dependent on the vast cast of minor characters
swirling about them, and although these bit-part actors have often been

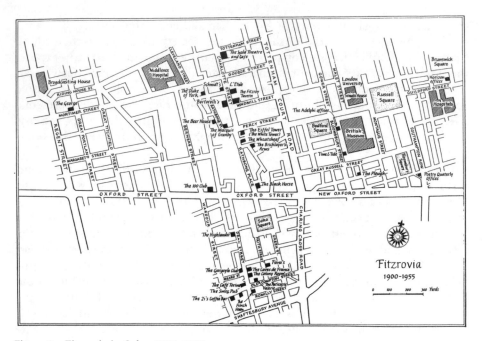

Figure 3 Fitzrovia in Soho: 1900–1955

remembered only in relation to the main protagonists their lives were just as interesting and often stranger. Yet only bits and pieces of those lives remain, adding further to the mystery of Bohemia and to its tantalizing quality.

Bohemia was a stage. It was also a mythical country. 'Bohemia,' wrote Henry Murger, 'leads either to the Academy, the Hospital or the Morgue.' For the journalist, Alphonse de Calonne, it was 'bordered on the north by need, on the south by misery, on the east by illusion and on the west by the infirmary.' For another, more optimistic writer, its frontiers were 'cold, hunger, love and hope'.[14]

Bohemia was both a destination and the journey to that destination. Today Arthur Ransome is remembered as the author of the *Swallows and Amazons* series of children's books, but at the turn of the century he was a young bohemian setting off for London 'as Columbus setting forth to a New World, a gypsy striking his tent for unknown woods.'[15] In 1923 novelist Kay Boyle likened her arrival in Paris to a pilgrimage. Accessorized in gypsy earrings and scarf, she made straight for Sylvia Beach's Left Bank bookshop, 'Shakespeare and Company,' where she hovered outside on the pavement, hoping to see George Moore or James Joyce, and felt she had arrived at an awesome destination. Thirty years later another hopeful writer, Bernard Kops, had only to get as far from London's East End as the Charing Cross Road to 'come into my kingdom of Soho,'[16] while Marianne Faithfull said of her

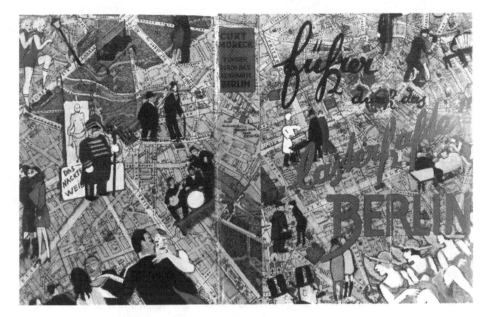

Figure 4 Weimar Bohemia in Berlin, the 1920s

teenage quest for Bohemia, 'I wanted to smoke Gauloises, drink black coffee and talk about absurdity and maquillage with wicked women and doomed young men. I wasn't interested in happiness, I was looking for the Holy Grail.'[17]

The bohemian search was indeed a secular Grail myth of escape and redemption, in which the modern industrial city took the place of Camelot. Bohemia was above all a quest, less an identity than a search for identity, less a location than a utopia.

The first part of this book looks at the way in which the bohemian myth was generated. Chapter Two is more theoretical than later chapters in its exploration of the social and economic circumstances that favoured the emergence of the bohemian. Chapter Three describes the urban culture that nurtured them. Chapters Four to Nine introduce some of the individuals who made a significant contribution to the myth. The neglected role of bohemian women has a special place here.

The second part is devoted to the themes of the bohemian quest: to the bohemian use of dress; to the place of erotic love; to the search for transgressive and extreme experiences; and to the intransigent politics of Bohemia. Finally, an exploration of the relationship between bohemian countercultures and mass culture does indeed suggest that rather than disappearing Bohemia has been transformed. The moral meanings of this transformation are, albeit largely ignored, at the core of some of the most heated cultural debates at the millennium.

Notes

1 Henry Murger, *Les Buveurs d'Eau* (Paris: Michael Levy, 1853), p 80.

2 Megan Tressider, 'The Awfully Funny Life of Beryl', *The Guardian*, Saturday, 8 April 1995, p 27.

3 Helmut Kreuzer, *Die Boheme: Beitrage zu ihrer Beschreibung* (Stuttgart: J.B.Metzlersche Verlagsbuchhandlung, 1968), p 17.

4 Jerrold Siegel, *Bohemian Paris: Culture, Politics and the Boundaries of Bourgeois Life, 1830–1890* (New York: Viking, 1986), p 12.

5 Kreuzer, *Die Boheme*, p. 278, quoting Kenneth Rexroth, 'San Francisco Scene', *Evergreen Review*, vol. 2, no. 2, 1957.

6 Marilyn Brown, *Gypsies and Other Bohemians: The Myth of the Artist in Nineteenth Century France* (Ann Arbor: University of Michigan Research Press, 1985), p 7.

7 Rudolf and Margot Wittkower, *Born Under Saturn: The Character and Conduct of Artists: A Documented History from Antiquity to the French Revolution* (New York: 1969), p 16, Weidenfeld and Nicolson, London: 1963.

8 I have throughout adhered to the view that Bohemia is primarily a Western phenomenon, and for reasons of space I have left unexplored the Bohemias of, for example, Latin American cities. The question whether these – and other bohemian enclaves that may have existed in certain African, Indian and South East Asian cities – were the result of colonialism and Westernization is an important one that I have not felt competent to address.

9 Roland Barthes, 'Myth Today', in *Mythologies*, trans Annette Lavers (New York: Hill and Wang, 1957), pp 109–59.

10 Johanna Brade, *Suzanne Valadon: vom Modell in Montmartre zur Malerin der klassische Moderne* (Stuttgart: Beber Verlag, 1994), p 7.

11 Klaus Mann, *The Turning Point* (orig publ 1942; London: Oswald Wolff, 1984), p xii.

12 Malcolm Cowley, *Exile's Return: A Literary Odyssey of the 1920s* (orig publ 1934; London: The Bodley Head, revised edition, 1964), p 62.

13 Russell Jacoby, *The Last Intellectuals: American Culture in the Age of Academe* (New York: Basic Books, 1987), p 32, quoting Milton Klonsky, 'Greenwich Village: Decline and Fall', *Commentary*, 6 November 1948, pp 458–9, 461. Jacoby's whole book is an elaboration of this theme.

14 All three are quoted in Joanna Richardson, *The Bohemians: La Vie de Bohème in Paris, 1830–1914* (London: Macmillan, 1969), p 14.

15 Arthur Ransome, *Bohemia in London* (orig publ 1907; Oxford: Oxford University Press, 1984), p 7.

16 Bernard Kops, *The World is a Wedding* (London: MacGibbon and Kee, 1963), p 172.

17 Marianne Faithfull, *Faithfull* (Harmondsworth: Penguin, 1995), p 47.

PART ONE
BOHEMIAN LIVES

CHAPTER TWO

ARTISTS IN A NEW WORLD

Poets cannot hope to fit in, either in a democratic or an aristocratic society, in a republic or an absolute or constitutional monarchy ... illustrious unfortunates, born to suffer the harsh apprenticeship of genius here below amidst the crowd of mediocre souls.

Charles Baudelaire: Edgar Allen Poe

The rise of the bohemian was related to the changes brought about by the French and industrial revolutions at the end of the eighteenth century. Industrial modernity ushered in a period of change, the rapidity and scale of which was startling and unfamiliar:

Uninterrupted disturbance of all social conditions, everlasting uncertainty and agitation distinguishes the bourgeois epoch from all earlier ones. All fixed, fast-frozen relations, with their train of ancient and venerable prejudices and opinions, are swept away, all new-formed ones become antiquated before they can ossify. All that is solid melts into air.[1]

The mythical figure of the bohemian represented in his person some of the conflicts involved in changes that occurred in artistic as in other forms of production. First and most important, the role of art underwent a transformation. In medieval society art had been seamlessly integrated into the social institutions of religion. Artworks had a religious significance and purpose (paintings depicting bible stories or legends of the saints, for example). They were produced collectively as a craft, and the mode of reception was also collective and public; the Christian congregation viewed these works as part of the act of worship.[2]

With the Renaissance there developed 'courtly' art, whose function was

equally clear: to celebrate the glory of the prince and to represent courtly society. The artist produced as an individual, but the mode of reception remained collective.[3] A further change took place with the rise of the bourgeoisie. Art was now both produced and received individually. To gaze at a painting was no longer to participate with others in a celebration either of Christianity or secular pomp; it became a private and subjective experience.[4]

The industrial economy ripped through the old established ways, denuded the countryside, threw up vast cities and showered huge new populations with goods and experiences they had never known they wanted. As wealth increased the aesthetic dimension of life expanded. The rising bourgeoisie required furniture, ceramics, paintings, ornaments, textiles and wallpapers for their homes, and formed a growing educated audience for literature, painting, music and the performance arts, requiring cultural activities of all kinds for their entertainment and edification. This resulted in the expansion of publishing houses, the opening of more theatres, concert halls, libraries and museums, and a revolution in journalism. Eventually a commercial culture, aimed at the masses, also developed.

Industrialization caused further upheaval in the *ways* in which the arts and crafts were produced and financed. Skilled craftsmen had for hundreds of years been crucial to the wealth of cities, and had formed themselves into powerful guilds, which organized the work of painters and sculptors in the same fashion as the work of masons, tailors or blacksmiths.[5] In the seventeenth century, however, the development of patronage began to separate the fine arts from other crafts. Composers, painters, writers and even philosophers (Voltaire, for example) were employed by aristocratic or princely patrons, sometimes retained on annuities or pensions, sometimes paid directly for the work they produced. Now, with industrialization, market relations increasingly replaced patronage.

In Britain particularly the commercialization of the arts had already been well under way in the eighteenth century. There, successful writers such as Alexander Pope were independent; while the novelist Oliver Goldsmith wrote in 1762 that: 'At present the few poets of England no longer depend on the Great for subsistence, they have now no other patrons but the public, and the public, collectively considered, is a good and generous master ... the ridicule therefore of living in a garret, might have been wit in the last age, but continues such no longer, because no longer true.'[6]

In France, the move towards the market, following the French Revolution, was rather more abrupt. Change had already begun in the mid-eighteenth century with the emergence of the role of critic, the practice of public exhibition and the creation of the French Royal Academy of painting and sculpture,[7] while writers and painters had already begun to separate themselves from craftsworkers and artisans.[8] After 1789 the rising bourgeoisie finally dissolved the old guild forms of organization, and an acute crisis developed. The structures for the support of art that had existed under the *Ancien Régime* were destroyed. For example, the French Royal Academy disappeared

in 1793. This opened the way for a free market in art, but the traditional clientele, the aristocracy and the clergy, had also disappeared, and a still existing critical community of connoisseurs, who understood art, were no longer necessarily those who could afford to buy and therefore support it financially.[9]

By the early decades of the nineteenth century, however, literature and the arts were established and constituted as 'autonomous fields ... each having its own laws of functioning.'[10] These changed circumstances, combined with the influence of the Romantic movement, resulted in the construction of a new definition of the 'artist' or 'writer.' While the market destabilized the organization of the arts and crafts, the Romantics elevated the artistic genius to the status of godlike hero. Art now expressed the originality of the unique creative individual, and the artist's duty was to realize himself and his unique vision rather than to create works that expressed the dominant beliefs in society.

Some artists welcomed the advent of market relations, which emancipated them from the rich and powerful. They believed that artists would now take their rightful place in society. 'Never,' wrote one French critic in 1832, in the influential journal, *L'Artiste*:

> has art ... in all its forms, exercised such universal authority; never has the artist achieved so much popular influence ... The artist today is at the very centre of society, he draws inspiration from the desires and sufferings of all, he speaks to all and creates for all; he is no longer servant but people; he earns his way simply and solely from his work and the free productions of his genius; thus his social position has become more moral, more independent, more apt to favour the progress of art.[11]

This euphoria was short-lived, for it soon became clear that the new freedom was for some merely the freedom to starve. Patronage might have been irksome, but at least was relatively predictable. Now long-established crafts were threatened by factory production and all forms of art were subject to the vagaries of the market. The artist no longer had an assured audience, for whereas the patron had commissioned specific works, the tastes of the bourgeois consumer were an unknown quantity, so that the artist had to guess what would please. Art was becoming just another commodity, to be produced speculatively in the hope that it would sell. The artist not only had to prostitute his art to the logic of profit, but was expected to entertain an audience, which (or so at least he felt) lacked discrimination.

Thus the artist was set against the bourgeois 'philistine'[12]: that crass and undiscriminating individual, for whom art was a status symbol, an opportunity for the display of wealth rather than taste. It was all very well for Oliver Goldsmith to portray the new public as a 'good and generous master', for he was one of the lucky ones, whose pious novels pleased a wide middle-class readership. Less fortunate artists felt that they had merely exchanged one master for another, worse one, and had now to produce works to please the

nouveaux riches. As a result, painters stuck to sentimental scenes designed for the boudoir or salon, instead of attempting heroic themes. 'The art of drawing is entirely dedicated to the production of lithographs, albums and vignettes, compositions rapidly done and quickly sold,' wrote the critic quoted above, 'and the great music of the opera has been replaced by the vaudeville orchestra.'[13]

Later, Baudelaire likened the artist in this new situation to the gladiator in ancient Rome, tortured to amuse the spectators, the hated bourgeoisie.[14] In a letter to his friend, the playwright Feydeau, Gustave Flaubert used the same comparison: 'The bourgeois hardly realise that we are serving up our heart to them. The race of gladiators is not dead: every artist is one of them. He entertains the public with his death throes.'[15]

The antagonism between bohemian and bourgeois gave rise to a paradoxical situation in which to succeed was, for the artist, to fail. The artist longed for fame and recognition, but since, as he believed, his new audience lacked taste, then it must follow that those artists who *were* successful had capitulated to bourgeois vulgarity. By the same token, to fail to please the bourgeois public was surely the most reliable proof of the artist's originality and genius: 'the art game is, in fact, in relation to the business world, a losing game, a game of loser takes all. The real winners are the losers: those who earn money and honours ... those who achieve worldly success surely jeopardize their salvation in the world beyond.'[16] The emerging bohemian role reflected this double ambivalence: society's ambivalence towards art and the artist's ambivalence towards worldly success.

Once the artist was identified as an antagonist of the dominant groups in society he was transformed into a symbolic figure, who carried a weight of ideological meaning. He not only personified the changed and uncertain status of art in the industrial age, but became the opponent of every aspect of bourgeois society, and acted out a wholesale critique of the social, political and moral values of modernity – or rather their absence.

For the central faultline of modernity was this: that the immense energy and rapid development of the economy and of consumption were essentially amoral. The machine-based industrial economy, dependent on scientific and technical advance and equally on the freedom of capital, not only revolutionized production; *all* traditional and accustomed relationships were disrupted – 'all that is solid melts into air'. The dynamic free-for-all of modernity generated the belief system of liberal individualism. This was a philosophy of personal autonomy, freedom and continual change: freedom of capital; freedom from the authority of established religion; freedom from the ties of custom and deference; a demand for the individual democratic rights of every citizen; and freedom of the artist to experiment rather than relying on tradition and craft. 'The fundamental assumption of modernity is that the social unit of society is not the group, the guild, the tribe, or the city, but the person. The Western ideal was the autonomous man, who, in becoming self-determining, would achieve freedom.'[17]

The bourgeoisie welcomed economic individualism, which benefited the members of this rising class so greatly. The new industrialists were bold in their adoption of radical individualism in the economic sphere, and more than ready to tear up the traditional relations between master and servant and to destroy the old paternalistic order in the process. They sought new horizons for their operations, constantly seeking to expand and innovate. Yet political and cultural freedom alarmed them. Artists, just like the bourgeois economic experimentalists, wished to explore new territory, but this was unwelcome. The new class of entrepreneurs 'feared the radical experimental individualism of modernist culture.' The feeling was mutual, for 'conversely, the radical experimentalists of the culture ... were willing to explore all dimensions of experience, yet fiercely hated bourgeois life.'[18] Those in power made strenuous attempts to maintain traditional codes of behaviour, or to establish new and more exacting standards in the realm of personal conduct, but in their efforts they encountered puzzling dilemmas.

The sociologist Max Weber believed that the 'Protestant ethic' – the puritan emphasis on thrift, restraint and the work ethic – had favoured the development of capitalism. Yet spending was as necessary as saving to the success of capitalism. A consumer society already existed in the eighteenth century (if not earlier) and was as much the motor for economic expansion as an emphasis on capital accumulation. This led to an uncertainty whether or to what extent the free individual should spend or save, how far he should indulge his desires and how far defer gratification and save his energies for work. There was therefore a fundamental tension between work and pleasure, restraint and excess. Christian ethical values were, moreover, in many respects at odds with the belief that every individual should be free to follow his or her desires at will, but also on occasion objected to the harsh social attitudes of some of the newly powerful class of industrial magnates. Consequently, the modernity of the nineteenth century was incomplete and contradictory. Bourgeois leaders tried to enforce a rigidly conservative moral code in order to stem the floodtide of immorality they feared might engulf them. This code was not itself part of the logic of capital, consistent rather with the puritanism of a former time than with the pleasure-seeking impulses of consumerism.

Weber wrote of the disenchantment of this world, whereby a widespread sense of loss tinged industrial society with melancholy. Modernity was an 'iron cage.' Many members of the educated classes felt a deep ambivalence towards the society upon which they depended for their existence, and were dubious about a social order that seemed mechanical and utilitarian, dominated by the wealth creation that should have been a means rather than an end in itself. In an age of doubt and debate regarding religion, even Christian writers and thinkers felt that religion alone was insufficient to counteract the tendency to perceive culture and education in utilitarian terms. Earnest, soulful Victorians turned to Art to give spiritual meaning to life.

Matthew Arnold wrote one of the best known attempts to elevate the role

Figure 5 Popular music spreads the bohemian legend

of culture to the moral and spiritual plane. In *Culture and Anarchy*, published in 1867, he castigated the 'philistines', those 'nine Englishmen out of ten at the present day [who] believe that our greatness and welfare are proved by our being so very rich'.[19] Arnold felt that the whole civilization had become 'mechanical and external', and that the unorganized 'anarchy', the uneducated, mob consciousness of the common people posed a danger to civilized society. His remedy for this debasement of society was: Culture. This was to be 'the great help out of our present difficulties; culture being a pursuit of our total perfection by means of getting to know ... the best which has been thought and said in the world'. Arnold further defined culture as 'the study of perfection, [which] leads us ... to conceive of true human perfection as a *harmonious* perfection, developing all sides of our humanity; and as a *general* perfection, developing all parts of our society.' It was above all 'an inward operation', which 'places human perfection in an *internal* condition.'[20] Culture as thus defined came to have a semi-religious function and value, even virtually to replace religion. This was possible because in spite of being

produced as a commodity, it remained to some extent distanced from capitalist values.

These currents of change resulted in a new conception of the creative artist and transformed his relationship with the public. As art developed private and subjective meanings, it lost its social purpose in an age that worshipped technical progress and the expansion of wealth, while as technology advanced, there no longer seemed a need for the individual artist, his skill rendered obsolete by mass production. Yet paradoxically, the developing role of the artist as an oppositional figure in society meant that even if the purpose and place of art were increasingly questioned, the role and identity of the artist became more prominent.

The term 'bohemian' signified the paradoxical situation of the artist, and what was felt to be his ambiguously marginal, yet challenging status. In France, 'bohemian' had been the traditional term for gypsies, because they were thought to have come from Bohemia in central Europe. Early-nineteenth-century researchers traced the gypsies' language, Romany, back to Sanskrit, which suggested that the wandering tribes had actually originated in India, but the name with its multiple derivations persisted.[21]

It was extended to impoverished artists, initially by the journalist (and in 1848 revolutionary deputy) Félix Pyat in 1834, who wrote of the way in which: 'the mania of young artists to wish to live outside their time, with other ideas and other customs, isolates them from the world, renders them strange and bizarre, puts them outside the law, banished from society; these are today's bohemians.'[22] They were a new race of nomads, whose wandering life from attic to attic, and moonlight flits to avoid paying rent, made them seem like the popular stereotype of gypsies. Like gypsies they moved outside the normal restrictions of society; like gypsies they dressed with ragged flamboyance; like gypsies they rejected honest toil and thrift, preferring to live on their wits; and, just as the gypsies scraped a living by the exploitation of their suspect skills as fortune-tellers, confidence-tricksters, entertainers and even magicians, so new bands of writers and painters produced artefacts that seemed incomprehensible and therefore alarming, often immoral and sometimes disturbingly magical. The vocation of artist became tainted with the social and moral ambiguity formerly attached to performers, wanderers and mountebanks, an association that further increased the ambiguity of the bohemian role.

Until this new meaning for the term developed, 'bohemian' had traditionally been used in France to refer to the semi-criminal underworld. Marx deployed it in that sense when he referred to the 'vagabonds, discharged soldiers, discharged jailbirds, escaped galley slaves, swindlers, mountebanks ... pickpockets, tricksters, gamblers, procurers, brothel-keepers, porters, *literati*, organ-grinders, rag-pickers, knife-grinders, tinkers, beggars − in short, the whole indefinite, disintegrated mass, thrown hither and thither, which the French term *la bohème*.'[23] Marx's own life − in exile or in hiding, embroiled with underground political groups, snatching a living from casual journalism,

forced to move from one shabby lodging to the next – was itself touched with bohemianism. Perhaps partly for that very reason, he consistently put a political distance between the bohemian riff-raff and the genuinely revolutionary socialists and communists. He preferred the more solid political loyalties of the industrial working class to the fickle political enthusiasms of what he called the 'lumpen proletariat'. In this he articulated a perennially uneasy relationship between the more conventional socialist movements and the aesthetic dissidents, the new bohemians, the artists, whose precarious economic status made them 'lumpen petty bourgeois', 'lumpen intellectuals'.

There was, nevertheless, a strong political dimension to the bohemian identity, particularly as it emerged after 1815 in Restoration France, when demographic change and political impotence acted to marginalize whole sections of bourgeois youth. The numbers of young men rose faster than the number of jobs available. In 1826 persons under thirty years of age constituted 67 per cent of the French population compared with 57 per cent a hundred years earlier, and there was a particularly high rate of unemployment among young men from middle-class families who were seeking professional or commercial positions.[24]

Some, rebels from upper-middle-class families, were able to pursue an artistic calling by virtue of an independent income. Indeed, remittance men who lived on large or meagre allowances from their families became, and remained, familiar figures in Bohemia. Others, however, were the 'poor relations' of the bourgeoisie, young men whose fathers were clerks, craftsworkers or owners of small businesses, a lower middle class in decline, whose livelihoods were contracting in the face of competition from factory production, new forms of commerce and the reorganization of white-collar employment. In addition: 'the literary and artistic fields attract a particularly strong proportion of individuals who possess all the properties of the dominant class *minus one*: money. They are ... aristocrats already ruined or in decline, members of stigmatized minorities like Jews or foreigners.'[25] Few bohemians came from working-class or proletarian backgrounds. Bohemia was essentially an oppositional fraction of the bourgeois class. It was that section of the bourgeoisie which preserved cultural values and was therefore a 'civilizing fraction'.[26]

Drawn to Paris, the cultural and political centre of France, in the 1820s, the young men from this fraction became all the more oppositional because of the repressively conservative political climate. The defeat of Napoleon and the restoration of the Bourbons had ushered in a period of extreme reaction. In 1825, Arsène Houssaye, future bohemian and impresario, found himself watching the archaic ceremony of Charles X's coronation seated next to a woman who in her youth had played the part of the Goddess of Reason in a revolutionary pageant of the 1790s. The contrast between the pseudo-medieval coronation, expressing autocratic monarchy, and the pageant, expressing the now defeated republican ideals, was symbolic of the whole attempt to turn back the clock.

Intransigence and excess seemed the only possible way to rebel in these

circumstances. 'Nothing else,' wrote Balzac, 'so openly revealed the marginality to which the Restoration condemned the young':

The youth of this generation, so full of life and vitality, but not knowing how to employ their talents, not only flung themselves into journalism, conspiracies, literature and art, but dissipated them in the strangest excesses. When in the mood to work, these fine young men wanted power and pleasure; when artistic, they desired treasures; when idle they longed to excite their passions; but the long and the short of it was that they wanted a place in life, when there was no part for them to play in politics.[27]

Even after the July Revolution of 1830, which placed the 'bourgeois' constitutional monarch, Louis Philippe, on the throne and at first promised greater democracy, the new regime benefited only the most powerful sections of the bourgeoisie. This was a bitter disappointment to the radicals and republicans who had fought at the barricades to get rid of Charles X. The disillusionment was artistic as well as political, as a letter to *L'Artiste* in 1832, made clear:

I am disgusted with politics. I've had enough of sterile discussion, of hopes betrayed and so much shame and cowardice accumulated over the past two years. I've lost more happiness and sacred illusions in two years than in a lifetime ... Modern governments have made a political theory out of their contempt for the fine arts ... [which] are seen as superfluous, the luxury of empires. It would be impossible to be more devoid of any feeling for beauty and greatness than all these governments based exclusively on the principle of utility.[28]

One expression of the prevailing disillusionment was the abandonment of politics in favour of morbid introspection, embellished by all the gothic horror trappings of romanticism, with its skulls and moonlit graveyards, medieval castles and wild landscapes, and indebted to the poetry of Byron. The mood of retreat and desperation led to a veritable cult of suicide. 'Never was death more loved than then,' claimed Maxime du Camp, years later: 'it was not merely a fashion as one might imagine, it was a general weakness of the spirit which made the heart heavy and sad, which darkened thought and made death welcome as a deliverance. [This] generation had a youth of despairing sadness, a sadness inherent in their being, in the whole epoch.'[29] The suicide pact of two young playwrights, Escousse and Lebas, in 1832 personified the despair of the young, and Théophile Gautier claimed that the sound of solitary pistol shots regularly punctuated the nocturnal silence as one youth after another followed the example of these tragic figures. Even more famous was the English poet, Thomas Chatterton, who had committed suicide in 1770 at the age of eighteen, an event celebrated in the mid–1830s in a hugely successful play by Alfred de Vigny.

Later generations of bohemians maintained a tradition of political intransi-
gence. Yet their utopian idealism was liable to sour into gloom or cynicism,
for their revolutions always failed, or, even worse, if successful were betrayed.
In this as in other ways the opposition between bohemian and bourgeois
masked a certain similarity, since revolutionary absolutism not infrequently
ended in apolitical indifference.

The successive modernist movements in art throughout the nineteenth
century, and the high noon of the avant-garde in the period, roughly, from
1880 to 1918 (but continuing on into the 1930s and beyond) were similarly
both within and against the dominant culture. Their search for new sensa-
tions and raw material for their art and their exploration of forbidden terri-
tory shocked the philistines, as was intended. Yet in their continual search
for the new they paralleled, or even parodied, the ideology of continual
progress and innovation central to the industrial, technological, consumer
society to which they belonged.

Their work was ambiguous in another way in that their defence of the
purity of high art free from commerce was accompanied by forays into
popular culture and everyday life. Baudelaire wrote that the task of the artist
of modernity was to see the marvellous in the banal. This, rather than the
outmoded heroics of pompous historical art, was 'the heroism of modern
life'. In the search for that heroism artists explored the most obscure, unpoe-
tical and shocking aspects of modern existence, and found there new
meanings and unexpected beauty. Therefore, while on the one hand the artist
saw himself as a romantic genius elevated above the common run, on the
other his fascination with the everyday, the obscure, the forbidden and the
sordid contributed to the perception of the bohemian artist as one who delib-
erately went 'slumming' or was filled with '*nostalgie de la boue*'. This eventually
led to a blurring of the very distinction between art and life. The bohemian
identity came to be associated with the gutter, with low life and the
forbidden. It was unclear, however, whether this was really a search for new
material or merely the result of lack of talent. It was often argued that: 'true
bohemian sectarianism is usually carried on by people of excitable imagina-
tions and modest talents, a combination which disables them from an
ordinary existence and forces them, as consolation, to a life of dedicated
unconventionality.'[30]

This was a further dimension of the ambiguity of the bohemian identity.
The bohemians brought into play all those aspects of daily life that were *not*
central to the production of works of art. They 'scorned recognized channels
of expression',[31] and brought an artist's sensibility to bear on all those
aspects of life that were peripheral to art; dress, surroundings and relation-
ships. By so doing they challenged the bourgeois insistence that art was a
realm apart. If in many cases the work of aesthetic production played only a
minor part in lives dedicated to the performance of bohemianism, this antici-
pated the way in which the most advanced avant-garde movements aimed to
collapse art into life, to abolish the boundary between the two, and to merge

the aesthetic with the political/critical.[32] So, although Bohemia was coextensive neither with 'modernism' nor with the 'avant-garde', all three overlapped.

The cliche that the bohemians were the artists without talent, those who, as Beryl Bainbridge put it, sat around getting drunk together all day, misses the much larger problem of the artist's role in modernity. For, by the early years of the twentieth century, the artist's role was no longer, perhaps, primarily to produce art. Rather, the artist became the 'representative figure of a society unable to set clear limits for the identities and activities of its members'. He became a figure whose role was to explore 'marginal states of being and consciousness,' and who challenged the 'limits of individual and social existence'.[33]

This only served to intensify the impossibility of the bohemian role, and it is this impossibility that elicits the impossible question: 'who *were* the bohemians?' If the artist could play this new and representative role in exploring the parameters of identity and subjectivity, then he was once more a privileged and even shamanistic character. At the same time the artist who did not create, instead *performing* a role, was suspected of being a mountebank, an impostor (a bohemian, in other words) who laid claim to a genius he did not possess. Thus, just as ambiguity clouded the meaning and purpose of art in the industrial period, so the bohemian acted out this aspect of art as well, his very 'artistic' way of life a crossing of boundaries and a challenge to conventional definitions of art.

Friendship and personal relationships played an important role in Bohemia, not least in the first widely publicized bohemian group, the *Petit Cénacle* or Little Circle,[34] also known as *les Jeunes France*, or as the Bouzingots, or Bousingos. This group appeared in 1829 (before the term 'bohemian' itself came into use), when a young architect and later writer, Petrus Borel, a Romantic who was one of Victor Hugo's most ardent admirers, gathered a group of friends around him. Their most famous exploit was in 1830 when Borel organized a demonstration in support of Victor Hugo on the opening night of his play, *Hernani*. This work was controversial because it was romantic rather than following the classical conventions still favoured by French critics, and its success signified the triumph of the Romantic Movement over the theatrical conservatives. Crowds of young students and hangers-on gathered hours in advance, eating garlic sausage, drinking wine and becoming increasingly boisterous as they waited in the unlit auditorium. When the play began they signalled their support with applause and cheers against the boos and jeers of Hugo's opponents and the evening ended in riot and uproar.

By 1831 the outrageous activities of *les Jeunes France* were providing frequent copy for *Le Figaro*. Between August and October of that year they featured in seven articles, and in the first six months of 1832 there were no less than twenty.[35] This was an early example of the relationship between the existence of bohemian groups and the construction, or at least amplification, of their legend in the press.

Following the publication of his collection of poems, *Rhapsodies*, Borel became an important literary figure for several years, but by the late 1830s his career was sliding into obscurity. In the 1840s he was poverty-stricken, dependent on crumbs of freelance work, and later still his friends secured for him a post as a colonial bureaucrat in Algeria, where, having once been a revolutionary republican, he became a bitter reactionary, whose death may have been a suicide. His life illustrated the deeply bohemian themes of failure, ambivalence and the dramatization of dissent.

These themes were developed by a procession of characters larger than life. They took to the boards of the urban stage to flaunt their genius, their deviance and their notoriety. They, the famous bohemians, became celebrities, a Mount Olympus of latter-day, secular gods and goddesses to star in the myths of modernity.

Notes

1 Karl Marx and Frederick Engels, 'Manifesto of the Communist Party', in Karl Marx and Frederick Engels, *Selected Works* (London: Lawrence and Wishart, 1970), p 38.

2 This section is based on Peter Bürger, *Theory of the Avant Garde*, trans Michael Shaw (Manchester: Manchester University Press, 1984).

3 Ibid.

4 Ibid.

5 Joseph Rykwert, 'The Constitution of Bohemia', in *Res* xxxi (Spring, 1997), p 110.

6 Ibid., p 16n. See also John Brewer, *The Pleasures of the Imagination: English Culture in the Eighteenth Century* (London: Harper Collins, 1997), for an extended discussion of these and other developments in British intellectual life and the arts at this period.

7 Annie Becq, 'Expositions, Peintres et Critiques: Vers L'Image Moderne de L'Artiste', *Dix-Huitième Siècle*, xiv (1982), pp 131–49. My thanks to Tony Halliday for drawing my attention to Annie Becq's work.

8 Ibid., p 133.

9 Annie Becq, 'Artistes et Marché', in S.C.Bonnet (ed), *La Carmagnole des Muses: l'Homme de Lettres et l'Article dans La Révolution* (Paris, 1988), pp 81–95.

10 Pierre Bourdieu, 'Field of Power, Literary Field and Habitus', in Pierre Bourdieu, *The Field of Cultural Production*, trans Claude Verlie (Oxford: Polity Press, 1993), p 162.

11 Saint Chéron, 'de la poesie et des beaux arts dans notre époque', in *L'Artiste: Journal de la Littérature et des Beaux Arts*, 1re Série, iv (1832), p 50.

12 Rykwert, 'The Constitution of Bohemia', p 112, suggests that the word developed its current meaning towards the end of the seventeenth century among German students, who as a result of riots between town and gown came to refer to their opponents as Philistines, i.e. the enemy, and 'by the last quarter of the eighteenth century, Eichendorff, Goethe, Schiller and Wieland were using the word to signify, generally, the unappetizing and art-alienated individual ... Through Thomas Carlyle and later Matthew Arnold, it was adopted into general English usage.' In France the alternative 'Boeotian' was used, a reference to the 'dull

witted' ancient Greek Boeotians, and popularized in Alain Lesage's *Gil Blas* (1715–35).

13 Saint Chéron, 'De la poesie et des beaux arts', p 178.

14 César Grana, *Modernity and Its Discontents: French Society and the French Man of Letters in the Nineteenth Century* (New York: Harper Row, 1967), p 141.

15 Bourdieu, 'Field of Power', p 169.

16 Pierre Bourdieu, 'Is the Structure of *Sentimental Education* an Instance of Social Self Analysis?' in Bourdieu, *The Field of Cultural Production*, p 154.

17 Daniel Bell, *The Cultural Contradictions of Capitalism* (London: Heinemann, 1979; 2nd edition), p 16.

18 Ibid., p 18.

19 Matthew Arnold, *Culture and Anarchy* (London: John Murray, 1867), pp 12–13.

20 Ibid., p 124.

21 They were also referred to as *gitanes* or *gitanos*, a corruption of *Egyptien*, alluding to another version of their origins. See Brown, *Gypsies and Other Bohemians*, chapter 2. The German term *Zigeuner* and the French *tsigane* came from the Greek *athinganoi*, meaning 'untouched' or 'touch me not'. Rkywert, 'The Constitution of Bohemia', p 114. The Athinganoi were a heretical early Christian sect, 'whose devotees were known as fortune-tellers and magicians'.

22 Félix Pyat, 'Les Artistes', *Le Nouveau Tableau de Paris* iv (1834), p 9.

23 Karl Marx, 'The Eighteenth Brumaire of Louis Bonaparte', in Marx and Engels, *Selected Works*, p 137.

24 Ellie Schamber, *The Artist as Politician: The Relationship Between the Art and the Politics of the French Romantics* (Lanham, MD: University Press of America, 1984), p 127, quoting Bertier de Sauvigny, *La Restauration* (Paris: Flammarion, 1955), pp 237, 319, 321.

25 Bourdieu, 'Field of Power', p 165.

26 See Raymond Williams, 'The Bloomsbury Fraction', in *Problems in Materialism and Culture* (London: Verso, 1980), p 169.

27 Honoré de Balzac, *Illusions Perdues* (orig publ 1837–43; Paris: Le Livre de Poche, 1983), p 329.

28 Anon., *L'Artiste* (5 Septembre 1832), p 79.

29 Enid Starkie, *Petrus Borel the Lycanthrope: His Life and Times* (London: Faber and Faber, 1954), p 60, quoting Maxime du Camp, *Souvenirs*, vol 1, p 160.

30 Grana, *Modernity and Its Discontents*, p 72.

31 Roger Shattuck, *The Banquet Years: The Origins of the Avant Garde in France, 1885 to World War One* (New York: Viking, 1968), p 18.

32 See Bürger, *Theory of the Avant Garde*.

33 Siegel, *Bohemian Paris*, p 389.

34 They chose this name in order to differentiate themselves from the established circle of older writers led by the Romantic writer, Charles Nodier.

35 Starkie, *Petrus Borel the Lycanthrope*, pp 92–3.

CHAPTER THREE

THE BOHEMIAN STAGE

The power of seeing the mystery traced like a watermark beneath the transparent surface of the familiar world is granted only to the visionary.
> *Henri LeFebvre:* Critique of Everyday Life

An essential precondition for the emergence of the bohemian was the expansion of urban society. In the vast new cities of modernity increased social mobility and the development of new callings and ways of life resulted in the appearance of new figures and identities that were less fixed, more fluid and changeable. The bohemian was one such figure, and for him the metropolis was a kind of counter-utopia. Nineteenth-century reformers and moralists might denounce the urban labyrinth as a satanic industrial hell, but the bohemians transformed the city into their own promised land, an unknown, foreign world, full of melancholy and nostalgia, danger and excitement.

City life offered practical advantages to the bohemian. It provided an escape from the responsibilities of the family, and made possible the formation of new groups and friendships based on interest and work rather than on kinship. The streets, bars and hidden corners provided a revolutionary source of material. More important still were its symbolic and aesthetic aspects. The bohemians modernized the aesthetic of Romanticism by applying it to urban life. Where romantic artists had invested past time and wild or distant places with glamour and meaning, the bohemians saw as wild and strange a beauty in the sublime desolation and ugliness of the industrial city. (For example, Impressionist painters, such as Manet, Caillebotte, and Monet, transformed the cityscape into works of art.)

In the first two-thirds of the nineteenth century Paris was the only metropolis capable of providing the preconditions for the development of an artistic counterculture. French political, intellectual and cultural life were far more concentrated in their capital city than was the case in Britain, and this centralized nature of French life meant that Paris was a magnet, which 'absorbed everything, attracted everything, and did everything,' as the Goncourt brothers observed. Germany and Italy, meanwhile, were not yet even united into nation states.

Paris, by contrast, had been a centre for luxury trades and the arts during the *Ancien Régime*, thanks to the proximity of the court at Versailles, and by 1830 it was a cultural and entertainment centre without rival. Continual carnivals, concerts and dances were staged there, and it boasted many more theatres than London for a population half the size. It also boasted an ancient university to which students from all over France and beyond had been drawn since the Middle Ages (the Latin Quarter had been so called because Latin had been the only common language of medieval students).

For the first bohemians Paris was a dream world. The nineteenth-century republican, Alphonse Delvau, maintained that 'one dies of Paris as one dies of poison taken in minute doses'. The city was as addictive as a drug. At the same time it resembled a natural formation rather than a human construction. For Delvau it was an ocean. Beneath its charming surfaces were depths hiding sinister monsters and turbulent currents, yet mingled with pearls and corals, wrote Delvau. The bohemian became a deep sea diver who plunged into an alien element and exposed himself to its dangers in order to extract its treasure, the truth of experience. He was an explorer in an exotic country, and while it was good, Delvau suggested, to learn about Mexico, Guatemala and Timbuctoo, 'wouldn't it also be good to know how the Caribs and Redskins [*sic*] of Paris are born, live, eat, love and die?'[1]

Writers such as Baudelaire, Marx, the novelist Eugène Sue and Privat d'Anglemont, compared Paris to the American wilderness of James Fennimore Cooper's novels. Cooper, wrote Privat, 'shows us the inhabitants of the American forest as forever young and carefree, giving themselves over to pastimes that a ten year old in civilized countries would despise. You see the same thing here among these savages of Paris.'[2] For Baudelaire too, the slums and back streets were filled with 'tribes we term savage,' but who were actually 'the ruins of great civilizations that have disappeared'.

In the 1840s an English urban explorer, the journalist Henry Mayhew, referred to the East End of London as an 'undiscovered country.' The echo, whether deliberate or not, of Hamlet's most famous soliloquy, gave the Victorian rookeries the sinister aura of being the country 'from whose bourne no traveller returns,' in other words, the underworld of death. In the 1880s and 1890s the East End became 'darkest London' (a reference to 'darkest Africa'). Such racialized comparisons seemed plausible in cities in which the gulf between rich and poor was huge; but were also intended to dramatize the figure of the bohemian adventurer who moved between the two, and who transformed his wanderings into the raw material for his work.

Early bohemians relished the dark obscurity of Paris. In 1835 Théophile Gautier and Gérard de Nerval rented rooms in the Impasse du Doyenné near the Louvre. This was then a melancholy and sordid district, chosen by Balzac as appropriate for the dwelling of one of his most unpleasant characters, Cousin Bette: 'The rue du Doyenné and the blind alley of the same name are the only passages that penetrate this sombre and deserted block, inhabited presumably by ghosts, for one never sees a soul.' The houses lay 'wrapped in

the perpetual shadow cast by the high galleries of the Louvre, blackened on this side by the north wind. The gloom, the silence, the glacial air, the hollow, sunken foundations, combine to make these houses seem so many crypts, or living tombs.' Not only was the area desolate, at night it was actually dangerous, 'a place of cut throats, when the vices of Paris, shrouded in night's mantle, move as they will'. Beyond the houses was a swamp, with 'small plots and sinister hovels … and steppes of dressed stone and half demolished ruins'. Yet such a desolate region in the very heart of Paris symbolized 'the close relationship of squalor and magnificence characteristic of the queen of capital cities'.[3]

For although the capital city was a dark labyrinth, it was also a glittering stage. Writing in 1836, Fanny Trollope described how Paris was thronged with people at all times of the day and evening, while Alphonse Delvau noted at the end of the 1850s that his fellow Parisians were 'never at home – there is so much to see and do outside, whatever the weather. So – their houses are dirty inside, while their streets are swept every morning. Their 100,000 dwellings are damp, unwholesome and sombre, while their public squares, corners, quays and boulevards are inundated with sun and light. All the luxury is out of doors.'[4]

This magical city acted as a magnet to the ambitious, and the move from the provinces to the capital, from the periphery to the centre, was an essential component of the bohemian quest. Typically the teenage would-be bohemian was inspired by a desperate longing to escape the narrow round of provincial life, the dreary promenade round the city square, the mournful walks on the ramparts with the two or three kindred spirits from among his student peers, the dreadful family gatherings of faded aunts, adoring cousins and an anxious mother. Worst of all was the baleful, authoritarian presence of the paterfamilias, urging the young genius to study law or get a post in the civil service, when all he wanted to do was to write poetry. Only the Capital offered a stage of sufficient size and limelight bright enough to reveal his true talent. Lucien de Rubempré, for example, in Balzac's *Lost Illusions*:

> saw himself while living in Angoulême as a frog under a stone at the bottom of a swamp. He had a vision of Paris in all its splendour: Paris, which rose up like Eldorado in the provincial imagination; clad in gold, wearing a diadem of precious stones, its arms opened to talent. He would receive a fraternal accolade from illustrious men. There genius was welcomed.[5]

Rastignac, another of Balzac's anti-heroes, confronted the capital as a realm to be conquered when he looked out over Paris from the Père Lachaise cemetery:

> and saw Paris spread out below on both banks of the winding Seine. Lights were beginning to twinkle here and there … There lay the splendid world that he had wished to gain. He eyed that humming hive with a look that foretold its despoliation … and said with superb defiance, 'It's war between us now.'[6]

The longing to escape the provinces persisted well into the twentieth century. In the 1930s Dylan Thomas was desperate to get away from Swansea. 'It's impossible,' he wrote to Pamela Hansford Johnson, 'for me to tell you how much I want to get out of it all ... out of narrowness and dirtiness, out of the eternal ugliness of the Welsh people, and all that belongs to them, out of the pettinesses of a mother I don't care for and the giggling batch of relatives.'[7]

Twenty years later it still seemed to the hero of Colin McInnes's *Absolute Beginners*, that London was 'as ripe for conquest as Balzac's Paris,' as the blurb on its cover put it. The improbable vantage point from which this pop bohemian photographer looked down on his capital city was the roof garden of Derry and Toms' department store in Kensington High Street. Listening to the number one hit of the moment, 'He's got the whole world in his hands', sung by a fourteen-year-old prodigy, Laurie London, he watched the city below:

Twisting slowly on your bar stool from the east to south, like Cinerama, you can see clean new concrete cloud kissers rising up ... from the Olde Englishe city squares, and then those gorgeous parks, with trees like classical French salads, and then again the port life down along the Thames ... and then, before you know it, you're back again round a full circle in front of your iced coffee cup.

The novel clearly linked bohemian insouciance with the new affluence of a newly discovered group, the teenager: 'This teenage ball ... had a real savage splendour, because we'd loot to spend at last, and this world was to be our world, the one we wanted.'[8]

The great city, with its immense and violent contrasts, not only provided raw material for the artist. It also provided the circumstances in which a range of new identities could develop, and the bohemian was one of the most ambiguous of these. In the underworld of the anonymous crowd the identities of *flâneur*, investigative journalist, spy, criminal and revolutionary became blurred with that of artist. The seditionaries, counter-revolutionary conspirators and police spies who mingled with the riff-raff of the back-street bars were often writers as well, contributors to the many political papers and periodicals that sprang up and died. As Marx observed, 'The whole way of life of the professional conspirators has a most decidedly bohemian character.' Proletarian conspiracy, he pointed out, 'naturally affords them only very limited and uncertain means of subsistence'. They led 'irregular lives whose only fixed ports of call are the taverns ... the rendezvous of the conspirators,' and as a result, 'their inevitable acquaintance with all kinds of dubious people, places them in that social category which in Paris is known as *la bohème*'.[9]

Besides these there were other groups with whom the bohemians identified as fellow outcasts. There were the rag-pickers and prostitutes celebrated by

Figure 6 Honoré Daumier: Saltimbanque playing a drum, ca. 1863. Courtesy British Museum

Baudelaire. There were also the hordes of street entertainers, organ-grinders, *saltimbanques* or jugglers and acrobats, musicians, singers and Italian puppet-makers. The way of life of these itinerant performers, like that of the bohemians themselves, questioned the boundary between crime and artistry, between the fine arts and the popular. Some performers were 'vagabonds of the intellect ... who write topical songs for poets to recite in the squares ... play cutters ... [whose] metier consists in abridging popular melodramas.'[10] They often came up against the law, since police and law courts regarded their activities as a cover for begging,[11] but Baudelaire's friend, Théodore de Banville, asked rhetorically, 'What is the saltimbanque if not a free and independent artist who accomplishes prodigious feats to earn his daily bread ... without hope of ever getting into any academy?'[12]

Urbanization and the birth of an industrial working class led to overcrowding and disease. Whole classes were falling into destitution and becoming criminalized.[13] One result was that cities became the focus of new forms of intellectual as well as social activity. The collection of statistics and the writing of reports were inextricably bound up with the new journalism, which described low life for an educated public, fascinated by this underworld. This strange love–hate relationship between bohemian and bourgeois, middle class and underclass, was repeatedly given expression in popular literary form. For example, when in 1843 Eugène Sue's novel, *Les Mystères de Paris*, began to appear in serial form it found a huge audience.

Alexandre Privat d'Anglemont was one of the most dedicated bohemian chroniclers of the Paris underworld. He was famous for his nocturnal walks, and told the story of how once when wandering through the streets at night he had been accosted by a group of robbers (including a woman in trousers). When he told them who he was they roared with laughter – for he was always notoriously hard up – and invited him to their home for a meal.

Although he called for the demolition of the worst slums, his articles read as a defence and celebration of old Paris, the capital, he felt, of diversity and strangeness. The Parisians were astonished by nothing, he said, since they turned so many unexpected corners and saw so many different costumes and ways of life as they visited the numerous little villages that went to make up the great city. Faced with a spectacle that would astound anyone else, the Parisian's response was a blasé 'Seen it!'

In this respect at least, Privat was no Parisian, since he never lost his capacity for astonishment. 'The changing kaleidoscope that is Paris makes this city the cause of perpetual surprises,' he wrote. Paris was a dream world. It was also a stage on which everything was a performance, unlike London, where 'everyone minds his own business, working, so to speak, in camera; equally in the street everyone is quick to forget his profession in order to live, walk, dress like everyone else. No-one there dreams of putting on airs.' But 'in Paris everyone is posing, everyone tarts themselves up, everyone has the *air* of being an artist, a porter, an actor, a cobbler, a soldier, a bad lot, or extremely proper.'[14]

Privat was a prose poet of the forgotten corners and eccentric characters of his chosen city. He celebrated its enormous resistance to regulation and order, typical of a bohemian sensibility which turned the whole of hidden Paris into a kind of counterspace and transformed its shabby, forgotten corners into sacred locations. These peripheral places provided the setting for the creation of the oppositional identity of bohemian.[15]

Within these special districts bohemians congregated in particular places: in bookshops, galleries, restaurants and private salons. The first and single most important bohemian meeting place, however, was the café. The café was the material location of bohemia. It was the end point of the bohemian journey.

Café culture was the consummation of the bohemians' love affair with urban life. They found there, or hoped to find, whatever had made them set out on their journey to Bohemia in the first place: the search for an enchanted way of life. The café was a chameleon environment, both hell and paradise. Van Gogh wrote of his painting of the Night Café that: 'I have tried to show the café as a place where one can destroy oneself, go mad or commit a crime.'[16] For Thomas Mann, by contrast, the café was 'neutral territory ... untouched by change of season ... [a] remote and sublime sphere in which one is incapable of grosser thoughts'.[17]

By 1900 the Munich suburb of Schwabing had become a radical Bohemia. There, the playwright Frank Wedekind described the importance in a writer's life of one of the city's smarter bohemian cafés, the Luitpold. 'For a hermit like myself, the crowds of people who continually throng the rooms mean a great deal. Now and then you find an acquaintance among them.'[18]

To participate in café life was, however, more than a matter of alleviating loneliness, for it was by participating in the social institution of café life that the lonely artist *became* a bohemian. The most famous cafés provided an immediate point of contact for newcomers to Bohemia. On his arrival in Munich in 1909, Leonhard Frank, for example, made straight for the notorious Café Stephanie:

One had only to go in to feel at home there. The principal room ... had a glowing coal stove, warm, upholstered seats with a strong musty smell, red plush, and Arthur the waiter. Arthur jotted down in a ragged notebook, held together with a rubber band, the pfennigs owed him by his customers. This ... room was crowded and had its own warm smell – a special mixture of coffee, mustiness and dense cigarette smoke.[19]

In the nineteenth-century world of freezing garrets the café was a cosy alternative, a 'home for the homeless.' In 1840s Paris Murger and his friends sat for hours in the upstairs room of the Café Momus for the price of a single coffee. At the turn of the century, Else Lasker Schuler, the Berlin poetess, and her partner, Herwath Walden, more or less lived in the Café des Westens. There, a fellow habituée described how 'the couple, with their

incredibly badly brought up son, could ... be seen from midday until late at night in the café ... with all the wild, arty young men and women. The little family nourished itself exclusively on coffee so far as I could see, brought by the ... head waiter ... who pityingly allowed them to defer payment, or for which an honest customer paid. The child, meanwhile, thoroughly at home, bore down on the plates of food and in the twinkling of an eye (while no-one else was looking) took whatever he fancied.'[20] (However, the owner of the Café des Westens eventually decided he had had enough, banned Else Lasker Schuler, because she didn't order enough, and took the café upmarket.)

The café, however, was more than a substitute home. It performed different and contradictory functions simultaneously. One of the most important of these was its role as a labour exchange for intellectuals and artists. When the post was slow and there was no telephone, fax or email, the café performed an essential function in bringing together journalists and editors, painters and models, actors and directors. From Canaletto in eighteenth-century Venice to Modigliani in Paris before the First World War, artists hawked their wares at café tables, and to this day cafés are used as informal art galleries.

Cafés were also used as studies or libraries for individual work. Ilya Ehrenberg recalled that paper was provided free for writers and artists in the Rotonde, which was one of the most famous hang-outs for bohemians in Montparnasse before the First World War. A German bohemian recalled that every day by late morning the Café des Westens was full of solitary artists sketching and writers scribbling; only in the evening did conversation dominate.

Conversation was nevertheless the most important aspect of the café. Some of those who gravitated to café life had had little education; the café was their university. In the mid-nineteenth century Gustave Courbet and his friends met in the Brasserie des Martyrs, a famous Paris café, to discuss the development of their work, and German bohemians before the First World War particularly tended to emphasize the seriousness of the café life. There was 'a rather formal atmosphere in the Café des Westens,' recalled one (not the impression gained from some other descriptions); 'opinions or achievements were carefully weighed, sharply criticized'.[21] There, 'at any hour of the day or night one could meet the people one wanted to talk with or start a press with, open a studio with, form a group with.'[22] Another regular at the Café des Westens described it as 'a school and a very good one at that. We learned to see there, to perceive and to think. We learned, almost in a more penetrating way than at the university, that we were not the only fish in the sea, and that one should not look at only one side of a thing but at least at four.'[23] This educational function was assisted by the practice of providing free newspapers and magazines for customers. Stefan Zweig described the Viennese café world of his youth before the First World War as 'a sort of democratic club to which admission costs the small price of a cup of coffee. Upon payment of this mite every guest can sit for hours on end, discuss,

write, play cards, receive his mail, and, above all, can go through an unlim-
ited number of newspapers and magazines.' Presented with the entire jour-
nalism of Europe, including the rarest and most specialized journals, the
clientele 'knew everything that took place in the world first hand.'[24]
However, Frank Wedekind more cynically (or perhaps because he was writing
his diary at the time rather than remembering his youth nostalgically while
in exile) reported that 'the illustrated papers generally vanish from their
folders the very first day: the empty folders evoke a certain embarrassment in
the reader, when he has taken the trouble to pick them out, taken them to
his seat and then opened one after the other with dwindling assurance.'[25]

Christopher Isherwood described the satisfaction of working, as a foreigner,
in the atmosphere of the Berlin cafés of the 1920s: 'It was most unlikely that
any of the people here would be able to understand what he was writing.
This gave him a soothing sense of privacy, which the noise of their talk
couldn't seriously disturb; it was on a different wavelength. With them
around him, it was actually easier to concentrate than when he was by
himself. He was alone, yet not alone. He could move in and out of their
world at will.'[26] And in the same period, Louis Aragon felt that the café
atmosphere positively encouraged the imagination. 'Reverie,' he wrote,
'imposes its presence, unaided. Here surrealism resumes all its rights. They
give you a glass inkwell with a champagne cork for a stopper, and you're
away! Images flutter down like confetti!'[27] Most famously of all, Jean-Paul
Sartre and Simone de Beauvoir used their favourite cafés as writing rooms; de
Beauvoir's letters and diaries are peppered with references to her daily visits.

Others, however, believed that cafés prevented serious work. Nancy
Cunard's friend, the writer Richard Aldington, summed up this view in the
1930s. 'The café addict,' he said, sat around drinking and talking, 'severely
critical of all work except that of his own little group, which he absurdly
overestimates, and holding forth at length on what ought to be done and
what he is going to do, instead of doing it.'[28]

Cafés were political as well as intellectual centres. The coffee houses of the
English Restoration and the French cafés of the eighteenth century had been
focal points for democratic opposition to autocratic monarchy, a role that
continued throughout the nineteenth century under successive repressive
governments in France and Germany. The Parisian journalist Firmin Maillard
wrote a romantic requiem for the famous Brasserie des Martyrs and its bohe-
mians, implying that political opposition had been stifled and found an alter-
native outlet in self-destruction. His bohemians:

dead before their time, fallen by the wayside, are not so deeply buried but
that they will hear your hypocritical talk of laziness, absinthe and women
... Some will raise themselves to cry to you: 'When we were young we
already had no future, we were defeated before we had the chance to fight,
and ... forced to stifle the ardent love of liberty in our hearts we took
refuge in an artificial paradise.'[29]

He was writing of the repressive years of Napoleon III's Second Empire, when cafés became a refuge for dissidents. As the imperial dictatorship began to disintegrate in the late 1860s, they nurtured conspiracies – as they had before 1789 – and the Café Robespierre, the Café Madrid and the Café Cabanet became the headquarters of the anti-Bonapartists.[30]

The compulsive attraction of café life was, however, ultimately due less to its practical than to its symbolic and imaginative functions. Walter Benjamin (again writing of the Café des Westens) felt that central to it was 'that passion for waiting without which one cannot thoroughly appreciate the charm of a café ... I see myself waiting one night amid tobacco smoke on the sofa that encircled one of the central columns'.[31]

Smoking, of course, was part of waiting, and was essential to the café atmosphere. 'A thick pall of smoke hung over the assembled customers and almost blotted out the huge mirror hanging on the back wall of the big room' in the Romanische Café, the Berlin headquarters of a new Bohemia during the Weimar republic. To smoke was more than a way of passing the time. It was the classic 'displacement activity', which gave coffee drinkers who had long since emptied their cup, lovers who had been stood up and intellectuals who had lost their 'circle' the feeling that they were doing something, had a purpose. I smoke, therefore I am. Smoking orchestrated time, gave it a rhythm, punctuated talk, theatrically mimed both masculinity and femininity, was the intellectuals' essential accessory, was also an erotic gesture, enhancing the mystery of some unknown drinker seated at her table, veiled in a bluish haze.

Smoking was also performance, and performance was the cornerstone of the café way of life. The café was a stage for that most ephemeral, yet infinitely repeatable, performance: the performance of personality. In fact the term *mise en scène* is more appropriate than stage, since mise en scène suggests the whole atmosphere, not just stage but stag*ing*, a totality and ambience suggestive of genius and individuality, craziness and camaraderie. It blurred the distinction between being 'at home' and 'out and about', between public and private. Thus there was an extraordinary atmosphere in the best cafés. Seated in the Café Stephanie, 'one would have thought that there was, somewhere in the building, an electric power station, and that the customers were wired to the supply. They twitched as under electric shocks; they gesticulated right, left and centre; they leapt from their seats, fell back exhausted and sprang up again in the middle of a sentence, eyes popping, in ceaseless verbal conflict about art.'[32]

Above all, the café was an actually existing castle in the air, a chameleon environment, a shimmering bubble suspended in the urban atmosphere. Here the bohemians cast off their cares and their poverty and became the geniuses of their dreams.

The performative and even illusionist element of café life has misled many commentators into dismissing café bohemians as poseurs, but it was rather that theirs was a different approach to life, an approach which made of

performance the truth of life. Life *was* artifice, was even art. The opposition
between the natural and the artificial, between the true and the false, the
meretricious and the authentic, was replaced by a commitment to life as
drama, life as a work of art. 'We found it boring and inconvenient to live at
home, think at home, suffer at home, die at home. We needed publicity, the
light of day, the street, the café, in order to testify ... to talk, to be happy or
unhappy, to satisfy all the needs of our vanity or our wit, to cry and to
laugh: we loved to pose, to make a spectacle of ourselves, to have an
audience, a gallery as we bore witness to our lives.'[33]

*

By the late-nineteenth century bohemian districts were well established in a
number of large European and American cities. All shared similar characteris-
tics. Munich, for example, was still the artistic capital of Germany, not yet
overtaken by Berlin. Schwabing, its bohemian quarter, was, said the German
bohemian and anarchist Erich Mühsam, 'like Montmartre, less a geographical
than a cultural concept ... Outwardly it was a district like any other, with
shops, long streets, tall residential buildings ... yet there was something
special about its atmosphere.' This was due to 'the unconventional nature of
personal relationships and behaviour'.[34]

The cultural life of Munich was enriched by the Catholic peasant festivals
and carnivals of the surrounding region.[35] It was a centre of the Arts and
Crafts Movement, attracting students from Eastern Europe, from Russia and
from Scandinavia as well as from elsewhere in Germany. 'Everyone painted –
or wrote poems, or made music, or took up dancing,' remembered Wassily
Kandinsky, 'in every house one found at least two ateliers under the roof ...
Schwabing was a spiritual situation, a spiritual island in the great world, in
Germany and in Munich itself.'[36] As well as the artists and writers living in
the city, there were others who retreated to artists' colonies in the
surrounding countryside.

Indeed, although bohemian culture was essentially urban, it had always
incorporated the alternative attraction of escape to exotic locations and pre-
industrial simplicity. This tension, like other forms of bohemian ambivalence,
expressed the 'impossible' nature of bohemian consciousness, always longing
for its opposite.

The non- or even anti-urban aspect of bohemian culture was especially
evident in California. In the 1870s San Francisco had left behind its wild,
Gold Rush days to become the cultural capital of the West. The leading
lights of its Bohemian Club were the writers Mark Twain and Bret Harte,
Jules Tavernier, who painted 'surreal' canvases and took opium, the poet
Charles Warren Stoddard and John Muir who discovered and wrote about
Yosemite. Another important local figure was Xavier Martinez, a Mexican
American painter of Aztec descent. With his long black hair, red cravat and
corduroy suits, he played the role of bohemian to the full, and had added
cachet from having studied under Whistler in Paris. For, in spite of its

vitality, the West Coast bohemians thought of their city as a backwater, and when Robert Louis Stevenson had visited in 1879 he had found artistic émigrés in Monterey who ached with nostalgia for the culture of Europe they had left behind.[37]

Yet with its Mediterranean climate and awesome landscape, California was a utopia for artists, and its bohemians cultivated the natural rather than the urban wilderness, building a bohemian colony at Carmel, south of San Francisco. Carmel attracted Martinez, Jack London, Ambrose Bierce and the tragic poet Nora May Finch, who committed suicide after a disastrous love affair. The novelist Mary Austin visited regularly, garbed in Greek or American Indian costume.[38]

Mary Austin was familiar, too, with the southern Californian Bohemia that took root in Pasadena and its adjacent wilderness retreat, the Arroyo Secco. One leading member of the 'Arroyo Set' was Charles Fletcher Lummis, who edited the periodical *Land of Sunshine* (later renamed *Out West*). He promoted an ideal of 'Arroyo Culture' which looked to the landscape rather than to the city for renewal, drawing on the ideas of William Morris and the Arts and Crafts Movement, and influenced by Mexican and American Indian art and design. Unlike the socialist Morris, however, Lummis promoted a 'racial myth' of Southern California as a new homeland for the Aryan race, an ideal echoed in the ideas about 'das Volk' developed by some of the bohemians in Munich in the same period.

Chicago, too, was developing its own Bohemia after the World Fair of 1893 inaugurated a flowering of cultural activities. Its Fine Arts building was an important focus, housing artists' studios, publishing houses and small theatres, with rooms for women's, political and artists' clubs such as the famous Little Room. There was also Browne's Bookstore, designed by Frank Lloyd Wright:

> The walls were rough cement, sand colour; the bookshelves, shoulder high, were in the form of stalls, each containing a long reading table and easy chairs. This was on the seventh floor of the buildings, looking onto the lake at one end and, at the other, into the shaded Italian court ... A corner of the shop with a higher ceiling – long, dark, reposing, with an enormous fireplace and great armchairs – housed the rare bindings. Here tea was served and everyone was very smart. All Chicago society came to Browne's Bookstore.[39]

An alternative community colonized the shops abandoned and then converted into studios after the World Fair had ended. Floyd Dell, who later chronicled Greenwich Village life, described how he and his partner Margery Currey each had an apartment consisting of one large room: 'hers had the luxury of a bathtub, but in mine the bathing arrangements were more primitive – one stood up in an iron sink and squeezed water over oneself with a sponge. We were delighted with this bohemian simplicity.'[40] Their neighbours

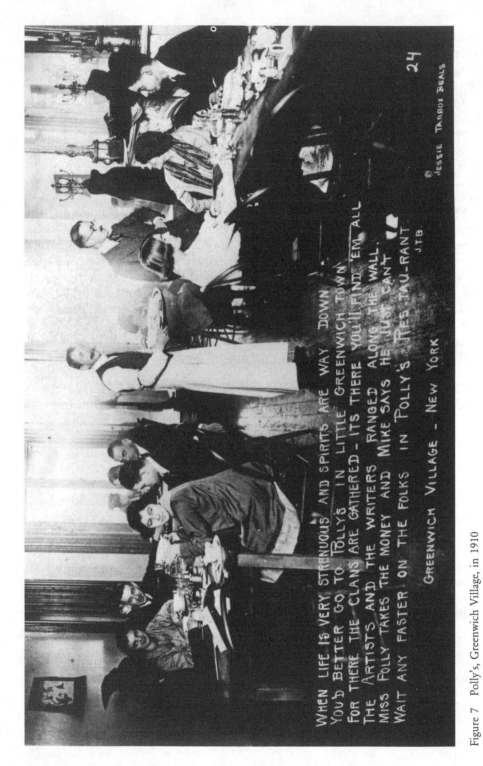

Figure 7 Polly's, Greenwich Village, in 1910

included a woman writer, a sculptress and two women students from the University of Chicago, who taught metalwork in their studio, while Margery Currey herself acted as an 'agent' for Charlotte Perkins Gilman, organizing the lecturing engagements given by this well-known feminist.

Chicago could not, however, compete with the most famous of American Bohemias, New York's Greenwich Village in its first heyday between 1910 and 1918. At this time the Village was a utopian alternative community, its radicals attempting 'a cultural revolution in which no aspect of life was to be exempt from revolutionary change'.[41]

Greenwich Village became the site of this revolution because unlike the rest of Manhattan, laid out on grid lines and, in Djuna Barnes' phrase, 'as soulless as a department store', its streets were winding and picturesque. Once a fashionable district, the Washington Square area had gone into decline as the industrial boom after the American Civil War bypassed its meandering streets, and by the 1890s had been colonized by Italians, Irish and African American communities. Now the cheap rents began to attract bohemians, who were soon converting stables and mews into studios, and crumbling brownstones into communal housing. Italian food, wine and festivals, and the Italian love of street life made the Village what it was.[42] The Bowery theatre, the Yiddish, Chinese and Italian entertainments added to the multicultural atmosphere. So also did the many restaurants, such as the Café Liberty on Houston Street, a Hungarian restaurant where a cheap meal came with as much red or white Hungarian wine as guests could drink, and was accompanied by wild Hungarian music.[43]

The favourite bohemian hang-out was Polly's Restaurant, situated in the basement of the Village Liberal Club, and run by Paula Holladay. She was an anarchist whose lover and fellow anarchist, Hippolyte Havel, had formerly been Emma Goldman's lover, and had served a prison sentence for his political activities. He 'assisted' at Polly's by waiting at table, and his abuse of the customers and violent scenes with Paula added to the bohemian atmosphere, but tested Paula's patience to the extreme. 'He promised me he'd commit suicide, he promised,' she confided to her friend Hutchins Hapgood, 'but he won't keep his word.' By 1916 she had had enough, closed Polly's, and opened the Greenwich Village Inn on Sheridan Square, with a new partner, Barney Gallant. This, however, was a night-spot with ersatz 'bohemian' atmosphere, and attracted the growing numbers of visitors for whom the Village was beginning to market a 'fantasy of Bohemia'.[44]

By the 1920s the established Villagers were horrified and disillusioned by its commercial atmosphere during Prohibition, when it became an illicit drinking haven. Floyd Dell had sniped at the 'genuine' villagers of the earlier years, but he much preferred them to loathsome uptown tourists, who were now turning the Village into 'a sideshow for tourists, a peepshow for vulgarians, a commercial exhibit of tawdry bohemianism'.[45] Greenwich Village had, he felt, become a parody of itself.

This was a familiar story. Bohemians had always colonized seedy, marginal

districts of cities, but an inexorable law decreed that every Bohemia of the Western world be subject to gentrification. The journalist André Billy blamed women: 'Love, pleasure and art are drawn to the same places. The initial choice generally comes from the artists. They bring their girl friends, then leave them, who return with more serious lovers, and thus it is that this or that quarter or village is transformed into a vulgar pleasure resort before becoming deplorably middle class.'[46] Once the artists had discovered an area and created its bohemian ambience, impresarios and property developers were quick to spot its commercial possibilities.

Even before 1900 bohemian atmosphere had become a marketable commodity. Not even that home for intransigents, the Café Stephanie, was immune, for there the waiter encouraged Erich Mühsam, with his wild revolutionary beard, and his friend, Roda Roda, in a red waistcoat, to play chess in the window in order to attract tourists. Bohemian Paris was considerably more open to commercial exploitation. Montmartre had first become a haunt of artists and weekenders because it was officially outside the Paris boundary and wine was therefore sold at a lower price than within the walls of the capital. Pleasure-seekers had been equally attracted by its taverns but also by its rustic charm. After the Commune the area had lost much of its gaiety, but in the 1890s it was revitalized, and its bars, cabarets and working-class music halls, above all the Moulin Rouge, transformed the district into an entertainment centre.

This was a more commercial scene, however, viewed with ambivalence by the bohemians. The famous Brasserie des Martyrs had 'died of what had sustained it ten years earlier', for the very *vie de bohème* that had been its *raison d'être* had been destroyed by hordes of tourists who came looking for bohemian atmosphere, and drove away its artistic and journalistic regulars. In 1907 Arthur Ransome preferred the more authentic London scene: 'It is likely that our Bohemia, certainly in these days, is more real than that of Paris, for the [Latin Quarter] is so well advertised that it has become fashionable ... Visitors to London do not find, as they do in Paris, men waiting about the principal streets, offering themselves as guides to Bohemia.'[47]

At the turn of the century Picasso, Braque, Vlaminck, Derain and the writers Mac Orlan, Roland Dorgelès and André Salmon were living in or near the Bateau Lavoir in Montmartre, a studio building so named because of its resemblance to the laundry barges on the Seine. But already a gang of them would cross the Seine every week and make for the Latin Quarter café, the Closerie des Lilas, where the poet Paul Fort held court,[48] and by 1910 Montmartre was so over-run by tourists that there was a permanent relocation to Montparnasse.

Two cafés, the Rotonde, owned by Victor Libion, and the Dôme, were at the centre of bohemian Montparnasse. Douglas Goldring remembered how, 'under the regime of the silver haired Libion, the Rotonde was shabby and uncomfortable, consisting only of a zinc [the bar] with a few tables at one

side of it, and a long room, on the walls of which the clients exhibited their pictures'.[49] For Goldring there was nothing special about the café itself, it was 'like a hundred others. Cabbies and taxi drivers stood at the zinc counter, clerks drank coffee and aperitifs. At the back there was a dark room impregnated for all time with the stale smell of smoke ... At night this room would fill with people and noise.'[50] It was the people that gave it its unique atmosphere.

After the end of the First World War Montparnasse in its turn was transformed into a commercialized entertainment centre. In 1923 the new Rotonde opened. Three times as big as the old, it had a bar, a grillroom, a brasserie and an upstairs dance floor. One old-timer surveyed the renovations with 'something like consternation':

The humble little restaurant I remembered with its floors sprinkled with sawdust had exploded into a vast gastronomic temple with brilliant lights and awnings ... The little cafés where genuinely poor genuine artists spent a few sous a night had not only monstrously expanded, but had seemingly multiplied. To my dazzled eyes it looked as if acres of café and sidewalk were covered with chattering multitudes.[51]

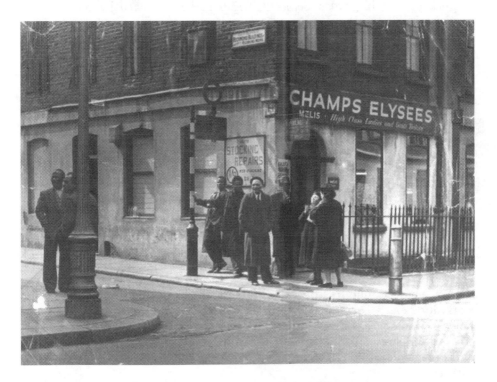

Figure 8 Dean Street, Soho, in the 1950s. Photograph Daniel Farson

The Dôme could not resist the trend and was redecorated in strident Art Deco.

Between the 1950s and 1980s this process was in full swing in Greenwich Village and SoHo. Abandoned industrial buildings were colonized by artists because of their large size and low rents, but sooner or later this bohemian way of life became the epitome of avant-garde chic, written up in style journals and later newspaper articles. Finally the once cheap buildings were transformed into fashionable apartments for rich urbanites, bankers, stock-brokers and lawyers.[52] The bohemians were the inadvertent shock troops of a property boom, the game was real estate, not art.

Having done all they could to gentrify SoHo, developers then set their sights on Manhattan's Lower East Side. In the 1980s, a culminating moment in the struggle for this hitherto dangerous and dilapidated area was the long-running battle for 'ownership' of Tompkins Park on Avenue A, where homeless people had set up an encampment. Squatters and housing activists created a political, subversive art attacking gentrification, the police and the art industry. Posters, sculpture and graffiti appeared on the streets and in marginal gallery spaces. Local residents, too, many of them Hispanic, mounted a vigorous anti-gentrification campaign. But once the occupation had ended in a riot and the eviction of large numbers of 'street people', 'Alphabet City', like SoHo before it, began to be colonized by a more fash-ionable crowd. During the struggle all the comparisons with the Wild West that Privat d'Anglemont had used in the 1850s to describe the lower depths of Les Halles and the slums of the 12e Arrondissement were recycled by culture critics and the media. They even unwittingly echoed Erich Mühsam's aphorism in stating that 'the Lower East Side is more than a geographical location – it is a state of mind'.[53]

The process of gentrification was international. London's Soho had been a magnet for artists since the eighteenth century. In the 1940s it had been one of the few multiracial entertainment areas: 'negro actors, lawyers, engineers, dockers up from Wales, waiters, dancers, students, merchant seamen, labourers and musicians' were welcomed at Friscos and the Caribbean Club.[54] In the 1950s a traditional Bohemia flourished in 'Fitzrovia', as the district was now called. Henrietta Moraes felt it was like living in a village: 'we knew every shopkeeper, every pub and club.' She and her friends ate out all the time in the cheap restaurants, beginning with breakfast at the Café Torino at the corner of Old Compton Street and ending late at night at the Gargoyle Club. Fitzrovia was a way of life, and the Indian poet, Tambimuttu, claimed that: 'If you get Sohoitis, you will stay there always day and night and get no work done ever.' The best known hang-outs were the 'French' (a pub), Muriel Belcher's Colony Room, the Gargoyle, Wheelers, the Wheatsheaf in Rathbone Place, Humphrey Lyttelton's jazz club at 100 Oxford Street and the Caves de France – 'a dead-ended subterranean tunnel ... an atmosphere almost solid with failure.' This was:

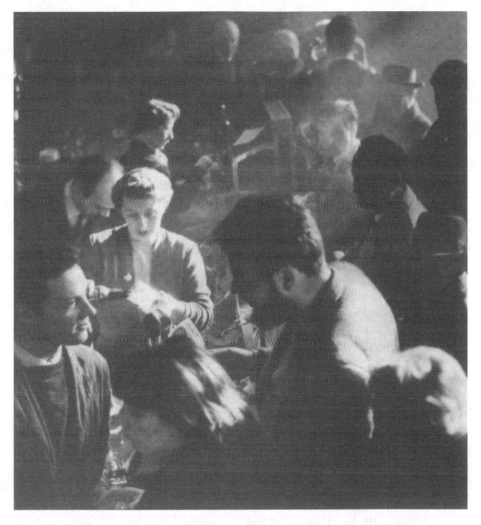

Figure 9 The French Pub, Fitzrovia, in the early 1950s. Photograph Daniel Farson

a true Bohemia ... The people who used the Caves were classless and nearly all were interested in the arts ... There were rejects of every kind, the drifters, the shabby genteel who had known better times. Their eyes were guilty with the recognition of impending defeat, ravaged faces barely crowned with thinning, silky hair, and musty clothes that needed changing.[55]

The Swiss Café, too, was haunted by failures:

Art students, artists, models and layabouts, all misfits like myself ... I could be as mad as I wanted ... I wrote the day away and wandered the

streets ridiculing the wage slaves ... Tearaways, layabouts, lesbians, queers, mysteries and hangers on. We just sat in the café, waiting. Waiting for another day to kill itself. Every time the door opened we looked up as if we were expecting someone.[56]

David Archer's bookshop in Greek Street, where Henrietta Moraes ran the coffee bar for a time, was a meeting place for more successful writers, but, like many of the old Paris cafés, it was more a way of life than a way of earning a living. David Archer 'wasn't in the slightest bit interested in selling any books, he just liked to be surrounded by them ... What David wanted was a literary salon in the style of Madame de Staël, and he got it. Colin Wilson, Christopher Logue, Colin MacInnes, Michael Hastings, George Barker ... came in every day.'[57]

When Marianne Faithfull did drugs in Soho at the end of the 1960s the district was still an odd, edgy place, 'full of dodgy clubs and seedy hotels ... A lot of "marginal" types lived there: junkies and prostitutes, music business hustlers, great painters and underworld faces ... It was all very Dickensian, with of course a bit of Burroughs.'[58] But by the eighties Hugh David, historian of London's Bohemia, felt that it had become a theme park: 'Soho Nouveau ... from topless bar to champagne bar' as the *Sunday Times* described it, 'colour supplement chic'.[59]

In the 1990s the gentrifiers seized on the Hoxton, Clerkenwell and Hackney areas of the East End, just north of the City of London. After the Docks closed down at the end of the 1960s, abandoned industrial buildings became derelict as the whole area decayed. Soon London artists began to colonize these spacious, cheap and convenient spaces, and by the 1980s this had led to the transformation of large parts of the adjacent areas of Shoreditch and Hackney. Out-of-the-way pubs and clubs had been refurbished, and artists were using their homes as galleries. With 10,000 artists, a quarter of Britain's total, East London's artistic community was second only to that of New York. In the 1990s numbers grew even more, since, according to one artist, 'in the past, being an artist was too risky, [but] the mentality seems to be that now, with job security undermined, everything is too risky, so you might as well do what you want'.[60] The rehabilitation of the area created an exciting atmosphere. As one incomer expressed it, 'in Spitalfields there's not necessarily beauty all around but there's a lot going on. Artists, designers, tailors, furniture makers, people reviving the traditional crafts. You've got this mix of style and energy.'[61] The local authority did not always agree, and at one point threatened to bulldoze an area near London Fields in Hackney, where artists had squatted in dilapidated houses, in order to return it to light industrial use.

In the long term a more serious threat came from the property developers. In 1996, *Time Out*, the London listings magazine, was celebrating 'Bohemian London.' Excited journalists wrote of 'cutting-edge cool in the Capital'. They discovered an energy 'emanating from dark corners and behind closed doors,

Figure 10 The London listings magazine, *Time Out*, celebrates 'Bohemian London' in 1996. Courtesy *Time Out*

resurfacing in different forms around the city ... a new set of movers and shakers, sick of the meaningless hedonism of dance culture or bored with the isolation of the Internet, on a quest for meaning and inspiration. They are the new bohemians.'[62]

Even as these gushing words were penned, property companies, advertising agencies and bankers from the City were moving in. By 1998 rents had tripled, and the estate agent allegedly responsible commented: 'Just because they're artists, they don't have a God given right to the area.' The Prince of Wales was trying to move his school of architecture into the district, Silvio's, the greasy spoon in Old Street, had become a cappuccino bar, and the avant-garde Blue Note music club was closed down when new residents complained of the noise. In 1996 the funeral of twenty-six-year-old Joshua Compston, the impresario who 'invented' the area with his Factual Nonsense Warehouse, had been attended by Gilbert and George, Peter Blake and hundreds of younger artists. Two years later his home was on the market for millions,[63] and artists' lofts had been replaced by 'loft lifestyle.' Yet predictions were that this style in its turn was about to go out of fashion, even as it was congealed into history by becoming an exhibit in the East End Geffrye Museum.

Figure 11 The performance artists Gilbert and George at the funeral in March 1996 of Joshua Compston, 'inventor' of Hoxton's Bohemia

The Parisian journalist and former radical publisher, François Maspero, likewise felt that since the centre of Paris had become 'a business hypermarket and cultural Disneyland, a ghost town and a museum'; the real life of Paris was now to be found beyond the *Périphérique*, the motorway encircling central Paris. Sure enough, in the high rise suburban wastelands of Aubervilliers he found over forty artists living in the Malian community of immigrant workers located on the vast concrete housing estate of La Maladerie: 'there, just a stone's throw from the capital, they find studios it is now almost impossible to rent in Paris, where the craftsmen's courtyards are disappearing and very few artists can afford the luxury of an "artist's studio", which has become the almost exclusive privilege of very wealthy bourgeois.'[64]

Yet artists and bohemians have always been able to move on. They have always found new forgotten enclaves in the cities, just as they found new Mediterranean hideouts when the original ones fell to the tourists. In the 1990s, for example, the musician Chris Cutler, once of the 1970s avant-garde band Henry Cow, was continuing his work in the far south London 'wilderness' of suburban Thornton Heath, which seemed more authentic than the inner city.[65]

Authenticity: that was the perennial aspiration. In the lives of individual bohemians the search for authenticity took strange forms and became so extreme that at times it appeared to collapse into its opposite.

Notes

1 Alphonse Delvau, *Les Dessous de Paris* (Paris: Poulet Malarus et de Brosse, 1861), p 8.
2 Alexandre Privat d'Anglemont, *Paris Inconnu* (orig publ 1847; Paris: Adolphe Delahaye, 1861), p 101.
3 Honoré de Balzac, *La Cousine Bette* (Paris: Livre de Poche, 1973), pp 60–61.
4 Delvau, *Les Dessous de Paris*, p 134.
5 Honoré de Balzac, *Lost Illusions*, trans Herbert Hunt (orig publ 1837–43; Harmondsworth: Penguin, 1983), p 116.
6 Honoré de Balzac, *Le Père Goriot*, trans Marion Crawford (orig publ 1834; Harmondsworth: Penguin, 1951), p 304.
7 Hugh David, *The Fitzrovians: A Portrait of Bohemian Society, 1900–1955* (London: Michael Joseph, 1988), p 140, quoting Dylan Thomas, letter to Pamela Hansford Johnson, October 1933.
8 Colin MacInnes, *Absolute Beginners* (London: MacGibbon and Kee, 1958), p 12.
9 Karl Marx, '*Les Conspirateurs* by A. Chenu, [and] *La Naissance de La République* by Lucien de la Hodde', in Karl Marx and Friedrich Engels, *Collected Works*, vol 10 (1849–51) (London: Lawrence and Wishart, 1978), p 315.
10 Privat d'Anglemont, *Paris Inconnu*, p 40
11 Jerrold Siegel, *Bohemian Paris*, pp 128–9.
12 Ibid., quoting Théodore de Banville, *Les Pauvres Saltimbanques* (1853).
13 See Louis Chevalier, *Labouring Classes and Dangerous Classes in Paris During the First Half of the Nineteenth Century*, trans Frank Jellinek (London: Routledge and Kegan Paul, 1973).

14 Privat d'Anglemont, *Paris Inconnu*, pp 40, 53.
15 For a discussion of the use of liminal places by marginal groups, see Kevin Hetherington, 'Identity Formation, Space and Social Centrality,' in *Theory Culture and Society*, xiii/4 (1996), p 39; and Kevin Hetherington, *The Badlands of Modernity: Heterotopia, and Social Ordering* (London: Routledge, 1997).
16 Vincent Van Gogh, 'Letter to Theo Van Gogh', 9 September 1888, in Ronald de Leuuw (ed), *The Letters of Vincent Van Gogh* (Harmondsworth: Penguin, 1996), p 399.
17 Thomas Mann, 'Tonio Kroger', in Thomas Mann, *Selected Stories* (Harmondsworth: Penguin, 1988), p 157.
18 Frank Wedekind, *Diary of an Erotic Life*, ed Gerhard Hay, trans W.E.Yuill (Oxford: Blackwell, 1990), p 105.
19 Leonhard Frank, *Heart on the Left*, trans Cyrus Brooks (orig publ 1928; London: Arthur Barker, 1954), p 11.
20 Elisabeth Kleeman, *zwischen symbolischer Rebellion und politischer Revolution* (Frankfurt: Peter Lang, 1985), p 36, quoting Tillie Durieux, *ein Tür steht offen*.
21 Ernst Blass, 'The Old Café des Westens', in Paul Raabe (ed), *The Era of German Expressionism*, trans J.M.Ritchie (London: Calder and Boyars, 1974), p 30.
22 Claire Jung, 'Memories of Georg Heym and his Friends,' in ibid., p 41.
23 Roy F.Allen, *Literary Life in German Expressionism and the Berlin Circles* (Epping, Essex: Bonher Publishing Co., 1983), p 24, quoting Wolfgang Goetz, *Im 'Größenwahn' bei Pschor und Anderswo ... Erinnerungen an Berliner Stammtische*, 1936, p 14.
24 Stefan Zweig, *The World of Yesterday* (London: Cassell, 1943), p 41.
25 Frank Wedekind, *Diary of an Erotic Life*, p 15.
26 Christopher Isherwood, *Christopher and His Kind, 1929–1939* (London: Methuen, 1977), p 24.
27 Louis Aragon, *Paris Peasant*, trans Simon Watson Taylor (orig publ 1926; London: Picador, 1980), p 94.
28 Richard Aldington, *Life for Life's Sake* (New York: Viking Press, 1941), p 312.
29 Firmin Maillard, *Les Dernières Bohèmes: Henri Murger et son Temps* (Paris: Librairie Sartorius, 1874), p v.
30 Henri d'Almeras, 'La Littérature au Café Sous le Second Empire', *Les Oeuvres Libres*, vol 135 (Paris: Fayard, 1933), p 343.
31 Walter Benjamin, 'A Berlin Chronicle', in Walter Benjamin, *One Way Street* (London: Verso, 1979), p 311.
32 Frank, *Heart on the Left*, p 11.
33 Alphonse Delvau, *Histoire Anecdotique des Cafés et Cabarets de Paris*, Paris: Poulet Malarus et de Brosse, 1862, p.100.
34 Erich Mühsam, *Unpolitische Erinnerungen* (Berlin: Verlag Volk und Welt, 1958), p 139. Ernest Jones attributes the same remark to Ludwig Klages, another major figure in Schwabing at this time, which suggests that the idea was in general circulation.
35 See Peter Jelavich, *Munich and Theatrical Modernism: Politics, Playwriting and Performance, 1890–1914* (Cambridge, Ma: Harvard University Press, 1985).
36 Peg Weiss, *Kandinsky in Munich: The Formative Jugendstil Years* (Princeton, NJ: Princeton University Press, 1979), p 3, quoting Kandinsky.
37 Kevin Starr, *Americans and the Californian Dream, 1850–1915* (New York: Oxford University Press, 1973), chapter 8.

38 Kevin Starr, *Inventing the Dream: California Through the Progressive Era* (New York: Oxford University Press, 1985), chapter 3.
39 Margaret Anderson, *My Thirty Years War: An Autobiography* (New York: Knopf, 1930), p 27.
40 Floyd Dell, *Homecoming* (New York: Farrar and Rinehart, 1933), p 84.
41 Leslie Fishbein, *Rebels in Bohemia: The Radicals of The Masses, 1911–1917* (Chapel Hill: University of Carolina Press, 1982), p 4.
42 Josephine Gattuso Hendin, 'Italian Neighbours', in Rick Beard and Leslie Cohen Berlowitz (eds), *Greenwich Village: Culture and Counterculture* (New Brunswick: Rutgers University Press, 1993), pp 142–50.
43 Hutchins Hapgood, *A Victorian in the Modern World* (orig publ in 1939; Seattle: University of Washington Press, 1972), p 349.
44 Lewis Erenberg, 'Greenwich Village Nightlife, 1910–1950', in Beard and Berlowitz (eds), *Greenwich Village*, pp 359–60.
45 Floyd Dell, *Love in Greenwich Village* (London: Cassell, 1927), p 290.
46 André Billy, *La Présidente et ses Amis* (Paris: Flammarion, 1945), p 27.
47 Ransome, *Bohemia in London*, p.7.
48 Charles Douglas (pseudonym of Douglas Goldring), *Artist Quarter: Reminiscences of Montmartre and Montparnasse in the First Two Decades of the Twentieth Century* (London: Faber and Faber, 1941).
49 Ibid., p 88.
50 Ilya Ehrenberg, *People and Life: Memoirs of 1891–1917*, trans Anna Bostok and Yvonne Kapp (London: MacGibbon and Kee, 1961), p 140.
51 Aldington, *Life for Life's Sake*, p 314.
52 Sharon Zukin, *Loft Living* (London: Radius, 1982).
53 Neil Smith, 'New City, New Frontier: The Lower East Side as Wild Wild West', in Michael Sorkin (ed), *Variations on a Theme Park: The New American City and the End of Public Space* (New York: Noonday Press, 1992), pp 61–93.
54 Stanley Jackson, *An Indiscreet Guide to Soho* (London: Muse Arts, 1946), p 106.
55 Daniel Farson, *The Gilded Gutter Life of Francis Bacon* (London: Vintage, 1993), p 68.
56 Bernard Kops, *The World is a Wedding*, pp 136, 172.
57 Henrietta Moraes, *Henrietta* (London: Hamish Hamilton, 1993), pp 41–2.
58 Faithfull, *Faithfull*, p 304.
59 David, *The Fitzrovians*, pp 251–2.
60 Dan Glaister, 'Artists Create a Left Bank in the East End of London', *The Guardian*, Wednesday, 10 July 1996, p 3, quoting Michael Craig Martin.
61 Ibid., quoting Kate Bernard.
62 Elaine Paterson, 'Bohemian Rhapsody', *Time Out*, 23–30 October 1996, p 16.
63 Imogen O'Rorke, 'The Battle to Save Bohemia has Begun – in an East End Warehouse', *Independent*, Thursday, 9 July 1998, p 8.
64 François Maspero, *Roissy Express*, trans Paul Jones (London: Verso, 1994), p 201.
65 Patrick Wright, 'Resist Me, Make Me Strong', *Guardian Weekend*, 11 November 1995, pp 38–46.

CHAPTER FOUR

CONTRIBUTIONS TO A MYTH

Worse than adversity the Childe befell;
He felt the fulness of satiety ...
With pleasure drugged he almost longed for woe,
And e'en for change of scene would seek the shades below.
George Gordon, Lord Byron: Childe Harold's Pilgrimage

Certain social, economic and geographic circumstances, then, were necessary in order for the bohemian to appear: it was possible for 'bohemian' to become a recognizable identity because there was a socially defined position for this character to inhabit. 'We must ... ask, not how a writer comes to be what he is ... but rather how the position or "post" he occupies – that of a writer of a particular type – became constituted.'[1]

Individual personalities nevertheless played a crucial part in the construction of the bohemian myth. Although *les Jeunes France* was the first widely discussed bohemian 'circle,' the rise and fall of a notorious Englishman prefigured and contributed to the creation of the bohemian identity two decades before Borel and his friends burst on the scene. Fame and self-destruction united in the person of George Gordon, Lord Byron, Romantic poet and aristocratic outlaw, political radical and sexual deviant, fatal man and tragic genius, who inspired the famous phrase so many later bohemians tried to live up to: 'mad, bad and dangerous to know.'

Byron was one, perhaps the first, of a pantheon of individuals who became bohemian icons, involved, whether inadvertently or deliberately, in the development of the bohemian myth. His career dramatically demonstrated the blurring of life and art that was central to this myth; he dramatized his personal conflicts partly by *becoming* the mysteriously flawed heroes about whom he wrote. In 1812, at the age of twenty-four, he became famous overnight

A HARROW SCHOOL BOY (1806)

Figure 12 Byron, the fatal man who inspired generations of bohemians, posed in pensive mood on a catafalque

with the publication of his narrative poem, *Childe Harold's Pilgrimage*. Every woman wanted to meet, and if possible go to bed with, the poet who, it seemed, was the living embodiment of his own doomed hero. The waltz was the craze of the moment in the Regency ballrooms and soon Lady Caroline Lamb had whirled him away into an affair that rapidly became an obsession on her side, wearisome on his. In 1815, after several more affairs, he married Lady Annabella Milbanke, a well-connected but pious young woman. Possibly he hoped she would reform him, or perhaps he imagined that their union would shield him from the scurrilous rumours now circulating, partly as a result of Caroline Lamb's malicious gossip. In this he was disappointed, for by 1816 Annabella had terminated the marriage, and Byron left England never to return, in flight from a storm of scandal and debt.

His money troubles were of long standing. More damning were the insinuations concerning his private life. Yet on the face of it his flight seemed unnecessary. The moral reformism we think of as 'Victorian' was already gathering pace – and Annabella Milbanke represented the new piety – yet upperclass sexual morals remained relaxed. Byron's affair with Caroline Lamb had caused comment largely because *she* had behaved in what, by the standards of

the time, was an exaggerated and hysterical fashion. His relationship with his half-sister, Augusta Leigh, was emotionally intense and probably incestuous, but Byron himself liked to draw attention to its ambiguity and brother-sister incest was a fashionable romantic sin.

There was, however, one form of sexual behaviour that elicited the full force of savage punishment in England as distinct from other European countries: the unmentionable and heinous crime of male homosexuality. Every year men convicted of sodomy went to the gallows, were gruesomely (and sometimes fatally) pilloried in the stocks, or fled abroad to escape retribution. Byron was sexually susceptible to women, and some of his relationships – with Teresa Guiccioli in Italy, for example – were relatively enduring as well as passionate; but he frankly regarded all women, with the exception of his half-sister, as inferior, and seldom spoke or wrote of his emotional bonds with the opposite sex in the language he reserved for certain men, or rather boys. In *Childe Harold* the hero's love for 'Thyrza', a woman, drew on the memory of Byron's adolescent love for John Edlestone, a friend from his Cambridge undergraduate days; during his wanderings through Greece, Turkey and Albania in 1810 and 1811 he had sexual relations with boys and returned to England only reluctantly; and when at the end of his life he returned to Greece to take part in the national liberation struggle there, his last, unrequited, passion was again for a boy.[2]

As their contemporary, the painter Benjamin Robert Haydon, commented, Byron and Shelley 'might have produced a revolution had they not shocked the country by their opinions on sexual intercourse. This forever bustled up the virtue of the country.'[3] Haydon was presumably referring to unconventional *heterosexual* behaviour; to be bisexual or homosexual was to challenge bourgeois respectability even more radically.

It was partly the half-acknowledged homosexual component in Byron that made him the 'fatal man' whose beauty and sexual magnetism only heightened the aura of alienation, melancholy and mystery, bordering on horror, that surrounded him. Even at the height of his fashionable popularity he remained in some unspecified sense an outsider, morose, longing for solitude when most courted and admired, and seemingly haunted by a dark and pervasive sense of moral guilt. His notorious public persona hinted at a general crisis in masculine identity. His style of looks – the marble forehead, the pallor, the sulky mouth and brooding eyes – formed the template for the fashion in effeminate male beauty during the first half of the nineteenth century; his love of boys surrounded him with an aura of doom, and prefigured the importance of homoeroticism and bisexuality in Bohemia; and although Coleridge, Shelley and even the youthful Wordsworth led lives that could be described as 'bohemian,' Byron's was the most intense distillation of bohemian themes. His reputation anticipated twentieth-century forms of fame, glamour and notoriety, his personality generating a legend that became more important than his work, although crucially bound up with it.[4]

His aura of fatality was such that it even came to be incorporated into one of the most sensational and long-lasting myths of modernity's mass culture: the vampire. Soon after leaving England, Byron, en route for Italy, stayed with Shelley near Geneva. Shelley's entourage included his lover, Mary Godwin, daughter of the radical atheist William Godwin. He had more or less run away with her, although married to someone else at the time. Mary's stepsister, Claire Clairmont, was also of the party. She had had a brief fling with Byron and was shortly to bear his child. Byron was accompanied by his physician, John Polidori, who was proving a tiresome companion and was soon to be sacked.

At night the friends amused themselves by telling ghost stories, and these evenings produced two of the most significant narratives of mass culture: *Frankenstein*, by Mary Shelley herself; and *The Vampyre*, published in 1819 by Polidori, but partly based, it seems, on a story told by Byron. The public at first assumed that Byron himself was the author of *The Vampyre*; in fact, even more potently, he was its anti-hero. The sinister central character in Polidori's tale was named Lord Ruthven; this was the name also of the main character in Lady Caroline Lamb's recently published novel, *Glenarvon*, and everyone knew that *her* Lord Ruthven was based on Byron. Both novels were acts of revenge that fixed Byron's image as the mythical, romantic fatal man and sinister aristocrat, embodiment of *Liebestod*, in which erotic love and death were fused.[5] In this way the Byron legend contributed directly to one of the central narratives of the twentieth-century culture industry; so that from the beginning the bohemian was as much a part of mass culture as of high art. This has implications for the later development of the myth.

Byron prefigured another common attribute of the bohemian in embracing radical beliefs; his maiden speech in the House of Lords, made when *Childe Harold* was about to be published, was a provocative defence of the Luddites, the desperate men who had smashed the machines that were destroying their livelihood, and an attack on the draconian legislation proposed for their suppression. At the end of his life he devoted himself to the cause of Greek national liberation. Yet his radicalism was regressive to the extent that he embodied anti-bourgeois values just when these were gaining ground, and he always remained essentially an aristocrat.

It may therefore seem strange that Byron attracted an adoring bourgeois reading public. He represented everything the rising bourgeoisie rejected, yet his audience thrilled to him in his embodiment of artist-as-outlaw. That he so perfectly fulfilled the role of fatal man and doomed genius, combining fame and disgrace, does not explain why this fascinated his public. Yet the figure of the aristocratic *homme damné*, incarnated in successive bohemians, *did* thrill the bourgeois audience. This was perhaps because, while in their heads they were committed to an orderly view of existence and to the utilitarian norms of business, in their hearts they were romantics too.

Byron's respectable readers could vicariously live dangerously, but at the same time in recoiling with shocked horror from Byron's misdemeanours

could reaffirm the superiority of their own values. They could have their cake and eat it, yet their appetite for this particular cake suggests a deep wound in the bourgeois psyche, in some way alienated from its own moral values of piety, virtue and social conformity. Bourgeois society generated a kind of self-hatred, as its members continually sought more lofty spiritual and emotional values than those on offer from economic advancement; the bohemians articulated this ambivalence and unease. That the Byronic figure was a radical aristocrat testified to anti-bourgeois values; yet the bourgeoisie aspired to the aristocratic in taste and culture, even when distancing itself from aristocratic morals.

That he was both artist/genius and morally beyond the pale reinforced the bourgeois ambivalence towards the art, and the Romantic movement, he represented: art was dangerous and disturbing, yet revealed and challenged the boredom of everyday life. The love affair of the public with Childe Harold, and with the values of the Romantic movement in general, asserted the superiority of feeling over reason, yet the Byronic and many later bohemian tragedies revolved around the contradiction between the authenticity and primacy of feeling expressed in art, and the economic and social imperatives of the industrial world. The bohemian dramatized in his person the theme of art against society, and expressed a longing inherent in the very structures of 'normal' life for some alternative form of experience. Even those most committed to the status quo experienced the ennui of the 'iron cage' of modernity, and envied the rebels who seemed to have escaped, yet the tragedies of excess and doom enacted by outlaw bohemians at the same time reassured them that the price of escape was more than they themselves could be expected to pay.

'Byronmania' grew up in the wake of the late-eighteenth-century cult of 'sensibility' or 'sentimentalism' in Britain, when the reading of Gothic and other sensational and melodramatic romances was likened to an addiction, a 'process,' suggests Colin Campbell, 'through which indulgence in self-illusory hedonism works to create both a sense of dissatisfaction with the world and a generalized longing for the fulfilment of dreams, thus making it appear very likely that the reading of novels was a major factor in the critical break with traditionalism which occurred in the second half of the eighteenth century.'[6]

Campbell suggests that the 'romantic ethic' was part of a general cultural crisis in which sections of the bourgeoisie rebelled against utilitarianism. Sensibility, taste, imagination and emotion came to be more highly valued than cold rationality, and this moved art and the artist to centre-stage, as aesthetic values were elevated into a philosophy of life.[7] As Keats phrased it, 'Beauty is Truth, Truth Beauty; this is all ye know on earth, and all ye need to know.'

During his period of exile in Italy, Byron, having dramatized his personal conflicts by partly becoming his own flawed and mysterious hero, distanced himself from this figure. He now preferred to be regarded as a man of the

world, and continued to act the Regency rake 'long after the species was extinct; at nothing was he more indignant than at being treated as a man of letters,'[8] wrote John Trelawney, an adventurer who spent some time with the Shelley-Byron circle at Pisa.

In Italy Byron encountered Lady Blessington, who was something of an *ur*-bohemian herself, for she was an Irish beauty who from obscure and disreputable origins had risen to the position of wife to an earl. At this time the Blessingtons were beginning a lengthy stay in Italy in what amounted to a *ménage à trois* with the dandy Alfred d'Orsay, but although most onlookers assumed that d'Orsay was Lady Blessington's lover, biographers have since thought it more likely that he had some kind of homoerotic relationship with the earl. Scandal mounted after the earl's death, as d'Orsay, although now married to one of Lord Blessington's daughters, continued to live with Lady Blessington. Ostracized by the more virtuous elements in aristocratic society, Lady Blessington nevertheless held court over a successful salon for some years, latterly at Gore House, Kensington, which had once been the home of the pious William Wilberforce, but now became, as one commentator put it, 'the headquarters of the demi-monde'.[9] There she entertained, among others, Henry and Edward Bulwer Lytton, Dickens, the young Disraeli, Walter Savage Landor and d'Orsay's kinsman, Louis Napoleon. Her success lasted until the 1840s, but she was eventually ruined by d'Orsay's extravagance.

During her stay in Italy she grew to have a real sympathy and liking for Byron, but, again like Trelawney, was at first most struck by 'his taste for aristocracy', his vanity as to his rank, and the vulgarity of his dress and surroundings – a snobbish, world-weary Milord rather than a glamorous *homme damné*.[10] Nevertheless, her reminiscences became part of the Byron industry. And Byron himself continued to recreate an air of ambiguity around himself, hinting at dark secrets to his friends, and always suggesting that he was even more wicked than his popular image. The mystery was only heightened when, after his death from fever at Missolonghi, his friend and executor destroyed his intimate diaries, possibly because they contained details of homosexual encounters.

So although Byron could not be described as a fully paid-up bohemian, he provided an identity to which bohemians could aspire. Aristocratic defiance, martyrdom, failure, misunderstood genius, sexual transgression and self-dramatization set the scene for generations of bohemians and gave them much to live up to. 'Byronmania' swept through the young Parisian bohemians of the 1830s. Young poets imitated the Byronic aura of doom and romantic excess which was utterly in tune with the morbid sensibility of the period.

In 1845, however, a new contributor to the bohemian myth appeared: Henry Murger, the first major popularizer of *La Bohème*. Murger came from the lower-middle class of artisans in decline and struggling white-collar workers occupying an uncertain niche in society; his father was a tailor and

his mother was the concierge to a fashionable apartment block. Poor without being manual workers, the occupations of this section of society often kept them in sordid servitude, yet engendered a commitment to respectability, and a longing for gentility. Murger expressed these longings by refusing to follow his father's profession, determined to have a literary career. At first he lived in acute poverty as he attempted to gain a foothold by writing in any periodical that would accept his work, including various trades magazines. In 1845 he began writing a series of sketches for the satirical *Le Corsaire*, in which he described the hand-to-mouth existence of himself and his friends, the disasters occasioned by their poverty, their comical escapes from landlords, their occasional successes, and their poignant love affairs, but his real breakthrough came when in 1849 he collaborated on a stage version, which became a huge success. This established with a popular audience the idea of the bohemian way of life, defined in Murger's terms, primarily by penury; and it was only now that the use of the term itself became common currency.[11]

Murger's bohemians were characterized by poverty and innocence rather than by being in any sense *hommes damnés*. His sketches sentimentalized the way of life he described, and rendered poverty picturesque, so that instead of being scandalized the public loved his hopeful young vagabonds, sowing their wild oats and having their first love affairs with working-class girls while struggling to gain a foothold in the arts – a picture with which the bourgeois audience, or at least its male members, could easily identify.

When in 1851 Murger attempted a definition of the bohemian in his preface to the novelized version of his *feuilletons*, he further insisted on their normality. He also displayed an obsession with the distinction between the 'real' and the 'false' Bohemia which was to bedevil future discussions. He identified several different types of pseudo-bohemian: there were the unknowns, 'a race of obstinate dreamers, for whom art is a religion and not a profession', and who lived isolated on the margins of society, heroic in their submission to poverty and obscurity; there were those without talent, 'a martyrology of mediocrity'; there were the amateurs, disaffected bourgeois who preferred slumming to 'an honourable future'; and lastly there were the real bohemians. They renounced the debauchery, laziness and parasitism of the others, and worked at their art, for 'all really powerful spirits have their story to tell and ... genius or talent will never remain in obscurity ... talent is like a diamond which can remained for a long time lost in shadow, but which is always seen by someone.'[12]

It was perhaps not surprising, in view of his own success, that Murger should perpetrate this blatant piece of special pleading. He had in any case never really wanted to be a bohemian, and always referred bitterly to his years of penury: 'It is all very well,' he wrote to a former school friend in 1844, 'for people to paint Bohemia in rosy colours, it will always be a sad and sorry existence ... For three months there was not a single day when I did not suffer the pangs of hunger ... I could neither look for a post nor go and see anybody, the state of my clothes preventing me from venturing into

the street in the daytime.'[13] And he spent the rest of his short life (he died in 1861 at the age of thirty-eight) in attempting unsuccessfully to distance himself from the representation of Bohemia upon which his success was based.

Murger's sentimental and popular version of Bohemia was more reassuring for its audience than the Byronic legend, but did not oust it. Now the two coexisted, rendering the bohemian a more complex and more contradictory figure, and contributing to the continuing debate as to the identity of the 'real' and the 'false' bohemians.

Less than a decade after Murger's death another figure appeared on the scene, whose life, far more shocking than Murger could have dreamt of, took the bohemian myth into further reaches of deviance and outrage. This was Arthur Rimbaud.

There were similarities between his life and that of Byron: an absent father, a difficult mother, an unhappy childhood – although Rimbaud's family was not aristocratic: his father was a minor army officer, his mother from a family of peasant farmers. Both poets were travellers and wanderers, unsettled beings forever in flight from their *cafard* or in search of impossible horizons. Both were drawn to the intransigence of radical politics and to the ambivalence of homosexuality.

In 1871 Rimbaud arrived in Paris from his home town of Charleville at the age of seventeen, to meet the established poet Paul Verlaine, to whom he

Figure 13 The London lodgings of Arthur Rimbaud and Paul Verlaine, where they stayed in 1873, still looking very seedy in the year 2000

had sent some poems. Verlaine's immediate response had been to invite Rimbaud to the capital.[14] He arrived at the Gare de Strasbourg (now the Gare de l'Est), but Verlaine, who was there to meet him, went to the wrong platform. He returned home to find the uncouth visitor seated in his mother-in-law's drawing room. As the evening progressed the manners of the newcomer increasingly appalled his hosts. Like a coopful of chickens in the presence of a fox they watched mesmerized as Rimbaud in his scruffy clothes blew pipe smoke all over them and communicated in monosyllables.

Verlaine, in his late twenties, had not long been married to his eighteen-year-old bride, Mathilde de Mauté, now pregnant, but with his new protégé he returned to his former café life and the bohemian literary world of Paris. Even in those tolerant circles the couple soon became notorious. They became a new and deviant version of the romantic ideal of fatal erotic passion, appearing in Rimbaud's *Une Saison en Enfer* as the Foolish Virgin and the Infernal Bridegroom.

Together they travelled to Brussels, then to London, where they stayed in sordid lodgings in Camden Town, and were to be found at the Café Royal, as well as giving French lessons and exploring the vast city. The infernal *ménage* was not a happy one. Verlaine became sodden with guilt on Mathilde's account and decided to return to her. He met her in Brussels, and, with Mathilde's mother, they set off for their home in Paris; but Rimbaud had followed his lover and was on the same train. At the frontier Verlaine stepped out on to the platform, and as the train moved off Mathilde and her mother realized he had not rejoined them. They called and gesticulated from the window of the train as it gathered speed, but Verlaine stood there on the platform and shook his head.

In Brussels the relationship between the two men deteriorated further, reaching a climax when Verlaine shot Rimbaud, wounding him in the hand. Rimbaud was hospitalized and Verlaine spent two years in prison, convicted on his lover's evidence. Rimbaud had been the school's most brilliant pupil in his home town of Charleville, but now returned as the prodigy disgraced and while his siblings toiled away on their farm in the heat of the summer he shut himself in his room, writing *Une Saison en Enfer*. This was his last literary work.

Only nineteen, he had already travelled to Paris, Brussels and England. Now he embarked on a series of journeys wandering further and further from home. He first made a series of trips through Italy, Germany and Austria. Then in 1877 he escaped from Europe altogether, when he enlisted in the Dutch colonial army and found himself 'surrounded by "no hopers", delinquents, vagabonds, mercenaries,' men for whom the sole reality was the present and who were therefore, perhaps, truly modern, 'individuals terrifying in their banality, pure adventurers, in whose company he submerged himself.'[15] With them he sailed to Java, but deserted on his arrival, managed to evade recapture, and somehow worked his passage home before leaving once again for Germany and Vienna. In 1878 and again in 1880 he was in

Cyprus, where he was employed as overseer of a multinational cohort of stonebreakers, but his second visit ended abruptly, and an Italian who knew him in North Africa afterwards claimed that the reason for this was that Rimbaud had accidentally killed one of the workers in his charge,[16] further contributing to his posthumous reputation as a man beyond all laws. He arrived, finally, in North Africa, and for the last ten years of his life became a trader, travelling through remote parts of the land, engaged in the coffee trade, in gun running and even, perhaps, in the slave trade. He wrote nothing, other than workaday letters to his family and business colleagues.

The apparent, and apparently incomprehensible, contrast between two halves of a life that do not add up to a coherent whole has nagged at generations of Rimbaud's biographers. His life resembles Byron's, but developed the legend of the bohemian further and more completely. Like Byron, he left literature to become a man of action. Like Byron his erotic life was characterized by transgression and suffering. Both young men courted, yet distanced themselves from notoriety. Their beauty attracted followers, lovers and hangers-on, yet their lives were under the sign of a dark and melancholy star.

Who created the Rimbaud myth? Unlike Byron, Rimbaud lacked a popular audience. He was not famous in his lifetime; on the contrary, it was precisely the 'forgotten' quality of his later years that reinforced the myth of the teenage genius. Yet after all the bohemian always oscillates between the two extremes of fame, or notoriety, and obscurity, the stark contrast between the two adding to the magic; and obscurity paradoxically prolongs the after life of an artist or poet, or even simply a 'character' since it makes it possible for them to be 'rediscovered' years or decades later.[17]

Rimbaud himself contributed to the myth, even to a 'mystification'[18] about his own attitude towards it and in particular towards his poetry. Although apparently indifferent whether his writing survived or not, he made sure that his poems did not disappear, for while staying in Stuttgart in 1875 he entrusted some of his work to one of the three literary friends, Verlaine, Ernest Delahaye and Germain Nouveau (it is not certain which) who continued to interest themselves in Rimbaud's movements after his renunciation of the bohemian world.[19]

All three friends wrote memoirs and reminiscences, in which they recorded Rimbaud's increasingly adventurous journeys as he moved towards his final destination in North Africa, and their accounts contributed to the literary process which transmuted the figure into a myth; they were 'impassioned, committed artisans, dedicated to the creation of an impressive saga centring on their hero.'[20] And from this time forward 'it is impossible to recover a "Rimbaud as he really was". It seems preferable to accept a *construction* deliberately set up by Rimbaud himself and perfected by his acolytes.'[21]

Verlaine was responsible for nurturing his former lover's literary reputation; in 1883 his article about Rimbaud was published in the journal *Lutèce*, and the publication of Rimbaud's poem, 'Vowels' caused a stir. The following year Verlaine's *Les Poètes Maudits* included a section on Rimbaud. A new

avant-garde, the group of poets known as the Symbolists, looked on him as a forerunner and pioneer, especially after the publication, in 1886, of the *Illuminations* in two editions of another magazine, *La Vogue* – in the introduction the author was referred to as 'the late Arthur Rimbaud' ('the report is exaggerated but not entirely inappropriate'[22]).

Two years later a journalist who had been a fellow collegian in Charleville wrote to tell him of his growing reputation:

> In Paris you have become, among a little coterie, a sort of legendary figure, one of those people whose death has been announced, but in whose existence certain disciples continue to believe ... Certain young people ... have tried to base a literary system on your sonnet of the colour of letters [*Vowels*]. This little group do not know what has become of you, but hope you will one day reappear, and rescue them from obscurity.[23]

In 1890 the owner of yet another literary magazine, *France Moderne*, wrote to Rimbaud, begging him to contribute. Receiving no answer, the publisher boasted in the February 1891 issue:

> 'This time we've really got it! We know where Arthur Rimbaud is, the great Rimbaud, the true Rimbaud, the Rimbaud of the *Illuminations*. This isn't another Decadent hoax. We affirm it: we know the abode of the famous fugitive!'[24]

Ironically, this was the year in which Rimbaud did die.

Death was only the beginning. After his first acolytes had laid the foundations, generations of critics and biographers contributed further touches to the legend. That Rimbaud traded in arms is not in dispute; but in the wild west world of the North African desert, arms were standard merchandise. Enid Starkie, a devoted researcher, went further, suggesting that he was a slave dealer as well.[25] Later writers have disputed this (although he probably kept a domestic 'slave'[26] himself); but the truth is less important than the further *frisson* Starkie's suggestion added to the myth. Equally, biographers have differed as to whether they believe that Rimbaud renounced homosexuality in his adult life or whether they believe he remained a lover of men (Jean-Luc Steinmetz, for example, suggests that the photograph of the woman usually taken to be Rimbaud's mistress may actually be that of a man or boy in female dress[27]); but in relation both to slavery and homosexuality it is not the truth which matters, at least for present purposes; what counts is the ineradicable contribution to a myth of damnation and transgression: the *poète maudit*.

From the time he died this cursed poet became the icon to whom all rebels, nihilists, avant-garde art movements and refractory ones tipped their caps. He set the standard which all must reach, or, better still, surpass. At the Café Voltaire in Zurich the Dadaists recited his works in their nightly

performances; the Surrealists acknowledged his influence as did the post-war Lettrists and the Situationist International.

In the sixties Jeff Nuttall, chronicler of the British counterculture, explicitly linked his poetry with the cult of madness: 'Psychosis has been the common language of art since Rimbaud.'[28] Charles Nicholl, who retraced Rimbaud's travels in North Africa a hundred years after his death, recalled how when he first heard of Rimbaud in 1966, 'what I heard about him was that he was Bob Dylan's favourite poet. I can now document this with reference to an interview with Dylan on San Francisco's [public service] channel, KQED on 3 December, 1965.' In this interview Dylan cited Rimbaud along with W.C. Fields, Smokey Robinson and Allen Ginsberg as artists who had influenced him, and songs from his 'early electric period' such as 'Visions of Johanna' were, suggests Nicholl, 'steeped' in Rimbaud's influence.[29] (Rimbaud's fame is relative, however; in North Africa, Nicholl's requests for information about the poet were sometimes misunderstood as a quest for 'Rambo.')

The rock singer Patti Smith developed what amounted to a 'crush' on Rimbaud after she saw his photograph, and identified with Rimbaud the seer and prophet in his attempt systematically to disorder the senses, to see visions and live dreams.[30] The figure of Rimbaud haunted the Punk movement too. Rock journalist Caroline Coon thought Johnny Rotten 'was like a young Rimbaud: thoughtful, angry, beautiful'; and a member of the band the New York Dolls told an interviewer: 'Rimbaud would write about the monstrous city and the effects it would have on the species ... that's what a lot of my songs are about.'[31]

Central to the Rimbaud myth is his renunciation of the poetry that made him famous and of the bohemian way of life with which he has been identified ever since. There are two ways of looking at this. It is possible to interpret his teenage years and his poetry as an adolescent process; Rimbaud the adult trader and traveller had put away childish things – as his own terse comments appear to suggest. This is the more reassuring reading of his life, since it confirms the well-established idea that youthful rebellion is a natural but transient 'stage' to be followed by maturity, when people 'settle down' (the Murger version of the myth). Alternatively we may see the flight from poetry, along with the absinthe, the 'disordering of the senses' and madness, as part of a process of self-destruction – or self-transformation.

One reason for the attraction of the more radical version of the bohemian myth – that of the perennial rebel, the complete outsider – is precisely its refusal of maturity, normality and 'settling down'. Rimbaud never settled down; he exchanged one form of refusal for another that may have been even more challenging. Harsh and bitter his life may have been in Abyssinia – and he often complained about it – but it was the fulfilment of the wish to escape oneself, the achievement, as Nicholl puts it, of 'that last impossible freedom, which is to lose oneself to become somebody else ... in that sense his African years might be seen as his masterpiece.'[32]

Rimbaud's story is the myth of Bohemia in its most potent form. It contains all the ingredients that combine to produce an impossible figure, a narcissistic object of desire. Rimbaud is the bohemian who renounced Bohemia, the genius who gave up his art for a life of action, the notorious practitioner of forbidden love who turned his back on outrage, the beautiful youth who destroyed his own myth, the hard-bitten traveller who created an alternative myth; the bohemian as legionnaire, gun runner, slave dealer. It is this radical disavowal that gives a final twist to the myth.

It was only a few years later that Augustus John began to live out an English version of the bohemian artist. This was neither Rimbaud's 'systematic disordering of the senses', nor Murger's penniless attic-dweller (for John's painting made him a rich man), nor was it Byron's sinister deviance; rather it was based on an exaggerated larger-than-life 'normality'. This was the 'lust for life' version of the bohemian, the bohemian of great energy and appetites.

Whatever the 'inner truth' of the man, in his appearance and behaviour Augustus John both created and simultaneously conformed to a popular idea of what the heroic genius should be like. Clad in slouch hat, cloak, beard and gold earring he was immediately recognizable. Nina Hamnett recalled her first sight of him in 1909: 'One day I was in the King's Road, Chelsea, and someone said: "There goes Augustus John!" ... I saw a tall man with a reddish beard, in a velvet coat and brown trousers, striding along; he was a splendid-looking fellow and I followed him ... keeping a respectable distance behind.'[33] Dorothy Brett, another Slade student, had a similar memory of him, also in the King's Road: 'Tall, bearded, handsome, shaggy hair with a large black homburg hat at a slight angle on his head', while Sir Charles Wheeler recalled him as 'tall, erect and broad-shouldered, wearing a loose tweed suit, with a brightly coloured bandana round a neck which holds erect, compelling features ... He is red-bearded and has eyes like those of a bull.' Wheeler, added, significantly, that John was 'doubtless conscious of being the cynosure of the gaze of all Chelsea'. Cynthia Asquith, again, found him 'magnificent, straight out of the Old Testament − flowing, well-kept beard, hair cut *en bloc* at about the top of the ear, fine, majestic features. He had on a sort of overall daubed with paint, buttoning up round his throat, which completed a brilliant picturesque appearance.'[34] That these witnesses described his *appearance* above everything else confirms the element of performance.

His genuine interest in Romany life and culture was part of this legend. In 1909 he set off with his family on an extended caravan journey. They camped in Grantchester, on the outskirts of Cambridge, and at once became the talk of the town. Maynard Keynes reported that 'John is encamped with two wives and ten naked children ... All the talk here is about John ... According to Rupert [Brooke] he spends most of his time in Cambridge public houses, and has had a drunken brawl in the streets smashing in the face of his opponent.' Such was the notoriety of the group that Cambridge university families made special trips to gape at his companion, Dorelia, and the

children in their field.[35] (However, when they reached Norwich, Augustus suddenly left the group to fend for themselves while he set off for Liverpool by train.)

Essential to the legend was his refusal of convention and cavalier attitude to love, so that his path through life was strewn with mistresses, carelessly sired children, and what might now be interpreted as child abuse; but equally essential to the legend was the suggestion that he in some sense betrayed his enormous talent; that playing the role of Artist and Genius eventually interfered with the artistic process itself. His biographer, Michael Holroyd, has suggested that this was an example of 'English eccentricity,' indicative of a general national decline as well as of John's individual failure fully to grasp his artistic destiny. 'Failure' of this kind however, was part of the general bohemian myth that John so strenuously lived up to; he gave it an English inflection, but it was essentially an international phenomenon.

As time went on John drank ever more heavily, and was also unable to resist London social life. During the First World War he steered a course between the Café Royal, the Crab Tree club (which he founded), various Soho establishments such as the Café Verrey, and the White Tower, Percy Street, a restaurant he and Nina Hamnett had 'discovered' and turned into a fashionable bohemian haunt. In the twenties he led a hectic life as a society portrait painter and was a hero to the Bright Young Things, seen at all their glamorous parties.[36] Yet the more popular and famous he became, the more he was lost to himself – again the failure in the midst of success that was the essence of the bohemian role.

Oscar Wilde illustrates another aspect of this contradiction. He claimed to have put his genius into his life and merely his talent into his work, so perhaps it is appropriate that it was the life rather than the art that met with disaster. Like Augustus John, he constructed his own legend, which was then amplified by others, when he was satirized by George du Maurier in the pages of *Punch*, and in the Gilbert and Sullivan operetta, *Patience*. His myth was the outcome of the unspoken pact that united protagonist, popularizers and audience; but whereas the public could continue to enjoy the John legend, in which the 'normal' manly appetites for drink and women were simply magnified, Wilde took nonconformity too far. Like Augustus John's, Oscar Wilde's version of the bohemian had the peculiarly English aspect of connections with raffish elements of the aristocracy and upper class (Edward VII's mistress, Lily Langtry, was his close friend, for example), but his *bohème d'orée*, far distant from Murger's dingy attic, nevertheless touched Marx's underworld through the working-class male prostitutes with whom he consorted. Not content with preaching a bohemian aesthetic of artificiality, once he had met his nemesis in Lord Alfred Douglas he was sucked into a whirlpool of excess and outrage, flaunting his rendezvous with young men of the streets, his personality a provocation too far for a society that, beneath its sophisticated veneer, distrusted art and was completely traumatized by the very idea of sexual love between men. En route to prison, he was made to

stand on the station platform so that all could witness his humiliation; passers-by spat on him in what almost amounted to a revival of the ritual of the stocks. His plays were suppressed, his sons had pseudonyms thrust upon them, young men were punished by distraught parents for even mentioning his name. His downfall, nevertheless, provided a fitting conclusion to this version of the legend.

In Montmartre and Montparnasse between the 1890s and 1914 the different strata of Bohemia were mingling: the Montmartre 'apaches'[37], as underworld characters were called; the serious art students; and the café bohemians. Amedeo Modigliani, one of the most 'bohemian' bohemians of this period, came from a cultivated family of Jewish merchants in Leghorn, but lived in abject poverty in Paris. Other bohemians were complicit in cultivating their own myth; the legend of Modi the crazed genius seems to have been largely the creation of those who surrounded him. His life was genuinely tragic, for not only did he make hardly any money from his work, but in his lifetime he never received the recognition for which he craved. Fellow artists, Augustus John and Nina Hamnett among them, would purchase his drawings for a few sous, but when Leopold Zborowski, his dealer and friend, organized an exhibition of his work during the First World War it was closed down by the police, who declared the canvases indecent because pubic hairs were painted on his female nudes. He drank to excess, combining alcohol with cannabis pills, and had a series of violent love affairs, including one with the eccentric Beatrice Hastings. His last girlfriend, Jeanne Héburne, killed herself after his death. Yet immediately afterwards his funeral was a kind of triumphal procession, his canvases were hailed as masterpieces and soon fetched thousands of francs, dollars and pounds.

This was a dramatic story, and fellow bohemians were soon exploiting it. Douglas Goldring, himself a Montparnassean of the period, wrote the first reminiscences, which set up the Modigliani myth, to which Beatrice Hastings contributed malicious reminiscences of their acrimonious love affair.[38] The Soviet novelist, Ilya Ehrenberg, who had lived in exile in Paris before the First World War, objected to the popular image of the 'hungry, dissolute, perpetually drunken painter, the last of the bohemians', yet, like everyone who had known Modi, he reinforced the stereotype in his own autobiography. Modi made 'colourful' appearances in many other volumes of memoirs as well. In the wake of the Existentialists and the Beats, the Modigliani legend was further enlarged in the 1950s, with, among other contributions, André Salmon's novelized biography, *La Vie Passionée de Modigliani*,[39] and in 1962 the painter's life became a film, *Montparnasse*, starring Gérard Philippe, a heart-throb of 1950s French cinema. Ehrenberg felt that this too was a vulgar travesty:

> how could a film director sit on a low stone step meditating on the tortuous ways of a stranger's life? ... The hero of the film and the novels is Modigliani in his moments of despair and madness. But, when all is

said and done, Modigliani not only drank at the Rotonde, not only drew on coffee-stained paper; he spent days, months and years in front of his easel, painting.[40]

Maurice Utrillo, Modigliani's friend and drinking companion, was similarly mythologized. Francis Carco observed with disapproval that 'Utrillo's admirers place more emphasis on the legend than upon their pretended love for his painting'.[41] Yet Carco's own successful literary career was largely based on the creation of a romantic, nostalgic Bohemia in scores of novels and memoirs.

Carco wrote of Modi's Paris as 'the last Bohemia,' but Bohemia was still flourishing in the 1950s, even if bohemians now had a series of new names – existentialists, beats, the counterculture – and traditional bohemians passed on the baton of genius damned to the heroes, male and female, of the new youth cultures. Marianne Faithfull emulated William Burroughs just as Patti Smith modelled herself on Rimbaud. Wild and often 'deviant' sexuality was a feature of the countercultural life; Nicholas Roeg's film *Performance*, in which Mick Jagger, Anita Pallenberg and James Fox starred, explored the mutual attraction of the rock world and the underworld in the London of the late 1960s, as did *A Box of Pinups* and *Bye Bye Baby and Amen*, in which David Bailey placed photographs of musicians, fashion models and artists next to the Kray brothers, then the most notorious gangsters in Britain.

The art celebrated in this new Bohemia was the art of a mass culture: popular music, photography, fashion. Many of the bohemians of earlier times would have rejected the idea that such ephemeral and perhaps minor contributions to culture could be set alongside works of genius. Yet Gavarni, the artist who, Baudelaire believed, best captured the fluidity of the nineteenth-century crowd, had been a fashion illustrator; Murger had been a popular writer. Indeed, many bohemians achieved popular success, and whether, like Augustus John, they continued to play the part of bohemian, or, like Picasso, preferred, in some respects at least, a plutocratic bourgeois style of life, they defied the association of genius with tragedy and self-destruction. This association nevertheless lived on in the new myth of the excessive rock star, down to the 1990s, when the tragedy of depression, sexual deviance or drug addiction and suicide was re-enacted by Curt Cobain and Michael Hutchence, in that 'Bohemia for the masses' with which the bohemian story will later conclude.

If any single individual contributed to the transformation whereby the bohemian moved from a character who symbolized the vicissitudes of 'high art' to a major influence on mass culture, it was Andy Warhol. Andy Warhol's cultivation of celebrity was such that he has become one of the most famous artists of any period. In the final decade of his life he was part of the Ronald and Nancy Reagan band of courtiers, and hobnobbed with Manhattan socialites and Hollywood stars, but in his early years he was as much of a bohemian as any of those mentioned so far. From obscure immigrant origins

in Pittsburgh he trained as a commercial artist. Doubly despised for this and
for being a 'swishy fag' in the macho New York art world of the 1950s, when
the hard drinking, womanizing Jackson Pollock was the Great Artist, he
began to make a name for himself as a fashion illustrator and window
designer. He became friendly with Charles Henri Ford, who had once had a
brief affair with Djuna Barnes; Ford was the lifelong companion of the
painter Pavel Tchelitchew, who had been a protégé of Edith Sitwell. This
friendship linked Warhol to an older Bohemia:

> I would go absolutely anywhere I heard there was something creative
> happening ... and Charles Henri and I began going around together to
> some of the underground movie screenings. He took me to a party that
> Marie Menken and her husband Willard Maas, underground film makers
> and poets, gave at their place in Brooklyn Heights ... Willard and Marie
> were the last of the great bohemians. They wrote and filmed and drank.[42]

By 1963 Warhol's Factory studio was becoming the focus of a new kind of
'scene.' His assistant Gerry Malanga began to introduce Warhol to the flam-
boyant habitués of the San Remo and soon Billy Name, a village dance-show
lighting co-ordinator, was living at the Factory, which, open to anyone and
everyone, became the stage on which hustlers and drag queens encountered
the New York art world and street life met up with society debutantes and
Harvard hipsters. There, decadence became lifestyle and voyeurism an art
form as art and life merged into one continual performance, reaching new
heights when the Velvet Underground created multimedia events at which all
boundaries were abandoned.

Speaking at the Institute of Contemporary Art in London in 1997, Billy
Name explained the spell cast by the Factory quite simply in terms of its
'glamour.' It was about 'a subterranean world of beautiful people and geniuses
and poseurs, the obsessed and the bored, who had come at last into their
glamorous own.'[43] But in more ways than one there were similarities to the deca-
dence of the *fin de siècle*. When Valerie Solanas shot Warhol, this, the ultimate
Happening, seemed to act out André Breton's statement that 'the simplest surre-
alist act consists of going out into the street, revolver in hand, and firing at
random into the crowd,'[44] and was also reminiscent of the anarchist bombings
of the 1890s, when the critic Laurent Teilharde had quipped, 'what do a few
human lives matter if the gesture is beautiful?' (a joke that was returned with
interest when he later lost the sight of an eye in one such bombing).[45]

Andy Warhol developed in particular the relationship between avant-garde
and mass culture to an eerie degree. His films (an eight-hour movie of a
sleeping man, long plotless trackings of drag queens camping it up as
cowboys) were experimental, his paintings celebrated the 'pop' surface of life,
so that the whole American landscape of drive-bys and hoardings became an
aesthetic surface. His celebrated dictum, that in the future everyone will be
famous for fifteen minutes, appeared to subvert the celebrity he cultivated so

assiduously, but gestured to a democratization of glamour. His avant-garde collapse of art into life turned everything into a surface and a simulacrum. On one occasion he sent one of his followers halfway across America in his place to give a lecture, and when the deception was discovered and the event cancelled he expressed surprise. What did it matter, and the lookalike was better looking than the 'original' anyway.

The Rimbaud legend managed to combine fame with obscurity, fusing these incompatibilities in his journey through life so that each intensified the impact of the other. The Warhol aesthetic subverted the opposition on which the legend relied. For in practice, obscurity was as necessary to Bohemia as notoriety. The unknown bohemians contributed as much, or more, to the legend as the famous. Obscurity provided the deeply bohemian themes of self-destruction and failure.

Notes

1 Bourdieu, 'Field of Power', p 162. It is for this reason (among others) that one of Byron's most recent biographers, Phyllis Grosskurth, utterly misses the point when she suggests that Byron's life would have been happier had he had more psychoanalytically satisfactory mothering. In her therapized account, Grosskurth fusses around Byron like a mother hen, her text an *example* rather than an analysis of the fascination exerted by the poet over those very representatives of the bourgeoisie whom he most appalled. See Phyllis Grosskurth, *Byron: The Flawed Angel* (London: Hodder and Stoughton, 1997).

2 Louis Crompton, *Byron and Greek Love: Homophobia in Nineteenth Century England* (London: Faber and Faber, 1985), *passim*.

3 Ibid., p 284, quoting Violet Walker, 'Benjamin Robert Haydon on Byron and Others', *Keats Shelley Memorial Bulletin*, vii (1956), pp 23–4.

4 A point also made by Benita Eisler in *Byron: Child of Passion, Fool of Fame* (London: Hamish Hamilton, 1999), p 752. As Anne Fleming points out in 'A Byron Shaped Space' (*Times Literary Supplement*, 5 November 1999, p 21–2), Eisler has attempted further to demonize Byron and to 'spice her confection with scandal'. Since homosexuality has lost much of its transgressive potential and is no longer shocking to the contemporary reader, Eisler has had to make unsubstantiated suggestions of wife rape and child sexual abuse, the 'unspeakable crimes' of the present time.

5 See Christopher Frayling, *The Vampire: From Byron to Bram Stoker* (London: Faber and Faber, 1992).

6 Colin Campbell, *The Romantic Ethic and the Spirit of Modern Consumerism* (Oxford: Blackwell, 1987), p 176.

7 Ibid., pp 182, 192. For Campbell, this explains the rise of consumerism, for he argues that the pursuit of pleasure and consumerism and the development of a refined aesthetic taste became indices of an individual's creativity and imagination, and thus admirable: 'Romanticism provided that philosophy of "recreation" necessary for a dynamic consumerism: a philosophy which legitimates the search for pleasure as good in itself ... At the same time, romanticism has ensured the widespread basic taste for novelty, together with the supply of "original" products, necessary for the modern fashion pattern to operate'. p 201.

8 Edward John Trelawney, *Records of Shelley, Byron and the Author* (orig publ 1858; Harmondsworth: Penguin, 1973), p 78.
9 Michael Sadleir, *Blessington D'Orsay: A Masquerade* (London: Constable, 1947), p 234, quoting Grantley Berkeley.
10 Ibid., and see Lady Blessington, *Conversations of Lord Byron with the Countess of Blessington* (London: Bentley, 1834).
11 See Siegel, *Bohemian Paris*.
12 Henry Murger, *Scènes de la Bohème* (Paris: Michel Levy, 1851), pp 7–11.
13 Quoted in Robert Baldick, *The First Bohemian: The Life of Henry Murger* (London: Hamish Hamilton, 1961), p 66.
14 This was actually Rimbaud's third or fourth journey to the capital. At the age of only sixteen he had run away to Paris in the hope of taking part in the political upheavals as Napoleon III's dictatorship began to collapse, but instead he had been arrested. Not long after, he returned a second time, in search of the artistic circles of which he was so deprived in the provinces. His friends all claimed that he made a third visit during the Commune period, although if he did he cannot have been in the city for long. His poem, *Le Coeur Supplicié*, may relate to a homosexual experience at the hands of fellow soldiers during the Commune visit, but this suggestion is speculative. See Jean-Luc Steinmetz, *Arthur Rimbaud: Une Question de Présence* (Paris: Tallandier, 1991), pp 76–7.
15 Ibid., pp 247–8.
16 Charles Nicholl, *Somebody Else: Arthur Rimbaud in Africa* (London: Jonathan Cape, 1997), p 87, quoting Ottorino Rosa, MS notes on Rimbaud, *c*. 1930; and extracts published by Lidia Herling Croce, 'Rimbaud à Chypre, à Aden et au Harar: Documents Inédits', *études Rimbaldiennes*, 3, 1972.
17 The British dress designer and 1960s *haute bohémien* Ossie Clark, killed by his boyfriend in 1996, is another example of this phenomenon, with the posthumous publication of his diaries, a television documentary and a projected feature film all contributing to the revival of his reputation.
18 Steinmetz, *Arthur Rimbaud*, pp 228–9.
19 Ibid.
20 Ibid.
21 Ibid.
22 Nicholl, *Somebody Else*, p 202.
23 Ibid., quoting Paul Bourde.
24 Ibid., quoting Laurent de Gavoty.
25 Enid Starkie, *Arthur Rimbaud in Abyssinia* (Oxford: Clarendon Press, 1937).
26 Slavery existed in these parts of Africa at the time, but had a different signification from the slavery, say, of the southern states of the USA, since although North African slaves were not paid, they were not usually ill-treated either and their status was closer to that of indentured workers. See Steinmetz, *Arthur Rimbaud*.
27 Ibid.
28 Jeff Nuttall, *Bomb Culture* (London: Paladin, 1970), p 151.
29 Nicholl, *Somebody Else*, p 321.
30 Patricia Morrisroe, *Mapplethorpe: A Biography* (London: Macmillan, 1995), p 50.
31 Jon Savage, *England's Dreaming: Sex Pistols and Punk Rock* (London: Faber and Faber, 1991), pp 58, 176.
32 Nicholl, *Somebody Else*, pp 12–13.

33 Nina Hamnett, *Laughing Torso* (orig publ 1932; London: Virago, 1984), pp 25–6.

34 Michael Holroyd, *Augustus John: A Biography* (Harmondsworth: Penguin, 1976), pp 538, 548, quoting letter from Dorothy Brett to the author, 7 August 1968; Charles Wheeler, *High Relief*, p 31; and Cynthia Asquith, *Diaries*, Tuesday, 9 October 1917.

35 Holroyd, *Augustus John*, p 364.

36 Ibid., *passim*.

37 The name comes from the warlike American Indian tribe.

38 See June Rose, *Modigliani: The Pure Bohemian* (London: Constable, 1990).

39 André Salmon, *La Vie Passioneée de Modigliani* (Paris: Intercontinentale du Livre, 1957).

40 Ilya Ehrenberg, *People and Life*, p 140.

41 Francis Carco, *From Montmartre to the Latin Quarter: The Last Bohemia*, trans Madeleine Boyd (London: Grant Richards and Humphrey Toulmin, 1929).

42 Andy Warhol and Pat Hackett, *Popism: The Warhol Sixties* (London: Pimlico, 1996), p 40.

43 Stephen Koch, *Stargazer* (New York: Praeger, 1973), p 5.

44 André Breton, *The Second Surrealist Manifesto*, 1924.

45 Shattuck, *The Banquet Years*, p 17.

CHAPTER FIVE

THE ORIGINALITY OF OBSCURITY

Glamour always surrounds a loser.

Derek Raymond: The Crust On Its Uppers

The myth of famous, larger-than-life bohemians depended upon the cast of less known but equally flamboyant and eccentric characters surrounding them. These were often more unusual than the stars, sometimes so original that their lives became works of art in themselves. Without them, Bohemia could not have existed; they did not merely provide the background essential to the myth, they actively created it, for the bohemian myth went beyond individuals; it was a world, a way of life, a permeable culture within the wider culture in which 'great artists' and 'minor characters' contributed to a whole greater than the sum of its parts. Indeed, even to distinguish between 'stars' and the rest does an injustice to the many bohemians who never became celebrities outside their own small circle.

It was sometimes hard to distinguish between bohemians whose work simply lacked wide appeal, and those who, immersed, were drawn to a life of improvisation and dreams. Some bohemians seemed almost consciously to seek poverty and failure. The bohemian cafés of the nineteenth and early twentieth century, such as the Brasserie des Martyrs, were peopled by:

> philosophers without a halfpenny, who couldn't have cared less what their philosophy was based on, those in search of ideas, of words, master pain-ters and ... phrase chisellers, knights-errant of the pen and the brush, brave searchers for infinity, impudent peddlers of dreams, entrepreneurs of towers of Babel, believers and enthusiasts, but all suffering from the same disease ... lack of money, having spent their all on superb castles in Bohemia, or long and costly journeys to the land of Make Believe; but all,

also, heroes of obscure daily struggles against the realities of everyday prac-
tical life. [They] returned each evening to rekindle their enthusiasm or to
spark off the work of which they dreamed, but would never accomplish.[1]

Or, as the Goncourt brothers less charitably expressed it: 'all those nameless
great men, all the bohemians of minor journalism, of an impotent and
dishonest world, all ready to cheat one another out of a new coin or an old
idea.'[2]

Yet there was a kind of genius in the originality that expressed itself in
unusual behaviour and lifestyles rather than 'great works.' Many bohemians
simply poured their creativity into that most ephemeral of arts, the 'art of
living', dedicating their lives to the evanescent arts of adornment, outrage, wit
and conversation.

Bohemia attracted its self-chosen citizens for many different reasons. It was
a refuge, a way station, a stage. For some it was a permanent home, for
others a transient port of call. Just as the bohemian was a protean character,
so Bohemia was a land of fantasy that could be shaped to fit the dreams of
those who visited or dwelt there.

Some bohemians devoted themselves to 'minor' or ephemeral arts and
crafts; there were also those whose output was small, and there were others
whose work directly challenged the distinction between art and life. In
addition, Bohemia offered all sorts of casual employment: for artists' models,
jobbing journalists, session musicians and out-of-work actors; and, as Marx
had observed, Bohemia's petty entrepreneurs included those on the margins
of criminality, who provided services of a more dubious kind: pimps, rent
boys, drug dealers, informers and conspirators. Bohemia was also a sanctuary
for men and women who had been excluded from respectable society and
found a more tolerant atmosphere among the bohemians. In the nineteenth
century this was particularly the case for women from the upper and middle
classes who had fallen from grace following an irregular love affair or the
birth of an illegitimate child. It was above all a home for black sheep and
rebels. Erich Mühsam recalled an evening in the old Café des Westens in
Berlin before the First World War, when he was seated at a table crowded
with 'novelists, painters, sculptors, actors and musicians'. Someone asked the
question: 'Who amongst us had come to his vocation as an artist without
family conflict? It emerged that all of us without a single exception were
apostates, had rejected our origins, were wayward sons.'[3]

On the other hand there were the many selfless bohemians who dedicated
themselves to the promotion of the artistic work of others: editors,
publishers, art dealers, hostesses. These created the institutions of Bohemia –
the cafés, salons, bookshops, galleries and publishing houses – upon which
the rest depended. Others nurtured and looked after the bohemians when
they had no money: hostesses and café proprietors again, landladies, restaura-
teurs or simply friends.

The establishments they set up attracted voyeurs and tourists along for the

ride: women who attached themselves to artists, young men sowing wild oats, dilettantes and pleasure-seekers who enjoyed the unbuttoned atmosphere of *la vie de bohème*. These visitors contributed to the atmosphere of the cafés and bars. They provided the audience for cabaret, for the *chanson réaliste* of *fin de siècle* Montmartre and the folk song of Greenwich Village in the 1950s. This audience, however, also became part of the spectacle, itself participating to some extent in the public world of Bohemia; and in any case some of those who hung about on the fringes must have hoped to penetrate the inner sanctum of Bohemia. The distinction sometimes made (for example, by Jerrold Siegel) between the 'real' bohemians and a passing audience of 'tourists' is therefore oversimplified, although popular in many Bohemias as a way of pulling rank.

Walter Benjamin described the fluctuating and permeable boundaries between these different groups in Berlin before and after the First World War. When the proprietor of the Café des Westens evicted his wild-eyed clientele, they colonized the Romanische Café instead. At first they had the place to themselves: 'the legendary, now departed waiter, Richard, distributor of newspapers – a hunchback who on account of his bad reputation enjoyed high esteem in these circles – was the symbol of their dominance.' But when in the early 1920s the German economy began to recover, 'the bohemian contingent visibly lost the threatening nimbus that had surrounded them in the era of the Expressionist revolutionary manifestos. The bourgeois ... found that everything was back to normal.' As a result the physiognomy of the Romanische Café began to change:

> The 'artists' withdrew into the background, to become more and more a part of the furniture, while the bourgeois, represented by stock-exchange speculators, managers, film and theatre agents, literary-minded clerks, began to occupy the place – as a place of relaxation. For one of the most elementary and indispensable diversions of the citizen of a great metropolis ... is to plunge into another world, the more exotic the better. Hence the bars haunted by artists and criminals. The distinction between the two, from this point of view, is slight.[4]

These customers – 'managers, film and theatre agents' – emerged from changes in the cultural industries. In the late 1920s the Romanische, although 'admittedly a different Bohemia,' remained a Bohemia nonetheless, but one:

> of practicalities rather than of ideals. Business, the slogan of the day, has taken hold, even in Bohemia. They ... no longer recite Iliads, write trilogies in hexameters or paint Raphaelesque idylls: they're photographers, illustrators, reporters, comperes, film directors ... and the question on the lips of these remarkable crossbreeds of art and business is: 'how much can I get for it?'[5]

At this end of the spectrum, bohemian values leaked into the mass culture of modernity. The Romanische, for example, was where Billy Wilder and Robert Siodmak hung out before they went to Hollywood and became *film noir* directors.[6] They were never 'tourists,' but they were, perhaps, transient bohemians, en route to the wider world. In contrast the permanent bohemians, those individuals who went in for total immersion in Bohemia, found there a wholly alternative life, which met their needs and seemed to be the solution to unresolved problems even when it manifestly exacerbated them.[7]

Bohemia, indeed, offered a refuge to psychological casualties too disturbed to undertake formal employment or conform to the rules of conventional society. It was a sanctuary for individuals who were so eccentric or suffered from such personal difficulties or outright psychological disorder that they could hardly have existed outside a psychiatric institution other than in Bohemia. Bohemia, however, not only offered them a tolerant haven, but a social setting in which they had a positive contribution to make by adding to its colourful eccentricity. A further function, therefore, of the bohemian café was as a do-it-yourself day centre or informal asylum for mentally disturbed bohemians.

On the other hand, the continual effort of permanent rebellion was itself sufficient to send some individuals over the edge. Oscar Panizza, for example, became a bohemian casualty of German repression. A doctor who trained and practised in Munich, he was also a writer. Inspired by the Catholic peasant culture of the surrounding area, he tried to incorporate the carnivalesque quality of their festivals into his scandalous plays, for Carnival, he felt:

'implies the conflation and inversion of concepts and values that are normally kept apart: sacred and profane, spirit and body, elite and popular, ruler and ruled, in short "high" and "low". Unlike the educated middle class "civilized" individual, who divides the world into the acceptable and the unacceptable, the peasant sees delightful and terrifying things close together ... and with the same equanimity and certainty perceives the nobility and baseness of humanity.'[8]

Bohemian life was itself a kind of carnival, transgressing conventional barriers in just this way, but Panizza's subsequent career illustrated the dangers of the carnivalesque approach to life, which in his case rapidly became a *danse macabre*.

In 1894 his anti-religious satire, *The Council of Love*, a blasphemous comedy about the sexual activities of the holy family, was banned, and Panizza was jailed for obscenity. On his release he renounced his Bavarian citizenship and for a time resided in Zurich, where he spent his time selling his anti-religious pamphlets *Christ in the Light of Psychopathology* and *Effeminateness in the Cult of the Messiah*.[9] In 1898 he was expelled as an undesirable alien, moved to Paris and wrote a book of poems attacking the Kaiser in obscene terms. Unable to extradite him directly, the Bavarian police confiscated his mother's trust

fund, which was the source of his income, and he was forced to return to Germany, where he stood trial in 1901. By this time he was developing a persecution complex, was judged unfit to plead and was permanently committed to an asylum in 1904. He became a Sadeian hero to Munich bohemians, who believed that his incarceration was due to the machinations of a Jesuit uncle, 'who intervened at the request of his family, as the Marquis de Sade's mother-in-law had done. He remained in the sanatorium for twenty years, shut off from the outside world and continuing to write until his death. Like the Marquis de Sade at Charenton, no-one was permitted to visit him,' wrote his fellow writer, Walter Mehring, who had himself attempted unsuccessfully to see Panizza in the asylum.[10]

The most radical approach to the possibility of failure was to bypass completely the criteria by which success and failure were judged. One way of doing this was for the individual to unite life and art in his or her person. This strategy could become a sort of madness too, the exploration of a paradox whereby art no longer imitated life, but, on the contrary, life became as unreal as a work of art.

In *fin de siècle* Paris, Alfred Jarry was the supreme example of such work. He was an 'unknown' bohemian in the sense that his work was so modern as to be wholly incomprehensible except to the avant-garde; his extraordinary life-as-work-of-art went beyond any popular bohemian stereotype, taking the implications of life as art as far as they could possibly go.

Even as a schoolboy Jarry was noticeably eccentric; one of his friends from that period recalled uneasily that he seemed to be controlled by his wit rather than being in control of it; and that when he opened his mouth he spoke 'like a machine driven by some demon.' His originality was 'too much like some mental anomaly.'[11] During his military service eccentricity became the weapon whereby he eventually engineered his discharge; he always appeared to obey orders yet in his manner of so doing somehow subverted them, revealing the underlying absurdity of military protocols. From then on his life became an absurdist drama, his existence a 'sustained hallucination.'[12]

He was only twenty-three when in 1896 his play *Ubu Roi* was staged at Aurelian Lugné-Poe's experimental Théatre de l'Oeuvre. The first shock for the audience was the appearance of Jarry himself when he made an opening announcement to the audience. They would, he told them, see: 'doors open on fields of snow under blue skies, fireplaces furnished with clocks and swinging wide to serve as doors, and palm trees growing at the foot of a bed so that little elephants standing on bookshelves can browse on them.' The initial scandal of Jarry's appearance and the peculiar stage setting was surpassed when the actor who played the part of Ubu stepped forward and uttered the single word 'shit', for in those days the mere utterance of an obscenity was sufficient to cause uproar.[13]

Ubu, described as a 'symbolist farce' by the English poet Arthur Symons, who was present at the opening night, was more than a play, even a shockingly

experimental one, for Jarry, not content with inventing Ubu, had to *become* his creation. The actor who played the role reproduced Jarry's staccato speech, and thereafter Jarry impersonated the fictional, or at least unreal, character he had himself invented. His face was a white clown's mask and he usually wore cycling dress, although on one occasion he turned up at a theatre in a dirty white suit and a paper shirt on which he had inked in a tie. He lived in a room that contained nothing but a pallet bed and the plaster cast of a larger-than-life penis. Meanwhile he slowly drank himself to death (latterly on methylated spirits which was all he could afford), engaging in a process of simultaneous self-creation and self-destruction.[14]

On several occasions Jarry was seen with Oscar Wilde and Lord Alfred Douglas at the Théatre de l'Oeuvre and homosexual ambiguity was a further feature of his mysterious life. Even if Wilde put his genius into his life rather than his art, he nevertheless still acknowledged the difference between art and life. The later Wilde, swollen and purple, somehow monstrous and at the same time tragic, never managed the miracle achieved by Jarry, for whom the obese, ridiculous Ubu became, by means of an inversion of meaning, a chosen identity. He transformed a grotesque, bizarre and conventionally 'ugly' appearance into a source of power[15] as he leapt from the precipice over which Wilde was pushed.

Since Jarry was and still is a cult figure, the importance of whose work has been recognized, it may seem misleading to count him among the obscure. Perhaps a more important difference was between writers such as Byron whose legend made him amenable to a celebrity status related to, yet separate from, the worth placed on his works; and artists such as Jarry, whose art and personality would only ever appeal to a minority.

Yet Bohemia existed precisely to challenge conventional distinctions between genius and failure, major and minor artists. Philip Heseltine, the composer Peter Warlock, for example, was a minor artist in the sense that he produced what he himself described as an 'exiguous output of tiny works.'[16] To describe this as the result of a 'lesser' talent may overlook the ambivalence towards art which was one aspect of Bohemia. Those, moreover, whose artistic output was dwarfed by their bohemian lifestyle, may have actually valued life-style above art, or they may have been dogged by lack of self belief and depression, for a bohemian way of life acted for many as a defence against low spirits and fear of failure.

That seems to have been true of Heseltine. His childhood, like that of many bohemians (Nina Hamnett and Henrietta Moraes, for example) was not especially happy, although he had an exceptionally strong bond with his mother, who was widowed when Philip was two years old. He was miserable at Eton and dropped out of Oxford, preferring London bohemian life during and after the First World War. He was good looking, tall and blonde, yet seemed to many slightly effeminate, even sinister. D.H. Lawrence, to whom he was close for a short period, described Halliday, a minor character in *Women in Love* who was based on Heseltine, as 'degenerate,' and the hostess

Figure 14 English bohemians: Eugène Goossens, the musician, the model 'Puma', Philip
Heseltine and Hassan Suhrawardy in 1915

Lady Ottoline Morell found him 'soft and so degenerate that he seems
somehow corrupt'.[17]

 His uneasy relationships with women suggested an unresolved homosexual
streak in his nature. He married a strikingly beautiful artists' model, Puma, a
familiar figure in the Café Royal, but it was not a happy union and they
eventually separated. (Puma committed suicide during the Second World
War.) His relationships with Viva King – later a bohemian salon hostess –
and with Barbara Peache, were also unhappy.

 Barbara Peache felt, as did many of Heseltine's friends, that there was a
kind of split in his personality, symbolized by his *nom de plume*. His own
music and his excavation and arrangements of early English music, published
under the name of Peter Warlock, expressed his sensitivity, while as the music
critic Philip Heseltine his aggressive streak came to the fore. This aggressive
side to his personality partly masked depression and vulnerability.

A desire to ward off depression may also have been one reason for his fascination with magic and the occult, a fashionable preoccupation in Britain during and after the 1914–18 war. This drew him within the orbit of the archpriest of the occult in Britain, Aleister Crowley, who included homosexual relations in his experiments with forbidden aspects of life. Heseltine also experimented with drugs, smoking cannabis from time to time with disturbing results.

For three years from 1925 to 1928 he had a cottage in Eynsford in Kent, where he kept open house. This greatly amplified his legend, since a stream of visitors came and went, carousing, dressing up and causing consternation to the local community. According to his friend Cecil Gray, 'poets and painters, airmen and actors, musicians and maniacs of every description, including pyrophils and claustrophobes – everyone who was in any way unusual or abnormal was sure of receiving a ready welcome at Eynsford.'[18] In her memoirs Nina Hamnett, a frequent visitor, confirmed the legend of hysterically manic Eynsford weekends.

Heseltine's success as a composer and music critic was always on a small scale and as he moved into his thirties he felt that his creativity was diminishing. He finally succumbed to his depression, and gassed himself at the age of thirty-six.

It could be argued that failure in itself was no worse for the artist than for the bankrupted businessman or the doctor struck off the register, indeed the disgrace and shame were less, since an artist depended less on a respectable reputation than a professional man. Yet the subtext of a life such as Heseltine's was the suggestion that 'failure', depression and a sordid death inevitably resulted from the bohemian claim that the Artist was superior to other mortals. It did therefore seem disgraceful and shaming. When combined with bohemian dissipation and self-dramatization, failure became a kind of self-fulfilling prophecy. It was not bad luck, bad judgement or even tragedy, but destiny, the price you paid for claiming to be that superhuman being, an artist. This was a further reason for the ambivalence with which artists were viewed: the threat of failure, always present, and indeed dramatized, in Bohemia, was the predictable, even just punishment for those who had aimed too high.

Anthony Powell's novel sequence, *A Dance to the Music of Time*, creates a panorama of London's upper-class Bohemia between the wars, and then, in three volumes devoted to the Second World War, demonstrates how unexpectedly well some of his more eccentric characters adapted to wartime conditions. Total war was a situation in which many normal social conventions were suspended, and even if they were replaced with new rules and regulations, there were bohemian aspects to wartime; a relaxation in sexual behaviour, for example.

The character of X Trapnel, a failed writer, in *Books Do Furnish a Room*, in which Powell describes the return of his characters to peacetime life, was based on Julian Maclaren-Ross. He, like his fictional *alter ego*, was a 'minor' writer. His *Memoirs of the Forties* has been described as 'the front-line account

of Bohemian wartime Soho by its longest-serving combatant ... based as
it then was on a handful of pubs within a few hundred yards of each other
just north of Oxford Street'.[19] Maclaren-Ross was usually to be found
holding court in the Wheatsheaf pub, where he would sit at the bar attired
in a cream suit, sunglasses and a teddy bear coat, the finishing touches to his
persona being a silver-knobbed cane and a cigarette-holder clamped between
his teeth. His friend Alan Ross described his daily routine:

> 'Midday in the pub till closing time, [then in mid afternoon], a late lunch
> at the Scala restaurant in Charlotte Street, a stroll to look at the bookshops
> in the Charing Cross Road ... Opening time again at the Wheatsheaf till
> closing time. A hurried dash to the Highlander, which closed half an hour
> later. Back to the Scala for supper and coffee. At midnight the tube home
> from Goodge Street.' All those hours Maclaren-Ross would have talked,
> virtually non-stop.[20]

Talk: it was to conversation that many bohemians devoted their genius; the
most transient work of art of all, and also the most fatal bohemian drug.

Ross states that 'it was impossible to imagine then that Julian was at the
peak of his modest and impoverished fame'. But, like many others, Maclaren-
Ross found the return to 'normal' life after the war difficult or impossible.
He was brought down by his chronically penniless state, by the insidious
effects of the daily diet of nicotine and alcohol and by his Wildean prefer-
ence for talk over writing. 'The Fifties for Julian were almost total loss,'
concludes Ross, 'personally and professionally. Usually broke, often homeless;
health deteriorating, relationships fragile to non-existent. He was kept going
by, as much as anyone, Anthony Powell, who gave him novels to review and
"middles" to write ... for *The Times Literary Supplement*.'[21]

Memoirs of the Forties is, indeed, a typically bohemian production: a series of
anecdotes, character sketches, and stories about eccentric personalities. Told
with wit and a kind of resigned fatalism, episodic and fragmentary, it
perfectly illustrates an approach to life that may appear cynical or flippant
on the surface, but which provides glimpses of a dark undertow of pessi-
mism. For bohemians such as Maclaren-Ross, life was an absurdist drama, a
black joke. This bleak, stiff-upper-lip stoicism was a rather British form of
bohemianism, and Fitzrovia was a very British Bohemia. *Memoirs of the Forties*,
in this respect resembling many British films of the period, exuded a grim,
noirish atmosphere of hopes that failed, of seedy boredom in landscape of
post-war austerity, and of the perversity of human self-destruction.

Similar yet different was the colony of bohemian writers and artists that grew
up in the mid–1950s on the West Coast of California at Venice Beach, just
north of Los Angeles. Excess and self-destruction were at least as much in
evidence here as in Fitzrovia; the sense of human absurdity was absent, for this
Bohemia was imbued with an American utopian impulse, wholly foreign to the
cynicism and deadpan humour of Maclaren-Ross and his contemporaries.

Venice Beach owed its existence to Abbott Kinney, a wealthy cigarette manufacturer turned connoisseur, and a believer in eugenics and dress reform. He had had it built at the turn of the century, envisaging it as a cultural Italianate quarter, 'a fantasy resort, the first of the many theme developments in Southern California, culminating in Disneyland'.[22]

By the 1950s the area had decayed, but its very seediness attracted a new generation of bohemians. Some were Korean War veterans, most came from working-class homes, all were complete outsiders. Together they created a radical community based on the belief that anyone could become an artist. 'By their own transmuted version of the Puritan ethic, a fully realized human being was one who lived for art, friendship, love and candour, and whose devotion was expressed through undistracted, unrelenting, unrewarded work. They even agonized about the temptations of fame in their own closed circle.'[23] They were influenced by the jazz philosophy of 'cool,' spontaneity and drugs. 'Death, alienation and addiction were all part of the mystique,' and 'when the jazz musician Charlie Parker killed himself through several sorts of excess, including heroin, it became as obligatory to produce a poem about it as it soon would be in other circles to eulogise Dylan Thomas.'[24] Their cult of 'death, alienation and addiction ... the dark side of creative compulsion'[25] was reminiscent of the Romantics and their fascination with death.

Stuart Perkoff was among those drawn to the colony. He had been a teenage member of the Communist Party in St Louis, but left after they forbade him to write love poetry. He moved to New York, where he claimed to have been the first post-war draft dodger, but relocated to California in 1948, when he was still only eighteen years old. There he met and in 1949 married Suzan Blanchard; she was six foot tall, he was five foot three, and she had suffered from TB and polio. She was also to have periods of mental illness and later became permanently insane. In reaction against her mother, who had been a successful career woman, she was determined to be a full-time wife and mother. Thus she reproduced a bohemian mirror image of the post-war ideology of women's role in mainstream society, and, indeed, although Bohemia was a more tolerant environment than Middle America, its nonconformity did not extend to equality between men and women.[26]

By 1956, when Perkoff's first volume of poems, *The Suicide Room*, was published, he and Suzan had settled in Venice, and soon afterwards he opened the first Venice West café, the Café Expresso. He wrote poems and words all over the white walls, and gradually it became 'a huge junk construction' with paintings, collages and little octagonal tables instead of the booths normally found in American coffee shops. The fridge and stove were visible behind the counter as though it were a private living room.[27] Later, under different management, the Expresso became a big success, but was commercially non-viable in its early years, and eventually Perkoff had to sell it.

By 1961 Venice had become a serious drugs scene, and Perkoff was using heroin. He served time in prison for dealing, and while he was inside his father cleared out his house and destroyed his whole literary estate. After he

Figure 15 Viv Stanshall in the 1960s

came out of prison in 1971 he opened a bookshop in Marin County, but
soon returned to Venice. By this time he had split up with Suzan, but in
Venice he met a new companion, Philomene Lowy. He had hoped to make
films and write poetry, but at the age of forty-four he contracted cancer, and
he died there in 1974.[28]

The 1960s, when Bohemia met mass culture in a more wholehearted
marriage of madnesses than had been achieved in earlier flirtations, saw the
rise of many music bands, some of which went way beyond pop or even rock
into eccentric regions of surreal humour and bizarre creativity. One such was
the Bonzo Dog Doo-Dah Band, whose lead singer was Viv Stanshall.
Mourned as 'the last English eccentric' when he died at the age of 51, he was
an inspiration for the humour of *Monty Python's Flying Circus*. Yet although,

according to one admirer, he was 'the one great comic talent British pop music has produced,' his life was a textbook version of eccentricity, excess and surrealism taking over the life of creativity. From his youthful performances on underground trains, when he would 'entertain' fellow passengers with 'the failed suicide' during which he attempted to hang himself ('Nobody tried to save me – nobody ever said a damn thing'), he progressed to the point at which his whole life was a dedicated performance. 'He would be sighted in Muswell Hill, London, addressing shopkeepers in a voice whose blithe Wodehousian cadences were an often uncertain indicator of his real mood, wearing nothing but a scarlet robe and octagonal glasses.' He never stopped working. He was a trained illustrator as well as a musician, but towards the end of his life 'his perfectionism had become pathological and he found it impossible to pronounce any of his numerous projects finished.' (This provides a further clue to the reasons for the under-performance of so many bohemians.)

In his last years his behaviour became increasingly erratic. He was heavily dependent on alcohol, Valium and nicotine. Because he suffered from insomnia, he often smoked and drank while in bed, and in 1995 he died from smoke inhalation when his bedroom caught fire. His life was emblematic of the undertow of excess that illuminated the sixties' 'underground' with such a lurid glare. It sheds some light, too, on the reasons for some of that excess. In Stanshall's case at least it seems to have been the result of hypersensitivity to suffering, an undefended awareness of the cruelty of life. He 'wanted to offer people other ways of looking at things,' but the effort eventually destroyed him.[29]

At the far end of the spectrum from eccentricity and madness were a number of bohemian women. They carried out the supportive functions that were so important in sustaining Bohemia, but in so doing oddly reproduced women's roles in the wider society. Before the First World War, for example, Rosalie's café was one of the best known bohemian institutions in Montparnasse. Rosalie Tobia had been Bougereau's favourite model, and Jimmy Charters, a well-known Paris barman in the twenties, believed she had had a child by Whistler. In middle age she devoted herself to feeding the poorest artists in the *quartier*. It was in Rosalie's that Nina Hamnett met Modigliani, who used sometimes to pay for his meals either by peeling the potatoes or with sketches the proprietor found incomprehensible and hid in a cupboard.

The Russian painter Marie Vassiliev was another woman who supported her comrades in practical ways. In 1908 she opened her own art school. When it was forced to close down during the war, she turned it into a canteen, which became a community centre for artists who were not at the front.

Joyce Johnson, who was Jack Kerouac's girlfriend during the period when his *On The Road* became a best-seller, entitled her memoir of the Beats *Minor Characters*, and many of the 'minor characters' of Bohemia were women. Yet their pivotal role in Bohemia was rarely acknowledged, and the

special difficulties of their lives have remained a forgotten aspect of Bohemia, the hidden secret of the bohemian myth.

Notes

1 Firmin Maillard, *La Cité des Intellectuels: Scènes Cruelles et Plaisantes de la Vie Littér- re des Gens de Lettres au XIX Siècle* (Paris: D'Aragon, 1905), p 401.
2 Edmond Goncourt et Jules Goncourt, *Journal des Goncourts: Mémoires de la Vie Littéraire*, le Vol., 1851–1861, Paris: Charpentier, 1887, p.185.
3 Mühsam, *Unpolitische Erinnerungen*, p 17.
4 Walter Benjamin, 'A Berlin Chronicle,' in Walter Benjamin, *One Way Street* (London: Verso, 1979), p 312.
5 Jürgen Schebera, *Damals im Romanischen Café: Künstler und ihre Lokale im Berlin der zwanzige Jahre* (Braunschweig: Westerman, 1988), p 33, quoting PEM (Paul Erich Marcus).
6 PEM (Paul Erich Marcus), *Heimweh nach dem Kurfürstendamm: aus Berlin's glanz- vollsten Tagen und Nächten* (Berlin: Lothar Blanvalet Verlag, 1952), p 92.
7 For Helmut Kreuzer one of the most important distinctions between different kinds of bohemians is that between the permanent and the transitory.
8 Jelavich, *Munich and Theatrical Modernism*, p 68, quoting Oscar Panizza, 'Die Haberfeldtreiben', in *Neue Deutsche Rundschau*, 5, 1894.
9 See Walter Mehring, *The Lost Library: The Autobiography of a Culture*, trans Richard and Clara Winston (London: Secker and Warburg, 1951).
10 Ibid., p 65.
11 Roger Shattuck, *The Banquet Years*, p 150.
12 Ibid., p 157.
13 Shattuck, *passim*.
14 Ibid.
15 Ibid.
16 Barry Smith, *Peter Warlock: The Life of Philip Heseltine* (Oxford: Oxford University Press, 1994), p 166.
17 Ibid., p 81.
18 Ibid.
19 Alan Ross, 'Introduction', in Julian Maclaren-Ross, *Memoirs of the Forties* (orig publ 1965; Harmondsworth: Penguin, 1984), p vii.
20 Ibid., p x.
21 Ibid., p ix.
22 Kevin Starr, *Inventing the Dream*, pp 79–80.
23 John Arthur Maynard, *Venice West: The Beat Generation in Southern California* (New Brunswick, NJ: Rutgers University Press, 1991), p 14.
24 Ibid.
25 Ibid., p 49.
26 In the 1980s her daughter Rachel, a graduate of UCLA, was the manager of a firm that packaged rock music programmes for world-wide satellite transmission.
27 Maynard, *Venice West*, p 102.
28 Ibid., p 172 *et seq*.
29 This section is based on Robert Chalmers, 'The World According to Viv', *Observer*, London, 'Life' section, 23 April 1995, pp 18–22.

CHAPTER SIX

WOMEN IN BOHEMIA

A woman can be a genius, can embody all the mental qualities I hold dear, yet all it takes is one single physical detail which displeases me for me to lose all interest.

André Breton: Investigating Sex: Surrealist Discussions

Meret Oppenheim came to Paris in the 1920s to paint, but also as 'a conscious decision to be free'.[1] Irène Zurkinden, an artists' model, believed that bohemian women were largely responsible for the atmosphere of freedom in Paris at that time; Jacqueline Barsotti, another model, agreed that the women of Montparnasse had 'helped create a new era with no hypocrisy, living an honest, natural and unprejudiced life'.[2] There was no sexual hypocrisy: 'It was not about couples.'

This search for freedom did not, however, originate in 1920s Montparnasse. From its earliest days Bohemia had appeared to offer women freedom from the social restrictions of respectable society, and recognition as autonomous individuals in their own right. The bohemian quest – for both sexes – had always been the search for a more authentic way of life as well as for an authentic art; but since women throughout the whole of society suffered restrictions that were different from and more severe than those affecting men, their relationship to Bohemia was necessarily also different from that of men, their search for authenticity more problematic; and, since the position of women in general changed more radically than that of men between the early nineteenth and the late twentieth century, the advantages and disadvantages for women of a bohemian way of life and its significance to them also changed more over time than was the case for men.

From the 1830s onwards, generations of bohemian women who had rejected the protection of the traditional family, carved out meaningful roles for themselves in the alternative world of the arts. Some created what were essentially variants of the traditional domestic and social roles assigned to women throughout society; some forged identities related to the transgressive forms of sexuality that were so important in Bohemia; others demanded

recognition as artists. A bohemian woman could be a *Grisette* or Mistress; Muse; Model; Wife; Mother; Salon Hostess; Independent Woman; Worker; 'Free Spirit'; Lesbian; or Artist. Some of these roles were already available in bourgeois society, some were distinct. In practice they blurred and over-lapped, and in any case perhaps what attracted many women to Bohemia was a potential freedom from all such roles, or even freedom from the restrictions of gender itself.

Throughout most of the nineteenth century middle- and upper-class women were under the tutelage of men, and lacked legal rights, entry to the professions and the freedom to appear independently in public life. Loss of respectability was regarded as an unmitigated disaster, from which there was no return. Men from bourgeois families, on the other hand, could sow their wild oats in Bohemia, and then rejoin polite society and settle down into a bourgeois profession or, indeed, become a successful painter or writer.

The majority of bohemian men represented a dissident fraction of the bourgeois class, but for women class relationships in Bohemia were more complicated. Bohemian men encountered and moved at will between different classes of women. The sculptor Jean Baptiste Clésinger, for example – most famous for his suggestive nude statue, 'Woman stung by a serpent', exhibited at the 1847 Salon and modelled from the salon hostess Appollonie Sabatier – arrived in Paris with his model, Louise, but he was so brutal to her that she left him. (She modelled for various artists on a freelance basis and became the mistress of Murger's friend, the writer Champfleury, for a time.) Clésinger later married Solange Dudevant, the daughter of George Sand, and behaved violently both to his wife and to her famous mother, as he had to Louise.

Thus these four women, Appollonie, George Sand, Solange Dudevant, and the model Louise, were connected through their relationships with one man, Clésinger, and three of them suffered violence at his hand, yet, apart, of course, from Sand and her daughter, they were not acquainted with one another. For although George Sand flouted bourgeois conventions, she still belonged to the land-owning gentry, so there was a yawning social gulf between her and women such as Louise, and the several different classes of women who sought either personal liberty or work in Bohemia seldom mingled.

There were the highborn, if somewhat déclassée, bohemian women such as George Sand. There were the courtesans and prostitutes of the demi-monde, and there was an intermediate class of women, in particular actresses and singers, and artists' models, whose professions as performers placed them outside conventional circles, but who were distinct from kept women. There were also craftsworkers of various kinds, and there were gypsy women and travelling performers.

Given the many obstacles confronting women who sought fulfilment as artists, it is hardly surprising that many of the best known bohemian women came from upper-class or wealthy families: for example, George Sand, Marie

d'Agoult, the lover of Franz Liszt, Delphine de Girardin and Louise Colet, all of whom were successful writers. Although it still required courage and determination to desert family and an established place in society, social confidence and an independent income made it possible for them to rebel. Bohemia provided them with a base and an alternative social setting in which they were accepted in spite of the irregularity of their lives. Like Lady Blessington in England, they lost relatively little by flouting convention, and gained by enjoying a position at the centre of social circles consisting of some of the most interesting and talented men of their generation.

Yet in the small and enclosed world of literary Paris in the early and mid-nineteenth century misogyny was rampant and openly expressed by male writers who may have felt threatened by the success of female rivals. Some were supportive, yet even their support was ambivalent. Arsène Houssaye, writing of the novelist Delphine de Girardin after her death, suggested that her work had been forgotten simply because she was a woman: 'A woman needs more genius than a man if she is to become famous. Public opinion is always frightened of blue stockings and "strong minded women".' Yet he himself added ambivalently that although he had always found in Delphine 'a good and frank literary friend,' yet 'I did not always find a woman ... The writer was always too closely grafted onto the woman.'[3] This suggests that he felt the role of writer *supplanted* and was incompatible with a feminine identity. He was theoretically committed to the view that women could write masterpieces and had every right to try, yet to do this was in some sense to be desexed: '*À propos* George Sand – it is said that no woman has ever written a masterpiece – it's a calumny. Why deny to women the right of thinking like men? ... Every time she has dared, woman has proved her strength beneath a feminine smile.'[4]

Théophile Gautier was equally supportive of women's literary ambitions. In his review of a satirical play, *The Blue Stocking*, staged in 1842, he asked what was so terrible about a woman becoming a writer. 'Is it so necessary for men to retain a monopoly? Either we must forbid women to learn to read and write and shut them up in harems, as do the Turks, or we must allow that since they participate in universal life, they may reflect, think and feel the need to express their ideas just like men.' It was ridiculous, he felt, for those who were opposed to the very existence of women writers to object that their writing led to 'the burnt roast and the vegetables not added to the stew', since after all, a woman as much as a man could employ a cook.[5] It did not seem to occur to him that a man might cook for himself, nor that most women were more likely to *be* cooks than to employ them.

Gautier lived with the singer Ernesta Grisi for twenty odd years. The fact that they were not married signalled that they were different, that they were not bourgeois (Gautier, like his friend Baudelaire, was ferociously anti-bourgeois). Ernesta's role nevertheless resembled that of a wife, although she solved the problem of childcare by boarding her two daughters out with a nurse. Judith Gautier, who became a writer, described her infancy in the

working-class district of Les Batignolles, and her bond to her foster mother. Her relationship with her real mother was hostile, but she adored her father; it was her mother who later placed her in a dismal convent, while Gautier claimed that he had never wanted her to go there. Yet he did nothing to prevent the arrangement, which suggests that responsibility for childcare was left entirely to his partner.[6] Since Ernesta left no account of her own, it is difficult to know why she more or less rejected the motherhood she may never have particularly desired. Her attitude towards family responsibilities may have been embittered by Gautier's infidelities – he even fell in love with her sister at one point; as a serious artist, she may have felt compelled to sacrifice her daughters to her career; or she may simply have done what most women who could afford paid help did in consigning her children to the care of others.

Gautier was generous in his assessment of Delphine de Girardin, describing her as a blonde beauty and accomplished hostess. She moved in the bohemian circles of the day, but her life more closely resembled that of a modern career woman than that of a bohemian muse or mistress. Her father had been in the imperial service under Napoleon, but fell from grace, after which his wife Sophie Gay supported the family by her writing. An accomplished social climber, she built up a fashionable literary salon, partly in order to promote her beautiful daughter, Delphine. At the age of twenty-two Delphine made a triumphant entry to the aristocratic Restoration circles of the Faubourg St Germain, where she recited her poetry to great acclaim. Her work included a panegyric to Charles X on his accession to the throne, but her political sympathies were liberal, and her friend Gautier remembered her dazzling appearance at the famous first night of *Hernani*, where she was among Hugo's supporters.

In 1831 she married Émile de Girardin. He was the illegitimate son of a count, but became a successful businessman, managed to make his way into society, and in 1836 inaugurated a revolution in journalism when he founded a new journal, *La Presse*. Until then, newspapers had been political organs with small circulations and high subscriptions, but *La Presse* was sold at a much lower price; this increased its circulation and brought in advertising revenue. His vision was that this would assist democracy and he intended that his paper should advocate socially progressive views, but in the long run the commercialization of the press had depoliticized a wider audience. Newspapers increasingly provided entertainment rather than serious commentary.[7]

Delphine was a literary wife, who entertained his friends in their tiny apartment and made up for Émile's lack of social graces. While he sat withdrawn in a corner, or departed for the *La Presse* offices, she looked after his famous contributors, smoothing rivalries, flattering egos and entertaining with her witty conversation. Theirs was also a literary partnership, however, for Delphine continued to write successful novels and plays and contributed a column (under the pseudonym of the Comte de Launay) in her husband's paper. Her articles gave a running commentary on Parisian life in the 1830s

and 1840s; her descriptions of the theatres, the salons, the cafés and streets recorded the excitement and discomfort of the rapidly growing city, the crowds, the stultifying summer heat, the opening of the first railway, and chronicled the passing seasonal theatrical and literary events and the changing fashions.

She also bitterly denounced the position of women and the behaviour of men, for in spite of her own success and secure position, she was highly sensitive both to the general oppression of women and to the specific difficulties of women writers, who paid a high price for their success by being continually and viciously attacked by their male rivals. For example she penned a lengthy riposte to an article by the journalist Alphonse Karr, a notorious misogynist, in which he had complained of the dearth of 'real women'.[8] (They had lost their romantic mystery, he complained, and were now too down-to-earth and practical.)

Louise Colet did not confine herself to a literary response when Karr attacked her, ridiculing her verse and alluding to her illegitimate child. She went round to his apartment and tried to knife him, an episode that caused much hilarity in the Parisian literary circles of the day. Louise came from a Provençal landed family, and at the age of twenty-three was already well known for her poetry in the salons of Aix en Provence. Eager to escape her difficult relationship with her family, she married a musician, Hippolyte Colet. The son of a vet, he could not be described as a good match in conventional social terms, but he shared her progressive views and artistic tastes, and with him she was able to move to Paris. There, she tirelessly sought publicity and the endorsements of established writers for her poetry. These efforts, and her liaison with a well-connected older man, Victor Cousin, paved the way to considerable literary success with a succession of best-selling novels, yet she is best known today for her unhappy love affair with Gustave Flaubert, who, like so many of his peers, was a thorough-going misogynist.[9]

Attacks from male colleagues failed to produce female solidarity. On the contrary the hothouse atmosphere encouraged intense rivalries in this world of changing relationships and sexual promiscuity. In 1835 Caroline Marbouty (who, like George Sand, wore trousered dress), accompanied Balzac to Italy. Madame Marbouty later had an affair with Jules Sandeau, for whom Sand had originally deserted her husband. Sandeau afterwards had an affair with Marie Dorval, who had been the mistress of Alfred de Vigny. Teresa Guiccioli, Byron's last female lover, had an affair with Hippolyte Colet, whose wife, Louise Colet, had affairs with Alfred de Vigny and others, as well as Gustave Flaubert. The sculptor Pradier, in whose studio Flaubert and Louise Colet first met, had a long liaison with Juliette Drouet, who afterwards lived with Victor Hugo, and Flaubert also had an affair with Pradier's ex-wife.

Alfred de Vigny had once wanted to marry Marie d'Agoult, but had then fallen in love with Delphine Gay, as she then was. Perhaps Marie nurtured a grievance over this early rivalry with a woman who was supposed to be her friend, for her memoirs included a barbed description of Delphine, although

by this time it was Delphine who had cause to resent Marie, with whom her husband Émile had fallen in love.

Marie d'Agoult had renounced her position in aristocratic society when she abandoned her husband in order to live with Franz Liszt, whom she first met in 1834 when she was twenty-eight, he six years younger. The attraction was instantaneous: 'The door opened and a strange apparition appeared ... I say apparition for want of a better word to describe the sensation immediately aroused in me by the most extraordinary person I have ever met,' she wrote in her memoirs. He was:

> tall and excessively thin with a pale face and large sea green eyes which glittered as brightly as the dancing waves; his expression was of suffering, yet powerful, and his step was uncertain so that he appeared to glide rather than touching the ground; he seemed uneasy and distracted, like a ghost whose hour to return to the shades has tolled. Such was the young genius I saw before me whose hidden life immediately aroused my curiosity.[10]

It may have been an awkward consciousness of his position, rather than otherworldly genius, that caused his pained looks and hesitant gait. Even a virtuoso as brilliant as Liszt was infinitely socially inferior to the beautiful young aristocrat, whose eyes had met his so intensely as he entered the room. (Musicians at this time were treated as servants rather than as guests, permitted to enter aristocratic salons only as performers.) The disparity made their relationship a social as well as a moral transgression, but to begin with only added to its romantic intensity.

Marie was happy to be Liszt's muse, and now moved in social circles more interesting than the stiff aristocratic society to which she had previously belonged. Both lovers hoped that the new relationship would stabilize Liszt, that he would put his performing days behind him and with Marie at his side would devote himself to composition, thereby fulfilling his musical genius. Unfortunately he could not resist the intoxication and wealth of the concert platform, and soon the recitals were renewed.

Liszt, like Byron, inspired mass hysteria in women. When he played he was said to have a manner of drawing off his gloves and letting them glide to the floor which maddened the female members of his audience before he had even touched the keyboard. Liszt could resist the advances of his female 'fans' no more than he could resist the financial rewards of being a virtuoso. By 1839 his relationship with Marie had run into serious difficulties ('shall we eat or shall we weep?' he enquired in exasperation one day at the dinner table in the middle of a violent scene). The affair dragged on until 1844, by which time Liszt's intrigues, especially with the adventuress Lola Montez, had become notorious. (One of the more sensational stories told how when Liszt grew tired of Lola Montez he locked her in her hotel room while he made his escape.) The deeply humiliating gossip forced Marie to acknowledge that

she was no longer even Liszt's main love; her position had declined until she was just one of many mistresses, rather than his unique Muse.[11]

Even more unbearable, if that were possible, was Liszt's behaviour once he had embarked upon a serious relationship with the somewhat hysterical and very rich Princess Carolyne Sayne Wittgenstein. The Princess was a devout catholic, notwithstanding her unsanctified liaison with Liszt. From this position of dubious moral superiority, she decided that Marie was a defective mother to her three children by Liszt, Blondine, Cosima (who later married Richard Wagner) and Daniel, and persuaded him to remove them from Marie's care. From then on they were brought up by pious governesses and saw their mother only once a year, while Liszt devoted himself to the promotion of Wagner's genius.

Ironically, Marie had begun to write when, in order to promote Liszt's career, she had ghosted articles for him to sign. Her subsequent success as a writer was based on her history of the Revolutions of 1848.[12] She became a prolific journalist, partly at the instigation of Émile de Girardin, and the salon she created became a centre for the intellectual opposition to Napoleon III. None of these successes was sufficient to compensate for Liszt's faithlessness. She had no other 'great love', but remained the tragic heroine and abandoned muse.[13]

In the early years of her liaison with Liszt, Marie became a close friend of George Sand, but they quarrelled after Sand suggested to Balzac that the Liszt-d'Agoult relationship would make a good novel. Marie became convinced that Sand had shared with Balzac juicy details of the hysterical dramas and scenes that had taken place when the Liszt ménage had stayed at Sand's country house in 1839; and Balzac did indeed base *Beatrix: Ou Les Amours Forcés* partly on the Liszt-d'Agoult relationship.

In spite of all this, it is nevertheless rather surprising that, of the four women writers mentioned, only Louis Colet was an ardent feminist (and even her feminism was expressed mainly through her writing). All four, after all, held political views of the most radical kind at a time, the 1840s, when the growing agitation for political change opened a space for the discussion of women's rights. Louise Gagneur, for example, had written *Women's Calvary*, an indictment of the fearful exploitation of working women, and during the revolutions of 1848, when numerous revolutionary clubs were set up, the Saint Simonian women were agitating for female suffrage. At this time Eugénie Niboyet, who led the feminist *Club des Femmes*, proposed George Sand as the first woman candidate for the new Constituent Assembly. Although Sand had written of the suffering of exploited working women, and although her views were then at the extreme left of republicanism, she rejected Niboyet's gesture, and dissociated herself from the Saint Simonians.[14]

That they failed to make common cause with political and working-class women may have been due to Romantic notions of genius, which was an advanced form of individualism. Although Bohemia was founded on a notion of collective identity and solidarity, the contradictory belief in genius

encouraged rivalry and envy and militated against solidarity. Moreover the woman writer or artist needed even greater self belief than her male counterpart in order to succeed, and an identification with all women to some extent ran contrary to a conviction of one's unique talent. It may also be that, having forfeited respectability and living an irregular life, even a woman as independent as Sand remained anxious to distinguish herself from the rough women of the revolutionary clubs, as well as from the prostitutes and *grisettes* of the underworld *bohème*.

The figure of the *grisette* was based on the seamstresses and salesgirls of the Latin Quarter, *grisette* referring to the grey material of their gowns. These young women were caught between their working-class status and the world of fashion, which gave them an air of refinement and elegance, so that, like their bohemian lovers, they were socially marginal. In the myth of Bohemia they lived with their student or artist lovers for a time, then happily married someone from their own class. Although, however, this was a light-hearted or at most bittersweet story for bohemian men, the situation may often have seemed more like an all too familiar seduction and betrayal scenario to the young women involved. It was a common enough situation between middle-class men and working-class girls, after all, and bohemians in this respect followed a perfectly conventional path.

The *grisette* was a mythical figure in rather the same way as the bohemian, and, like him, a partly literary creation, celebrated, for example, in Alfred de Musset's 1845 novel, *Mimi Pinson*, and above all in Henry Murger's tales. The legendary coupling, however, of the bohemian with a *grisette*, rather than with a woman who was herself an artist or writer, was an insulting denial of female creativity. Ironically, it also flew in the face of the facts, given the relationships listed earlier, and the success of many women artists and writers. Even working class women, such as Baudelaire's companion, Jeanne Duval, invariably written off as a prostitute, seems to have tried to make a living as an actress. Admittedly this was an ambiguous profession for a woman in the mid-nineteenth century, and 'actress' then and later could be a euphemism for a woman who lived by the sale of her sexuality. But it was more often the other way round: bohemian women classified as mistresses, courtesans, prostitutes and wives, their artistic aspirations and achievements ignored or denied.

Arsène Houssaye romanticized the *grisettes* as rebels, as adventurous or reckless romantics. Among them, he wrote, were 'janitors' daughters in rebellion, dressmakers' apprentices who had snapped their needles, chambermaids who had thrown their bonnets over the windmill, governesses who had tasted too fully of the tree of knowledge, actresses without a theatre, romantics in search of Prince Charming'.[15] Between 1830 and 1840, he maintained, 'one saw, wandering around Paris, in the salons, in the theatres, on the promenades, romantic women; one recognized them by their air of the vapours, by their moist, searching eyes, by their unkempt hair. Passion had made them pale – passion for poetry, for an ideal, or for love.'[16] Gustave Flaubert, on

the other hand, stated frankly that he would a hundred thousand times rather 'have a tart than a *grisette*'. He found the *grisettes*' longing for romantic love a bore, and loathed 'their simpering, their cleanliness, their clothes consciousness and flirtatious mannerisms, their affectations, their jaunty pretensions and their stupidity, which fucks you up all the time.'[17]

Given that such attitudes were widespread it was not surprising that successful women writers were attacked, nor was it surprising that the prostitute was romanticized. The relationship of bohemian men to prostitutes was problematic. Like the *grisette*, the prostitute was a figure of fantasy as much as of reality, simultaneously sentimentalized and degraded. At an abstract level, she might be said to personify for them the sexualization of the city and erotic adventure freed from responsibility. Privat d'Anglemont used to spend his monthly remittance on buying meals for the girls of the Latin Quarter, and the Communard bohemian Jules Vallès denounced the sexual exploitation of the bohemians' girlfriends, the *grisettes*. However, for the most part 'light women' were treated in a light-hearted way, and when inescapably confronted with their suffering, bohemians retreated into moralism. On a visit to the Salpetrière, a huge workhouse and asylum housing 4,000 indigents, Alphonse Delvau, for example, in a macabre moment, recognized a former *grisette* among the patients. This led him to reflect on the fate of such women, who had been 'bohemians from love or chance, who had started out by indulging their feelings, then their soul, then their body ... These creatures, without a name, shaved, brutalized, in strait-jackets – they had been beautiful!'[18] But this moralizing discourse was little more than the familiar bourgeois horror story of the 'fallen woman,' destined for an early death or a hideous and diseased old age.

Artists in mid-nineteenth century England seemed less defiantly hostile to bourgeois society than French bohemians, perhaps partly because the artist was a more marginal figure. The French bohemian, wrote William Thackeray, could look down 'from the height of his poverty with the greatest imaginable scorn on the bourgeois philistine because the ordinary citizen's respect for art was immense'. In England, by contrast, 'a grocer's daughter would think she made a *mésalliance* by marrying a painter, and ... a literary man ... ranks below that class of gentry composed of the apothecary, the attorney, the wine-merchant, whose positions, in country towns at least, is so equivocal'.[19]

This was a Protestant, not a Catholic culture. Evangelicalism led to a preoccupation with the morals of the masses. Civic reformers of English society emphasized the importance of education, libraries, parks and drains in lifting the poor out of their miserable condition, while frowning upon the licentiousness of theatre, music, dancing and even the fine arts. London lacked anything approaching public entertainments and social life on the scale found in Paris; the high-minded atmosphere dampened bohemian spirits.

The Pre-Raphaelite Brotherhood, formed by Dante Gabriel Rossetti, Holman Hunt and John Everett Millais in 1848, bore some similarity to bohemian groups in Paris. Of its three founders, Rossetti was the most

bohemian. His father was Italian, curator of bronzes at Naples museum and librettist at the San Carlo opera house, but later exiled because of his revolutionary political activities. His mother was a member of the Polidori family, and thus related to Byron's physician, author of *The Vampyre* (this being only one of many international and cross-generational links among bohemians at all times and in all places). The Rossetti home in Charlotte Street, Soho, was a centre for Italian dissidents, and there Rossetti's Pre-Raphaelite friends experienced a continental atmosphere in which political and artistic dissent mingled.

In the 1850s an enlarged Pre-Raphaelite group, which now included Ford Madox Brown, William Morris and Edward Burne Jones, joined with John Ruskin and the architect Pugin to create the Arts and Crafts Movement. More than an artistic project, this implied a total reform of life in all its aspects, envisioning a new society in which the beauty and truth-to-function of everyday objects would be part of a crusade to improve the whole social and cultural fabric.[20]

This movement would spread throughout Europe by the turn of the century, and in Germany was to be linked with what became known as the erotic revolution, but the British Pre-Raphaelites appeared more to subscribe to middle-class ideals of marriage than to wish to subvert them. French bohemians sometimes simply maintained the conventional double standard of behaviour between the sexes (a man could have a mistress, but his wife must remain virtuous), but they did recognize that a departure from the conventional sexual code was a potential weapon in the war against the bourgeoisie. The Pre-Raphaelites were more idealistic. There was no real equivalent of the *grisette* (insofar as she ever existed outside the pages of popular novels) and, while the Pre-Raphaelites never doubted masculine superiority in art, their behaviour towards women seems consistent with high-minded, albeit oppressive, Victorian attitudes of chivalry.

Ford Madox Brown, Morris and Rossetti married women of lower social status than themselves, rather than simply living with them. The father of Janey, whom William Morris married, was an ostler. Rossetti's wife, Elizabeth (Lizzie) Siddall, came from the uncertain reaches of the lower-middle class, since her father was a cutler, and her family had pretensions to gentility. She was also, unlike Janey Morris, an artist, and both Rossetti and Ruskin recognized her talent up to a point. For some years Ruskin paid her a yearly allowance of £150 (at a time when a governess, for example, might earn as little as £25 a year) so that she could devote herself to art, but her work was never considered to be as important as that of the men. Her social status – attached to, but for some years not married to Rossetti – was ambiguous and to the melancholy vicissitudes of their relationship was added the burden of her recurring ill health. It would appear that by the time Rossetti regularized his relationship with Lizzie, it was out of a sense of duty rather than love, since he had fallen in love with Janey Morris. After the stillbirth of her child Lizzie became deeply depressed and it was uncertain whether her death from an overdose of laudanum was accident or suicide.

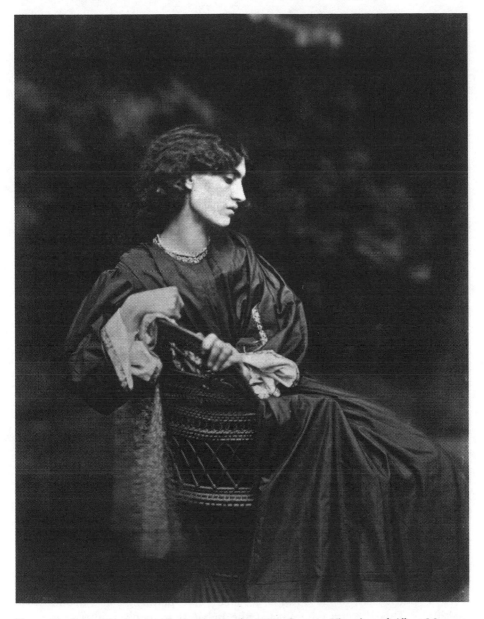

Figure 16 Janey Morris in aesthetic dress in the 1850s. Courtesy Victoria and Albert Museum

The lives of these women illustrate how Bohemia offered different possibi-
lities to different classes of women. Marie d'Agoult, the aristocrat, and Lady
Blessington – whose background was dubious but who married into the aris-
tocracy – inevitably became déclassée when they threw convention to the
winds. Yet they hosted unconventional salons and carved out a position for

themselves in the alternative society of Bohemia. The potential advantages to working-class women of entry to Bohemia were even more obvious. For them, attachment to an artist, even one with no money, could be a move up rather than down the social scale, and secured entry into what could be the glamorous and exciting world of the arts. It was hardest for middle-class women to cut loose from family and convention and enter this world. They were the most hampered by ideas of respectability and fears of loss of caste, but it was they who were most likely to wish to pursue an artistic career.

By the 1890s the respectable and the 'fallen' woman were no longer so clearly and so harshly separated as they had been. However the dominant view was still of the sexes as by their nature radically different, so that women continued to be defined in gendered terms which denied female creativity. Pregnancy and motherhood, it was asserted, limited women's mental capacities. Immersed in the particular, they were incapable of abstract and generalizing thought, and equally of creating great works of art. In painting, for example, their 'feminine' talent for unimaginative copying suited them to what were considered the lesser genres and subjects of flower painting, domestic scenes, animals and children.[21]

It was still the conventional view that women's rightful role was within the family. It was therefore then argued in a circular fashion that women should not be educated or trained to too high a standard, since that might overdevelop their intellect, strip them of their femininity and turn them into 'mannish women', or, worse still, a third sex unwilling to bear children or even incapable of doing so. These arguments applied as much to painting as to medicine, the law and other academic subjects. Auguste Renoir merely enunciated a common set of beliefs when he asserted that:

> women are monsters who are authors, lawyers and politicians, like George Sand ... and other bores who are nothing more than five-legged beasts. The woman who is an artist is merely ridiculous, but it is acceptable for a woman to be a singer or a dancer. In Antiquity and among simple people women sing and dance and they do not therefore become less feminine. Gracefulness is a woman's domain and even her duty.[22]

Another, and contradictory, argument against women painters was that the act of producing art was itself sexual. 'I paint with my prick,' was Renoir's way of putting it, while Picasso insisted that painting was 'actual love-making'.[23] This directly contradicted the belief that men's genius resided in their ability to take the general view and *not* be immersed in the immediacy of their feelings. Logic, however, was never a characteristic of these prejudices, all of which did little more than reiterate a confident conviction that women were inferior.

It should not surprise us that George Sand and her contemporaries were writers, for it was even more difficult for female painters and sculptors than for novelists to succeed. Throughout the nineteenth century French women

artists were excluded from education, training and professional associations. But by the 1880s they were beginning to fight back. The year 1881 saw the formation of the Union of Women Painters and Sculptors. Its members organized their own exhibitions, campaigned for equal access to artistic training for women and encouraged an 'atmosphere of co-operation rather than competition.'[24] Throughout the 1890s the Union campaigned to secure the right of women to enter the *École des Beaux Arts*. By this time the injustice of excluding women from state-funded art (or any) education was recognized. Nevertheless, the crucial issue – the right of women to attend the life class – aroused fears similar to those elicited by women's entry into the medical schools, for both forms of training involved a situation held by many to be dangerous or downright immoral: mixed groups of male and female students in the presence of the naked human body, male or female, dead or alive. Yet just as anatomy was an essential part of medical education, so drawing from the life was at the heart of the artist's training.

In the 1880s some women artists had already been sufficiently successful to open private establishments exclusively for women students. By the time women finally gained the right of entry to the *École des Beaux Arts* in January 1900, the many flourishing private academies for men had actually become more important than the *École* as learning environments. Many of them, run by well-known artists, some of whom also taught at the *École*, accepted women students, and by 1910 mixed classes were offered at most of them.

In England, too, the atmosphere was changing. The Royal Academy Schools had long discriminated against women, but in 1903 they gained entry to the Life Room. The Slade School of Art was unusual in that it had offered equal opportunities to men and women from the time it first opened in 1871, and by the 1890s a brilliant generation of women outshone the men, as Augustus John later freely admitted: his sister Gwen John, Ida Nettleship, Gwen Salmond, Ursula Tyrwhitt, Edna Waugh and later Dorothy Brett were the stars of his generation.[25]

Yet their careers were to be fraught with difficulty, for although Bohemia made possible a freer life for at least some women, their place in it, especially as creative individuals, was contradictory and insecure. Dissident male artists defined themselves socially in opposition to bourgeois moral values as well as aesthetically to the 'philistines,' but, as we have already seen, often reproduced the very ideologies of womanhood that dominated the bourgeois world. Many bohemians took for granted the inferiority of women, and even those who paid lip-service to feminist ideals often failed to live up to them in practice. Bohemians of both sexes attacked the conventional bourgeois family and female imprisonment within it. The alternatives available in bohemian circles too often, however, appeared merely as new – or more likely, all too familiar – forms of servitude, and women's freedom was hotly contested there as in the wider world.

Especially difficult for women was the association of bohemian ways of life with erotic transgression and 'free love'. Bohemia provided men with

opportunities for sexual adventure, but that was a relatively superficial aspect of its importance. More significantly bohemian life involved the exploration of intense feeling and of new and forbidden sources of material, including erotic experience, for artists' work. For women, too, Bohemia promised erotic licence, but of a deeply ambivalent kind. They were not expected to create 'master'pieces out of their experiences; on the contrary, they were more likely to be perceived simply as raw material for the great works of their lovers. They were redefined in essentially traditional terms – as erotic beings; for the male bohemian, women were more likely to represent the 'Other', a mysterious country to be explored, than to be seen as fellow artists and comrades in the struggle against the philistines. Their beauty, while it lasted, was to be celebrated in works of art created by men; their talent and ambitions were irrelevant to this masculine fantasy. In addition, even if bohemian women were in theory erotically 'free,' in practice it was considerably more difficult for women than for men fully to explore, or even express, their erotic needs. For men, erotic and social freedom was consistent with the development of their art, even if both poverty and excessive indulgence in pleasure made bohemian life hazardous at times. For women social and sexual liberation could easily go against the grain of the development of their art; those, such as George Sand, who did claim erotic autonomy took considerable risks, and at the very least were liable to be portrayed as dangerous, castrating, even vampiric.

So while there certainly were bohemian women, their quest for their artistic Grail was even more difficult than for their male companions. Yet in Bohemia, notwithstanding the difficulties and prejudice, many women artists found a uniquely stimulating and creative atmosphere. Not only that, but in Bohemia some of women's traditional forms of creativity could achieve an enhanced status.

Notes

1 Billy Klüver and Julie Martin, *Kiki's Paris: Artists and Lovers 1900-1930* (New York: Abrams Inc., 1989), p 173, quoting an interview with Oppenheim.

2 Ibid., interview with Irène Zurkinden, and quoting letter from Jacqueline Barsotti Goddard, p 238n.

3 Arsène Houssaye, *Les Confessions: Souvenirs d'un Demi Siècle*, vol 2 (Paris: Dentu, 1885), p 92.

4 Ibid., vol 4, p 232.

5 Théophile Gautier, *Histoire de l'Art Dramatique en France Depuis Vingt-cinq Ans* (Series 2, Paris: Hetzel, 1858-9), p 217.

6 Judith Gautier, *Le Collier des Jours: Souvenirs de ma Vie* (Paris: Juven, 1907).

7 Siegfried Kracauer, *Offenbach and the Paris of his Time*, trans Gwenda David and Eric Mosbacher (London: Constable, 1937), pp 62-3.

8 Delphine de Girardin, *Oeuvres Complètes*, tome 4 (Paris: Plon, 1860), Letter VIII (1840), p 469.

9 See Francine du Plessix Gray, *Rage and Fire: A Life of Louise Colet – Pioneer Feminist, Literary Star, Flaubert's Muse* (London: Hamish Hamilton, 1994), *passim*.

10 Comtesse Marie d'Agoult, *Mémoires 1833-1854* (Paris: Calmann Levy, 1927), p 21.
11 See Charlotte Haldane, *The Galley Slaves of Love: The Story of Marie d'Agoult and Franz Liszt* (London: Harvill Press, 1957); and Ernest Newman, *The Man Liszt* (London: Cassell, 1934).
12 She used the pen name of Daniel Stern, being unable to use her own name since this would have required the permission of her estranged husband. That women writers frequently or usually used male pseudonyms is an index of the prejudice they were liable to encounter, and, again, was a way of preserving their respectability.
13 A recent biographer suggests that she was mentally unstable and cites her passion for Liszt as proof of this. See Charles Dupêchez, *Marie d'Agoult* (Paris: Librairie Académique Perrin, 1989), p 12.
14 See Renée Winegarten, *The Double Life of George Sand: Woman and Writer: A Critical Biography* (New York: Basic Books, 1978).
15 Henry Knepler (ed), *Man About Paris: The Confessions of Arsène Houssaye* (London: Victor Gollancz, 1972), p 38.
16 Houssaye, *Les Confessions*, p 22.
17 Yvonne Kniebler *et al.*, *De la Pucelle à la Midinette: Les Jeunes Filles de l'Age Classique à nos Jours* (Paris: Temps Actuel, 1983), p 160.
18 Alfred Delvau, *Les Dessous de Paris*, 1860, p 125. It was actually Privat d'Anglemont, by whom he was accompanied, who recognized the woman in question.
19 William Makepeace Thackeray, *The Paris Sketchbook, Collected Works*, vol 5 (London: Smith Elder and Co., 1898), p 43.
20 Peg Weiss, *Kandinsky in Munich*, p 8.
21 See Christine Battersby, *Gender and Genius: Towards a Feminist Aesthetics* (London: The Women's Press, 1989).
22 Ibid., p 55, quoting Barbara Ehrlich White, 'Renoir's Sensuous Women,' in Thomas B. Hess and Linda Nochlin (eds), *Woman as Sex Object* (London: Allen Lane, 1973), p 171.
23 Witney Chadwick, *Women Art and Society* (London: Thames and Hudson, 1996), p 279, quoting John House, 'Renoir's World' in *Renoir* (London: Hayward Gallery, 1985), p 16, and John Golding, 'The Real Picasso,' *New York Review of Books*, vol 35, 21 July 1988.
24 Tamar Garb, *Sisters of the Brush: Women's Artistic Culture in Late Nineteenth-Century Paris* (New Haven: Yale University Press, 1993), p 10, and *passim*.
25 See Alison Thomas, *Portraits of Women: Gwen John and her Forgotten Contemporaries* (Oxford: Polity Press, 1994), p 1.

CHAPTER SEVEN
FEMININE ROLES

Women represent the interests of the family and the sexual life; the work of civilization has become more and more men's business; it confronts them with ever harder tasks, compels them to sublimations of instinct which women are not easily able to achieve.

Sigmund Freud: Civilization and Its Discontents

By the 1890s women in Europe and the United States were gaining new social freedoms and were entering the workplace in increasing numbers. Between 1903 and 1914 the struggle for the women's vote was reaching a climax in England, while in America's 'progressive era' women were campaigning on many different issues, and the 'new woman' of the period was beginning to be able to go around unchaperoned. Christopher St John (Christabel Marshall), for example, described the untrammelled life she enjoyed in London just before the First World War. An Oxford graduate, she worked as a secretary and bookseller, experimented in a relationship with a married man, and her evenings, 'which once I had been content to spend in solitude, often found me in the company of some man who had taken a passing fancy to me. I dined with him, went to the theatre or music hall, sat up late in my rooms with him, smoking and drinking'.[1]

Stella Bowen was another young woman who found that an independent and unconventional life was a feasible option in post-Edwardian London. She arrived from Australia in 1914 to study under Walter Sickert at the Westminster School of Art, and for four years enjoyed an unattached artist's life of freedom, which continued in spite of the war. She lived in her own studio, attended poetry meetings at Harold Munro's bookshop, and gave bohemian parties.

Unfortunately, new social freedoms were not matched by equality of opportunity in the field of art. This was partly because while women might have more freedom before marriage, marriage and motherhood continued to be regarded as callings which over-rode all others, and the fate that awaited the brilliant generation of students at the Slade with Augustus John was evidence of this.

Their difficulties began as soon as they ceased to be students. Ursula Tyrwhitt resisted marriage for many years, but since single women were expected to devote their lives to parents rather than to themselves this did not solve the problem of how to live as an independent painter. Gwen Salmond and Ida Nettleship married fellow artists, possibly hoping (in vain, as it turned out) that the dilemma of combining an artistic career with domestic life would thus be avoided. Edna Waugh's marriage to Willie Clarke Hall was an equally tragic example of the way in which conventional views of a married woman's role thwarted such hopes.

Willie Clarke Hall was a barrister, not a fellow artist, who fell in love with Edna when she was only thirteen and he twice her age. Convinced of her talent, he at first stalwartly encouraged her ambitions. 'If there is any meaning in [life],' he argued, 'surely it is this, to cultivate to the very utmost everything that is best and most beautiful in oneself and others.'[2] He persuaded her family that Edna's 'wonderful imaginative power ... possible genius' made it imperative that she study at the Slade. Yet although his love for Edna seemed deeper than hers for him, he was already becoming critical of her introspective nature and dedication to her inner vision, misunderstanding it as self-centred egotism. When he proposed to her she was stunned and confused, but drifted into a situation in which everyone assumed they were engaged, and they were in fact married at the end of 1898.

Marriage brought a chilling transformation. Not only was Edna lonely, deprived of her student friends at the Slade, but Willie was swiftly transformed into a conventional husband of the kind criticized by E. M. Forster in *A Room with a View*. Forster's heroine summoned up the courage to reject her stuffy suitor. Edna, less fortunately, found herself married to a man who had once written: 'I want you to consider Art your profession and I will not have you hampered in any way by stupid household details', but who now had not only lost interest in her painting, but seemed actively to dislike it. He referred to her paints and work as 'rubbish lying around', and wished her to sink herself in what she regarded as 'the small tyrannies of everyday life'.[3]

In her first confusion, she sought the advice of her great friend, Ida Nettleship, who told her to devote herself entirely to her painting. But Ida in her turn was shortly to succumb to domestic life with Augustus John, and this turned out to be as fatal to feminine artistic talent as the bourgeois conventions of the Clarke Hall household.

Ida and Augustus John were married in 1900. Almost immediately their life together began to illustrate all too clearly the pitfalls of bohemian love for its female practitioners. They soon had a child, but in 1902 Augustus fell in love with Dorothy McNeill. She was then a legal secretary, but was attracted to artistic circles, attended lectures on art, and soon, with the help of Augustus, transformed herself into Dorelia, a gipsy-like figure of haunting beauty and unconventional dress. Meanwhile Ida's commitment to her art was completely swamped by the necessity to care for a rapidly increasing number of small children as she struggled along in the ménage à trois that

developed. The two women made common cause over childcare, finding each other's company surprisingly congenial. They supported each other when Augustus embarked on an affair with a third woman. But when she became pregnant for the fifth time, Ida again began to sink into a state of despair. She died of a puerperal infection after the birth of her last child in 1907.

Dorelia was close to John's sister, Gwen, and in 1903 the two young women had set out to walk to Italy together. They never got further than Toulouse, but lived a completely wild and independent gypsy life for months on end, sometimes sleeping in fields or barns, and literally singing for their supper on at least one occasion. During this time Dorelia met a Belgian painter, Leonard, who fell in love with her, but both Augustus and Ida persuaded her to return to England and her life with them.

After Ida's death an arrangement gradually developed whereby Augustus retained a base in London while Dorelia and his 'gypsy tribe' stayed in the country, first at Alderney in Dorset and later at Fryern Court in Hampshire. There he was the head of an extensive retinue of children, friends and hangers-on, becoming in later years, as a son-in-law unflatteringly said, like an old stag with his herd, fighting off all rivals.[4]

In 1917 Augustus John's friend, the poet Francis Macnamara, left his wife, Yvonne, and she and her four children joined the John ménage. Yvonne had an affair with Augustus, but her main emotional focus was another woman, Nora Summers.[5] At Fryern, Yvonne's daughters, Nicolette and Caitlin, lived a wild life with the John children. The girls were not educated at all, for fear that education would 'spoil' their loveliness. Dorelia's sister Edie (to whom Macnamara was later briefly married) also lived there, as did another young woman, Fanny Fletcher, together with 'a shifting population of long and short term visitors ... drifts of young women floating about the place', as Nicolette later remembered. She recalled, too, the impression created by the household on a visit to the local gymkhana. There were Dorelia and Edie in their gypsy clothes, 'Fanny with her wild face, and her home-block-printed tunic and straggling hair beneath a big straw hat, stuck like Ophelia with pretty grasses and buttercups', and 'the ragamuffin lot of boys and girls'. The locals would walk slowly past, gawping at the 'wild lot', a spectacle of bohemianism that rivalled 'the horses, the beer tent, the shooting range and coconut shies'.[6]

Dorelia was a life companion, a muse, a mother, a handmaiden. Like many bohemian women she created a beautiful life and home, devoting herself to the garden, to the interior, to delicious meals and to the eccentric and original clothes she made for herself and her children. It was not easy to tolerate Augustus's behaviour, although she had her own consolations, in her love affair with another painter, Henry Lamb, for example. She was true to her own vision of this bohemian life. For example she refused to marry Augustus when, because he had been offered a knighthood on condition that he discreetly regularize his domestic situation, he finally proposed to her in

the early days of the Second World War. She found it ridiculous to marry for such a reason, and did not wish to be known as Lady John.[7]

The John ménage exemplified how, in bohemian circles, the distinction between being legally married on the one hand and simply living together on the other was less clear than in bourgeois society. Whereas in more conventional circles the relationship of a mistress with her married lover was likely to be clandestine, in Bohemia the social exclusion to which this could lead did not operate. Indeed, it often meant a widening of opportunities, a working-class woman's attachment to an artist signifying a move up rather than down the social scale.

Fernande Olivier came from a deprived background similar to Suzanne Valadon's: illegitimate, her father unknown, an unhappy childhood, cruelly treated by foster parents. Many young women were, like her, drawn to the bohemian life of Montmartre and Montparnasse; her history, although better known, was similar to many others.

As she wrote later, 'several writers who have written about Picasso have simply referred to me as "la belle Fernande",' which certainly indicated the extent of their interest in me. For them apparently I was simply a physical asset.' She added tartly, 'there is a tendency in France, particularly amongst intellectuals, to regard women as incapable of serious thought.'[8]

In fact Fernande had an undeveloped gift for painting. When Paul Poiret first visited Picasso's studio he bore down on a self-portrait Fernande had executed and began to congratulate Picasso, much to everyone's embarrassment. But Fernande's talent could hardly flourish next to her lover's. He never lacked self-belief or the egotism of genius, whereas she had insufficient ambition or energy to persevere in the absence of wholehearted encouragement. Picasso recognized her ability, and years later he told the photographer Brassaï that he still kept many of her drawings among his own papers: 'very beautiful drawings, you'll see ... She was very gifted, but she didn't possess that sacred fire of work. Her work resembled Marie Laurençin's a little, but Fernande had a more vigorous line, less pretty-pretty.'[9] For some years the drawings were preserved in the Picasso archives, but by the 1980s they had disappeared.[10]

The vivid charm of Fernande's memoirs reveal her as a talented writer as well, although Picasso's biographer, John Richardson, suggests that 'so vivid is the writing, one can only assume that Paul Léautard, [who contributed a preface to the book] or her other literary friend, Max Jacob, lent a hand.'[11] Her style of writing *is* similar to that of Léautard's preface, and since Richardson had read Fernande's diary, on which the memoirs were based, he may have noticed a distinct difference in quality. Nevertheless, the suggestion seems rather ungenerous, although all too characteristic of the dismissive attitude displayed by so many artists and critics towards the women of Bohemia. This attitude is further illustrated by the way in which Brassaï and Picasso casually chatted about the women Picasso painted. Brassaï remarked that:

The thing that has always fascinated me in the female body is the aspect of it that seems to be some sort of vase, or musical instrument, or fruit. In the art of the Cyclades Islands, this characteristic is very noticeable: woman was transposed into a kind of violin. And I was surprised when I first noticed how much the fruit of the coconut palm – the largest fruit there is – resembles the lower torso of a woman.[12]

Picasso agreed, remarking that 'the eye passes directly from the line of the feminine body to the curving line of the valleys.'[13]

Fernande wrote rather enviously of the support Marie Laurençin received from *her* devoted lover, Guillaume Appollinaire. 'There is no doubt,' she wrote, 'that without Appollinaire Marie would have trodden much the same path as women painters like Madeleine Lemaire and Louise Abbema, and would have failed to get anywhere ... Affectation combined, I think, with bogus näivety, is the mainspring of some of the strange effects of her compositions.'[14]

Fernande's beauty made it almost inevitable that she would live her life through men. She never modelled professionally, as Suzanne Valadon had done, but pursued the bohemian way of life, initially as a means of escape from a violent husband. So long as Picasso was in love with her, he was morbidly jealous and: 'forced me to live as a recluse ... [but] with some tea, books, a couch, not much housework to do, I was very very happy. It was Picasso who swept the studio and did the shopping.'[15] (Although the state of the studio horrified visitors, so he evidently did not spend much time on housework.) Yet Picasso's friendships were with the members of his 'gang' – Appollinaire, Max Jacob and the rest – rather than with his mistress(es), and Fernande admitted that she was often very lonely during the long hours of boredom when Picasso was shut up with his canvas.

As their relationship lost its charm, she indulged in intrigues and earned a little money by giving French lessons to Alice B. Toklas, who had recently arrived in Paris and fallen more or less straight into the arms of Gertrude Stein. The three women became close friends, and the Americans were instrumental in patching things up between Picasso and Fernande after their first major separation in 1907.[16]

Their relationship deteriorated further when in 1909 Picasso moved from the Bateau Lavoir, a classic bohemian artist's studio, in complete disorder and with only a few sticks of furniture, to a new apartment in the Boulevard de Clichy, where a more bourgeois way of life signalled that their affair was nearing its end. For Fernande, the bitterness of Picasso's subsequent enormous fame and wealth was that she was left behind: 'I know some of the women who lived with those artists, companions of the good and the bad hours of their youth: and they are growing old alone too, with only their memories as constant companions.' Picasso, by contrast, was never alone; a succession of beautiful women fulfilled his needs, and even in his eighties he had a youthful companion.

For Fernande the line of least resistance was to live through love. Once Picasso had deserted her for her best friend Eva (then the mistress of the painter Louis Marcoussis) life became difficult. She worked as a vendeuse for Poiret, recited poetry at the *Lapin Agile*, read horoscopes. Although she had other affairs, and lived with an actor Roger Karl from 1918 to 1938, her whole life was stamped with Picasso's fame, although she never saw him again after they parted. Muse, mistress, 'free spirit', she was a victim of the double poison of bohemianism mixed with celebrity, trapped in the past as that romantic figure: 'Picasso's first great love.' Yet her life was surely more colourful and more fun than the lives of most working-class women of the period.

Ensconced in the Boulevard de Clichy, she insisted on being addressed as Madame Picasso. Yet formal marriage seemed to bring few benefits to bohemian women. The effort to combine conventional marriage with a bohemian existence could be extremely stressful and bohemian wives seem to have been among the worst treated and most disgruntled of all bohemian women. Their chronic discontent usually arose either because their own efforts to paint or write were thwarted, or for the opposite reason: that they were making a quixotic effort to live life within a 'normal' framework and according to established rules in a subculture explicitly opposed to rules and normality. Children in particular caused intolerable conflicts and difficulties.

In 1918, Stella Bowen married Ford Madox Ford, and her life changed drastically. The much older Ford was already a successful novelist, but wracked with uncertainty and in need of continual reassurance:

> Ford put it to me that he could not finish his book if his mind was upset, and that I must manage to keep all worries from him ... My painting had of course been hopelessly interfered with ... for I was learning the technique of quite a different role; that of consort to another and more important artist ... I simply had not got any creative vitality to spare after I had ... struggled through the day's chores ... A man writer or painter always manages to get some woman to look after him and make his life easy, and since female devotion is a glut on the market, this is not difficult. A professional woman, however, seldom gets this cushioning unless she can pay money for it.[17]

They moved to Paris, where Ford had an affair with Jean Rhys, fictionalized by her in *Quartet*. This novel is told entirely from the point of view of the rejected mistress – herself also a wife as it happened; but whichever point of the triangle a woman was impaled upon, it was usually the wrong one.

The arrival of children caused even further difficulties for bohemian women, 'female devotion' to these vulnerable creatures being even harder to resist than the demands of powerful men. As Caitlin Thomas put it, 'The cord that binds a mother to her child is not love in the sophisticated give and take sense: it is an organic, vegetable, all-giving function from the mother with no dotted-line returns, to which the child responds with the

impersonality and egotism of a plant to the sun, as their natural and neces-
sary birthright, in the smugly dominant kingdoms.'[18]

The Russian painter, Marevna Vorobëv, who lived in Paris before and after
the First World War, was less brutally frank about children, but echoed Stella
Bowen's sentiments, and described the difficulty of combining motherhood
and art: 'I was scared of marriage and having children: the idea of being
shackled to a young family frightened me ... I saw in it the loss of my cher-
ished freedom and the cramping of my work,' she wrote. Yet she was gradu-
ally drawn into an affair with the Mexican muralist, Diego Rivera, who was
already married. Marevna had his child, but he never definitively left his
wife, Angelina – or rather, he left both women when he returned to his
native land in 1921.

Once she had a child, Marevna's life became a balancing act, the need to
look after and provide for her daughter continually coming into conflict
with her work:

> My exhibitions were always followed by long blanks, because I had to fight
> fearfully hard to bring up my child, devote much time to commercial art
> and to decorative art, and give up exhibiting for lack of money ... All my
> life, unfortunately, money has come between me and my work. In order to
> paint a woman must enjoy a certain security ... For a man the problem is
> easier to solve: he nearly always has a woman, wife or mistress, who earns
> money: she works for 'her man' ... A male artist can more easily live for
> his art alone: he is not bothered by questions of *duty* as a conventional
> man is – or a woman.[19]

And although hundreds of women artists were working in Paris before and
after the First World War, the triumph of modern art between the two world
wars was largely a triumph of male artists. Many of the female companions
of the painters who made their names at this time have been forgotten,
although they were artists too. Jules Pascin had a long relationship with the
painter Hermine David. The Polish cubist Louis Marcoussis married Alice
Halicka, a fellow cubist, who was 'astonished' that he took her to visit
Picasso – as though, as a woman, she did not merit such an honour. She was
always 'the wife of Marcoussis', and her period of engagement with cubism
ended when her husband returned home from active service in 1918. It seems
that he discouraged her from continuing to work in this way and prevented
her from signing a contract with Modigliani's dealer, Zborowski. She
returned to figurative styles, and later to collage and the 'feminine' craft of
needlework.[20] Man Ray meanwhile was involved with Kiki, a model and
successful chanteuse who also painted. Yet she is remembered largely as a
sexual stereotype of the good-time girl, the 'life and soul of Montparnasse'.

This was despite the way in which women's emancipation seemed to have
been achieved in the 1920s, symbolized by short skirts, smoking and
drinking. They became 'the smile of modernity,' their new freedoms a gloss

on the society of consumption that was developing ever more rapidly. The whole epoch appeared androgynous. Young women looked like boys and boys looked like girls. Unisex clothing, mask-like makeup and skullcap hairstyles for both sexes recalled Pierrot costume, a look reminiscent of the *Commedia dell'Arte*.

This was a traditional popular form of theatrical performance that fascinated modernist artists. It was organized round the three central characters of Pierrot, Harlequin and Columbine, an erotically involved triangle whose relationships were always outside the law, 'antimarital' and 'antifamilial',[21] and thus in some sense the period was culturally subversive, challenging the old rules of behaviour.

It was now possible for a heterosexual woman who refused to commit herself exclusively to one man, to lead an independent social and sexual life, especially in bohemian circles, but there was a price to pay for this independence. Nina Hamnett, for example, who arrived at the Slade in 1910, lived out the bohemian stereotype as energetically as did Augustus John. In the early years she was a flamboyant, lively figure, and a talented and successful painter. But the bohemian identity, for women even more than for men, required not only the right costume, but a whole way of life that, paradoxically, often worked against the creation of actual works of art, and the reason Nina Hamnett rather than Gwen John became 'Queen of Bohemia' both in Paris and Fitzrovia, had much to do with the way in which she seemed compelled to fling herself into wild bohemian drinking and partying in order to escape what she referred to as 'boredom'. 'Boredom' is often a euphemism for anger, unhappiness, depression, and the insouciant, brittle, anecdotal style of her memoirs, *Laughing Torso*, amounts to a literary denial of all the emotions she stifled by her heavy drinking, emotions that could perhaps have been more constructively channelled into her work.

By the 1930s she had become an alcoholic who stank of urine[22] and pursued exploitative young men, cruelly caricatured in Ethel Mannin's fictionalized description of the famous Fitzroy Tavern in north Soho:

Reinhardt's was crowded to the point of overflowing ... A frowsy woman in a disreputable old pony-skin coat was standing beside a table swaying a little, and declaring in a loud voice that she had lost her young man. 'He's a very – beautiful young man,' she was saying, between hiccoughs, 'and he's just come out of gaol for refusing to pay for his bastard.' Her eyes were glazed; she was disgustingly drunk.

'Who is that ghastly woman?' Starridge asked ...

'Don't be too hard on poor old Laura. She's been a good sort – and no end of a vamp in her time. She's a sculptress and some of her work's pretty good ... In Montparnasse she's a legend. But see what gin and sex will do for an honest gal.'[23]

Figure 17 Viva King in 1941, with her signature seal bracelet worn on her dress.

Another 'Queen of Bohemia' was Viva King, to whom Osbert Sitwell wasp-
ishly gave this title in the 1920s; he also referred to her as the Scarlet Woman
on account of a favourite red dress. Viva King was never promiscuous on the
lavish scale of Nina Hamnett, although she had a troubled affair with Philip
Heseltine. Her marriage to Willie King was unconventional (both were said
to proposition young gay men), but it enabled her to become the hostess in
the 1940s of a successful salon at Thurloe Square, in London. Her guests
included Ivy Compton-Burnett, Margaret Jourdaine, Norman Douglas,
Beverley Nichols, Angus Wilson, and later Yoko Ono and the pioneer trans-
sexual, April Ashley.[24] She cared for Nancy Cunard in the latter's declining
years, and her last affair, at the age of seventy, was with a Maori seaman,
Mat, whom she lacked the resolution to get rid of, although he repeatedly
stole valuable items from her antique shop.[25]

Viva King was beautiful and vivacious and her originality of mind – like
that of many bohemian characters – expressed itself in endless curiosity about
human life and eccentricity, rather than in the production of works of art. In
her salon she collected people as some might collect *objets d'art*. Yet, like

Hamnett's *Laughing Torso*, her autobiography strikes a rather desperate note of deadpan humour, a 'plucky' attitude, a kind of inconsequential fatalism, concealing unbearable sadness. Both she and Julian Maclaren-Ross significantly entitled their memoirs *The Weeping and the Laughter*, and weeping and laughter coexisted in Bohemia, unreconciled, unresolved, absurd and tragic.

Nina Hamnett and Viva King were 'Free Spirits' of the period. They were not 'light' or 'fallen' women in the nineteenth-century sense, since, even if it was still daring for an unmarried woman to take lovers, the pursuit of sexual adventure no longer meant the ostracism of their class and the conventional social world. The Free Spirit was independent, she was in advance of her time, caught between two eras. She claimed sexual freedom and autonomy, but her independence and sexual adventures hid an inner vulnerability. Promiscuity and a defiant manner might mask this vulnerability, but the restless pursuit of love from man to man often seemed to be a search for an ever-elusive security and sexual fulfilment.

While Bohemia and the world of radical politics overlapped, European bohemian women were not necessarily or primarily involved in the suffrage movements. Feminist politics appear to have played a more pivotal role in bohemian America. Greenwich Village was a Mecca for independent women, not only artists, but also socialists, feminists and all kind of radical campaigners, and it was even suggested that 'the restlessness of women was the main cause of the development called Greenwich Village'.[26] The Hetero-doxy Club, a Saturday afternoon luncheon club, was founded in 1915, continuing until 1940. Its members included such well-known feminists as Charlotte Perkins Gilman, Mary Seaton Vorse and Crystal Eastman, sister of Max Eastman, editor of *The Masses*. Indeed, she had arrived in the Village long before her brother, and was more radical than he. For several years the apartment she shared with several other women 'became one of the major communication centres for labour and suffrage activities'.[27] She was a founder member of the American Civil Liberties Union, an active trades unionist and a member of the Women's Peace Party. In 1919 she became co-editor of *The Liberator*, along with her brother and Floyd Dell, and in this capacity she visited Bela Kun's short-lived communist republic of Hungary. But, with failing health, she was blacklisted in the reactionary climate of post-war America, and 'spent most of her last years unemployed, in England' with her British husband. There she had a regular column in the feminist magazine, *Time and Tide*, but this did not satisfy her, and in 1927 she returned to New York, but soon afterwards died at the age of 48, having sacrificed her health to the causes in which she believed so passionately. As a friend wrote: 'In her personal as in her public life her enthusiasm and her strength were spent without thought ... her strength and her rich and compelling personality – these she threw with reckless vigour into every cause that promised a finer life to the world. She spent herself wholly, and died – too young.'[28]

Dorothy Day was another young feminist and radical of this period. As a

young woman she worked for *The Masses*, as assistant to Floyd Dell. He patronizingly described her as 'an awkward and charming young enthusiast, with beautiful slanting eyes',[29] but she was much more than this, a militant suffragette who had been imprisoned for her activities in Washington, where she had staged a hunger strike in order to be recognized as a political prisoner. Malcolm Cowley described her ability to drink her companions under the table, and she wrote a novel *The Eleventh Day* about her (innocent) *ménage à quatre* with three men.

Although she never left Greenwich Village, she became a Roman Catholic convert, and in the 1950s she was running an outreach centre for poor families and working with destitute alcoholics on the Bowery. By now she had renounced her bohemian past, and even tried to buy up remaining copies of *The Eleventh Day*. However, she was still a radical; for example she opposed the Korean war, although it had been blessed by Cardinal Spellman, head of the Roman Catholic community in the United States.[30]

This transformation may seem in some ways emblematic of the conservative cultural turn taken after the Second World War, not only in the United States but throughout the West. Those wintry, *film noir* years saw a retreat from socialist ideals, even in Britain with its extensive welfare state and labour government. Cyril Connolly, novelist, *Sunday Times* critic and editor of the influential literary magazine *Horizon* voted Labour with some enthusiasm in 1945, but two years later was disillusioned by the currency restrictions which made it difficult for him to return to his favourite pre-war Mediterranean haunts.

Bohemia in Britain had always been closer than elsewhere to upper-class raffishness and eccentricity. Connolly epitomized the English mixture of aristocratic connections and shabby chic, while suffering from a haunting and typically bohemian sense of under-achievement as he oscillated from the Ritz to freezing country cottages, floated between the South of France and seedy saloon bars. This was a Bohemia remote from Murger's type of poverty; Connolly's hand-to-mouth existence encompassed threadbare family heirlooms, public school men on their uppers and well-connected beauties untrained for any career, even that of kept woman.

The indeterminate status of English bohemian women was an effect of the strong yet permeable class system in Britain with its elastic frontiers and unspoken rules. This was also a masculine world in which, exceptions such as Nina Hamnett notwithstanding, it was taken for granted that women were at worst disruptive, at best distractions from the serious work of art and literature. Ideally their role was to provide ambience, atmosphere and sex, to entertain and at other times to keep out of the way.

Connolly's second wife, Barbara Skelton, was a product of this society. For the painter, Michael Wishart:

she possessed the uncommon combination of prettiness and great beauty. Her slender, almost boyish body, was surprisingly, not to say disturbingly,

voluptuous. As feline in appearance as she later proved to be in character, she had a tantalizing quality of needing a tamer, while something indefinable about her indicated that she was untameable.[31]

Seduced at a young age by a friend of her father, Barbara Skelton found the life of kept woman boring. She formed a relationship with a naval officer which led to his being cashiered, and she had affairs with numerous leading lights of the London artistic world[32] as well as with King Farouk of Egypt. Her relationship with Connolly provided an ideal field for the expression of her unhappiness and resentment. He divorced her on the grounds of her infidelity with the publisher, George Weidenfeld, whom she married, but Weidenfeld in his turn soon divorced her because of her continuing relationship with Connolly. A third rich, but seemingly not greatly loved husband deserted her for Augustus John's daughter, Poppy, another bohemian beauty who came to a sad end.[33]

The life of Caitlin Macnamara illustrated even more painfully the pitfalls of bohemian life for a woman whose talents were never nurtured or even acknowledged. She was a precocious beauty by the age of twelve, and by her mid-teens Augustus had seduced her. There were even rumours that Caitlin was John's daughter, his 'byblow' as one journalist contemptuously phrased it, just another of the many children he begot – and forgot. Caitlin's biographer discounts the idea, although it is theoretically possible, since Augustus John did have a brief affair with Yvonne Macnamara.[34] However, whether biologically related or not, Augustus had been a social father figure to his friend's daughter, so the affair was a betrayal. But the whiff of 'pagan' incest was part of the bohemian sexual legend, and augmented John's glamour even as it demeaned and damaged Caitlin.

The affair came to an end when Caitlin met Dylan Thomas, to whom she was married in 1937. Caitlin, beautiful and ill-educated as she was, had wanted to become a dancer, but was never trained. Soon the Second World War and the arrival of children permanently ruled out the possibility. Instead she became both reluctant muse and wife to genius, roles she did not enjoy. Dylan Thomas was already recognized as a promising, even a great poet, and began to live out a caricature of the bohemian genius even more enthusiastically than Augustus John. He drank heavily and before the end of the war had already lost his cherubic appearance and become mountainously fat. There were many stories of his excesses, which naturally fuelled his legend. At one poetry reading in Richmond, for example, at which he arrived very late and quite drunk, he managed to perform, but having won over his audience of 'maidenly or matronly poetry fanciers' with his wonderful voice, concluded the reading by being violently sick on the suburban carpet.[35]

By the time he died in New York in 1953, he had become a byword for monumental drinking binges, uncontrolled lunges at women, insults and hangovers. On his lecture tours in America he reached a stage at which he could no longer function without drink, and seemed to be almost deliberately

drinking himself to death. Every day was punctuated with his convulsive retching and coughing and the necessity to enter every bar passed en route to wherever he might be going. There was also the recurrent nightmare of celebrity parties at which he propositioned women, was sick over the furniture or even broke it up. On his second visit to the USA, when Caitlin accompanied him, they surpassed even themselves at an evening party, given in their honour:

> After watching their skirmishes, incredulous guests had abruptly departed from rooms littered with smashed glasses, overturned tables, and broken *objets d'art*, leaving their hostess in a state of hysteria as she contemplated her loss, part of which was a plaster section of the wall of her bedroom.[36]

John Brinnin, who organized the tours, believed that the underlying cause of Dylan's drunkenness was his belief that his creative powers were failing. There was the added pressure of success, which imposed an intolerable strain because it led to a situation, especially on the American lecture tours, in which Dylan was never offstage. Brinnin's book about these tours further contributed to the posthumous Dylan Thomas legend, recycling the classic tale of the tragic, self-destructive genius.

Caitlin had no such excuse. Since she was openly unfaithful to her husband, and since she could give as good as she got, the marriage might be seen as one of drunken and promiscuous equals, who fought continually and could live neither together nor apart. In her astonishing and ominously entitled autobiography *Leftover Life to Kill* she raged with powerful fury both at herself and at her destiny:

> He said he loved me; that I was the only woman for him; and, whatever the evidence to the contrary, I believed him, and still do; and I am grateful for that important bit of faith ... But the sudden removal of such a love, such a special love, on such an immortal scale, and the only one, was bound to cause a dropping out of the bottom of my all-in-Dylan world.[37]

But while both were bohemian, there was only one genius. Much was forgiven Dylan, even on the primly horrified lecture circuits of American academia, on account of his poetry. Caitlin's tragedy was that she was defined by her beauty and exploited by men rather than encouraged to develop gifts that in the event were barely even discovered, let alone fulfilled. After Dylan's death she romanticized their relationship, but acknowledged its self-destructive aspect:

> Then I could wholeheartedly revile my fate, and say I was meant for better things. But now that I have got better things, and only myself to revile, what do I do but complain about my lack of chains, and go searching,

and screeching, and banging into walls, like a blinded demented hen, looking for a master to tell me what to do.[38]

Dorelia had been able to endure the difficulties of her life with Augustus:

> not for love but from belief. She believed he was a great artist whose vocation demanded that he throw himself into every form of life. She scorned people's conventional indignation, often expressed on her behalf, about his 'goings-on'. But if he were not to prove a great artist, she once told Helen Anrep, then her life had been wasted.[39]

Her life and that of Caitlin Thomas shed some light on the psychological power of an entrenched belief, to which bohemian women were as much in thrall as men, that women were the handmaidens of men, or were the midwives to masculine genius.

Dylan Thomas was romanticized by the American Beats. Allen Ginsberg, for example, felt that Thomas had been destroyed by bourgeois society. The Beats were the new bohemians in cold war America, but there was even less room in their world for women than in Fitzrovia. Allen Ginsberg and William Burroughs were gay, although William Burroughs was married twice, first to a Hungarian Jewess, whom he married so that she could escape the Nazis,[40] and then to Joan Vollmer.

Burroughs' friend, Herbert Huncke, thought that Joan was the most beautiful woman he had ever seen; 'her electricity seemed almost palpable ... her inner radiance overflowed.'[41] But after they moved to a remote farm in Texas she became lumpish and lifeless with thin hair and the round, sightless eyes of a doll, and Huncke believed that although Burroughs 'respected her ... I'm sure he had no deep affection for her. She was sort of interesting to him and that's all.'[42] Her unrequited love for Burroughs and her addiction to Benzedrine were destroying her. The couple moved to Mexico City, and there Burroughs shot her dead in a bizarre 'accident.' Years afterwards he said: 'I am forced to the appalling conclusion that I would never have become a writer but for Joan's death.'[43] Women were, even if inadvertently, the sacrifice to male genius.

To love a gay man might be destructive, but at least the situation was clear, and Joan Vollmer, self-destructive as she appears to have been, knew what she was letting herself in for. The buddy relationship between Jack Kerouac and Neal Cassady was more confusing to the women who became involved with these disturbed and restless men, who seemed happy only when roaming America with each other, far from the restrictions of domestic life.

Neal Cassady had a wonderful, rich, seductive voice; 'piercing blue eyes and chiselled features', and a marvellous physique. His insatiable sexual energy – symbolized by his large penis – mesmerized both women and men.[44] His personality has evaporated from the pages of the novels and memoirs that attempt to capture and preserve his charisma (and Burroughs was always impervious to the enchantment). To Kerouac and Ginsberg,

however, Cassady was the authentic working-class hero who lived rather than thought, an icon of vitality in a grey post-war world. Carolyn Cassady was equally mesmerized. A trained theatre designer, her only wish, as she recounts in her memoirs, was for a 'conventional family life,' a 'normal domestic life,' phrases that reappear with stubborn persistence as she describes her husband's pathologically irresponsible behaviour. This included a prison sentence, the embezzlement of her savings with the help of another woman, and various infidelities, one of which was with Ginsberg (Carolyn found them in the marital bed together); and, while her husband gave his tacit approval to her own affair with Kerouac, this appeared to confirm their male bonding rather than her importance.

Carolyn Cassady's account of her marriage displays little awareness either of the significance of Beat culture or of its unrelenting misogyny. She seems simply to have wanted a good husband of the kind women were supposed to have in Eisenhower's America. Whether with wilful blindness to the incorrigible misfit between conventional ideas of marriage and the bohemian way of life, or cockeyed optimism, she continued to pursue her vision long after most women would have given it up as hopeless. Her dogged commitment to her role and her pursuit of the conventions and ideology of married love in such very unpromising circumstances testify either to her vision or to the strength of the ideology of domestic happiness in 1950s America. There was the additional difficulty that in order to survive at all, most bohemian marriages had to be based on a commitment to genius, whereas Neal Cassady was himself a kind of male muse to the Beats rather than a self-nominated great artist.[45]

Joyce Johnson has described the low esteem in which women were held in the artistic and literary world of the period. Women were excluded from the classes at Columbia University in New York, at which Allen Ginsberg had sat at the feet of the academic stars of the day, Lionel Trilling and Mark van Doren. At the sister college of Barnard, her English professor asked the class of women he was teaching how many wanted to be writers. All raised their hands, whereupon he said: 'Well, I'm sorry to see this ... Because if you were going to be writers, you wouldn't be enrolled in this class ... You'd be hopping freight trains riding through America'[46] – although, as he must have known, that was something no middle-class girl could do.

Yet in gravitating to the Upper West Side and then to Greenwich Village, Joyce Johnson was in search of the spirit of freedom that continued to attract young women to Bohemia on both sides of the Atlantic. In the drab London of 1950 Henrietta Moraes was a secretary, but she hated it and became a model instead, which gave her the entrée to Fitzrovia. Her beauty was memorialized by her lover Lucian Freud and by the photographer John Deakin (who sold his nude snaps of her to punters in the Soho pubs, as if they had been dirty postcards). She married the poet Dom Moraes, but one day he went out to buy some cigarettes and never came back, and after that her life went gradually into a downward spiral.

By the time she resurfaced it was the sixties and her life reflected the cultural change as bohemians mutated into hippies. She no longer drank at the French Pub in Soho; now she smoked marijuana and took acid. She dropped out and travelled with a group of upper-class friends to Wales. The journey took four years, travelling at around four miles a day in a caravan of 'dogs and horses and gypsy wagons'.[47] Later she stole hundreds of drynamil tablets and picked up a biker who took her to Cornwall, and later still she lived in a collective household on the Welsh borders. When that broke up she worked in a Hay-on-Wye bookshop and then was employed by Marianne Faithfull for a time.

At this period Marianne Faithfull was making a musical comeback after a long period on drugs. Like that of so many bohemians, her journey had begun in the provinces: 'I began to do a little bit of folk-singing in coffee bars and folk clubs. There was a beatnik dive in Reading called the Shades coffee bar and another one Café au Lait.[48] I sang ... "House of the Rising Sun", "Blowing in the Wind", and Joan Baez songs.' She was aware that the roots of the sixties counterculture were in the intellectual movements of the preceding decade: 'The names of Sartre and Simone de Beauvoir, Céline, Camus and Kafka were in the air ... I devoured papers for every scrap of hipness and outrage I could find. Articles about Brigitte Bardot and Juliette Greco – she was the big Existentialist icon.'[49] Her later descent into drug addiction had bohemian connotations too, in the connection to William Burroughs. 'Ever since I'd read *Naked Lunch* I'd wanted to be a street addict.'

Many different kinds of self-destruction were romanticized in Bohemia, but its allure was also in its eternal hopefulness, Joyce Johnson recognized:

> As a female she's not quite part of this ... a fact she ignores, sitting by in her excitement as the voices of the men, always the men, passionately rise and fall, and their beer glasses collect and the smoke of the cigarettes rises toward the ceiling and the dead culture is surely being awakened. Merely being there, she tells herself, is enough.[50]

Of course it never was. Bohemia nonetheless offered women who were able to exploit it certain specific avenues for personal triumph, and these – the roles of muse, hostess, sexual adventurer, creative individual – were ultimately more important than the pitfalls.

Notes

1 Christopher St John, *Hungerheart: The Story of a Soul* (London: Methuen, 1915), p 197.
2 Thomas, *Portraits of Women*, p 24.
3 Ibid., p 59.
4 Holroyd, *Augustus John* (1976), p 662.
5 Nora was married to Gerald Summers; both were rich dilettante bohemian painters. Nora was also what Yvonne's daughter Nicolette referred to as 'one of the

first of the women "trouser brigade", who liked austere tailored clothes from the best London tailors. The relationship of the two women lasted for years, and Yvonne and the girls lived with the couple both before and after the John period. See Nicolette Devas, *Two Flamboyant Fathers* (London: Collins, 1966), p 47.

6 Ibid., p 98.

7 Michael Holroyd, *Augustus John: The New Biography* (London: Chatto and Windus, 1996), p 564.

8 Fernande Olivier, *Picasso and his Friends*, trans Jane Miller (orig publ 1933; London: Heinemann, 1964), p 13.

9 Brassaï, *Picasso and Co.*, trans Francis Price (London: Thames and Hudson, 1937), p 183.

10 John Richardson with the collaboration of Marilyn McCully, *A Life of Picasso, Volume I: 1881-1906* (London: Jonathan Cape, 1991), p 312.

11 Ibid., p 310.

12 Brassäi, *Picasso and Co.*, p 69.

13 Ibid., p 70.

14 Olivier, *Picasso and his Friends*, p 108.

15 Ibid., p 17.

16 See Gertrude Stein, *The Autobiography of Alice B. Toklas* (New York: Vintage Books, 1933); and John Richardson, *A Life of Picasso*, vol 2, 1907-1917 (London: Jonathan Cape, 1996), pp 79-82.

17 Stella Bowen, *Drawn From Life* (orig publ 1941; London: Virago, 1984), p 78.

18 Caitlin Thomas, *Leftover Life to Kill* (London: Ace Books, 1959), pp 20-1.

19 Marevna Vorobëv, *Life in Two Worlds* (London and New York: Abelard Schulman, 1962), p 187.

20 Gillian Perry, *Women Artists and the Parisian Avant Garde* (Manchester: Manchester University Press, 1995), pp 60, 66.

21 See Martin Green and John Swan, *The Triumph of Pierrot: The* Commedia dell'Arte *and the Modern Imagination* (New York: Macmillan, 1986).

22 Personal communication from Frances Mahoney.

23 Ethel Mannin, *Ragged Banners* (London: Macmillan, 1932), pp 78-9.

24 Margaret Drabble, *Angus Wilson: A Biography* (London: Secker and Warburg, 1995), pp 120, 484.

25 Viva King, *The Weeping and the Laughter* (London: Macdonald and Jane's, 1976).

26 Hapgood, *A Victorian in the Modern World*.

27 Blanche Weisen Cook, 'The Radical Women of Greenwich Village: From Crystal Eastman to Eleanor Roosevelt', in Beard and Berlowitz (eds), *Greenwich Village*, p 244.

28 Ibid., p 251, quoting Freda Kirchwey.

29 Dell, *Homecoming*, p 296.

30 Dan Wakefield, *New York in the Fifties* (New York: Houghton Mifflin, 1992), p 84.

31 Michael Wishart, *High Diver: An Autobiography* (London: Quartet Books, 1978), p 148.

32 For example with Feliks Topolski, the illustrator, and Peter Quennell, the critic and Byron scholar.

33 See Barbara Skelton, *Tears Before Bedtime* and *Weep No More* (London: Pimlico, 1993), *passim*.

34 See Paul Ferris, *Caitlin: The Life of Caitlin Thomas* (London: Pimlico, 1993), p 42.

35 Derek Stanford, *Inside the Forties: Literary Memoirs 1937-1957* (London: Sidgwick and Jackson, 1977), p 135.

36 John Brinnin, *Dylan Thomas in America* (London: J.M. Dent, 1956), p 146.

37 Thomas, *Leftover Life to Kill*, p 9.

38 Ibid., p 40.

39 Holroyd, *Augustus John* (1976), p 478.

40 In the United States she became secretary to the exiled Ernst Toller, a Weimar writer and bohemian.

41 Joyce Johnson, *Minor Characters* (London: Harvill Press, 1984), p 3.

42 Herbert Huncke, 'Guilty of Everything' in Arthur Knight and Kit Knight (eds), *Kerouac and the Beats: A Primary Source Book* (New York: Paragon House, 1988), p 99.

43 Ted Morgan, *Literary Outlaw: The Life and Times of William S. Burroughs* (New York: Henry Holt, 1986), Morgan, p.199.

44 James Campbell, *This is the Beat Generation* (London: Secker and Warburg, 1999), pp 54, 58, 65.

45 See Carolyn Cassady, *Off The Road: My Years with Cassady, Kerouac and Ginsberg* (London: Black Spring, 1984). Carolyn Cassady has continued to this day to insist on the falsity of the Beat legend. In a 1999 interview she said: 'Jack and Neal had nothing to do with the Beat generation. They were gentlemen. They opened doors; they held chairs [for women].' She even appears to blame herself for Neal Cassady's premature death: 'One of Neal's greatest drives was for respectability and that's where I came in. He was a home owner; he had a family. He had a perfect record on a job for 10 years. He was getting to be respectable. I didn't realize this at the time. But the two pillars of his support were the railroad job and as a homeowner and a head of the family. He lost both *through no fault of his own* [italics added]. First by going to prison. Then I divorced him, thinking I was setting him free.' Anon., 'On the Road with a Real Gentleman,' *The Guardian*, London, Saturday, 20 November 1999, p 16.

46 Johnson, *Minor Characters*, p 80.

47 Moraes, *Henrietta*, p 111.

48 John Stokes, then a student at Reading University, remembers the coffee bars as student hang-outs, but 'Café au Lait' must have been mis-transcribed, or misremembered by Marianne Faithfull, because it was actually called the Café Olé. Personal communication from John Stokes.

49 Faithfull, *Faithfull*, p 19.

50 Ibid., p 211.

CHAPTER EIGHT

THE SPIRIT OF FREEDOM

*He wants me different, completely different. And that's what I want as well –
but when I'm on my own my other, vain self rises to the surface and wants to
be let free.*

Alma Mahler: Diaries 1898–1902

'One should render homage to the profound and sparkling women who live
in the shade of the men of their epoch and who, within the artists' world,
through the simple fact that they emanate a radiance more beautiful than
necklaces, exert an occult influence.'[1] Thus Jean Cocteau praised the muse.
The Muse was more than a mistress, adored for her beauty, charm and fasci-
nation; her role was to provide a genius with both stability and inspiration,
thus enabling him to produce masterpieces – surely a noble vocation for a
woman, or so it would seem to the genius in question. There was a second
and more seductive aspect to the vocation of muse, for the lovers who
painted her, wrote about her, filmed her or celebrated her in their music
bestowed upon her the priceless gift of immortality. The role of muse was
feminine. It included and legitimated the homage that a beautiful woman
might feel was her due. Simply, therefore, to deplore the attraction of the
role and the persistence with which some bohemian women insisted on
living through the greatness of a man, does not allow for the ways in which
the role of consort to a great artist could reinforce a woman's sense of her
feminine identity. Nor should we assume that to play a traditionally
feminine role within Bohemia necessarily involved an unwilling capitulation
to male domination. It could be pleasanter and more rewarding to be a
mistress, a wife or a hostess than to struggle in vain for artistic recognition.
Many bohemian women had no wish to outshine or compete with their
lovers. Rather they were attracted to Bohemia in the belief that it provided a
more glamorous and more tolerant field of operations for their beauty, taste
and personality.

The power of the muse was nevertheless unstable and even one as fascinating
as Alma Mahler found that the role could be a bitter disappointment. She grew

up in Vienna in the 1890s. *Fin de siècle* Vienna was unlike most other European countries in 1900, in that its liberal bourgeoisie, unable either to destroy or fully to fuse with the aristocracy, substituted 'the life of art for the life of action'. They directed their energies towards culture rather than politics, with the result that the cultural world was more integrated than elsewhere into bourgeois life.[2] Nine-tenths of Viennese culture, moreover, according to Stefan Zweig, was 'promoted, nourished or created by Viennese Jewry.'[3] This culture enjoyed an extraordinary flowering at the turn of the century as the Austro-Hungarian Hapsburg Empire, of which Vienna was the centre, slowly imploded.

Alma Mahler came from the rich upper-middle class, her father the successful landscape painter Emil Schindler. Her third husband, the Austrian writer Franz Werfel, described her as a living sorceress, one of the very few, as if she had some quality that while not amenable to creative endeavour in the normal sense, was nevertheless creative.

Of course, she lived through men. She was a promising musician, and as a young student her ambition was to become the first woman to compose an opera. When she became engaged to Gustav Mahler, however, he told her that he considered the marriage of Robert and Clara Schumann 'ridiculous' (Clara Schumann had been a talented musician and more famous than her husband). 'He sent me a long letter with the demand that I instantly give up my music and live for him alone.'[4]

The British (male) editor of the English translation of Alma Mahler's diaries suggests that marriage may have provided a convenient escape from pretensions to an artistic talent that Alma did not have. 'The few scraps of musical notation in Alma's diaries,' he writes, 'betray a woefully defective ear and an astonishing ignorance of ... theory and notation.'[5] The German editor (a woman), on the other hand, believes she did have a musical gift. Mahler's egotism and his demands, however, were not in doubt. If Alma was to become his wife she must lose herself completely in him, as he wrote to her before their marriage:

> One thing is certain; if we are to be happy ... you must be my wife and not my colleague! ... What do you think a household of composers would be like? Can you not imagine the extent to which such a bizarre rivalry would inevitably be ridiculous, and would later degrade us both? What would happen if you were 'inspired' when you should be looking after the house and of everything I need, if, as you assure me, you wish to relieve me of all petty daily cares.[6]

Such sentiments were similar to Freud's often quoted, if milder, strictures to *his* fiancée in the same city and the same period, and were common currency in the exaggerated atmosphere, at once feverish and repressed, of *fin de siècle* Vienna.

For Alma, it was unthinkable not to be married. Her diaries show how deeply she valued her virginity, in spite of her passionate nature. Marriage

would provide the only acceptable way in which her erotic desires could be fulfilled. Surrounded by admirers, her choice was momentous, she was a living version of the heroine of Henry James's *Portrait of a Lady*. Her biographer, Françoise Giroud, suggests that Alma chose Mahler in a moment of 'intoxication' and to spite her mother, who, to do her justice, was horrified by Mahler's demands. It seems more plausible that, torn between Mahler and a rival suitor, the composer Alexander Zemlinsky, Alma chose the glory of being the wife of the director of the Viennese opera, the more famous – and controversial – composer. She herself questioned her motives:

> I don't know what to think, how to think – whether I love him or not – whether I love the director of the Opera, the wonderful conductor – or the man ... whether, when I subtract the one, anything is left of the other. And his art leaves me cold, so *dreadfully* cold. In plain words, I don't believe in him as a composer. And I'm expected to bind my life to this man ... And what if Alex [Zemlinsky] were to become famous?[7]

There was a further and more honourable motive, in that in choosing Mahler she also chose the man who presented himself as the teacher capable of leading her to a more serious life. During their courtship both repeatedly returned to the contrast between Alma's exciting, but frivolous life at the heart of the feverish Viennese social whirl, and the life she would have with Mahler. 'Your youth, your whole life has been endangered by your friends, who in their misguided confusions sought the darkness of false paths,' he wrote. She had been seduced by the 'false and detestable antimoralism of Nietzsche's superman' and the 'cloudily intoxicating dreams' of Maeterlinck. Mahler's vision of a completely new life for his bride seemed nobler, but was also itself intoxicating. 'He wants me different, completely different,' she confided to her diary. 'And that's what I want as well.' It was as if the thought of complete self-abnegation before a man was intoxicating: 'My longing is infinite. I would give everything for him – my music – *everything* – so powerful is my longing! That's how I want to be his – I am already* his.'[8]

Once married, however, it was less a question of erotic ecstasy than of putting Mahler's financial affairs in order, reading to him aloud in the evening when they were at home, and entertaining his much older friends. Alma, like Fernande Olivier, also discovered the loneliness of the muse. When Mahler took her away to his country house, he spent all day composing while she was left utterly isolated, deprived of her friends and even of her music. She was not allowed to play the piano, since it disturbed him, although his study was completely separate from the main house, two hundred yards away up a hill.

Alma eventually rebelled, and her adulterous love affair with the architect, Walter Gropius, did bring Mahler to a recognition of his egotism. But he died from an infection the following year, at the age of fifty-one, and one of Alma's biographers has gone so far as to suggest that Alma's infidelity was

indirectly the cause, because it broke his spirit and left him powerless to resist.[9] If that were the case, then the muse was indeed powerful.

Alma had other affairs, the most passionate with Oskar Kokoschka. She married and divorced Gropius, and finally married Franz Werfel, who had been considered one of the most promising Austrian poets in his youth and then became a best-selling novelist. Although, like Mahler, he was Jewish, while Alma was increasingly anti-Semitic,[10] she followed him into exile, where, in Hollywood, he was almost the only German exile able to live comfortably on his royalties. Yet by this time Alma's role as muse was in danger of verging on caricature. Once consort to one of the greatest twentieth-century composers, then to one of its great architects, she ended with a man whose best-known book was turned into the Hollywood weepy, *The Song of Bernadette*.

In her memoirs Alma explicitly stated that to become the muse of a great man was a substitute for becoming a creative individual in her own right. She added:

> I buried my dream and perhaps it was better so; I have been privileged to see the realization of my creative talent, what there was of it, in greater brains than mine. And yet, somewhere within me a wound kept smarting.[11]

Still, to become the muse, at least of someone famous, offered instant fame instead of the utter uncertainty of personal achievement, especially for a woman, and for this reason alone was deeply seductive. For a woman who set store by her femininity, the role emphasized woman's mystery and her essential difference and otherness from men, and her erotic power. And, while *l'art de vivre* and the creation of a salon were ephemeral, the muse to a genius, after all, achieved a sort of immortality. It has been said that without her famous husbands and lovers – Gustav Klimt was another early admirer – Alma Mahler would be forgotten, whereas without her they would still be acclaimed. But the fact is that she has not been forgotten. Her attraction for these famous artists was due to the fascination of her personality as much as her beauty, and because she lived with and through them, what would otherwise have been totally ephemeral – her beauty and intoxicating fascination – have been in some sense preserved.

If Alma Mahler's artistic ambitions conflicted with and were overcome by the 'reasons of the heart', Georgette Leblanc's life, in the same years, demonstrated the way in which the seduction of being a great man's muse could appear to fit seamlessly with the woman's own artistic career. Her relationship with the Belgian symbolist poet, Maurice Maeterlinck, had begun when she had read his poem *Pelléas et Melisande*. She was a young singer who had recently been taken on by the Opéra Comique in Paris, but she immediately broke her contract and went to Brussels, convinced that Maeterlinck was her destiny. At first she was taken aback by the great man's appearance, but

Figure 18 Georgette Leblanc

managed to overcome this by seeing their relationship through a veil of
symbolist romanticism, whereas his main interests, symbolist poetry notwith-
standing, were sports, motorbikes and regular meals.

In their first years together they spent long hours discussing philosophy
and mysticism, and Maeterlinck incorporated some of Georgette's ideas into
his philosophical works. He even admitted this: 'I've stolen a little bit from
you, haven't I?' He always attributed these ideas to an anonymous 'friend' or
'an old philosopher'. When she asked him why he refused openly to acknowl-
edge her role, he said it would look ridiculous for him to quote an actress
and singer; no one would take him seriously. He did finally agree to make a
general acknowledgement to her in a dedication, but after their relationship
ended he had it removed from the next edition of the work.[12]

As Maeterlinck's fame grew, Georgette devoted herself increasingly to arran-
ging performances of his works, and after a time appeared only in operas
written by him, notably *The Bluebird*, and Debussy's setting of *Pelléas and Meli-
sande*. Their relationship gradually deteriorated. It ended brutally when
Maeterlinck married a much younger woman.[13] Yet Georgette had been
complicit in her role, had even created it, trying to mould her lover as well
as herself into the false personae of Genius and Muse.

The male Surrealists of the 1920s and 1930s liked to think of woman as
muse, but after the Second World War the idealization of women (however
ambivalent) which it implied was out of fashion. In his 1997 obituary of the
journalist Lesley Cunliffe, Jonathan Meades meditated on the decline of the

muse. Although Lesley Cunliffe had a career, it was 'all fits and starts and false dawns,' he wrote. This was because 'she put her talent into her life rather than into *Harpers and Queen* or the *Sunday Times*', and because 'she lived, in a way that has been unusual among her generation and milieu, through men'. Like Barbara Skelton, she was 'an exotic, an adventuress, a dilettante, a dandy' in the English mould, veering from much older to much younger men, from urban sophistication to squats and rural cottages, her relationships 'stormy,' as she drank and smoked to excess. She prepared for her death 'in style, as though her demise was the culmination of a most subtle, serene and defiant work of performance art'.[14]

A second, rather less risky, supportive role enabled women to play an important part in Bohemia. This was the role of salon hostess. The institution of the salon had emerged in France in the seventeenth century in opposition to the frivolity of court life, and in the eighteenth century continued to provide intellectual women with a field for their interests. In the nineteenth and early twentieth centuries, salons – which existed as much in fashionable society as in bohemia, and sometimes forged links between the two – played an important role. The salon hostess was responsible for the creation of an environment in which artists, writers and intellectuals could not only meet one another but could also make contact with members of the professions, the aristocracy or wealthy connoisseurs and patrons who could assist their careers.

Since nineteenth-century bohemian women did not have the same freedom of entry to cafés and other public places as men, they made a virtue of necessity by turning the institution of the salon to their own end, creating aesthetic interiors and an atmosphere that attracted intellectual and artistic stars. The salon hostess, whether a society lady or a demi-mondaine, created a welcoming environment, cared for her guests, acted as a mother figure, and, above all, provided the *mise en scène* against which her guests shone. To design a beautiful setting in her drawing-room, to provide delicious food (Louise Colet herself cooked chicken Provençal every week for her regular guests) and to encourage her guests to sparkle was an art in itself, yet totally ephemeral – like family life, destined to live on only in memory. On the other hand, the salon hostess gained a measure of control in playing the part of collective spiritual mistress to her galaxy of talents. It was both a creative and a reassuringly feminine role, and because the salon as an institution was useful to artists and writers, the bohemian hostess called the shots. Her role might seem traditional, but her salon brought her social power. The lives of three famous hostesses, French, American and English, illustrate the subtle nature of this power.

Appollonie Sabatier was the illegitimate daughter of a provincial administrator. She commenced training as a singer in her teens, but on her very first appearance, at a charity concert, she was noticed by the banker Alfred Mosselman. Already married, he set Appollonie up in the rue Frochot, near what is now the Place Pigalle, and was then known as the Quartier Bréda, a district popular with artists and 'light women'.

Clésinger's 1847 sculpture, 'Woman Stung by a Serpent', for which Appollonie had posed, was scandalous, because, as Gautier suggested, a snake had been added to throw a pseudo-mythological veil of respectability over what seemed obviously to be the real subject: a reclining woman in the throes of orgasm. Although the statue had Appollonie's body, the face had been altered, but a portrait bust of 'Madame A.S.' placed close to the statue in the Salon (1847) exhibition more than hinted at the model's identity. Appollonie became notorious. (She was also immortalized in Flaubert's *L'Éducation Sentimentale*.)

The delighted Mosselman inaugurated a weekly Sunday evening dinner at his mistress's apartment. Gautier suggested that Appollonie herself should be president of the group, and thus arose her nickname 'La Présidente'. Regulars at these Sundays included the writers Baudelaire, Gautier, Maxime du Camp and Ernest Feydeau and the artist Meissonier, whose wife Emma became a close friend of Appollonie. Gautier also encouraged his daughter Judith to visit her. Appollonie herself, however, was the only woman present at the dinners, since she alone of all the women in this circle could be trusted not to object to coarse language and obscene jokes, but on the contrary to enter into the spirit of the conversation.

Appollonie Sabatier was the bohemian ideal: Judith Gautier described her as tall and beautiful, but distinguished above all by her 'air of triumph', which seemed to surround her in a halo of light and happiness.[15] Charming, complaisant, never an economic or literary threat to her circle of male companions, she was a muse as well as a hostess. It was possible to combine the role of muse with that of creative artist and independent woman, but Appollonie illustrated the more usual way in which artistic taste and originality were channelled into *'l'art de vivre'*.

Most of those who knew her described Appollonie as always full of gaiety and *joie de vivre*, although the Goncourt brothers sounded a characteristically sour note, snobbishly describing her as coarse, low, vulgar and trivial.[16] Her abortive affair with Baudelaire, who retreated, alarmed, after the one night he spent with her, did not throw her off balance for long; and, even after Mosselman had abruptly dispensed with her services in 1860, Judith Gautier found her as charming and cheerful as ever, although she now lived in poverty in a little apartment, had to do her own cooking, and was trying to earn some money by painting portrait miniatures. (She exhibited at the Salon in 1861 and at the *Salon des Refusés* in 1863 – and so was typical of many bohemian women in having at least a degree of artistic talent that was never fully developed.)[17]

Her fortunes revived when she entered into a relationship with the wealthy Roger Wallace, who settled a large sum of money on her after their relationship ended.[18] In later years she lived happily in Neuilly with another lover, and once more held a salon, but never again did she attract artists as famous as those she had entertained in her youth.

The best-known example of an American bohemian hostess was Mabel

Dodge—Luhan, who returned to the United States in 1913 after living in Florence for some years. There, her rich but, she increasingly felt, vulgar husband ('I was so sick of Edwin's being commonplace') had provided her with a magnificent setting, the Villa Curonia, in which she had held parties for the international *bohème d'orée*. In New York, Edwin Dodge set his wife up in a double apartment just north of Washington Square, and then tactfully made himself scarce. Mabel decorated her new home in white, filled it with 'delicate old grey French chairs and chaises longues upholstered in light colours, grey-blues and pale yellows,' and adorned it with her collection of coloured glass. Her setting accomplished, she launched herself on the New York art scene, with the help of two writers, Lincoln Steffens and Carl Van Vechten.

1913 was the year of the famous Armoury Show, the huge International Exhibition of Modern Art held at the Sixty-Ninth Regiment Armoury on Lexington Avenue, which scandalized New Yorkers with its display of the outrage that was contemporary European modernism. Mabel had known Gertrude Stein in Italy, and her article on the American writer's work, together with Stein's literary portrait, 'Mabel Dodge at the Villa Curonia,' appeared in *Arts and Decoration*, coinciding with the opening of the Armoury Show. Thus Mabel was thrust into the limelight at an explosive moment in American culture.

Although she participated in Greenwich Village life for only a few years, from 1913 to 1917, those years spanned the first heyday of the Village. Her contribution was to provide a forum, in the shape of the 'Evenings' she organized in 1913 and 1914, for the exploration of the revolutionary ideas and experiences that were sweeping Bohemia. These 'Evenings' usually consisted of a speaker and discussion. On one occasion Big Bill Haywood (an International Workers of the World organizer) addressed his audience of artists, telling them that 'artists thought themselves too special and separate, that some day there would be a Proletarian Art, that the State would see to it that everybody was an artist and that everybody would have time to be an artist'. On a different evening Haywood and Elizabeth Gurley Flynn debated with Emma Goldman and fellow anarchist Alexander Berkman. There were evenings devoted to birth control, female suffrage, 'sex antagonism' and psychoanalysis. There were also less intellectual evenings, such as the first, when Van Vechten brought two black dancers from Harlem, and an evening when Mabel and her guests took peyote.[19]

For Mabel, as for so many bohemian women, artistic radicalism was about extending the boundaries of personal experience as well as about art, and she soon met and fell passionately in love with the radical, John Reed. He was involved in the Patterson, New Jersey, silk workers' strike at the time, and Mabel Dodge played a role in the struggle, which was supported by the bohemian community, when she suggested and masterminded a Patterson Strike Pageant to gain favourable publicity for the strikers. This was a success, at least in the short run, but later in the year the strike ran into stalemate

Figure 19a Mabel Dodge-Luhan in Taos, New Mexico

Figure 19b Tony Luhan

and defeat. The affair with Reed likewise began to founder, doomed by
Mabel's longing for a total love. 'As soon as I gave myself up to Reed I was
all for love and everything else well lost!' she wrote. 'Everything seemed to
take him away from me, and I had no single thing left in my life to rouse

me save his touch.' It was only when Reed was away that her energy returned: 'the peculiar thing was that when I was living with Reed at home my power seemed to leave me.' Hutchins Hapgood felt she was like 'a cut flower ... it accounts for her never-ending movement; she continuously seeks the nourishment which some harsh fate has withheld from her.'[20]

After the affair ended she embarked on another unfulfilling relationship, this time with a sculptor, but in 1917 she moved to Taos, New Mexico, where she married Tony Luhan, an American Indian. She renewed her role as a hostess, (to D.H.Lawrence, Frieda Lawrence and Dorothy Brett, among others) and concerned herself with the plight of the American Indians by promoting their culture and crafts.

In England, the Lawrences and Dorothy Brett had been familiar figures at the homes of Lady Ottoline Morell. She had cut loose from her conventional upper-class background when she married a Liberal MP, Philip Morell. She was attracted to Bohemia and Bloomsbury because they were circles in which she was able to live among artists, and carved out her own role, finding fulfilment in hosting a salon.

Her 'famous Thursdays' began at her home in Gower Street in 1907. A few intimate friends would be invited to dinner, and afterwards more guests would drift in. There was often a concert, after which her husband played dance music on the pianola. Dressing up was a feature of these occasions, and D.H.Lawrence, who caricatured Ottoline as Hermione Roddice in *Women in Love*, described one such evening in the novel:

> A servant ... reappeared with armfuls of silk robes and shawls and scarves, mostly Oriental, things that Hermione, with her love for beautiful, extravagant dress, had collected gradually ... The idea was to make a little ballet, in the style of the Russian Ballet of Pavlova and Nijinsky.[21]

During the First World War, Garsington Manor, the Morells' country house near Oxford, became a setting and a refuge for their bohemian and intellectual friends. Lytton Strachey, Dorothy Brett, D.H.Lawrence, Frieda Lawrence and Aldous Huxley were among the many visitors. Henry Lamb and Bertrand Russell, two of Ottoline's lovers, also stayed there, as did conscientious objectors for whom the Morrells provided acceptable alternative war work on their farm.

The villagers called Ottoline the 'gypsy queen' and Ottoline herself wrote of her 'wild, bohemian, artistic side which never gets a look in except in my extravagance about colour and dress and pictures'.[22] Juliette Huxley, who lived at Garsington as a governess for two years (where she met Aldous Huxley, who became her husband), observed that Ottoline 'longed to be creative.' Like Dorelia John, she had a gift for creating wonderful interiors, settings and atmosphere. Her houses 'were works of art in themselves ... the lovely colours, the harmony, the pictures, the lampshades which threw their light of intimate appeal'. The Garsington rooms were curtained in cerise or

lemon yellow, and decorated in Venetian red, or panelled in grey tinged with
pink, and 'in all its seasons and moods, Garsington Manor was alive with
inner beauty: its colours, its glow, the pools of light under the wide lamp-
shades, its faint scent of incense enhancing one's sense of privilege, of living
in a "habitable work of art".'[23]

Ottoline Morell and Mabel Dodge were rich,[24] well-connected women, who
owed their 'independence' to the complaisance and support of their husbands.
Nevertheless, each played a creative and generous part in their respective
social circles. They were emotionally focused on men, and their hostess role
seemed compatible with, or indeed to facilitate, their search for erotic fulfil-
ment; but they were not neglectful or contemptuous of other women.

The same could not be said of Muriel Belcher, who to all intents and
purposes ran a salon at the Colony Room in 1950s Fitzrovia. She has
achieved the status of a bohemian 'legend,' a kind of dominatrix suitable for
this misogynistic period. Apart from young beauties and models, her own
West Indian girlfriend, Carmel, and the alcoholic Nina Hamnett, she was
almost the only woman character in this world. She referred to everyone as
'cunty' and to men as 'she' in camp gay male fashion, and guests to whom
she took a dislike were referred to as 'Lottie,' but this misogyny was part of
the aggression of the period. 'In the early fifties everyone was extremely rude
to one another,' wrote Henrietta Moraes, who became part of Fitzrovia at the
age of nineteen. 'I was terribly shy in this frightening company and couldn't
talk at all ... Every night there would be fighting, insults were lobbed into
the air ... Everyone was very critical of one another, but there was a high
standard of wit.'[25]

Every successful salon hostess had to have either an ability to create an
atmosphere to which guests became addicted and in which they shone, or to
turn herself into a unique character. Muriel Belcher did both. Her genius,
thought one of the Colony Room habitués, 'was in her ability to mix her
members.'[26] This gave her club more variety and a touch of the unexpected
not to be found in other drinking clubs that catered for one specific group,
whether it was gay men, policemen, or society debutantes and their beaux.
But above all the Colony Room was a success because 'Muriel created an
atmosphere where you could be yourself.' This atmosphere was the result
partly of Muriel's sure instinct, which led her to cultivate Francis Bacon,
certain that he would bring in exciting people. Bacon and Muriel hit it
off from the moment they met, and Muriel offered to pay the young
painter ten pounds a week, 'and you can drink absolutely free here and don't
think of it as a salary but just bring people in ... the people you like.' In
return Bacon made the Colony Room his home from home, finding it 'a
place where you can lose your inhibitions. It's different from anywhere else.
After all, that's what we all want, isn't it? A place where one feels free and
easy.'[27]

That might not have been a description of the Colony Room with which
everyone concurred, but it summed up one aspect of Bohemia as a whole.

That it was such a camp or 'queer' environment was also consistent with the way in which the bohemian way of life provided a subcultural umbrella beneath which gay men and women who loved other women could find shelter and live more openly than elsewhere.

Lesbian relationships appeared as the polar opposite of the role of muse, and as a less ambivalent alternative for women determined to retain their independence. The lesbian might appear in literature as a destructive or mutilated and sterile figure, but this was a masculine fantasy. It was far removed from the merry and constructive lives led by many lesbians, who formed their own alternative salons and circles within Bohemia. Before the First World War Natalie Clifford Barney's lesbian salon hosted a coterie of mostly wealthy and/or upper-class women, since these women alone could lead independent lives and had the confidence to ignore the conventions. By the 1920s this subculture had merged with Bohemia.

Between the two world wars Adrienne Monnier ran the Maison des Amis des Livres in the rue de l'Odéon, one of the most important literary centres in the city, or indeed in the Western world. She brought together the best writers of the day, and the shop functioned as a cultural centre and library, with regular poetry readings and literary evenings. Across the street her companion, Sylvia Beach, opened Shakespeare and Company, devoted to English books, and the relationship of these two women was crucial to the reputation of Paris as an international literary centre. Sylvia Beach in particular was responsible for the publication of *Ulysses* in book form, and gave James Joyce endless help and support (for which he showed little gratitude).[28]

Margaret Anderson was another of Joyce's female supporters. She was part of the literary bohemian avant-garde in Chicago. In 1914 she founded the *Little Review*, which for more than a decade was a showcase for the most controversial writing of the period, its renown and influence based on Margaret's willingness to challenge censorship. Her publication of *Ulysses* in instalments resulted on several occasions in the whole issue being burnt and once in a prosecution. The journal reflected Margaret's every ecstatic political and literary enthusiasm. When she met Emma Goldman and became a passionate anarchist for a time, she did not hesitate to risk losing less radical subscribers and backers by broadcasting her new enthusiasm in her review.

She never had any money and one summer the magazine was so in debt that in order to evade creditors she and her sister Lois, together with Lois's two children and a grand piano, camped for weeks out on the shores of Lake Michigan. 'Reporters heard of us and featured us as a back to nature colony, a Hellenistic revival, a freak art group, a Nietzschean stronghold.'[29] (The list sums up some key bohemian obsessions of the period.)

She had no objection to these bohemian associations, for she made a point of her separation from all conventional ties, declaring proudly that she always held herself 'quite definitely aloof from natural laws.' 'I have no place in the world,' she wrote in her autobiography. She was neither wife, mother nor mistress, but had succeeded, she felt, in escaping *all* feminine roles.

Figure 20 Jane Heap

In 1916 she met Jane Heap, a handsome woman who dressed in a masculine fashion, who had graduated from the Chicago Arts Institute and had subsequently acted and designed sets for the Chicago Little Theater.[30] She joined Anderson on the *Little Review* and soon they moved to Greenwich Village.

Both women took individualism to extremes and were oppositional even within Greenwich Village circles. 'We were considered heartless, flippant, ruthless, devastating … Sincerity was the great test in those days … "I have never understood the overwhelming interest in sincerity," Jane would say. Because we could always laugh we were always suspected of being frivolous … but after an hour or two we would stand revealed as two simple sincere people with serious ideas.'[31]

Georgette Leblanc had been devastated by Maeterlinck's rejection, and at the end of the First World War she tried to relaunch her career as a singer by touring and giving concerts in the United States. There she met Margaret Anderson, who fell passionately in love with her.

They moved to Paris in the 1920s, where Jane Heap, now with a new lover of her own, joined them, and soon established themselves in the largely expatriate lesbian colony. Djuna Barnes and her lover Thelma Wood were there, as was Dolly Wilde, Oscar Wilde's niece, together with Janet Flanner, who wrote a Paris newsletter for the *New Yorker*, and her lover, Solita Solano. They lived in cheap hotels, ate all their meals in little local restaurants, and were free of domestic cares of any kind. Solita was especially close to Margaret and Georgette, sharing their interest in the mysticism of Gurdjieff, whose colony was not far from the city.

These interlocking groups of women practised what they termed female fidelity. This combined freedom from jealousy and possessiveness in their sexual relations with solidarity in friendship, and they tried to look after one another when the need arose. Djuna Barnes, for example, sold portions of the annotated manuscript of *Ulysses* in order to maintain the eccentric Baroness Freytag von Loringhoven in a Paris flat, until, in 1927, the Baroness and her dog died as the result of a gas leak.[32] In turn, other members of the group cared for Djuna when she took to drink after the breakdown of her relationship with Thelma Wood.

Yet lesbianism could not bypass all the problems of heterosexual love. A decade earlier, Christopher St John had flirted with men as part of her free life in London. However, she was primarily drawn to her own sex, and abandoned her life of casual friendships when she met Ellen Terry's daughter, Edy Craig, became immersed in Edy's life, and attempted suicide when Edy became engaged to be married. The engagement was broken off, and the two women stayed together, were involved in theatrical life, and were active in the suffrage struggle. Later they moved to Rye, where they maintained a ménage à trois with Clare Atwood (Tony), a painter, and became friendly with Radclyffe Hall. They devoted their lives to the preservation of Ellen Terry's memory, and staged gala theatrical events from time to time. The relationship between Edy and Chris was never an easy one, especially when Chris, aged sixty, fell hopelessly in love with Vita Sackville West. Even a life devoted to other women brought its own difficulties and traumas, and the roles of muse and 'wife' were not unknown in lesbian circles, Radclyffe Hall's companion Una, Lady Troubridge, for example, playing a most traditional role.[33]

Figure 21 Judith Malina in the 1950s

When, in the 1960s, Bohemia was merging with new forms of countercul-
ture, the role of muse might be degraded into the even more exploitative one
of 'rock chick'. Women were no longer placed, even temporarily, on a
pedestal. Yet the blurring of boundaries and expansion of culture meant that
with confidence women could themselves exploit the very contradictions that
others found exploitative.

Judith Malina, for example, was the founder with her husband Julian Beck
of the Living Theatre. This was the most radical theatre group of the period,
and it was as much the work of Malina as of Beck. Influenced by Robert
Graves' *The White Goddess*, Judith Malina projected herself into the role of
muse in her relationships with the creative men she met in the avant-garde
demi-monde. This in no way inhibited her from being a dedicated actress,
anarchist and peace campaigner, inspired by Dorothy Day whilst not sharing
the older woman's catholic faith.

As individuals she and her husband developed both together and apart,
Julian accepting Judith's relationships with other men and she his pursuit of
gay encounters. At the centre of a complex web of erotic relationships, they
lived out the most radical aspects of the 1960s artistically and in their
personal lives. So uncompromising were their politics, and so challenging the
plays they produced – such as *The Connection*, about drugs, and *The Brig*, the
subject of which was the brutality of the armed forces – that they suffered
continual persecution, censorship and imprisonment. The situation became
so intolerable that they eventually left the United States for some years, to

become a travelling theatre in exile.[34] Judith Malina's uncompromising and enduring politics were inseparable from her art and her self-belief. In 1991 she had a small part in the film of *The Addams Family* (the money would support her theatre company). When the Gulf War broke out and everyone on the set was given a little American flag to wear, Judith Malina refused, a gesture which cost her her role in the sequel.[35]

In the 1970s feminist artists and art historians reacted against the way in which women had been 'objectified' in high art and mass culture. Embarking on an excavation of women's exclusion from the masculine preserves of the life room and from official professional societies, they rediscovered women artists. They also analysed the voyeuristic male gaze, which had first reduced women to their bodies, and then reduced the female body to sexual parts and even dismembered limbs.

Women as bohemians were outside the remit of this feminist re-evaluation of art history. This was ironic, given that the women's movements of the Western world came with all the trappings of bohemian lifestyle, from picturesque clothing to communal housing, from collective childcare to health food and from illegal substances to sexual experimentation. The connection between 'lifestyle politics' and an earlier bohemianism was never made. Feminists in the 1970s and 1980s were concerned with the struggle of women artists for recognition; and they saw their movement as part of a general cultural revolution. But, as in the bohemian enclaves of Greenwich Village and Munich's Schwabing district before the First World War, feminism and the bohemians occupied in part the same terrain and yet diverged.

The lasting, if diffuse, influence of the feminism of the 1970s was to change women's self-perception and sense of identity. This occurred at a time when the restructuring of Western economies brought more opportunities for female employment, although not on terms that feminists would have wished. One effect was that by the 1990s the economically and sexually independent woman had become an ideal. Women were now expected to combine work and motherhood, and the phrase 'traditional family values' no longer necessarily implied a wife and mother who stayed at home, an ideal to which few apart from extreme conservatives and religious groups still subscribed, at least not openly.[36] Women artists could expect more recognition, although they still struggled to be judged on the same terms as men.

At the same time, feminism delegitimated the role of muse and cast doubt on its emotional rewards. To live for love, to live through men, to devote your life to the creation of an ambience worthy of a male genius, to pour your creativity into 'the art of living', all this was hardly an option at the Millennium. In an era in which even lesbian 'partnerships' have become respectable, the glamour of transgression is hard to achieve and viewed with suspicion.

If, at the start of the twenty-first century there are still bohemian heroines today, they are likely to be admired primarily for their professional success. For example, in a starry-eyed interview with the British publisher Alexandra

Pringle, Joanna Briscoe described her as 'wild and bohemian.' A heroine of 'extreme thinness' and 'dissipated glamour ... she rose through the ranks of publishing by day, while at night she was often to be seen horizontal on a Groucho club sofa in some torn cobweb of an antique dress that was gradually disintegrating through partying and inebriation.' In her Hampstead house 'bare-footed, she leads me past reassuring pools of disorder to a room blooming with alluring decay: torn antique curtains, chaises longues, old china, important modern art, and tapestry stools. And there she sits, cross-legged, like a beautiful Sixties model who never quite got away from [Chelsea].'[37] This, however, was a bohemian heroine for the year 2000, who 'combines party girl activity with hard business.'

Pringle's career began at the feminist publishing imprint Virago in the 1970s, and her success assumes a feminist agenda. Yet bohemianism and feminism to this day still do not sit easily together. The American writer, Camille Paglia, who claims to be a feminist and cultural outlaw, has celebrated Madonna and Princess Diana as feminist icons, but she has also always insisted on the supreme importance, for her, of traditional 'high culture.' Her claim to 'feminism' is contentious, for her discussions of art are based on the belief that the creative impulse is masculine – an extremely conservative view; while although she identifies herself as a lesbian, her vision of the erotic relies on a Lawrentian notion of phallic power, so that she seems more like Ayn Rand reinvented for the nineties than any kind of feminist thinker.

The British couturière, Vivienne Westwood, rejected feminism because she believed it was 'anti sex,' and in the past decade has dedicated herself to producing fashions that promoted woman's erotic power. She first became well known as the midwife of Punk in the seventies. At that time she developed 'confrontational dressing' and *bricolage*, building on the inventiveness of the kids who made punk what it was. Many punks insisted in retrospect that punk wasn't political, 'it was just mayhem'; 'in the beginning,' said Boy George, 'all it was about was dressing up and looking ridiculous and having fun.'[38] At the time it didn't seem quite like that. Punk spoke the anger of youth in a crumbling economy administered by out-of-touch politicians, and, insofar as nihilism is political, it *was* political; it was anti-establishment, it was about outrage, shock, violence, pornography, anarchy and self-destruction. Vivienne Westwood was able visually to interpret the ideas of Malcolm McLaren, who organized the punk band, the Sex Pistols. Their shop in Chelsea, named at various times Sex, Seditionaries and Too Fast to Live, Too Young to Die became the GHQ of Punk.

Vivienne Westwood was never amenable to sisterly solidarity, and after her relationship with McLaren ended she looked to other men for ideas and inspiration. When she came under the influence of her 'guru,' Gary Ness, in the 1980s, she plunged into an unfamiliar world of books, art and museums. She played with the idea of reviving the salon – although with her prickliness and self-absorption she lacked the personality required in a successful salon hostess. She began to express her belief in elitism and 'civilization' and reproduced

Ness's hatred of mass culture: ' "What one is rebelling against all the time is orthodoxy," she insisted. "The orthodoxy today is an ugly casualness which I believe is a tyranny imposed by Hollywood because no one's supposed to look better than anyone else. It's a tyranny of you're all supposed to look the same. It's against elitism. Whereas, in the past, everything that happened was the work of the avant-garde and they were always an elite." '[39]

Journalists have dismissed these views as eccentric, and questioned her education and intelligence, but despite her celebrity and success as a dress designer, Vivienne Westwood seems in many ways like a traditional bohemian from earlier times. She continued until the late 1990s to live in a south London council flat and to travel round London on her bicycle. Moroever, in espousing what might seem like conservative views in contrast with her earlier association with punk, she has evoked the perennial bohemian tension between the revolutionary political impulse and the belief that art was everything. Bohemia was always internally inconsistent, was always both reactionary and radical. In Westwood's later work there was still a link to older bohemian ideals, in the individualism of her views and in her insistence on beauty and the aesthetic. Her 'Portrait' collection in 1990, for example, drew inspiration from the old masters with its corsets printed with Arcadian scenes, its rococo prints and huge pearls; and during the recession of the early nineties she produced 'sumptuous collections.' This was at a time when most designers 'were timidly offering ... modest, low key design ... as a reaction to popular criticism that the built-in obsolescence of fashion was morally questionable and ecologically unsound'. Hers by contrast were 'boldly baroque ... characterised by a richness, formality and attention-seeking drama.'[40]

As a Muse for the millennium Westwood may seem flawed or even ridiculous. Yet in her insistence on going against the grain, she voices a well-founded suspicion of the facile populism with which many former radicals have embraced mass culture. And in a culture in which elitism is the cardinal sin, her political incorrectness may be more subversive than the 'outlawry' of music videos and rave clubs (an issue further discussed in Chapter 14). It has also to be admitted that the feminist ideal of the 1970s – to merge politics with art and to define art in political terms that in retrospect seem rather narrow – did not wholly succeed. Moreover, in its evolution through the 1990s, as feminism has filtered into the mainstream, it has been diluted and distorted, becoming not so much populist as conformist, part of the contemporary work ethic rather than the bohemian spirit of play.

Notes

1 Jean Cocteau, quoted in Misia Sert, *Two or Three Muses* (London: Museum Press, 1953), p 168.
2 Carl E. Schorske, *Fin de Siècle Vienna: Politics and Culture* (London: Weidenfeld and Nicolson, 1961), p xxvi.

3 Stefan Zweig, *The World of Yesterday* (London: Cassell, 1943), p 28.

4 Alma Mahler-Werfel, *And the Bridge is Love* (London: Hutchinson, 1958), pp 23-4.

5 Anthony Beaumont (ed), *Alma Mahler-Werfel: Diaries 1898-1902* (London: Faber and Faber, 1998), p xiv.

6 Françoise Giroud, *Alma Mahler ou l'Art d'être Aimée* (Paris: Laffont, 1988), p 52, quoting Gustave Mahler.

7 Beaumont, *Alma Mahler-Werfel: Diaries*, p 449.

8 Ibid., p 464.

9 Giroud, *Alma Mahler*, p 121.

10 See Beaumont, *Alma Mahler-Werfel: Diaries*, p xvi. Her anti-Semitism was quite 'normal' in Vienna.

11 Mahler-Werfel, *And the Bridge is Love*.

12 Georgette Leblanc, *Maeterlinck and I*, trans Janet Flanner (London: Methuen, 1932). It appears that Flanner was unsympathetic to Leblanc's romantic approach to life, and the heavily ironic tone of parts of the translation may be the result of this. (I was unable to obtain a copy in the original French.)

13 A similar fate befell Misia Sert, when the painter José Maria Sert abandoned her for a much younger mistress. Misia Sert later became seriously addicted to drugs.

14 Jonathan Meades, 'Adventuress and Muse', *The Guardian*, Thursday, 3 April 1997, p 19.

15 Judith Gautier, *Le Collier des Jours: Souvenirs de ma Vie – le Second Rang du Collier* (Paris: Juven, 1910), p 183.

16 Edmond Goncourt et Jules Goncourt, *Journal des Goncourts: Memoires de la Vie Littéraire*, 1e vol, 1851-1861 (Paris: Charpentier, 1887), p 191.

17 Billy, *La Présidente et Ses Amis*, passim.

18 Roger Wallace was an illegitimate son of the Marchioness of Hertford. He inherited his fortune, including the paintings and other art objects which later became the Wallace Collection in London, from a cousin, Richard Seymour, half brother of Lord Henry Seymour, founder of the French Jockey Club and also an illegitimate son of the Marchioness. Wallace wanted to leave the paintings to France, but was prevented by the provisions of Seymour's will. See Starkie, *Petrus Borel the Lycanthrope*, p 75.

19 Steven Watson, *Strange Bedfellows: The First American Avant Garde* (New York: Abbeville Press, 1994), p 137. Mabel Dodge hated both the Harlem dancers and peyote.

20 Hapgood, *A Victorian in the Modern World*, p 349.

21 D.H.Lawrence, *Women in Love* (Harmondsworth: Penguin, 1982), p 147. (orig publ 1920)

22 Miranda Seymour, *Ottoline Morell: Life on the Grand Scale* (London: Hodder and Stoughton, 1992), p 173.

23 Juliette Huxley, *Leaves of the Tulip Tree* (London: John Murray, 1986), pp 37, 39.

24 In fact, the Morells did have money troubles, and were less well off than many of their friends.

25 Moraes, *Henrietta*, p 28.

26 Ibid., pp 58, 60.

27 Farson, *The Gilded Gutter Life of Francis Bacon*, p 56.

28 See Andrea Weiss, *Paris was a Woman* (London: Pandora, 1996), p 38.

29 Anderson, *My Thirty Years War*, p 91.

30 Watson, *Strange Bedfellows*, p 382n.

31 Anderson, *My Thirty Years War*, p 154.

32 Watson, *Strange Bedfellows*, p 338.

33 See Michael Baker, *Our Three Selves: A Life of Radclyffe Hall* (London: Gay Men's Press, 1985), chapter 21. Edy Craig appears as a fictionalized character in Virginia Woolf's last novel, *Between the Acts*.

34 See John Tytell, *The Living Theatre: Art, Exile and Outrage* (London: Methuen, 1997).

35 Ibid., pp 346-7.

36 However, a June 1999 survey of fathers undertaken by BBC's *Newsnight* revealed that 45 per cent of their sample preferred the 'male breadwinner, female home-maker' pattern of family life, other things being equal, i.e. they would have preferred their wives not to be in employment.

37 Joanna Briscoe, 'Alexandra Pringle', *Evening Standard*, London, ES Magazine, 30 July 1999, p 16.

38 Jane Mulvagh, *Vivienne Westwood: An Unfashionable Life* (London: HarperCollins, 1999), p 86.

39 Ibid., p 312.

40 Ibid., pp 254-5.

CHAPTER NINE

OUTSIDERS IN OUTSIDERLAND

There is a zone of non being, an extraordinary sterile and arid region, an utterly naked declivity where an authentic upheaval can be born. In most cases the black man lacks the advantage of being able to accomplish this descent into a real hell.

Frantz Fanon: Black Skin White Masks

After Rimbaud died, Verlaine described his long lost friend as 'the white Negro, the splendidly civilized, carelessly civilizing savage'.[1] Sixty years later Norman Mailer returned to the theme. Baudelaire had identified with the rag-pickers, the outcasts of his time; now Mailer wanted to identify with the most oppressed group in Eisenhower's America: 'There was a new breed of adventurers, urban adventurers who drifted out at night looking for action with a black man's code to fit their facts. The hipster had absorbed the existentialist synopses of the Negro, and ... could be considered a white Negro.'[2] Mailer recognized that the life of an African-American man was a dangerous one – 'any Negro who wishes to live must live with danger from his first day' – but in romanticizing what he perceived as the method American blacks had chosen for survival, he fell into cliché and stereotype. It was *because* of constant danger that the Negro had remained alive: 'knowing in the cells of his existence that life was war, nothing but war, the Negro ... could rarely afford the sophisticated inhibitions of civilization, and so he kept for his survival the art of the primitive'. The black man 'lived in the enormous present, he subsisted for his Saturday night kicks, relinquishing the pleasures of the mind for the more obligatory pleasures of the body, and in his music he gave voice to the character and quality of his existence, to his rage and the infinite variations of joy, lust ... and despair of his orgasm. For jazz is orgasm, it is the music of orgasm ... and so it spoke across a nation

... it spoke in no matter what laundered popular way of instantaneous existential states to which some whites could respond.'[3]

In this sense, Neal Cassady was a 'white negro', but if Bohemia, bourgeois society's Other, had its own 'white negroes,' then the role of the non-white and non-Western, both individuals and cultures, was positioned as 'Other' to Bohemia. Bohemia was a Western phenomenon that lived off its critique of Western society. It was therefore not surprising if in their search for an escape from industrial civilization, bohemians turned a romantic eye on distant cultures, and searched for a spontaneity and authenticity in simpler societies which, they felt, no longer existed in their own. Byron loved Greece, a land in which he could be himself, fulfilling the homosexual side of his nature in a manner impossible in Regency London. Later bohemian travels, likewise, were often predicated on the belief that in Spain, Egypt or Tahiti would be found a sexuality untouched by bourgeois morality and the effete and debilitating decadence of Western civilization.

In 1850, for example, Flaubert set off for Egypt with his friend Maxime du Camp in the hope of exotic sexual adventures. During his visit he spent the night with the famous courtesan, Kuchuk Hanem. He may also, or may not, have had sex with men.[4]

In France itself there were the gypsies, after whom the bohemians were named. The gypsies were a visible Other, whether wandering through the provinces or subsisting in the shanty towns of Batignolles and Belleville on the outskirts of Paris. Persecuted and harried by the police and the law, they survived heroically. They provided artists with real-life models and with a subject that became blurred with the self-referential vision of the artist as outcast. Bohemians could subjectively identify with these 'real bohemians,' while manipulating them as subject matter for paintings and *feuilletons* that appealed to a bourgeois audience. This leads the art historian, Marilyn Brown, to dismiss the 'bohemian myth' as wholly inauthentic and indeed exploitative.[5] Although, however, such a view is convincing at one level, it projects a late-twentieth-century set of political pieties back on to a very different society, in which those who desired to escape Western civilization did not yet understand how exploitative this might be.

When Gautier and Alexandre Dumas travelled through Spain in the 1840s they often wore gypsy costumes as if to make the willed identification more real, and a longing for escape into the exotic became a reality for many (male) writers. Gérard de Nerval, for example, made many journeys abroad in search of adventure and material for his writing. Petrus Borel's involuntary exile to Algeria had been a kind of death, but Flaubert travelled to Egypt out of desire for a 'visionary alternative,' for mystery, for colour 'in contrast to the greyish tonality of the French provincial landscape'.[6] Yet when he actually arrived in North Africa he was impressed by its 'decrepitude and senescence' and the Orient he created in his writings, both in informal letters and in his fiction, was a 'laboured reconstruction', an orientalist Western stereotype of colourful exoticism.[7] Nevertheless, he felt that the

'decrepitude and senescence' resided also in Europe, which had lost its spontaneity and virility.

Baudelaire's hatred for the bourgeoisie similarly expressed itself in an idealization of non-industrial societies:

Theory of true civilization.
It does not reside in gas, steam or table-turning ...
Nomadic and pastoral peoples, hunters, farmers and even cannibals – *all* these may be superior, by reason of their energy and their personal dignity, to our Western races.[8]

Today this sounds insufferably patronizing, since 'dignity' had become a euphemism for underdevelopment, lack of sophistication and ersatz local colour manufactured for tourists.

Although the association of the Orient with sexual promise and threat, with virility and fecundity, was persistent and in no way confined to self-proclaimed bohemians or indeed artists in general, its bohemian moment distilled and combined the dreams of escape through travel and the erotic combined. For many bohemians this double escape was intended as part of a radical strategy to defy and subvert bourgeois society, but today it is difficult not to see this element of bohemianism as an inverted imperialism. Even in the 1840s it also appeared inseparable from the kind of consumerism that conceals exploitation by means of an apparently flattering imitation. Gautier, for example, was well aware of the way in which the culture of a conquered nation could become a fashionable imperialist gloss:

We believe we have conquered Algeria, and Algeria has conquered us. Our women already wear scarves ... which have served the harem slaves, our young men are adapting the camelhair burnous. The tarbouch has replaced the classic cashmere skull cap, everyone is smoking a nargileh, hashish is taking the place of champagne ... [we] have adopted all the Oriental habits, so superior is primitive life to our so-called civilization. If this goes on, France will soon be Mahometan and we shall see the white domes of mosques ... on our horizons and minarets mingling with steeples.[9]

Gautier added that he would welcome such an invasion, but the frivolous tone, even for a newspaper column, reduces Arab culture to its superficial aspects and the idea of mosques in Paris to a joke.

On the other hand bohemian Paris provided a haven of sorts for non-white artists. Gautier befriended the black singer Maria Martinez, known as 'la Malibran noire,' but when she kissed Ernesta Grisi the latter recoiled, and spoke of her afterwards in the most racist terms (perhaps also jealous of her as a rival artist). Gautier nonetheless continued to do his best to protect the entertainer throughout her fitful and fluctuating career, and even wrote an operetta for her: 'the Negress and the Pasha'.[10]

Baudelaire's mistress, Jeanne Duval, was of mixed race, and one of the poet's closest friends was Alexandre Privat d'Anglemont. A leading Latin Quarter figure in the 1830s, he was of Creole descent, tall, with reddish, frizzy hair, lively grey eyes and a face covered in freckles. He claimed that he was the natural son of an aristocrat and a woman of mixed race – although his friend Théodore de Banville claimed that he was always making up different stories about his past. Dressed in clothes tailored in the English fashion, he cut a striking figure, having, one onlooker decided, 'the air of an American plantation owner'.[11] His family did own a sugar plantation, and sent him a regular remittance on which he eked out a nomadic, hand-to-mouth existence. With no settled abode, he camped out in various cafés or in the Hotel Corneille, a 'tower of Babel of students from all countries and speaking all languages';[12] but he claimed the whole of Paris for his home, having, he said, pitched his tent forever on the banks of the Seine. Forced to return home to Guadeloupe on one occasion to sign some family papers, a journey that took several weeks, he stayed on the island for just twenty-four hours before re-embarking for the city he regarded as his spiritual home.

One reason for Privat's love of Paris was its ethnic diversity – the whole world in one city. Its Arab and African cafés and music were to be discovered for popular culture in the 1920s, but at the turn of the century it was non-Western art that took the avant-garde by storm. The brother of Picasso's friend, the homosexual poet Max Jacob, was an explorer. When he brought home a portrait of himself from one of his trips, painted by an artist in Dakkar, what interested the Picasso circle was the way in which the gold buttons on the explorer's coat were represented not in their proper place, but as a halo round his head: by abandoning realism, the painter had made an obscure but vivid point.

Maurice de Vlaminck was one of the earliest members of the Paris avant-garde to become interested in African art, collecting African artworks from 1904 onwards.[13] According to Francis Carco, Vlaminck's interest was first aroused when he discovered an African statue in some dingy bistro, and showed it to André Derain, proclaiming that it was almost as beautiful as the Venus de Milo. Derain replied that it was just as beautiful, and when they sought Picasso's opinion he topped them both by pronouncing it *more* beautiful than the famous Greek statue.[14]

Derain took Picasso to the Ethnographic Museum at the Trocadéro (the Musée de l'Homme), and Picasso afterwards described the significance of the experience to him:

It was very important: something was happening to me ... They were magic things ... *intercesseurs*, mediators ... they were against everything – against unknown, threatening spirits ... I understand; I too am against everything ... I understood what the Negroes used their sculpture for ... To help people avoid coming under the influence of spirits again, to help them become independent. Spirits, the unconscious (people still weren't

talking about that very much), emotion – they're all the same thing. I understood why I was a painter. All alone in that awful museum ... *Les Demoiselles d'Avignon* must have come to me that very day ... it was my first exorcism painting.[15]

The cult of African primitivism and African art spread from Picasso's circle throughout the avant-garde. Guillaume Appollinaire, poet, critic and pornographer, became a connoisseur; in 1911 Raymond Roussel's *Impressions of Africa* was performed and in the following year the art gallery-owner Paul Guillaume held an exhibition of African artworks. For some the anti-realism of this art unwittingly prefigured modernism, the implication being that since the prefiguration was unconscious, it was for Western artists to discover and interpret it; in other words, Western artists appropriated it. Rather than existing in its own right, it was seen as a source of regeneration for Western culture.

The Dada movement went even further. Dada was the brainchild of Hugo Ball, who had trained at the Max Reinhardt theatre school in Munich, and embarked on a career as a director, collaborating with Kandinsky, whose extraordinary plays, *Black and White, Violet, Blue Note* and *Yellow Sound*, he admired.[16] In 1913 he met Emmy Hennings, an adventurous Danish woman who had wandered through Europe appearing in night-clubs, had been married and separated, had an affair with Erich Mühsam, and claimed to have been imprisoned on account of her political activities. After the outbreak of the First World War the couple moved from Munich to Berlin, but there Emmy came under suspicion of involvement in assisting draft evaders and participating in an anti-war demonstration.[17]

Like many other pacifists and opponents of the War, the couple fled to Zurich. On their arrival they were destitute, reduced to sleeping rough and scavenging for food, but eventually Ball found work playing for a vaudeville troupe,[18] while Emmy Hennings sang at a low night-spot in the red-light district.[19] Early in 1916 Ball persuaded the owner of the café at 1 Spiegelgasse to allow them to open a cabaret, and with a group of friends they organized nightly entertainments at what became the Café Voltaire. Among their fellow performers were Richard Huelsenbeck, Hans Arp, sculptor and poet, Arp's wife, Sophie Tauber, who was a dancer, the painter Ernst Janco, and Tristan Tzara. They cited Rimbaud and Oscar Wilde among their influences and their performances ranged from recitations of Turgenev and Chekov, and recitals of Liszt and popular songs such as 'Under the Bridges of Paris', to experimental works which attacked the fundamental assumptions of Western art, challenged the philosophical assumptions of humanism and acted out the idea that we live in a chaotic universe.[20] For Hans Arp, for example, Reason was not the culmination, but the nemesis of Western civilization: 'The Renaissance taught men the hubristic exaltation of their Reason. The new times with their sciences and their techniques have dedicated them to megalomania. The confusion of our epoch is the result of this

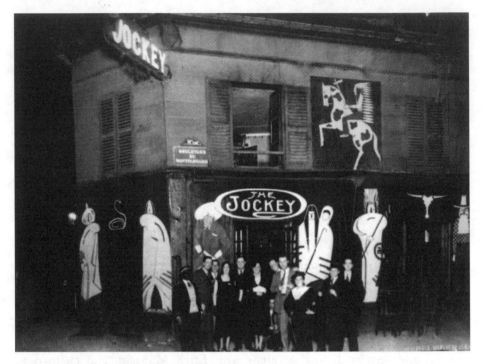

Figure 22 The Jockey Club, Paris, in the late 1920s

over-estimation of Reason.'[21] His poetry broke up language and used 'nonsense' as a deliberate strategy, an assault on rationality and logic. With Tristan Tzara and Walter Serner, an eccentric doctor who gravitated to the Zurich dadaist after evading the draft in Berlin, he invented the 'anonymous society for the exploitation of the Dadaist vocabulary'. They collectively composed illogical 'simultaneous poems' and *chants nègres*. Ball described these poems as 'a contrapuntal recitative in which three or more voices speak, sing, whistle, etc at the same time in such a way that the elegiac, humorous or bizarre content of the piece is brought out.' Their aim was 'to elucidate the fact that man is caught up in the mechanistic process ... [and] shows the conflict of the human voice with a world that threatens, ensnares and destroys it, a world whose rhythm and noise are ineluctable.'[22] 'Chant Nègre I' was performed 'in black cowls and with big and small exotic drums.'

These performances constituted a wholesale attack on Western reason and civilization, which the Dada group felt had led to the utter barbarity of the war from which they had sought refuge in neutral Zurich. Hugo Ball, at least, was aware of the dangers of a superficial appropriation of non-Western art, as he wrote in his diary: 'From the Negroes ... we take only the magical-liturgical bits, and only the antithesis makes them interesting [to us]. We drape ourselves like medicine men in their insignia and their essences but we want to ignore the path whereby they reached these bits of cult and parade.'[23]

While African sculpture was of interest largely to an avant-garde minority, who had seen it as representative of the primitive and magical, there developed in the 1920s a cult of the Afro-American in popular entertainment as jazz swept the Western world. Now it was the black American as representative of urban popular modernity and hedonism who fascinated a wider audience. In a desire to express their disillusionment and disorientation in the wake of the war, a whole new Western generation threw off the restraints of their culture, and for them, as for Norman Mailer in the 1950s, black dancers and musicians represented an unrestrained and openly sexual side of life. Paris and Harlem were the main centres of this cult of 'negrophilia.'[24] Montparnasse was now an international centre, and indeed the whole of Paris, wrote Klaus Mann, 'was swarming with foreigners of all races, colours and social backgrounds'. Art and pleasure venues were 'jammed with the motley crowd from Tokyo and Birmingham, Detroit and Tunisia, Rio de Janeiro and Hamburg, Shanghai, Stockholm and Kansas City. It was a veritable invasion ... of pleasure-seeking Babbits, frustrated painters, stingy professors, flippant journalists, ladies of the monde or demimonde, drunkards, scholars, art collectors, dressmakers, loafers, philosophers, criminals, millionaires, celebrities and nobodies.'[25]

In 1921 the Café Caméleon was opened in Montparnasse as a cheap restaurant and venue for literary and musical evenings – an 'open university' – but after only two years was revamped as Le Jockey and became a fashionable night-club, presided over by Kiki, the singing star. Night-clubs, the most famous of which was the Boeuf sur le Toit, were all the rage, and popularized jazz and 'negro' culture.

In 1926 the Surrealist artists Robert Desnos and André de la Rivière moved into studios in the rue Blomet, next door to the Bal Nègre, a bar frequented by immigrant workers who lived in a hostel in the same street. Riveted by the jazz clarinettist who played there, the Surrealists colonized the place, driving away its erstwhile clientele. Ada Smith, an Irish African-American, opened another night-club, Bricktop, named after Ada herself, whose short hair was dyed bright orange, and in 1927 the Jungle opened in Montparnasse. Louis Aragon hated its gloomy, vaguely exotic setting, while the barman Jimmy Charters described it as a 'madhouse' where money was made hand over fist by serving 'inferior drinks at fancy prices'.[26]

As the rhythm of jazz filled the bars and night-clubs, modernist composers such as Poulenc, Auric and Eric Satie came under its influence.[27] In 1924 the Rolf de Maré's *Ballets Suèdois* staged *La Création du Monde*, based on Blaise Cendrars' *Negro Anthology*. This was a success, but the following year Erik Satie's jazz-influenced ballet flopped. Rolf de Maré closed the company, but still had the lease of the Théatre des Champs Elysées, so to fill the gap he brought over the American revue, *The Blackbirds*, in 1926. They were followed by Josephine Baker's *Bal Nègre* in 1927.

Josephine Baker became one of the biggest international stars of the period, her act presenting black female eroticism as the audience wished to

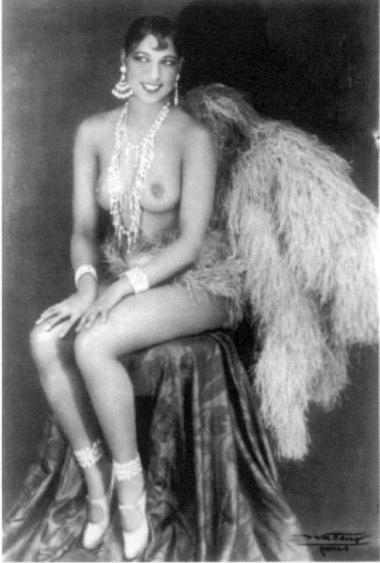

Figure 23 Josephine Baker, in dancing costume

see it. She danced almost naked, one notorious costume consisting simply of a string of bananas round her waist (suggestive of the jungle as well as the male genital). By some, she was seen as a reincarnation of 'the black Venus [Jeanne Duval] who had haunted Baudelaire',[28] but more usually her dancing was described as animal in its intensity, and the dancer herself was usually described in terms that suggested an exotic and alien species. Count Harry

Kessler, the urbane and liberal German diarist, for example, encountered her at a private party given by Max Reinhardt in Berlin: 'The Landshoff girl dressed as a boy in a dinner jacket and she and Josephine Baker ended up lying in each other's arms like a pair of lovers, between us males who stood around.' Baker was 'bewitching ... but almost quite unerotic. Watching her inspires as little sexual excitement as does the sight of a beautiful beast of prey.'[29]

According to some accounts Josephine Baker played up to the 'jungle' image expected of her, but it was a question of survival. As a black music critic pointed out, '"the big names among Negro performers are only those who have appealed to the whimsicalities of the white race and conformed to their idea of what a Negro should be."'[30] But when Baker commented ironically: 'People have done me the honour of believing I'm an animal ... I love the animals, they are the sincerest of creatures'[31] she was subtly turning the stereotype against those who used it.

Kessler's comments on the review in which Baker starred in Berlin summed up the ambivalence of the encounter between the races in the mass culture of the time: 'All these shows are a mixture of jungle and skyscraper elements. The same holds good for the tone and rhythm of their music, jazz. Ultramodern and ultraprimitive. The extremes they bridge render their style compulsive ... In comparison, our own products hang like a limp bow string, lacking inner tension and therefore style.'[32]

Some commentators were openly racist. One French critic denounced the Blackbirds as a 'lamentable exhibition' which 'brings us back to the monkey much quicker than we descended from the monkey ... We are asked to celebrate the cult of ugliness, the reign of disequilibrium, the apotheosis of discordance.' Another complained that 'the troop of negresses with their puerile mimicry, their sad frenzy, their meaningless cries, had not even the excuse of voluptuousness or exotic charm ... It is not primitive humanity that is shown, but degenerate humanity. The dancers are not simple savages in a virgin forest, but folk of the cities.'[33]

More often, envy and objectification were mixed with genuine appreciation in an uneasy cocktail, the uneasiness in part due simply to the novelty, for Europeans, of the very presence of black men and women. Both class and inter-racial proximity were still considered shocking. It simply was 'not done' to mix even socially with musicians and boxers, and especially not when they were black. There was consternation, for example, in the British press over a 'bright young things' swimming party at St George's Baths in London, because a Negro band had played in the presence of young white women wearing bathing costumes, and thus there had been the appalling spectacle of black men looking at the semi-clad bodies of white debutantes.[34] For a white woman actually to take a black lover, as the upper-class bohemian Nancy Cunard did, was to move completely beyond the pale.

Bohemia was, as it had been in the nineteenth century, more tolerant than the rest of society, and if bohemians valued ethnic difference in part because

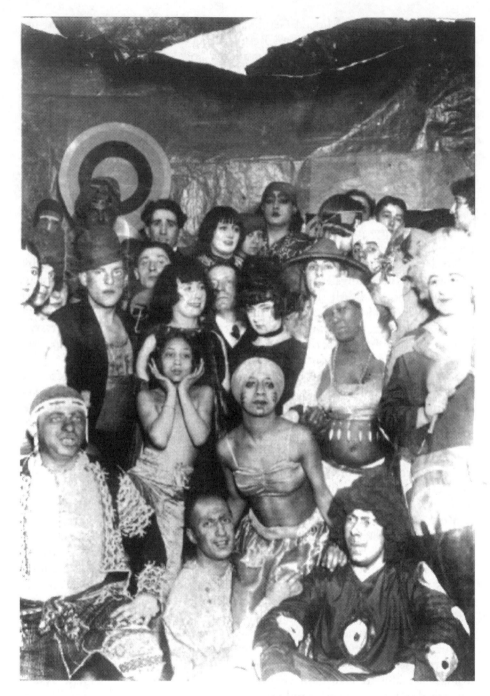

Figure 24 The Paris model, Aicha, seated (in turban) with friends at a fancy dress ball

they found it exotic, that was at least better than total exclusion. Non-whites therefore gravitated to this marginal and transgressive subculture (as it was at least to begin with) in search of recognition. The artists' model Aicha, for example, was a star of Montparnasse, discovered as a circus rider by Pascin, and thereafter modelling for him and his fellow painters. She appeared as a semi-nude Hamlet in a series of music-hall performances, and felt she had paved the way for Josephine Baker.[35] Her birthday banquet in 1929 was a major event of the bohemian calendar of that year.

Afro-American musicians and performers were drawn to Paris by the prospect of success in a society that was at least less segregated than the United States. Henry Crowder, who became Nancy Cunard's lover, was one of these. He soon found work as a pianist in a band, and while the group was playing in Venice he met Nancy Cunard, who had just ended her love affair with Louis Aragon.

Nancy Cunard personified the mood of the hedonistic and iconoclastic twenties. Like Augustus John, she was famous for *being* bohemian, and was portrayed in several novels of the period.[36] She was the daughter of the shipping magnate, and her mother Lady Emerald Cunard was a successful London salon hostess. Nancy never got on with her mother, and had been a rebel from the moment when in 1914 she daringly lit a cigarette in the Café Royal – respectable women did not then smoke in public – and announced: 'My mother is having an affair ... and I can do as I like.' With her fashionably boyish good looks she almost amounted to a work of art in her own right. Louis Aragon shared with her his love of African art and, photographed by Cecil Beaton, she looked as angular as a piece of Nigerian sculpture with her Eton crop and armfuls of heavy African bracelets. A lifelong rebel, she has been criticized for her 'pseudo-exotic personality'[37] – her raffish ways, her showing off, her wayward sexuality and high-handed upperclass manners. But she took a serious interest in the arts and founded her own press (she claimed to have discovered Samuel Beckett). Her relationship with Crowder was at one level another way of annoying her mother, and London society was certainly horrified. (Indeed, over thirty years later a fellow undergraduate who was related to one of Nancy's lovers cited her to the present author as the classic example of the road to perdition: 'drink, drugs and black men.')

She has also been criticized for the exploitative aspects of her relationship with Crowder. One friend described how Nancy would urge her lover to act more like an African, to be more primitive, to which Crowder would reply, 'but I ain't African. I'm American.'[38] With Crowder, however, she not only gained access to the still in many ways separate world of black Paris, a creative demi-monde of entertainers and boxers, but developed a serious interest in the situation of the Afro-American people in general. This led to the publication in 1934 of the anthology *Negro*, which she both edited and printed. A huge tome with an eclectic mixture of material – from photos of African sculpture to an article on colonialism by Jomo Kenyatta, from

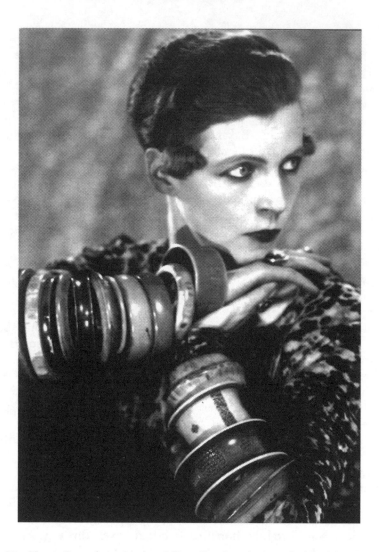

Figure 25 Nancy Cunard wearing her African bangles, photographed by Man Ray

speeches by black American communists to poetry by Langston Hughes – it
offended as many as it pleased, but she was very proud of it. The project
drew her away from the *bohème d'orée* and into the orbit of left-wing politics.
In London she was close to Edgell Rickword, who joined the Communist
Party in 1934, and she was active in the campaign to free the Scotsboro Boys
(nine black Alabama youths accused of raping a white woman). She also
visited Harlem in 1931 and 1932, rather insensitively assuming they would
welcome her and her desire to better their lot.

During its 'Renaissance' in the 1920s, which ended with the 1929 crash,
Harlem had been a unique cultural centre. It had seen a literary flowering with

the works of such writers as Langston Hughes, Zora Neal Hurston, Wallace Thurman and Bruce Nugent. It had also been a political centre – Marcus Garvey's black nationalist movement and W.E.B. Dubois' National Association for the Advancement of Coloured People had their headquarters there. Above all it was an entertainment centre. During prohibition whites flocked to the glamorous Harlem night-clubs where they could sample bootleg booze and the sophisticated floorshows. At the Cotton Club and the Everglades the performers were black, the audience exclusively white, but more adventurous 'tourists' could mingle with Harlem residents on their own ground, in smaller cabarets and 'rent parties' (where guests paid to get in). Because the authorities turned a blind eye to 'vice' rackets throughout the twenties, Harlem also became a Mecca for those in search of sexual adventure, for beyond the voyeurism of white men and women watching black dancers was the possibility of trans-racial encounters, the great American taboo.

An added cross-current was the extensive lesbian and gay culture of black Harlem. Drag queens, 'bulldykes' and 'pansies' created an alternative world for themselves within entertainment culture. Blues lyrics contained open references to same-sex love and many black entertainers were gay or bisexual, although they were seldom open about it. Gladys Bentley was the nearest to being 'out,' famous for her costume of dinner jacket and top hat and her string of girlfriends, while in 'Prove it on me Blues' Ma Rainey sang directly of lesbianism. Huge costume balls offered opportunities for spectacular drag and there were speakeasies and bars at every level designed for a gay clientele. The literary renaissance was equally suffused with a gay sensibility: Nugent, Thurman and possibly Hughes were gay.[39]

In the 1930s the Depression eliminated many of the night-spots and tea-rooms in both Harlem and Greenwich Village, but this more political decade brought about a revival of the former radicalism of the Village. It was on Sheridan Square that the 'first politically oriented night-club in New York City'[40] was opened, Barney Josephson's Café Society, which was also the first racially integrated club in the city, as well as being a rendezvous for Popular Front artists. Benny Goodman, who led the first well-known racially integrated band, was one of its backers, and Josephson prohibited performers from indulging in 'minstrel,' 'southern' or 'jungle' themes. It was here that Billy Holliday first sang 'Strange Fruit,' the subject of which was a lynching.

During the post–1945 McCarthy period Café Society was closed down. Josephson and Benny Goodman were interrogated by the House un-American Activities Committee. Habitués Zero Mostel and Paul Robeson were black-listed. The witch-hunting atmosphere in the United States was so oppressive that some of the best known black American artists left for the more tolerant atmosphere of Paris. The novelist, Richard Wright, for example, had been investigated by McCarthy for suspected communist affiliations, and he and his white wife found it virtually impossible to rent an apartment in New York. Chester Himes, James Baldwin and Sidney Bechet were among those

who followed Wright to France, where they mingled with Beats and Existenti-
alists in left-wing cafés and jazz dives.

Greenwich Village in the 1950s nevertheless remained true to its radical
tradition, and was one of the few places in America in which trans-racial
couples could then exist. Even there, ugly incidents occurred from time to
time, and Hettie Jones reckoned that she and her partner Le Roi Jones were
one of only about half a dozen such couples.[41] A kind of naivety, which
Hettie Jones shared to begin with, meant that the decent thing, the progres-
sive, the liberal attitude was to disregard the difference. A sexual relationship
was personal and private, the two partners individuals first and foremost, not
cardboard cut-out representatives of their respective races. In an ideal world
individuals *should* be united by their common humanity, not divided by race
prejudice, so radicals tried to act as though that world already existed. It was
also one reaction, Le Roi Jones felt, of a generation of black intellectuals,
who, 'seeing segregation and discrimination as the worst enemy, sought a
more open contact with the world'.[42]

However it was gradually borne in on Hettie Jones that despite their best
efforts she and Le Roi Jones were haunted by the stereotypes of white lady
and black stud. With children of mixed race, she found herself at the wrong
end of racist taunts and innuendoes she had never experienced as a young
Jewish woman. The couple was further bedevilled by the heterosexual uncer-
tainty of the time, when men saw no reason to alter their domestic arrange-
ments, but women wanted something different. Once they had children the
pattern was set: he was making his name, but no money, as a Beat playwright,
so she had to go to work to support them, leaving no time for *her* writing.
John Clellon Holmes, who wrote an early Beat novel, *Go*, described a similar
situation; it was simply taken for granted that girlfriends and wives would do
secretarial or other work to support those geniuses, their men.

In the 1960s the Civil Rights Movement caused many blacks, including Le
Roi Jones, radically to reassess their relationship to the white world. The
inter-racial couple was now no longer a manifestation of progressive toler-
ance, but a damning instance of reformist liberalism, and of an assimila-
tionist agenda blown apart by the violence meted out to peaceful protesters
and by the assassinations of Martin Luther King and three civil rights
workers in Mississippi. In 1965 Le Roi Jones came under the influence of the
Black Muslims, changed his name to Amiri Baraka and moved to Harlem.
There he led the Black Arts Theatre, from which whites were barred. In the
seventies his experience of the sectarianism of various black groups led him
towards Marxism-Leninism.

In retrospect, Amiri Baraka rejected bohemianism of every kind, including
'black bohemianism' – the adoption of 'weird' clothes or 'African' hairstyles.
He felt that the Village life of the 1950s had been little more than a 'deadly
hedonism,' that he and his friends had lived by the pleasure principle, and
that this had cut them off from ordinary people. Yet the flourishing experi-
mental culture of the Village in the late 1950s and early sixties had opened

up a space for black artists, even if their agenda was different from that of their white colleagues. For the white avant-garde, black culture offered a radically different creativity and an indispensable revitalization. The Afro-American search, however, was for a distinctive African-American art and voice.[43] Yet for members of ethnic minorities, as for women and gays, Bohemia offered a space, however marginal, in which those excluded from mainstream society could breathe a different air. It was a stage on which the demand for change could be made, and a launching pad for radical movements. At a period when Bohemia was an umbrella sheltering all the rejected and persecuted, it displayed some elements of that 'hybridity' which cultural radicals celebrate today.

Notes

1 Quoted in Campbell, *This is the Beat Generation*, p 1.
2 Norman Mailer, 'The White Negro: Superficial Reflections on the Hipster', in Norman Mailer, *Advertisements for Myself* (London: Panther, 1968), p 273.
3 Ibid.
4 Francine du Plessix Gray points out that 'opinions ... vary wildly among Flaubertists ... Jean-Paul Sartre wonders whether Flaubert truly "consummated" anything ... with ... the males mentioned in [his] ... letters. He does not believe any of [his] homosexual banter is for real'. Gray, Francine Du Plessix, *Rage and Fire*, p 191. And cf Jean-Paul Sartre, *L'Idiot de la Famille* (Paris: Gallimard, 1971).
5 Brown, *Gypsies and Other Bohemians*, chapter 1.
6 Harry Levin, *The Gates of Horn: A Study of Five French Realists* (New York: Oxford University Press, 1963), p 285.
7 Edward Said, *Orientalism* (Harmondsworth: Penguin, 1985), pp 185–7.
8 Charles Baudelaire, 'Mon Coeur Mis à Nu,' in Charles Baudelaire, *Fusées: Mon Coeur Mis à Nu: La Belgique Déshabillée* (Paris: Gallimard, 1975), p 111.
9 Joanna Richardson, *Théophile Gautier: His Life and Times* (London: Max Reinhardt, 1958), p 76, quoting Théophile Gautier in *La Presse*, 6 January 1845.
10 Judith Gautier, *Le Collier des Jours*, 1907, p 176.
11 Victor Cochinat, 'Obituary', in Privat d'Anglemont, *Paris Inconnu*, p 18.
12 Ibid.
13 John Richardson, *A Life of Picasso*, Vol II, p 26.
14 Francis Carco, *From Montmartre to the Latin Quarter*, p 42.
15 Richardson, *A Life of Picasso*, Vol II, p 24, quoting André Malraux, *Picasso's Mask*, trans June Guicharnaud with Jacques Guicharnaud (orig publ as *La Tête d'Obsidienne*, Paris: Gallimard, 1974; New York: Da Capo Press, 1994), p 11. Richardson charts the way in which Picasso changed his story later, when he wished to deny that the African sculptures had influenced *les Demoiselles d'Avignon*.
16 These plays used 'nonsense' language and non-musical sound to create their effects, together with visual displays, some of which could not be produced at the time, but have since been made possible with the use of laser beams.
17 Sabine Werner Birkenbach, 'Emmy Hennings: A Woman Writer of Prison Literature', in Brian Keith Smith (ed), *German Women Writers 1900-1933* (Lampeter: Edwin Mallen Press, 1993), pp 171–2. Birkenbach points out that it is impossible

to deduce all the facts from the writings of Hennings, since she repeatedly changed her story.

18 Hugo Ball, *Flight out of Time: A Dada Diary*, trans Ann Raines (orig publ 1946; New York, Viking, 1974), pp xviii-xvix.

19 Christian Schad, 'Zurich/Geneva: Dada', in Raabe (ed), *The Era of German Expressionism*, p 165.

20 Richard Sheppard, 'Introduction' in Richard Sheppard (ed), *New Studies in Dada: Essays and Documents* (Hutton, Duffield, Yorkshire: Hutton Press, 1981), p 11. See also Timothy Benson, *Raoul Hausmann and Berlin Dada* (Ann Arbor: University of Michigan Research Press, 1987).

21 Rudolf Kuenzli, 'Hans Arp's Poetics: The Sense of Dada "Nonsense" ', [in Sheppard., p 47], quoting Hans Arp, 'Dadaland', in Hans Arp, *On My Way* (1948).

22 Ball, *Flight out of Time*.

23 Ibid.

24 Petrine Archer-Straw, 'Negrophilia: Paris in the 1920s: A Study of the Artistic Interest in and Appropriation of Negro Cultural Forms in Paris during the Period,' unpublished Ph.D dissertation, Courtauld Institute of Art, University of London, 1994.

25 Klaus Mann, *The Turning Point*, p 119

26 Jimmy Charters, *This Must be the Place: Memoirs of Montparnasse* (London: Herbert Joseph, 1934), p 67.

27 Archer-Straw, 'Negrophilia: Paris in the 1920s', p 127.

28 Ibid., p 180.

29 Harry Kessler, *The Diaries of a Cosmopolitan: Count Harry Kessler, 1918-1937* (London: Weidenfeld and Nicolson, 1971), p 280.

30 Anne Chisholm, *Nancy Cunard* (Harmondsworth: Penguin, 1981), p 287.

31 Quoted in Ann Douglas, *Terrible Honesty: Mongrel Manhattan in the 1920s* (London: Picador, 1996), p 52.

32 Kessler, *The Diaries of a Cosmopolitan*, p 282.

33 Sisley Huddlestone, *Paris Salons, Cafés and Studios: Being Social Artistic and Literary Memories* (New York: Blue Ribbon Books, 1928), p 36. Huddlestone belonged to a British fascist organization after the Second World War.

34 Robert Graves and Alan Hodge, *The Long Weekend: The Living Story of the Twenties and Thirties* (orig publ 1940; Harmondsworth: Penguin, 1971), p 118.

35 Douglas Goldring, *The 1920s: A General Survey and Some Personal Memories* (London: Nicolson & Watson, 1945).

36 For example in Michael Arlen's *The Green Hat* and *Point Counter Point* by Aldous Huxley.

37 Archer-Straw, 'Negrophilia: Paris in the 1920s', p 51.

38 Chisholm, *Nancy Cunard*, p 186, quoting Harold Acton. Anne Chisholm analyses the relationship at length, pointing out that the exploitation was not entirely one way. Crowder may have felt humiliated when Nancy was supporting him financially, but both acquiesced in the situation, and she was deeply committed to him, regarding their affair as the most important relationship in her life.

39 See George Chauncey, *Gay New York: Gender, Urban Culture and the Making of the Gay Male World, 1890-1940* (New York: Basic Books, 1994), chapter 9; and Ann Douglas, *Terrible Honesty*, pp 96-8.

40 Erenberg, 'Greenwich Village Nightlife', in Beard and Berlowitz (eds), p 360.

41 Hettie Jones, *How I Became Hettie Jones* (New York: Penguin, 1984).

42 Amiri Baraka, *The Autobiography of Le Roi Jones* (New York: Freundlich Books, 1984), p 129.
43 See Sally Baines, *Greenwich Village 1963: Avant Garde Performance and the Effervescent Body* (Durham, NC: Duke University Press, 1993), chapter 5.

PART TWO
BOHEMIAN THEMES

CHAPTER 10

THE HEROISM OF EVERYDAY LIFE

The aristocratic habit is one that mobilizes all the minor activities of life which fall outside the serious specialities of other classes and injects into these activities an expression of character and power.
Erving Goffman: The Presentation of Self in Everyday Life

For maximum effect upon their urban stage the bohemians needed a *mise en scène*, theatrical sets and costumes for the performance of revolt and identity. True, some bohemians were reduced to a state of poverty that could only with the greatest difficulty be recuperated for any notion of the picturesque. Henry Murger's garrets were furnished with nothing but a few sticks of furniture – provided the bailiffs had not seized them. At the end of her life Nina Hamnett lived in a room furnished only with a broken-down chair, a line of string on which she hung her clothes, and a bedstead covered with newspaper in lieu of a mattress.

Bare surroundings, however, did not always signify poverty. When Gérard de Nerval was living in the Hôtel de Pimodan on the Ile St Louis, his apartment had no study or dining room 'nor anything which was reminiscent of the compartmentalized arrangement of a bourgeois apartment. Cupboards built into the wall hid everything'[1] – minimalism *avant la lettre*. And for many, perhaps most bohemians, poverty was no bar to the expression of their creativity in their intimate surroundings.

Before the First World War, many Greenwich Village apartments were influenced by the art movements of the period. Floyd Dell's apartment in Greenwich Village had 'paintings by Nordfeldt, and Japanese prints on the walls; orange-yellow curtains at the windows ... brass candlesticks and candles to light our dinner table ... and in the large kitchen, gaily painted shelves, with an array of Chinese cups and saucers and plates, orange-red and

yellow'.[2] Margaret Anderson and Jane Heap also managed strikingly original effects in their New York home, although they had very little money: 'The woodwork was pale cream, the floor dark plum, the furniture old mahogany ... A large divan bed [was] hung from the ceiling by heavy black chains. It was covered with dull-toned blue and on it were four silk cushions – emerald green, magenta, royal purple, lime. Between the windows was a large reading table and yellow reading lamp.' A second room was decorated throughout in gold.[3]

Some bohemians gave their surroundings a symbolic meaning. The Schwabing apartment of the philosopher, Ludwig Derleth, containing pictures of Napoleon, Luther, Nietzsche, Alexander VI, Robespierre and Savonarola, was a secular shrine to the avant-garde beliefs of the period:

> One end narrows into an alcove lit more brightly than the rest and furnished half as a chapel, half as a cabinet – antique lamps, candelabra, bookshelves, a white covered table with a crucifix, seven-branched candlestick, goblet of red wine and piece of raisin cake on a plate. At the very front a low platform beneath an iron chandelier, on it a gilded plaster column. The capital of the column was covered with an altar cloth of blood red silk, and on this lay a thick folio manuscript – [Derleth's] proclamations.[4]

'It is all symbolic,' the philosopher's sister tells the visitors.

In the 1920s the Surrealists Yves Tanguy, Jacques Prévert and Marcel Duhamel turned their home into a Surrealist work of art. They had moved to the rue du Château in the dingy proletarian district near Montrouge and Vaugirard in Paris, for the very reason that its streets 'were dark and cramped, and ... contained a good number of dead ends, alleys and shady hotels ... a setting virtually designed for crime',[5] but once guests entered their magical house the dreariness of the surrounding streets was left behind. The main interest of these Surrealists at the time was film – Prévert later collaborated with Marcel Carné to create the ultimate bohemian film, *Les Enfants du Paradis* – and Tanguy, responsible for the interior decoration, transformed their home into a kind of film set, designed to 'surprise and disturb':

> The entrance door had the ambiguous character that such openings often assume in dreams, in which outside and inside get muddled up. After crossing the threshold the visitor confronted a stairway whose seven steps led up to another house. If he took another step, a trapeziform mirror, inspired by the décors of *Dr Caligari*, reflected his image from eight yards away. He then found himself in a sort of theatre yard furnished like a small garden.[6]

This fantasy courtyard, roofed with glass and thus both an interior and an exterior, was furnished with cane furniture, a tea trolley on wheels, black

leather mattresses and a long, wide curtain with cubist designs. The walls were covered with collages, Lurçat wallpapers and cinema posters (then highly unusual forms of decoration). The rooms were littered with strange Surrealist objects, often picked up in flea markets, such as a human head covered with fur, with glass eyes and a leather nose, and an 'arm of light' (a lamp in the shape of an arm) made of gilded bronze.

Interiors expressed both avant-garde aesthetic and individual personality and taste. In the 1940s, William Burroughs' hustler friend, Herbert Huncke, decorated the Lower East Side flat he shared with a friend in a manner he felt was appropriate for their drug-centred lifestyle. 'We had decided that we should really turn this place into a den, and make of it what we thought would be a good environment for getting high ... I must say it was pretty weird.'[7] The curtains, invariably drawn to shut out the daylight, were black and yellow, as were the walls, and the ceiling was Chinese red with a central medallion painted in all the colours of the spectrum.

Bohemian dress was equally fraught with meaning. It might express both the poverty and the artistry of the individual, suggesting a superior sensibility, it might be childish playacting, it might be symbolic, might be theatrical or deeply authentic. Writing of the clothes she wore when longing to become a beatnik in Greenwich Village in the fifties, Joyce Johnson wrote of the way in which certain key garments or accessories acted as badges, 'a sign of membership in the ranks of the unconventional. The way is smoothed for the wearer ... because the problem of outside matching inside is so beautifully resolved by this simple means'[8] – the inner identity must express itself in an outward and visible style.

Richard Sennett has suggested that in earlier times dress had signified straightforward display and a somewhat detached and theatrical attitude towards the self, so that elaborate forms of fashionable dress were masks, disguises, veils. He argues that with nineteenth-century urbanization a change occurred as dress became more closely and hauntingly involved with a deeply felt sense of personal identity. In the anonymity of the industrial city appearances became 'direct expressions of the "inner self" ... guides to the authentic self of the wearer and clues to private feeling. One really knew about a person by understanding him at the most concrete level – which consisted of details of clothes, speech and behaviour.'[9] Among strangers it was necessary to signal 'who you were' by what you wore.

In this case, the bohemians by 'making a statement' with their style of dress, were doing only what everyone else was doing. To adhere to the rules of polite dress was to signal your commitment to the good manners of a gentleman; it therefore followed that to flout them was both to commit a real social transgression and to announce a different inner individual truth.

For Murger the truth was simpler and more brutal: shabby clothes simply spoke the poverty of the struggling artist, and the bohemian's strange or slovenly appearance was due entirely to a lack of adequate clothing, of having to stay in bed because your only shirt was dirty or your shoes worn out.

Before he became successful, Murger himself was ashamed of his appearance, and went out only after dark in his threadbare coat.

However, in thus reducing the appearance of the bohemian to economic necessity, Murger ignored the expressive potential of dress. Many dedicated bohemians flaunted their poverty, a disregard for social niceties demonstrating superiority to the bourgeois rules of polite behaviour, and if the bohemian artist looked unkempt, it was not just that he was wearing his oil- and paint-stained clothes, or even just that he was penniless: he was telling the world of his defiance, of his dissent from bourgeois values and of his poverty therefore as a moral rather than an economic condition.

The use by groups (rather than individuals) of dress to signify opposition to the dominant beliefs of society goes back at least to the aftermath of the French Revolution. The Incroyables of the Thermidorean reaction were monarchists who expressed their opposition to republican ideas by dressing in a style that recalled the *Ancien Régime*; they wore the cravats and tight breeches of the period, but with velvet waistcoats and lace. They attached beauty spots to their faces, and their hair was cut short at the back but was long at the front in the style known as *à la victime*, since it reproduced the way in which the hair was cut in preparation for execution. Their female counterparts, the Merveilleuses, wore red ribbon chokers, another gruesome reference to the guillotine.[10] At the opposite end of the political spectrum, utopian socialists devised special forms of dress for themselves, such as trousers for women, which symbolized women's equality with men. They also devised a waistcoat that did up at the back, so that co-operation in the act of getting dressed was required.[11]

In 1800 some artists who were studying under the republican painter, Jacques Louis David, were said to have formed themselves into a group known as *Les Barbus*, the Bearded Ones (in spite of the fact that several women belonged to the group). Charles Nodier remembered them as having worn a form of dress based on ancient Greek costume, but which also included white pantaloons and red waistcoats, two articles of clothing which Maxime du Camp many years later recalled as having been the uniform of the utopian socialist St Simonians in the 1830s.[12] Lucile Franque was the leading woman member of the group, and she and other young women associated with the *Barbus* wore black crepe, wreaths of flowers and veils imitating 'the veil of Andromache or that of the priestess Cassandra'.[13]

Like the *Incroyables*, the *Barbus* opposed the dominant republican ethos, but in their case from a Christian perspective. They were romantics in following the enormous vogue in France for the works of the poet Ossian, recently translated from English. (These poems were allegedly Celtic or Erse works attributed to a legendary third-century Gaelic bard, but later turned out to be a forgery, actually written by the eighteenth-century Scottish poet, James Macpherson.)[14] The *Barbus* displayed a number of features later to become typical of bohemian subcultures; they lived in a seedy part of town; they were derided as artists *manqués*, and used dress to distinguish themselves and their beliefs.

Less than twenty years later the Nazarene 'brotherhood' of German painters working in Rome, likewise dressed in a manner which caused comment, wearing large cloaks and wide hats. In 1818 the English sculptor, John Gibson, reported that they 'excite the looks of all by their whims in dress. I certainly like this dress which they adopt, but still it does not do for twelve men to dress different to [sic] all the rest of men.'[15] And by the 1830s the idea that artists *looked different* from their fellow citizens was widely accepted.

In 1830 the painter Canonnier was among the rioters at the opening night of *Hernani*, and lost two of his teeth in the fracas, a badge of honour he afterwards displayed with pride.[16] He was one of a band of painters in the romantic style who colonized the Galleries of the Louvre from 1828 to 1834, and whose appearance made them conspicuous: 'Nothing but pointed hats, long hair, long beards ... and pseudo-medieval dress.'[17] This 'hairy band of artists' made common cause with the leading literary lights of *les Jeunes France*, for whom dress was equally important in signalling their affiliation to romanticism and their distance from the bourgeois philistines.

Gautier and Arsène Houssaye came from the upper-middle-class bourgeoisie, and were supported by family money as they sowed their bohemian wild oats in the early 1830s, so that poverty was hardly an issue for them in the way it later was for Murger. Gautier devoted a whole chapter of his *Histoire du Romantisme* (written many years later) to a description of the red waistcoat he wore to the first night of *Hernani*. It was actually a doublet, tailored like a Renaissance cuirass, which came to a point over the stomach and did up at the back like the St Simonian waistcoat. Gautier insisted that the red colour of the waistcoat did not represent revolution (although he was a lifelong republican). 'In order to avoid the infamous red of 1793 we added a light proportion of purple, for we did not wish anyone to attribute any political intention to us. We were not imitators of St Just and Robespierre ... rather we were medieval ... feudal, ready to take refuge from the invasion of the century in [medieval] castles.'[18] With the waistcoat Gautier wore very pale water green trousers, banded down the seam with black velvet, a black jacket with wide velvet revers, a moiré ribbon instead of a cravat, and an ample grey overcoat lined with green satin. Beneath his hat his 'Merovingian' chestnut curls tumbled down to his waist.

By 1855 Champfleury noted that a general change had taken place: 'eccentric daubers' were seen only on the vaudeville stage. This implies that the bohemian had become a recognized stereotype in popular culture. However, he no longer frequented the Louvre Galleries:

Today poverty forms the basis of the painters' costume. No more medieval dress, no more pointed hats and hardly any long hair ... You now see ... only ancient hats, jackets and trousers stained with oil, and shoes whose owners tremble at the least sign of rain. Other than that one invariably sees painters in the workaday unpretentious clothes of the minor official

... those fortunate enough to be employed by the government as copy-
ists.[19]

This, however, may have been due as much to the political repression of
Napoleon III's dictatorship as to poverty.

The costuming of Bohemia had no single chronological line of develop-
ment; rather various strategies were deployed consistent with the shifting,
ambiguous and protean character of the bohemian him- or herself. While
Gautier, for example, dressed with colourful romantic excess, his friend Borel
(who influenced Baudelaire in this) dressed entirely in black or dark colours,
wore his hair short and had a neatly trimmed beard, his appearance, Gautier
thought, like that of a Spanish grandee. He was 'the perfect specimen of the
romantic ideal ... [the] Byronic hero,' for at that time, 'it was fashionable
among the romantics to be pale, livid, greenish, even a little cadaverous if
possible. This gave one the fatal Byronian air, that of [one] ... devoured by
passion and remorse.'[20] Privat d'Anglemont remembered one healthy-looking
friend who 'had the misfortune to arrive on the scene at the moment when
the high point of good taste was to have a fatal, even tubercular air; at this
period of aberration and Byronmania ... everyone wanted to look like ...
one of those individuals with a ravaged countenance, exhausted by the
passions and sufferings of the great poet.'[21] Byron's appearance was important
because it made the crucial link between self-presentation and moral and poli-
tical oppositionalism in the formation of the bohemian counterculture. To
dress the part of the 'suffering poet' was to express the idea that to be an
artist was not simply to possess and develop a particular talent, but was to be
a special kind of dissident person.

Charles Baudelaire explored in his life and in his poetry the Byronic asso-
ciation between creativity and excess. During a brief period of affluence as a
young man he, like Nerval, lived in the Hôtel de Pimodan, where his neigh-
bour was the wealthy writer, Roger de Beauvoir, famous for his dandyism.
Typical of de Beauvoir's style was an ensemble consisting of a tight-fitting sky
blue coat with gold buttons, a primrose coloured waistcoat and pearl grey
trousers. Under his influence Baudelaire, too, became a dandy, but of a more
restrained kind, his perfectionist black ensembles enlivened only by the pure
white of his open-necked shirts and oxblood cravat.[22] His appearance set him
apart, suggests Valerie Steele, both from the medievalism of the romantic
movement and from the vulgarity of the Jockey Club aristocrats[23] (who aban-
doned the severity advocated by Beau Brummell despite their admiration for
the English style).

An implicit theory of bohemianism may be found in Baudelaire's brief
essay on the dandy, in which he suggests that the dandy was an aristocrat by
reason of talent rather than birth. His aristocratic values were at odds with
the philistinism of the day, and his mode of dress accordingly positioned
him as an enemy of society. Dandyism demonstrated the superiority of the
artist over the vulgar bourgeoisie; it was 'an expression of opposition and

revolt', he last blaze of heroism in a time of decadence. The dandy was no mere clothes horse, on the contrary, he was always an outlaw;[24] and his creation of the self as a work of art involved the blurring between art and life that was characteristic of bohemianism.

Although the dandy artist was an aesthetic aristocrat, he was also the hero of modern life, looking forward as well as back. His disdain for vulgarity emphatically did not mean that he aimed to recreate the art of the past. On the contrary, Baudelaire took issue with critics who called for a return to heroic styles. They were wrong, he argued, to dismiss modern painting as decadent because it sought contemporary themes. Modern life had its own forms of heroism:

> Scenes of high life and of the thousands of uprooted lives that haunt the underworld of a great city, criminals and prostitutes ... are there to show us that we have only to open our eyes and see and know the heroism of our day ... Parisian life is rich in poetic and wonderful subjects. The marvellous envelops and saturates us like the atmosphere.

Modern art must take its inspiration from this new world. It was ridiculous to paint the great men of the day clad in togas and wreaths of laurel; had not the 'much abused frock-coat ... got its own beauty and native charm? ... There is a modern type of beauty and heroism!'[25]

Thus to the 'poor look' on the one hand and romantic medievalism on the other was added this third, Baudelairean approach to dress. A fourth kind of bohemian dress was directly critical of nineteenth-century fashion. 'Aesthetic dress', pioneered by the Pre-Raphaelite Brotherhood on behalf of its female associates, called both for more beautiful and for more 'rational' forms of clothing and a return to styles of dress for women inspired by medieval painting in protest against the ugly industrialism of the age.[26] The gowns adopted by Janey Morris had wide armholes and full sleeves permitting the free movement of the arms, and were worn, shockingly, without corsets. In the 1870s the harsh, garish tones produced by chemical aniline dyes were rejected in favour of soft vegetable tints, 'off' shades of salmon, sage green, indigo and the famous 'greenery yallery' lampooned in the Gilbert and Sullivan operetta, *Patience*. Outlandish as these appeared to begin with, they soon began to influence fashion. The London department store, Liberty, opened in 1875, based its marketing strategy on the commercial production of Arts and Crafts styles in textiles, dress and interiors, along with the import of Japanese artefacts, which were fashionable and influential among artists and cognoscenti. By the end of the century aesthetic dress had merged with the various movements for dress reform in the United States and Europe, which had called for rational and hygienic clothing to replace the corsets, bustles and heavy materials of late-nineteenth-century fashion.

The Arts and Crafts Movement was founded by William Morris as a counter-influence to what he felt were the many ugly industrial designs

Figure 26 ReformKleid costume designed by Kandinsky ca 1904

displayed at the Great Exhibition at Crystal Palace in 1851, to disseminate an alternative aesthetic. These ideas, too, proved extremely popular, and Morris himself marketed aesthetic fabrics, wallpapers and furniture for the homes of the rich but aesthetically minded bourgeoisie. Wassily Kandinsky encountered the Arts and Crafts Movement on a visit to Britain in 1887. In 1896 he moved to Munich, and by the early 1900s, when the German *ReformKleid* movement was in full swing, he was designing aesthetic garments for and with his lover and fellow artist, Gabriele Munter. One dress, sketched by Kandinsky, was to have been dark green with a pale green blouse, the skirt decorated with stylized floral embroidery motifs, while the jacket was adorned with a leaf pattern and fastened with a silver clasp and chain. Gabriele Munter was also photographed in the journal *Dekorative Kunst* in 1902 in a *ReformKleid* design created and executed by Margarethe von Brauchitsch, a Munich craftswoman whose work was important in transforming embroidery into a fine art.[27]

In Munich was to be found a fifth kind of bohemian costume: fancy dress. In her diary the 'Queen of Schwabing', the Countess Franciska (Fanny) zu Reventlow, described the fancy dress parties she and her circle of Nietzschean friends devised and attended. The eccentric Alfred Schuler usually came attired as a Roman matron, sometimes with Fanny Reventlow in attendance

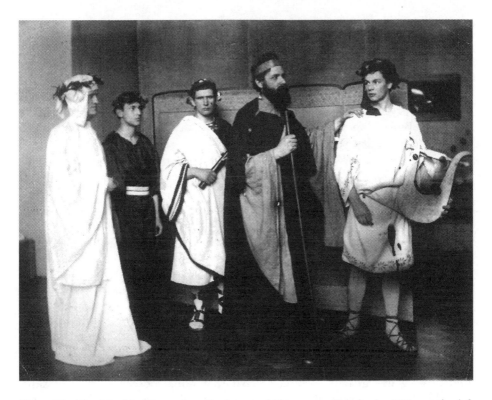

Figure 27 The Munich 'Enorms' at the house of Henry von Heiseler in 1904; on the left
Stefan George, second from right Karl Wolfskehl as Homer

as Hermaphrodite. At one masked ball Fanny dressed as a 'tattered gypsy girl'
in a big peasant blouse, a bright blue skirt caught up at one side to show her
petticoat, with bare legs and shoes tied with red laces, a red peasant scarf tied
round her loose hair, and gold earrings. On another occasion a fellow writer
remembered her wearing a Turkish costume, with a length of blue crepe de
chine tied round her head as a turban and gold spangled trousers tied to her
feet with two men's handkerchiefs. Her boyfriend Such appeared in a
different costume every evening, while she herself wore a Dutch costume to
another party with another young lover, Roderich Huch; and on one
occasion the three of them went to a dance dressed as (modern) Greek
youths in black sweaters with red garlands, their legs criss-crossed with white
laces.[28]

Fanny Reventlow was never too serious about these transformations. Geor-
gette Leblanc by contrast took her role as muse very seriously indeed, and
created a 'symbolist' style of dress consistent with her lover Maeterlinck's
work. For their first meeting she contrived a costume that was 'highly
Melisandesque ... Like wood shavings, my hair quivered in curls about
my head, and a trailing gown of gold-flowered velvet prolonged my person

indefinitely.'[29] At this period of her life Georgette always dressed fantastically, copying the garments depicted in gothic paintings by Van Eyck, Memling or Quentin Matsys. 'I can still see myself crossing a Brussels street on a winter day,' she wrote, 'in an amethyst velvet dress enriched by gold braid borrowed from some chasuble. Trailing behind me a long train ... I conscientiously swept the pavements clean ... At home I looked like a Gozzoli angel. Fra Angelico, Burne Jones and Watts were my models. I was always dressed in azure blue or golden yellow.'[30]

In 1896 *La Bohème* inaugurated a revival in Paris of the romantic male fashions of 1830:

> Trousers are drawn in tightly at the ankles. The dark velvet jacket is meant to be Venetian ... and the tie is loosely knotted. This appearance is rounded off with a rascally felt hat, which haloes ... a head romanticized by long hair. And there you have the fin de siècle art student of Montmartre. He is deliberately 1830 ... Murger has come into fashion again.[31]

The female bohemians were 'less committed in style; they are influenced by the general fashion. They contrive Mimi's kind of dress with the decadent dreams of the symbolist poets.' Arthur Ransome saw similar trends among London's bohemians. For example the hostess at one of his first bohemian parties was dressed in what sounds like an anticipation of Diaghilev's *Ballets Russes*. She wore 'an orange-coloured coat that hung loose over a green skirt, with black tassels sewn all over the orange silk, like the frills on a red Indian's trousers'.[32]

In 1911 Diaghilev's *Ballets Russes* took Western Europe by storm, and soon the couturier Paul Poiret translated the *fauve* colours and 'Oriental' styles into fashionable dress. Smart society women began to appear in turbans, tunics and jazzy colours, and their ropes of pearls and semi-precious beads ended in tassels like those which ornamented the bolster cushions that were piled up on their divans. Poiret also incorporated some of the ideas of reform dress into his designs. And, while Georgette Leblanc was costuming herself as a symbolist bohemian muse in Brussels, aristocratic fashion leaders were following the same route in Paris. In 1896 Marcel Proust's friend, Robert de Montesquiou, published a volume of symbolist poetry, *Hortensias Bleues*, inspired by which, Madame de La Ville La Roulx commissioned the couturier Jacques Doucet to create a simple, princess-line gown embroidered with these flowers. De Montesquiou's cousin, the Comtesse Grefuhle, who was advised by him in matters of dress, likewise had an evening dress made in black velvet appliqued with white satin hortensias.[33]

After the First World War, Dorelia John's distinctive artistic look, part aesthetic dress, part gypsy, part peasant, a timeless style with gathered skirts and moulded bodices, and one which she continued to wear for the rest of her life, influenced generations of Chelsea art students. She made her children's clothes from beautiful Liberty materials, but her son, Romilly

described how much he hated having to wear 'pink pinafores reaching to just below the waist, and leaving our necks bare; brown corduroy knickers, red socks and black boots'. His sisters were clad in 'buff-coloured woollen dresses ... saffron yellow ankle socks and square-toed black slippers'.[34] Nicolette Devas believed that the reason for these fashions was that Augustus, unable to paint the fashions of the day, required his household to be dressed to suit his work: 'The materials used were those beloved by the artists through the ages; cotton velveteen for the quality of the drapery, and the highlights on the ridges of the folds, the depth of colour in the crease. Shantung was another favourite material; it came in clean, bright dyes and the shimmering surfaces described the body beneath.'[35]

Even the self-effacing Gwen John took great care with her appearance, visiting the *Bon Marché* department store in Paris to choose items for the construction of an appearance which, according to Alicia Foster, steered a careful line between fashion and a bohemian or 'artistique' look.[36] Among her garments was a long, waistless 'jacquette' of black velvet. The cut of this was 'anti-fashion', but the velvet with which it was made was very fashionable, as was the grey and pink silk she was wearing in 1906.[37]

In 1912 Nina Hamnett cut off her hair, as a short bob was now the fashion among the Slade's women students. They were known as 'cropheads', and the cut signalled that the wearer was an artistic, radical woman. Nina Hamnett's dress was equally bohemian and her autobiography contains many descriptions of her outlandish clothes. For example, she wrote of this period: 'I wore in the daytime a clergyman's hat, a check coat, and a skirt with red facings, including the button-hole, which was faced with red too ... I wore white stockings and men's dancing pumps and was stared at in the Tottenham Court Road. One had to do something to celebrate one's freedom and escape from home.'[38] In Paris a few years later she wore flat-heeled, button strap shoes, and 'a wonderful collection of stockings' in bright colours; some were even checked. She also possessed a cubist jumper, orange, blue and black, designed at Roger Fry's Omega Workshops, where she worked for a time during the war.

In the 1920s, caught up in *being* bohemian, she played a multiplicity of roles. In his 1920s novel, *Les Montparnos*, Michel Georges-Michel described her morning appearance in workman's garments – corduroy trousers and blue shirt – in the role of serious painter. Later in the day she might be more exotically dressed for drinking aperitifs with French fellow bohemians. In the evening she would dress up in haute couture borrowed from or donated by the rich society friends with whom she spent her evenings in the fashionable night-clubs of the *bohème d'orée*.[39]

For Ottoline Morell, too, dress was an essential component in the creation of an original identity. Her clothes were truly theatrical, sometimes copied from her own sketches, sometimes from paintings, sometimes from actual theatre costumes, unlined and tacked together by her seamstress, Miss Brenton.[40] Stephen Spender, who knew her towards the end of her life (in

POOR THINGS, THEY COULDN'T THINK OF ANY FANCY-DRESS FOR THE BOHEMIAN ARTS BALL.

Figure 28 Punch cartoon satirizing bohemian dress in 1934

the 1930s) described how she dressed like an eighteenth-century shepherdess, in antique silks and satins, and when she went out, 'she had attached to her, or to her shepherdess's crook, by ribbons, two or three pekingese dogs. She never ceased to be surprised that people stared at her in the street.' By this time 'she always had the air of falling apart, with hair like a curtain suddenly dropping over one eye, or a bodice bursting open. On one occasion, when she was in the middle of a sentence, a large earring fell off the lobe of one ear and dropped into her teacup. Without interrupting what she was saying, she fished it out and attached it to her ear again.'[41]

Every style of bohemian dress was to be found in Paris before the First World War. The followers of Raymond Duncan, Isadora Duncan's brother, who ran a school of dance, strode around in hand-woven togas, sandals and headbands. Gertrude and Leo Stein wore brown corduroy.[42] When Nina Hamnett met Amedeo Modigliani, he was still wearing an artistic outfit in the romantic style of the 1890s: brown corduroy or black velvet suit, coloured neckerchief and broad-brimmed hat. Picasso admired his taste. 'There's only one man in Paris who knows how to dress, and that is Modigliani,' he said.[43] At this time Picasso himself wore 'black, striped trousers, a short jacket, also black, wide open and displaying a broad, pink girdle wrapped round his waist in the pure toreador style'.[44] (This, at least, was how

Marevna Vorobev remembered him, although the costume sounds more like something worn for fancy dress than everyday.)

At the other extreme, there were those artists who distanced themselves from anything resembling fancy dress. The composer, Erik Satie, who had played the piano at the famous cabaret, the *Chat Noir*, and had a tempestuous relationship with Suzanne Valadon, moved to the suburbs and took to wearing the most unremarkable bourgeois suits.[45] By this time the avant-garde had abandoned the romantic style. They no longer wished to conform to what had become a bohemian stereotype. Picasso took to 'blue overalls, so patched and washed that they suggested a study in delicate pastel shades, set off by a red cotton shirt with white spots, which he had bought in the Place St Pierre for 99 centimes, canvas shoes and a cap'.[46] Needless to say, the artists' adaptation of workmen's clothing merely inaugurated a *new* way of looking like an artist, and again, as happened so often, the innovation was taken up by the fashion world – in this case by Chanel with her transformations of work-wear chic.

Greenwich Village style in the twenties made gestures towards revolutionary dress in the wake of the Russian revolution of 1917:

> The women had evolved a regional costume ... hair cut in a Dutch bob, hat carried in the hand, a smock of some bright fabric (often embroidered Russian linen), a skirt rather shorter than the fashion of the day, gray cotton stockings and sandals. With heels set firmly on the ground and abdomens protruding a little – since they wore no corsets and dieting hadn't become popular – they had a look of unexampled solidity ... But ... some women preferred tight-fitting tailored suits with buster brown collars ... The men, as a rule, were more conventional, but tweedy and unpressed. They did not let their hair grow over their collars, but they had a good deal more of it than was permitted by fashion. There were a few Russian blouses among them.[47]

This form of costume was largely gestural in its radicalism, but during the Second World War sartorial defiance could be lethal. In California young Afro-Americans devised the Zoot Suit, wearing long draped jackets, excessively wide trousers narrowed at the hem, fedora hats and elaborate watch chains – a costume that enraged authorities and public alike, leading to riots, and even fatalities, because the young men – not in uniform – were incorrectly perceived as draft dodgers.[48]

These young men belonged to the poor, often unemployed black contingents who were moving from the American south to cities such as Los Angeles. They were not bohemians, but, as had often happened and was to happen again, young middle-class men and women created a bohemian style from what had originally been 'street' dress. In occupied Paris the 'Zazous' – dissident youth – borrowed the zoot suit style. The young men dressed in long jackets and tight trousers, and slicked their hair down with salad oil,

their girlfriends devised a 'tramp' style with cheap ponyskin coats, polo-neck sweaters, skirts held together with safety pins and laddered stockings. All carried rolled up umbrellas.[49]

Even in Nazi Germany, American popular music, especially jazz, became a focus for disaffected young men and women, mainly from middle-class homes, who shunned the Nazi Youth movement and called themselves *Swing-jugend* or Edelweiss Pirates. They gathered in semi-clandestine groups, first in Hamburg, then in other cities, to listen to the 'decadent Jewish' music of the American jazz giants, and adopted a style to express their defiance. The boys 'gained credibility from long hair, often reaching down to the jacket collar … Mostly they wore long, often checked English sports jackets, shoes with thick light crepe soles, showy scarves, homburg hats, an umbrella over the arm … Girls favoured a long, overflowing hairstyle. Their eyebrows were pencilled, they wore lipstick and their nails were lacquered.'[50]

After 1945 bohemianism spread into a series of new youth movements. In post-war France, Existentialism was associated with freedom in dress and morals at a time of repressive conservatism. The Existentialists revived Petrus Borel's minimalist urban aesthetic of black (although Simone de Beauvoir believed that this was adapted from the black worn by Italian fascists[51]). The popular singer most closely associated with the Existential movement, Juliette Greco, remembered how wearing no makeup and having long, straight hair seemed daring and liberated. Once she became well known she abandoned her duffel coats and tartan trousers and, for her performances at least, always appeared in a simple, full-length black dress with long sleeves and high neck. This signalled 'Existentialism,' but at the same time reworked an established tradition, for the *chanteuses* of the French music hall and cabaret, most famously Édith Piaf, had created a distinctive visual code for the plaintive songs of 'old Paris,' dressing in black which set off their white faces, red lips and dark hair.[52]

In the United States the Beats explicitly referred to Existentialism as a source of inspiration. Beatnik women created a look, which, like Existentialist dress, rapidly became a mass cultural phenomenon and popular stereotype. Joyce Johnson recalled the Greenwich Village style of this period:

Oh, the belts I see in the Sorcerer's Apprentice, which is tucked away in a little courtyard off 8th Street, like a cobbler's shop in a fairy tale … There are two styles that are popular. One laces up the front like the girdle of Lena the Goosegirl; the other fastens dramatically with a spiral made of brass about the size of a saucer … [A] dirndl skirt of lumpy, hand-woven material … usually goes with it, not to mention the sandals criss-crossing up the ankle, or the finishing touch of a piece of freeform jewellery like a Rorschach test figure dangling down to the midriff by a thong.[53]

Later, in the mid-fifties, when she was living in Greenwich Village, she and Hettie Jones based their outfits on the ubiquitous polo-neck and on dancers'

tights bought locally, nearly a decade before tights began to be mass produced for all women. By then the beatnik women's uniform of black had become universally recognized, popularized in the mass media, in countless cartoons, in the Audrey Hepburn fashion musical, *Funny Face*, and even in an American television soap opera.

The bohemians themselves reacted to the popularization of their uniform by moving on. Joyce Johnson described how some of the 'old ladies' of the painters living in the Soho lofts pioneered the thrift shop dressing that was later to become the hallmark of hippie style. They wore 'limp, thrift shop dresses made interesting with beads,' and picked up 'Spanish combs and beaded dresses from the twenties ... They draped themselves in embroidered piano shawls, put on purple mesh stockings and called themselves "Beat Pre-Raphaelites".'[54]

In 1956 Liberty revived some of its original Morris textile designs, and by the mid-1960s the influence of William Morris was everywhere to be seen, part of a general Art Nouveau aesthetic. When Henrietta Moraes became part of the sixties drug culture she wore Afghan robes and crushed velvet trousers and shirts with stars on them, purchased at the Chelsea boutiques 'Hung on You' and 'Granny Takes a Trip.' Her boots were made from Morris flower prints; 'They laced up to the knee, and, depending on how stoned I was, took at least ten minutes to put on ... I spent quite a lot of time shopping, going into the Antique market to buy old forties summer dresses, lace petticoats and embroidered shawls.'[55] This hippie look, romantic, druggy, murky and floaty, not only expressed the mood of the movement, but was again a form of dressing that turned poverty on its head, demonstrating creativity and individual expression in the use of discarded remnants, second-hand clothes and ethnic items.

The punks took this a stage further and gave it new meanings. They used bondage gear, army surplus clothing, 'trashy,' kitsch textiles such as lurex and fake leopardskin and non-dress items such as plastic bags and safety pins, to create a form of sartorial collage.[56] This was neither aristocratic minimalism nor hippie picturesqueness, indeed it was developed as a reaction against and angry critique of the hippie 'peace and love' philosophy. However, it did take over from the hippies their use of the profoundly *un*fashionable, items that cost little, the disregarded detritus of the fashion world.

Punk was trash culture gone avant-garde and/or the avant-garde gone trash, and just as Dada had tried to destroy the institution of art, so the punks seemed bent on destroying the very institution of fashion. Fans and followers invented many of the most striking punk modes for themselves:

Fetish t-shirts weren't the only Sex clothes the [Sex Pistols] were wearing: pleated trousers, corduroy straight legs, suede slingbacks and velvet-collared fifties jackets were all supplied to the group. Members also offered their own innovations: Matlock with his artfully paint-spattered black drain-pipes, or Lydon with his hand-painted shirts and torn-up 'Steptoe' clothes

– tiny sweaters, huge cardigans and fifties flannels. The effect was striking but indefinable, something like a skewed Mod with both bohemian and hooligan touches.[57]

One young fan described how she:

hated the world ... that thing of everyone trying to be nice and well-mannered, and behind the scenes, people weren't really ... so I ripped my clothes, scalped myself, pierced my ears. I was dyeing my hair; I used to get old grannies' corsets and things from thrift shops ... it was my hatreds coming out with a sense of humour. John Lydon came up to me because he couldn't believe I dressed like that. He asked if I'd ever been in a shop called Sex; there was a girl called Jordan there who dressed like me.[58]

Punks blurred the boundary between the body and the garments that clothe it, a blurring or even erasure reviving a feature of the avant-garde art associated with bohemianism at earlier periods: in Zurich Dada, and in the performance art of Greenwich Village in the 1960s.

The radical gesture of discarding clothes altogether was another recurring feature of bohemian life. The *Barbus* sometimes went naked, and Petrus Borel and his friends sat around in their garden with no clothes on (much to the disgust of their neighbours). It was also a strategy used by the Beats during poetry readings. On one occasion Allen Ginsberg stripped when an academic in his audience asked him what he meant by 'naked'; on another, Gregory Corso undressed when accused of cowardice by a heckler; in the early 1970s the Gay Liberation Front collective, Bethnal Rouge in the East End of London, explored the potential of nudity. They had no money, but more important was nakedness as a way of simultaneously challenging consumer capitalism and reaching to the inner core of an essential self.

Throughout the whole post-1945 period, overlapping and competing youth cultures, each with a distinctive dress style, have been associated with popular music rather than with high art or the avant-garde. Their many labels have to some extent displaced the umbrella term 'bohemian',[59] but they have continued the bohemian tradition of the use of dress as a signifier of dissidence, and thus have taken it into mass culture.

Finally, dress could be part of the creation of a self poised delicately between living work of art and outright insanity. During the First World War, the exiled German Baroness Freytag von Loringhoven was to be seen in the Greenwich Village streets dressed as a perambulating Dada object, expressing her psychosis in extraordinary costumes:

She wore a red Scotch plaid suit with a kilt hanging just below the knees, a bolero jacket with sleeves to the elbows and arms covered with a quantity of ten-cent-store bracelets – silver gilt, bronze, green and yellow. She wore high white spats with a band of decorative furniture braid round the top.

Hanging from her bust were two round tea-infusers, from which the nickel had worn away. On her head was a black velvet tam o'shanter with a feather and several spoons – long, ice cream soda spoons.[60]

On one occasion she upstaged the visiting singer at an important concert by appearing dressed in 'a trailing blue-green dress and a peacock fan. One side of her face was decorated with a cancelled postage stamp. Her lips were painted black, her face powder was yellow. She wore the top of a coal scuttle for a hat, strapped on under her chin like a helmet. Two mustard spoons gave the effect of feathers.'[61] Later, when the poet William Carlos Williams rejected her advances, she shaved her head and lacquered it vermilion, declaring that this was like having a new love experience.

The desire to become a living work of art was still be encountered eighty years later. Leigh Bowery arrived in London from Australia in the early 1980s, determined to be a dress designer. He became involved in the club scene, and made New Romantic outfits and clothes based on some of Vivienne Westwood's ideas. Gradually his clothes became more like extensions of his body. Like the Baroness Loringhoven he painted his shaved head, and then took this further into extraordinary head-dresses, worn with outfits which completely altered his body shape, for example costumes to which enormous protruding bottoms or bustles were attached. He even experimented with a contraption with light bulbs that lit up his head.[62] (This idea had been anticipated by the Marquesa Casati, a member of bohemian high society before and after the First World War. At one party she had planned to appear as Saint Sebastian, wearing armour 'pierced with hundreds of arrows, each studded with glittering stars that were to light up when the Marquesa appeared.' Unfortunately when the contraption was plugged in it short-circuited, giving her a severe electric shock.)

Every time Leigh Bowery went out it was a performance. He was a star turn on the club scene, 'art on legs', according to Boy George, gradually becoming a kind of performance artist, and towards the end of his life he worked with the avant-garde dancer Michael Clark. (He also posed nude for a series of powerful studies by Lucian Freud.) If he had a forerunner, it was surely Alfred Jarry, and, like Jarry, he died young. After his death an exhibition of his costumes and photographs was organized at the Fine Arts Society in London. One reviewer felt that Bowery's project – to make his body, his presence, a work of art in itself – was ambiguous. It seemed unclear whether the grieving friends in attendance at the private view 'were marking the passing of some wonderfully unflinching artistic success, or were at a wake for a life that had gone slightly wrong, a life distracted and dogged by – or sacrificed to – the idea of making an exhibition of oneself, to adolescent habits of shock and disguise'.[63]

It is impossible more succinctly to sum up the ambiguities of bohemian dress: its interminable ambivalence, caught between pose and deadly seriousness, its dissidence, madness and art fusing into the heroism of everyday life.

Notes

1 Théodore de Banville, *Petits études: Mes Souvenirs* (Paris: Charpentier, 1882), p 82.
2 Dell, *Homecoming*, pp 84, 102.
3 Margaret Anderson, *My Thirty Years War*, pp 152-3.
4 Thomas Mann, 'At the Prophet's', in Thomas Mann, *Stories of Three Decades* (orig publ in 1904; London: Secker and Warburg, 1946), p 284.
5 André Thirion, *Revolutionaries without Revolution*, trans Joachim Neugroschel (London: Cassell, 1975), p 87.
6 Ibid., pp 87-9.
7 Herbert Huncke, 'Guilty of Everything', in Arthur Knight and Kit Knight (eds), *Kerouac and the Beats: A Primary Source Book* (New York: Paragon House, 1988), p 73.
8 Johnson, *Minor Characters*, p 31.
9 Richard Sennett, *The Fall of Public Man* (Cambridge: Cambridge University Press, 1974), p 153.
10 César Grana, *Modernity and its Discontents*, p 73.
11 See Katherine Luck, 'Trouble in Eden, Trouble with Eve: Women, Trousers and Utopian Socialism in Nineteenth Century America', in Juliet Ash and Elizabeth Wilson (eds), *Chic Thrills: A Fashion Reader* (Berkeley: University of California Press, 1993), pp 200-12, for an account of the later development of utopian dress.
12 Maxime du Camp, *Literary Recollections*, vol 2 (London: Remington and Co., 1893), p 91. His description does not accord with others, and it is unclear how accurate it is. Like Nodier, he was writing of events long in the past.
13 Charles Nodier, 'Les Barbus du Présent et les Barbus de 1800', *Le Temps*, 5 October 1832, published in the Appendix to M.E.J. Delécluze, *Louis David, Son École et Son Temps* (Paris: Didier, 1855), p 431. Nodier's reminiscences, written over thirty years later, constitute virtually our only source of knowledge of the *Barbus*, apart from brief contemporary descriptions of the outlandish Greek costumes worn by some young men at this period, so that it is difficult to know how reliable it is. *Fashionable* women's dress at that time was, after all, based on an idea of classical garb, so the female *Barbus*, other than wearing black, may still have followed the mode. Yet, even if apocryphal, Nodier's account is important as an early literary representation of a group of non-conforming artists. It may also be significant that it was published in 1832, as if in response to the emergence of *les Jeunes France*, whose antics were then the talk of Paris; possibly it was the older, established romantic writer's attempt to lay claim to having been associated with aesthetic dissidents long before Gautier and his friends appeared on the scene. (It was also republished, again in the 1850s, in the wake of the extensive journalistic interest in the bohemians after the 1849 success of Murger's play.)
14 George Levitine, *The Dawn of Bohemianism: The Barbu Rebellion and Primitivism in Neo-Classical France* (Philadelphia: Penn State University Press, 1978).
15 Keith Andrews, *The Nazarenes: A Brotherhood of German Painters in Rome* (Oxford: Clarendon Press, 1964), p 39.
16 Champfleury, *Les Excentriques* (Paris: Michel Levy, 1855), p 230.
17 Ibid., p 228.
18 Théophile Gautier, *Histoire du Romantisme* (Paris: Charpentier, 1874), p 94.
19 Champfleury, *Les Excentriques*, p 235.
20 Ibid., p 51.

21 Privat d'Anglemont, *Paris Inconnu*, p 101.
22 A number of descriptions of the youthful Baudelaire at the height of his beauty and elegance have been collected in Eugène et Jacques Crépet, *Charles Baudelaire: Étude Biographique, suivie des Baudelairiana d'Asselineau* (Paris: Vannier, 1906); and in W.T. Bandy et Claude Pichois, *Baudelaire devant ses Contemporaines* (Monaco: éditions du Rocher, 1957).
23 Valerie Steele, *Paris Fashion: A Cultural History* (New York: Oxford University Press, 1988), p 82.
24 Charles Baudelaire, 'Le Dandy', *Écrits sur l'Art*, 2 (Paris: Livre de Poche, 1971), pp 171–6.
25 Charles Baudelaire, 'The Salon of 1846', *Selected Writings on Art and Literature*, trans P.E.Charvet (Harmondsworh: Penguin, 1972), pp 105–7.
26 Stella Mary Newton, *Health Art and Reason: Dress Reformers of the Nineteenth Century* (London: John Murray, 1974), remains the most comprehensive account of these trends in Britain.
27 Weiss, *Kandinsky in Munich*, pp 96, 124.
28 All quoted in Helmut Fritz, *Die erotische Rebellion: das Leben der Franziskza Gräfin zu Reventlow* (Frankfurt: Fischer Verlag, 1980), pp 13–14.
29 Leblanc, *Maeterlinck and I*, p 26. Janet Flanner's irony seems particularly in evidence here.
30 Ibid., p 27.
31 Joanna Richardson, *The Bohemians*, p 195, quoting Georges Montor Gugil, *La Vie à Montmartre* (1899).
32 Ransome, *Bohemia in London*, p 54.
33 Information obtained from the 1998 exhibition 'Mode et Jardin', Musée Galliera, Paris, in which both dresses were exhibited.
34 Holroyd, *Augustus John* (1976), p 474, quoting Romilly John, *Seventh Child: A Retrospect* (London: Heinemann, 1932), p 134.
35 Devas, *Two Flamboyant Fathers*, p 40.
36 Alicia Foster, 'Dressing for Art's Sake: Gwen John, the Bon Marché and the Spectacle of the Woman Artist in Paris', in Amy de la Haye and Elizabeth Wilson (eds), *Defining Dress* (Manchester: Manchester University Press, 1999). For an opposing view see Janet Wolff, 'The Artist and the *Flâneur*: Rodin, Rilke and Gwen John in Paris', in Keith Tester (ed), *The Flâneur* (London: Routledge, 1994), pp 111–37.
37 Foster, 'Dressing for Art's Sake', pp 119–20.
38 Hamnett, *Laughing Torso*, pp 47–8.
39 Denise Hooker, *Nina Hamnett: Queen of Bohemia* (London: Constable, 1986).
40 Seymour, *Ottoline Morell*.
41 Stephen Spender, *World Within World* (London: Hamish Hamilton, 1951), pp 160–1.
42 Hooker, *Nina Hamnett*, p 41.
43 Charles Douglas (Douglas Goldring), *Artist Quarter*, p 112.
44 Vorobev, *Life in Two Worlds*, p 187.
45 See Shattuck, *The Banquet Years*.
46 Douglas, *Artist Quarter*, p 46.
47 Cowley, *Exile's Return*, p 70.
48 Stuart Cosgrove, 'The Zoot Suit and Style Warfare', *History Workshop Journal*, 18 (Autumn 1984).

49 Paul Webster and Nicholas Powell, *Saint Germain des Prés* (London: Constable, 1984), p 96.
50 Michael Burleigh and Wolfgang Wipperman, *The Racial State: Germany 1933-1945* (Cambridge: Cambridge University Press, 1991), pp 221-2, quoting *Report of the Reich Hitler Youth Leadership* (1942). Eventually a few of these youths progressed from sartorial defiance to terrorism, one group of Edelweiss Pirates assassinating the Mayor of Hamburg. They were caught and executed.
51 Simone de Beauvoir, *Force of Circumstance* (Harmondsworth: Penguin, 1963), pp 151-2.
52 Jeannette Vincendeau, 'The *Mise en Scène* of suffering: French *Chanteuses Réalistes*', *New Formations*, 3 (Winter 1987), pp 107-28.
53 Johnson, *Minor Characters*, p 31.
54 Ibid., p 210.
55 Moraes, *Henrietta*, p 101.
56 Dick Hebdige, *Subculture: The Meaning of Style* (London: Methuen, 1979).
57 Savage, *England's Dreaming*, pp 187-8.
58 Ibid., p 144.
59 See Ted Polhemus, *Street Style* (London: Thames and Hudson, 1994), *passim*.
60 Anderson, Margaret, p 178.
61 Ibid., p 149.
62 Cecil Beaton, *The Glass of Fashion* (New York: Doubleday, 1954), pp 175-6.
63 Quoted in Sue Tilley, *Leigh Bowery: The Life and Times of an Icon* (London: Hodder and Stoughton, 1997), p 292.

CHAPTER 11

BOHEMIAN LOVE

Kenneth tells me of the latest way-out group in America — complete sexual licence. 'It's the only way to smash the wretched civilization,' I said.

Joe Orton: Diary

The bohemians' defiance of the conventions of public behaviour in their manners and dress deeply offended bourgeois society, but even worse were the transgressions in their private lives at which their appearance hinted. They flouted bourgeois family values and made the private public by flaunting their deviance. Above all they challenged sexual convention, for in Bohemia sexual love, instead of being compartmentalized in marriage and hidden in prostitution and deviance, took centre-stage. There was thus a challenge to social convention in the flouting of unsanctioned sexual behaviour. Bohemian shock tactics brought eroticism into the open so that it suffused the social realm.

At a more profound creative level, erotic experience became the raw material for many of their most challenging works. The imaginative exploration of sexuality eventually profoundly altered assumptions concerning gender, identity and reality itself.

In 1831, the first performance of Alexandre Dumas the Elder's play *Antony* caused a sensation, and its hero took his place alongside Byron and the tragic poet Thomas Chatterton as a model for rebel artists. In love with Adèle d'Hervey, a married woman who returned his love, Antony nobly stabbed her to death in order to preserve her virtue and prove himself worthy of the title of romantic hero *damné*. Many years later Théophile Gautier attended a revival of the play. Recalling that famous first performance, when Alfred de Vigny's mistress, Marie Dorval, and the great actor Brocage had played the leading roles, he wrote that this was 'modern love' in all its intensity, the fateful meeting of the fallen woman and the 'fatal man'.[1]

'Modern love' was romantic love. The Romantic Movement privileged feeling over reason. In reaction against eighteenth-century 'sense', romantic love expressed 'sensibility', authenticity and the truth of emotion. This was

the great paradox and irony of modernity: that as scientific advance, repre-
senting reason and rational thought transformed the material world, it
unleashed unprecedented unreason and violence. Romanticism was one
expression of this, as it moved in the opposite direction from scientific objec-
tivity, to make subjectivity and sensation its criteria of value.

Gautier's 'modern love' expressed a crisis in relations between the sexes and
in definitions of gender. George Sand explored one painful aspect of this
crisis in her novel *Lélia*, published in 1833. The eponymous heroine of *Lélia*
described the frigidity that had turned her into a sadistic predator, unable to
abandon herself to erotic pleasure, although she longed to do so. She
described the divorce between her body and her soul, caused by over-intellec-
tualism, which made it impossible for her to be the equal of anyone. 'The
coldness of my senses places me below the most abject of women, the exalta-
tion of my thoughts lifts me above the most passionate of men,' she wrote.[2]

George Sand was already a successful writer and a notoriously unconven-
tional young woman, who had left her husband and lived openly with a
succession of lovers, beginning with Jules Sandeau. Yet the apparent freedom
of her life was problematic. She was known to dress as a man on occasions
and although she later insisted that this was so that she could explore Paris
unaccompanied, an activity otherwise impossible for any middle- or upper-
class woman, no matter how emancipated, it had other, more deviant conno-
tations. Her relationships with Chopin and Alfred de Musset, in which she
was the older and more dominant partner of weak, rather feminine men,
were fraught with difficulties. Her apparent masculinity even gave rise to
rumours of lesbianism, Alfred de Vigny, for example, becoming jealously
convinced that her emotional friendship with his mistress, Marie Dorval, was
sexual.

George Sand's discussion of erotic love in *Lélia* raised the troubling issue of
the relationship of erotic pleasure to gendered identity. Théophile Gautier's
novel, *Mademoiselle de Maupin*, published two years later, made this its central
preoccupation. At one level the ambiguous passion of the hero, d'Albert, for
Mademoiselle de Maupin functions as a metaphor for the relationship of the
artist to his art, and in his preface to the novel Gautier defended 'art for art's
sake'. Pierre Bourdieu has suggested that romantic passion was, in fact, the
erotic equivalent of 'art for art's sake', translating the impossibility of the
artist's position into the sphere of love,[3] and the novel certainly reads as a
meditation on the impossible nature of 'modern love'. It goes further than
that, however, for it anticipates by many decades Freud's questioning of the
nature of sexual identity and the ambiguities of gender.

Set in the seventeenth century, *Mademoiselle de Maupin* tells the story of a
triangular love affair. At a country château d'Albert and his mistress Rosette
meet a mysterious young man, Théodore, to whom both are strangely drawn.
Matters come to a head during some amateur theatricals in which Théodore
plays a female role, when d'Albert realizes to his horror that he is falling in
love with the person he believes to be a man. But of course Théodore is a

woman – Mademoiselle de Maupin – in disguise. Thus the double error of
the plot, whereby d'Albert falls in love heterosexually but believes his love is
homosexual, while Rosette, also enamoured of Théodore, believes she has
fallen in love with a man, 'acts to place homosexual love, both masculine
and feminine, at the centre of a tale in which no one actually admits to it'.[4]

Gautier was very much aware of his own good looks in youth and later his
loss of them – he told his daughter Judith that no man should look in his
mirror after the age of thirty. (In 1869, two years before his death, Louise
Colet described how 'his swollen lids and bloated features turned his face
into a waxen mask ... his lips seemed barely strong enough to hold onto a
cigar'.[5]) It is perhaps not too surprising that his preoccupation with mascu-
line beauty in *Mademoiselle de Maupin* has been dismissed as narcissistic. This
hardly does justice to the novel, however, which uses the well-established
conventions of theatrical drag to develop an incoherent, but deeply felt inves-
tigation of sexual ambiguity, questioning the very nature of gender in a
manner for which there was no adequate language at the time. The passage,
for example, in which 'Théodore' reflects on her condition suggests a genuine
disruption of gender boundaries: 'I was imperceptibly losing the idea of my
sex, and I remembered only at long intervals, hardly at all, that I was a
woman ... In truth, neither of the two sexes is mine ... I belong to a third
sex apart, which has as yet no name.'[6] Even more transgressively, d'Albert, in
the throes of his forbidden love, finds it possible to confess to the normally
repressed male wish to be a woman: 'I have never wished anything so much
as to encounter in the mountains those serpents which cause one to change
sex, as Tiresias the prophet did.'[7]

In the context of these ambiguities of gender, it is hardly surprising if
homoeroticism appears in the novel as the most romantic – because most
transgressive – form of erotic love, far surpassing other forms of eroticism in
crossing the boundary between the fashionably sinful and the satanically
damned, a damnation in which d'Albert almost glories as he describes his
passion for Théodore as utterly compelling:

> as compelling as the perfidious sphinx with the dubious smile and ambig-
> uous voice, before whom I stood without daring to attempt an explanation
> of the enigma ... to love as I loved, with a monstrous, inadmissible love
> ... to feel oneself devoured by longings that even the most hardened liber-
> tines would regard as insane and inexcusable; what are the ordinary
> passions besides this?[8]

This was, in fact, the logical conclusion of 'modern love' since it was always a
fatal and a forbidden passion: erotic love as transgression, destiny and death.

In *Lost Illusions* and *Splendeurs et Misères des Courtisanes*, written in the same
years as Gautier's novel, Honoré de Balzac traced the adventures of Vautrin,
criminal, priest and policeman, a character based on the notorious Charles
Vidocq. Vidocq was a real-life reformed criminal who became a police chief,

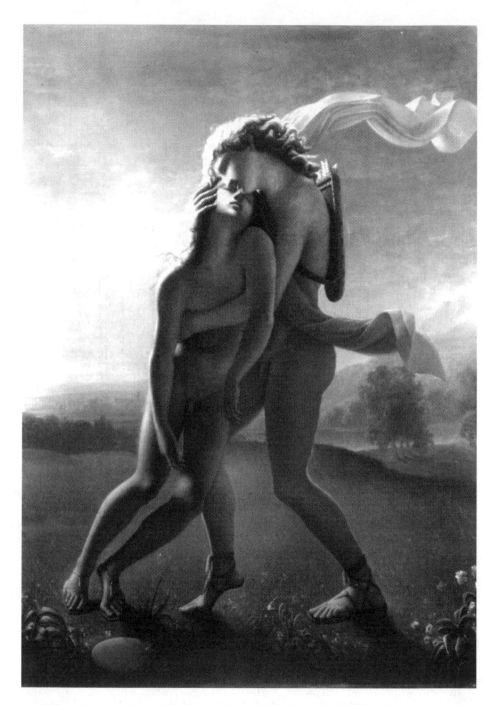

Figure 29 *Hyacinthe*, oil painting by Jean Broc, 1801. Courtesy Musée St. Croix, Poitiers. Broc was a member of the 'Barbus' group and this painting anticipates the homoerotic component of bohemian love.

and whose memoirs were published in 1828. In this widely read autobiography no hint of deviant – or indeed any – sexuality appeared; Balzac's Vautrin, on the other hand, is homosexual.

Vautrin is a satanic figure, endowed with enormous strength and cunning, yet he is also heroic and, in his love for the youthful, flawed 'hero' of these novels, Lucien de Rubempré, poignant and even tragic. Lucien, the would-be poet, is, by contrast, a weak, effeminate and narcissistic dandy, who, although he is supposed to be in love with the devoted courtesan, Esther, is fatally seduced by and appears to succumb to Vautrin's power. Lucien's self-centred passivity opens up a disturbing vista of ambiguous masculinity by contrast with Vautrin's charisma.

Vautrin cannot be described as a bohemian, yet anticipates the way in which the emergent bohemian's anti-bourgeois rebellion would embrace every form of outlawry, sexual deviance included. Nineteenth-century bohemian men consorted with prostitutes and lived openly with their mistresses, refusing the conformity of bourgeois marriage. Bohemian women, with considerably more difficulty, laid claim to the same rights to sexual freedom as men. The popularized bohemian legend has tended to emphasize the wine, women and song aspect of bohemian lifestyles, but although the majority of rebel artists were, unsurprisingly, heterosexual, more disturbing possibilities lurked behind the reassuring jollity: the homoeroticism and bisexuality that were central to bohemian life.

It was not surprising that sexual dissidents should have gravitated to circles in which the bourgeois conventions surrounding sexual relations were suspended or actively challenged. The incidence of homosexuality in bohemian circles was nevertheless more than a simple matter of social convenience. A possible and unwelcome link between sexual deviancy and artistic creativity was simultaneously recognized and disavowed.[9] A deviant eroticism was more than merely rebellious, for it involved the exploration of forbidden areas of experience, it permitted the assumption of new identities, it heightened awareness. As the critic Paul Schmidt has written: 'to be homosexual, even bisexual, is to be constantly aware of one's life in a way that heterosexuals are not forced to be ... to be aware of another possibility, another dimension.'[10] Homoeroticism, suggests Schmidt, separates sex from the reproduction of the species, and thereby denies time, becoming, potentially at least, a perpetual present moment of the extraordinary, of magic and exaltation. Western culture has delegitimated it and reduced it to the status of a psychological aberration. As a result, it has been experienced as a state of alienation and negation, when it might more constructively be seen as a cultural potentiality, the very alienated marginality of the lesbian and the queer a privileged viewpoint from which s/he gains a different perspective of critical vision.[11]

The new urban society called masculine identity in question. Charles Baudelaire suggested that new, more virile types of womanhood emerged from the labyrinth of city life: lesbians, female labourers and prostitutes. At

the same time the society of the spectacle was feminizing men. Both as obscure writer and as passive consumer the voyeuristic *flâneur* or bohemian became a kind of woman as he observed the urban world. This disturbing alteration was explored by Walter Benjamin, who interpreted the hesitancy of the *flâneur* and his wanderings in the urban labyrinth as a form of impotence – a perpetual deferral of the moment of consummation.[12]

Théophile Gautier's fascination with effeminacy did not amount to an investigation of its causes of the kind attempted by Benjamin. He and his friends seemed more concerned with a principled exploration of the further reaches of sexual pleasure. The brothers Goncourt recorded a conversation in which Gautier celebrated the asexual women, 'that is, the woman so young that she repels all idea of childbirth and obstetrics'. Not to be outdone, Flaubert, 'his face inflamed', proclaimed in his coarse voice that 'beauty is not erotic ... and that ultimately sexual love is the result of something unknown, which produces arousal, but very rarely beauty'.[13]

There were also bohemians, Gérard de Nerval and Alexandre Privat d'Anglemont, for example, who remained bachelors, of whose erotic lives almost nothing is known.[14] Gautier's friend, Charles Baudelaire, was yet more equivocal. Ten years or so younger than Gautier, he was the perennial rebel and poseur, the ultimate anti-bourgeois and bohemian. The adored son of a young woman and a much older man, who died when he was six, Baudelaire became enmeshed in a triangle of Oedipal jealousies when his mother was married again, this time to a handsome army officer, to whom she seems to have been much more passionately attached than she had been to Baudelaire's father. The stepfather, General Aupick, opposed Baudelaire's literary ambitions, but more serious even than that was the way in which Baudelaire felt he had been displaced in his mother's affections.

Baudelaire became the black sheep, and remained so throughout his life, plagued for most of it by poverty (largely as a result of his own extravagance, which resulted in his being declared legally unfit to manage his own affairs) and for many years by the syphilis that eventually killed him. His was a lifelong 'immaturity'. His failure to settle down and lead a respectable life, his endless difficulties and disappointments in the literary world, his Creole mistress and frequent flights from one sordid lodging to another in attempts to ward off his creditors, all these questioned the assumed natural order, the bourgeois conventions and the complacency of the philistine. But where Gautier flirted with transgression, Baudelaire flung himself into the role of outcast and *homme damné*.[15]

In later reminiscences his friends insisted obsessively on Baudelaire's beauty as a young man. Théodore de Banville wrote ecstatically that 'if ever the word seduction might be applied to a human being, it was to him', and described his beauty as 'at once virile and childlike ... seeing him, I saw what I had never yet seen, a man who was as I thought a man should be'.[16] Gautier was franker about Baudelaire's 'perhaps rather too insistent stare' and his lips 'as ironic and voluptuous as the lips of the faces painted by Leonardo da Vinci

... his nose, fine and delicate, a little rounded, with flared nostrils, seemed to smell vague, far off scents', while 'a vigorous cleft accentuated the chin, like the finishing touch to a statue; rice powder gave the carefully shaved cheeks a bluish, velvety bloom; the neck, as white and elegant as a woman's appeared casually, rising from a shirt collar which was turned back'.[17] The young Baudelaire, another friend remembered, took great care of his appearance, 'to which he brought a feminine coquetry'. He was proud of his small, soft, beautifully manicured hands (a trait shared with Byron) and took pride in 'an exaggerated cleanliness, with just a hint of scent and rice powder'.[18]

The Communard and republican, Jules Vallès, who belonged to a younger generation of bohemians, met Baudelaire much later, and dissented from the admiration of those who had known him in his youth: 'He had the head of an actor; shaven cheeks, rosy and bloated, a greasy nose, bulbous at the tip, his lips simpered nervously, his expression was tense ... he had something of the priest, something of an old woman and something of the ham about him. Above all he was a ham.'[19] At this period he often reminded his friends of a priest − a defrocked one, presumably.[20] Indeed, in Vallès' cruel description he more closely resembled a raddled old queen.

There *was* something of the homosexual manqué about Baudelaire. His thwarted but persistent attachment to his mother could have been a homosexual scenario, and homoerotic meanings have been read into some of his poems. The nature of his relationships with his mistresses is uncertain and his friend, the photographer Nadar, suggested that Baudelaire was a virgin (notwithstanding the syphilis that killed him). His misogyny may have been in part a defence against an inner femininity,[21] while his fascination with dandyism is also consistent, since the self-sufficiency of the dandy was part of a deviant and ambiguously gendered identity; on the one hand the dandy was a strangely asexual being, on the other homosexuality was reputed to be widespread among the Parisian dandies of the 1830s and 1840s.[22]

*

By the turn of the century an artistic subculture more radical than any yet seen had developed in Wilhelmine Germany. There, in the Expressionist Bohemias of Munich and Berlin, Gautier's 'modern love' underwent a significant transformation. The belief in romantic passion as a fatal destiny was being superseded by the idea of eroticism as sexual liberation: a move from the tragic to the ecstatic, from the doomed to the utopian, from emotion to sensation.

Anarchism was a potent force in the German bohemian rebellion against the authoritarian, patriarchal world of Germany under the Kaisers, but of even greater importance for the 'erotic revolution' was psychoanalysis. 'The bohemian way of life,' wrote Franz Jung, a bohemian of the period, 'was being drawn into the maelstrom of the twentieth century, and the most important role in the social critical destruction of the "good old days" was played by Sigmund Freud's concept of psychoanalysis.'[23]

The electrifying figure at the centre of the 'erotic revolution' was the psychoanalyst Otto Gross, 'erotic Dionysus' and drug addict. He was described by

Freud's English disciple, Ernest Jones, as 'the nearest approach to the romantic ideal of a genius I have ever met, and he also illustrated the supposed resemblance of genius to madness, for he was suffering from an unmistakable form of insanity that before my very eyes culminated in murder, asylum and suicide.'[24]

Gross[25] was the adored, and to begin with dutiful son of an ultra-Prussian patriarch, Hans Gross, jurist, magistrate and expert on detection. (Georges Simenon quotes his classic work on the subject of sleuthing.) Otto studied medicine and then worked as an assistant at Kraepelin's psychiatric clinic in Munich, but after he had graduated in 1899 he sailed for Latin America, where his lifelong addiction to narcotics seems to have begun.

In 1903 he married Frieda Schlosser (a Wagner enthusiast who had also considered doing social work at Toynbee Hall in London). Hans Gross approved the match, but two years later the relationship between father and son had become intensely antagonistic, as Otto developed theories of sexual repression and free love which he did not hesitate to put into practice.

His involvements with women rapidly became scandalous and even sinister. Not only did he end his love affair with a young woman, Regina Ullman, when she became pregnant, but she claimed he left poison in her reach, hoping she would commit suicide.[26] Gross then became involved in a series of scandals at the Munich outpost of Ascona, a settlement on the shores of Lake Como in the Italian-speaking part of Switzerland. In 1900 a group of seven Germans from Munich had arrived there, with the intention of setting up a commune. Among them were Ida Hofmann and Lotte Hattemer, emancipated women who wore reform clothing, left their hair loose (then extremely shocking) and travelled around by themselves. In 1906 Otto was involved with Lotte, and was staying with her in Ascona, as were Erich Mühsam and his companion, Johannes Nohl. Lotte was suicidally depressed, and when Otto provided her with poison, she, unlike Regina Ullman, conveniently put an end to her life.

A year later Gross became involved with the sisters Else and Frieda von Richthofen, also radical, emancipated women. Else had been a school friend of Frieda Gross and had married Edgar Jaffé, a wealthy industrialist turned academic, who was associated with Max Weber's circle;[27] her sister Frieda was unhappily married to an English professor, Ernest Weekley.

Shortly afterwards Otto became the father of sons born to Else Jaffé and to his wife, Frieda Gross (both infants were rather strangely named Peter, a hint that these 'free love' arrangements may have been fraught with rivalry). Otto's most intense love, however, seems to have been reserved for Frieda Weekley. She felt equally passionately about him, for it was her first erotically fulfilling relationship. What thrilled her, she afterwards wrote, 'was his vision, his new approach to human problems.' She was, she said, passionately grateful to him for giving her a new faith, that 'the human world could be happier and better than it was and more charitable'. Yet she resisted her lover's urgent demands that she leave her husband, recognizing his lack of balance: 'The everyday life he ignored. On visions alone you can't live. He hardly knew

whether it was night or day ... somehow ... something was wrong in him; he did not have his feet on the ground of reality.'[28]

The two Friedas afterwards shared another lover, Ernst Frick, later accused of having detonated a bomb in Zurich, but by the time of his arrest Frieda Weekley had eloped with D.H. Lawrence, with whom she spent the rest of her life. Frieda Gross was left miserable and impoverished, while her husband continued on the path that was to lead to his destruction.

Like many men as well as women, Leonhard Frank had been overwhelmed by the force of Gross's personality when he first arrived in Munich. He became part of Gross's circle, and fell in love with another member of the group, Sophie Benz. After a time Gross objected to the monogamous nature of this relationship, and in 1911 travelled with Sophie to Ascona. By this time he had introduced her to cocaine, and Leonhard Frank saw her for the last time at Munich railway station:

> Her hair and dress were dirty as though she had slept for weeks out of doors. Her shrunken, waxen face was that of a dead girl still unaccountably breathing. The doctor [Otto Gross] sniffed cocaine in full view of the travellers standing around him, and repeated the dose a few minutes later. He had lost all self-control. There were spots of blood on his crumpled collar. Blood and pus ran from his nostrils.[29]

Now it was Sophie's turn to become suicidal. Gross refused to allow her to be hospitalized and for the third time provided a fatal dose of poison.

By this juncture the name of Otto Gross was well known to the Swiss, Italian, German and Austrian police, and there was a warrant out for his arrest. In 1913 Hans Gross persuaded the Berlin authorities that his son was a dangerous psychopath and that the warrant should be activated. Otto Gross was apprehended and shut up in an asylum.

Here was the ultimate patriarchal act against the son who had refused his father's version of masculine identity. It was a symbolic attack on the very core of the erotic, anarchist and artistic Expressionist movements. So at least it seemed to the youthful adherents of these movements, and such was the uproar in the intellectual community that a protest campaign, orchestrated by Franz Jung, succeeded in gaining Otto's release a year later, although on condition that he underwent an analysis with Wilhelm Stekel.[30]

During the First World War Otto Gross lived in Prague, where he met Franz Werfel and Franz Kafka. (Kafka had actually been taught by Hans Gross, and his novel of nightmarish incarceration, *The Trial*, was written in the twelve months after Otto's imprisonment.) After the war Otto returned to Berlin. There he became completely destitute, and Jung described how: 'in December in the streets of Berlin could be seen a starving and ragged man, running through the snow flurries. He howled aloud ... and then huddled himself together, to get his fingers and chest warm. People stopped to stare at him.'[31] He died in hospital in 1920.

Gross acted out the whole youth crisis of the period. As an answer to that crisis he had tried to adapt psychoanalysis to a radical worldview. His work had begun to diverge from Freud's by 1908 or 1909, when, anticipating Wilhelm Reich, he redefined the sexual drive as a benign force, which is distorted by social institutions. The logical conclusion of this position was that to act out all one's sexual desires was to diminish repression and was in itself liberating. This was similar to the gratifying idea – revived by followers of Wilhelm Reich in the 1960s – that sexual intercourse automatically advances the revolution, a view propagated by Erich Mühsam, for example, when, in 1913, he listed in the first issue of the expressionist journal *Revolution* a 'few forms of revolution'; these included tyrannicide, creation of a work of art and 'the sexual act'.

Mühsam devoted his life to direct action, played a leading role in the Munich *Räterepublik* of 1919 and was murdered in Oranienberg concentration camp by the Nazis in 1934. But he believed as passionately in the erotic as in the workers' revolution. While still a schoolboy in Lübeck he and a friend, Curt Siegfried, began to write for the newspapers and move in journalistic circles. Even at this early age Mühsam was interested in the workers' movement and revolutionary struggle; Siegfried by contrast was an aesthete who took Wilde's Dorian Gray as a model: 'he dressed in the height of elegance, wore a large chrysanthemum in his buttonhole and claimed to be tired and blasé.' In 1903 he put a revolver to his head and shot himself.[32]

It would be possible to read a homoerotic subtext into Mühsam's account of this friendship, and Mühsam chose homosexuality as the subject of his first book, published in 1903. Given his hatred of German patriarchal society in general and of his own father in particular, it is hardly surprising that Mühsam argued for the validity of erotic love between men, since it attacked the authoritarian family at its core, questioning the rigid Prussian definition of manliness. Not only did Mühsam defend homosexuality in print, for many years he was content to let it be believed that he was homosexual, although he does not discuss this in his memoirs and also had a reputation for womanizing. Whatever its nature, his most important relationship between 1904 and 1909, his 'wandering years', was with Johannes Nohl, with whom he travelled between Berlin and Munich, to Paris, central Europe and Ascona. Nohl, another defector from a cultured bourgeois family, was openly homosexual, usually recalled in memoirs from the period with a string of young boys in tow, and he was, like Curt Siegfried, a Wildean character. Mühsam and he were thought to be lovers during their visit to Ascona at the time of Lotte Hattemer's suicide and Mühsam dedicated his collected love poems to Nohl when they were published in 1913. By this time, however, the two men had moved apart, and both later settled into relatively conventional marriages.

With the exception of Frieda Lawrence, it might seem that the bohemian women of Schwabing suffered more than they benefited from the 'free love' of the period. However, this was not true of Fanny Reventlow, variously known as the 'Queen of Schwabing,' the 'Schleswig Holstein Venus' and

Figure 30 Fanny Reventlow, the 'Schleswig Holstein Madonna' and Queen of Schwabing

'Pagan Madonna', Mühsam's friend and the lover of Ludwig Klages and many others. Like Frieda Lawrence she came from an upper-class family, which may have given her the confidence to rebel against her family and strike out on her own.

She was beautiful, 'a Danish type,' wrote one admirer, 'small, petite, supple, un-made up, far more Parisian than the real Parisians with all their rouge, a little brash, offhand, very witty, a little sentimental. On her dainty feet she stalked through the sodden Munich suburb of Schwabing and seemed always untouched, washed and shining, even when she almost sank.'[33] Mühsam recalled especially her huge blue eyes, hearty laughter and tragi-comic aura, while Frieda Lawrence described her at the age of forty as having 'the face of a young madonna', in spite of the wild life she had led.

Her attempts to achieve success as a painter and later as an actress met with no success. She had better luck with journalism and wrote two autobiographical novels, but poverty was a perennial source of bitter torment and hilarity. This being the case, she did not hesitate from time to time to accept payment from men with whom she had enjoyed an erotic encounter. She sometimes worked as a masseuse, seriously considered becoming a courtesan, and in her diaries recorded several erotic adventures involving money. In 1898, for example, she met three students with whom she had supper and an 'orgy', for which they paid her 150 marks:

> Afterwards I told them something about my life and my plans for acting ... and we killed ourselves laughing. Then between lust and tragedy and I know not what. 'We will live together so that you can become a star' ... Marie had stayed with Bubi [her baby boy] and I returned home at four o'clock in the morning through the beautiful dawn. I did not let them accompany me, since I wished to retain my incognito ... Oh, dear God, if they only knew that I was a countess, had been married, etc.[34]

So her casual erotic liaisons involved performance, disguise and a kind of make believe. Even when she engaged in what others might have perceived as casual prostitution, she was the princess in disguise, to some extent simply slumming.

Her belief in women's freedom was not feminist in the usual sense, although she had feminist friends, for she believed that the path to women's liberation lay through the freeing of their sexuality. In her novels she wrote of herself as a 'martyr for freedom' and a 'gladiator of the new time', but she also wrote in her diary that 'working women are always rather horrible' and believed that writing and gainful employment generally made women old and ugly.[35]

She evaded the pleas of Otto Gross that she should undergo psychoanalysis, understandably sceptical, in the circumstances, as to its merits. Any radical observer of the transformation undergone by Freudian theory after it was exported to Greenwich Village might well share this scepticism.

*

The influence of psychoanalysis once it had crossed the Atlantic inaugurated – or at least was part of – a further transformation in bohemian love and indeed of Bohemia generally. Greenwich Village was a more open and less extreme Bohemia than the German, and in its atmosphere psychoanalysis was domesticated. Harnessed to the erotic revolution in pre-war Munich, Freudian

theory lost its radical edge when it crossed the Atlantic. This may have been partly due to the personality and prejudices of Dr A.A. Brill, who was responsible for bringing Freud to the United States for his first lecture tour and for promoting psychoanalysis there.

Early in 1914 Brill spoke on psychoanalysis at one of Mabel Dodge's 'Evenings'. This was probably the first formal discussion of Freudian theory in Greenwich Village,[36] and Mabel Dodge was one of the first Villagers to undergo a course of treatment with Dr Brill. She was not impressed, describing psychoanalysis in her memoirs as little more than 'a kind of tattle-taling,' and she recalled that Brill: 'had not much use for my radical friends, and he considered that their beliefs were generally only rationalized prejudices, and that their prejudices were due to their conditioned early years and that when they got together they bolstered up each other's complexes.'[37]

The role of psychoanalysis in the Village was to depoliticize, to emphasize the personal and individual side of New York's 'cultural revolution' rather than the political. Max Eastman and Floyd Dell were immediately attracted to the new doctrine, and were soon writing articles publicizing Freud's views in the popular press. In the December 1915 issue of *Vanity Fair*, for example, Dell wrote that 'psychoanalysis is the greatest discovery made by intellectual conversationalists since Bergson and the International Workers of the World'.[38] The mocking tone was typical of his style, but he took Freud very seriously, and in 1917 he underwent analysis with Dr Samuel Tannenbaum.

Dell was one of the most influential chroniclers of the Village at this period. Yet although he lived a bohemian life there and had a number of love affairs with independent women, including Edna St Vincent Millay, he invariably wrote of its radicalism of lifestyle and belief in 'free love' in a cynical and sneering tone. His course of analysis seems to have crystallized his judgement that Greenwich Village and bohemian ways of life generally were immature and 'adolescent'. The Village, he decided, 'was a place where people came to solve some of their life problems ... a moral health resort, that is what it was'. The women of this community claimed to believe in free love, but, he asserted, secretly longed to get married, and some of them 'saw in the Village only a better place than the home town to find husbands'.[39] By the late 1920s his hostility to independent women was explicit: 'I did want to find marriage ... I did not care if my new sweetheart were not an intellectual. Her beautiful breasts were perfect for the suckling of babies ... I felt quite sure now that I did not want to be married to a girl artist; I wanted to be married to a girl who would not put her career before children – or even before me. One artist in the family was enough.'[40]

His second wife, Marie Gage, whom he married in 1919 and with whom he departed to the suburbs, *had* been an intellectual, a socialist and feminist at the University of Wisconsin and a pacifist who had been prosecuted in California for her activities against the war effort. After her marriage to Dell at the age of twenty-three, however, she devoted herself to the roles of wife and mother. This whole generation of male radicals in Greenwich Village,

including Max Eastman and Hutchins Hapgood, had difficulty in aligning their supposedly radical ideals and belief in feminism with their desire for love relationships in which women remained subordinate.[41] And psychoanalysis could all too easily be wheeled in to justify such views.

Its influence was double edged. As it developed into an adjustive therapy, both in the United States, and to a lesser extent in Britain, it became increasingly intolerant of bohemian eccentricity. A vulgarized Freudianism reduced social movements and radical politics to no more than a side effect of family trauma, a collective neurosis that merely represented each individual radical's rebellion against his or her father. On the other hand it promoted a belief in the importance of sexual fulfilment, and integrated eroticism more fully into the rest of life.

Bohemian love, however, had begun to infiltrate the wider culture long before this. In the nineteenth century the bourgeoisie had been seduced by the Romantic Movement, which had seemed to express a refinement of feeling far removed from the coarse and cynical worldliness of the eighteenth-century aristocracy. The middle classes adopted romantic love as their own, although in squeezing it to fit a new form of marriage, they suppressed its tragic elements in favour of happy families. The figures of 'fallen woman' and 'fatal man' have continued nevertheless to haunt Western culture, incarnated in new forms – Marilyn Monroe, Ann Rice vampire heroes, Princess Diana and Dodi al Fayed.[42]

Western secular societies no longer believe in self-control and sublimation, nor that familial duty must always triumph over wayward desire. The nineteenth-century bourgeoisie attempted to domesticate Gautier's 'modern love,' but today liberal Western society has gone much further in adopting what is essentially a bohemian belief in the transcendent value of erotic passion as the touchstone for the authenticity of relations between the sexes. There is a widespread belief that these relationships must be spontaneous. Thus Western marriage ceremonies today more often testify to the unique spontaneity of erotic love between two individuals than to religious and contractual obligations regarding family and property. To the bohemians is partly owed the liaison between Romanticism and consumer culture in which transgression, excess, feeling and sensation triumph over reason, with Sigmund Freud as the Enlightenment midwife to an offspring that no longer salutes Enlightenment values. In this sense, we can say that even if Bohemia is in decline or has disappeared altogether, today we are all bohemians.

Notes

1 Théophile Gautier, *Histoire du Romantisme*, p 92.
2 George Sand, *Lélia* (Paris: Henri Dupuy, 1833), p 16.
3 Pierre Bourdieu, *The Field of Cultural Production*, p 155.
4 Paul Bénichou, *L'École du Désenchantement: Sainte Beuve, Nodier, Musset, Nerval, Gautier* (Paris: Gallimard, 1992), p 525.

5 Gray Du Plessix, *Rage and Fire*, pp 346–7, quoting Louise Colet, *Les Pays Lumineux: Voyage en Orient* (Paris: E Dentu, 1879).

6 Théophile Gautier, *Mademoiselle de Maupin* (orig publ 1835; Paris: Garnier-Flammarion, 1966), p 356.

7 Ibid., p 112.

8 Ibid., p 266.

9 Evidence that this disavowal continues to operate may be found in the Penguin editions both of *Splendeurs et Misères des Courtisanes* (the title rather clumsily translated as *A Harlot High and Low*) and of Arthur Rimbaud's *Collected Poems*. Balzac's translator, Rayner Heppenstal, suggests that to interpret Vautrin's love for Lucien as homosexual is to put a twentieth-century spin on what was more likely to have been a 'normal' degree of affection between an older and a young man. Yet it does not require a particularly close reading of the novel to grasp the absurdity of this assertion. In a semi-comic interlude, for example, Vautrin, in prison, discovers a former lover there. Balzac refers to this (male) lover as Vautrin's paramour and mistress, and tells us that he is being held in a section of the prison especially reserved for 'queens' and for the 'third sex'. Oliver Bernard, in his introduction to Rimbaud also rather ludicrously states: 'I do not think his homosexuality matters nearly so much as what sort of person he was', as though the poet's sexuality could be entirely divorced from 'the sort of person he was', for even if, following Michel Foucault, one rejects the idea of sexual 'master identities' it does not follow that an individual's sexual behaviour is wholly irrelevant in the context of his life and work as a whole. Both these introductions were written in the 1960s, but significantly Penguin has seen no reason to update them.

10 Paul Schmidt, 'Visions of Violence: Rimbaud and Verlaine', in George Stamboulian and Elaine Marks (eds), *Homosexualities and French Literature: Cultural Contexts/Critical Texts* (Ithaca NY: Cornell University Press, 1979), p 235.

11 Ibid.

12 Walter Benjamin, 'Central Park', *New German Critique*, trans Lloyd Spencer, 34 (Winter, 1985), p 40; and see Susan Buck-Morss, 'The Flâneur, the Sandwichman and the Whore: the Politics of Loitering', *New German Critique*, 39 (Fall 1986), pp 99–140.

13 Goncourt and Goncourt, *Journal des Goncourts*, vol. 2, p 177.

14 Bénichou, *L'École du Désenchantement*.

15 See Claude Pichois and Jean Ziegler, *Baudelaire*, trans Graham Robb (London: Vintage, 1991), *passim*.

16 De Banville, *Petits Etudes: Mes Souvenirs*, pp 73–4.

17 Bandy et Pichois (eds), *Baudelaire devant ses Contemporaines*, p 22, quoting Théoile Gautier.

18 Ibid., quoting Edmond Croset, 'Fantaisie Baudelaire', in *La Vogue Parisienne*, 7 September 1867.

19 Ibid., quoting Jules Vallès, 'Charles Baudelaire', in *La Situation*, 5 September 1867.

20 Jean-Paul Sartre describes Baudelaire in similar terms. See Jean-Paul Sartre, *Baudelaire* (Paris: Gallimard, 1963), p 194.

21 Similar in this regard to William Burroughs.

22 Pierre Citron, *La Poésie de Paris dans la Littérature Française de Rousseau à Baudelaire* (Paris: Gallimard, 1963), p 194.

23 Franz Jung, *Der Weg Nach Unten: Aufzeichnungen Aus Einer Großen Zeit* (Berlin: Hermann Luchterland Verlag, 1961), p 89.

24 Ernest Jones, *Free Associations* (London: Hogarth Press, 1958).
25 I am indebted throughout this section to Martin Green, *Mountain of Truth: The Counter Culture Begins: Ascona 1900-1920* (Harvard, Ma: University Press of New England, 1986), *passim*; and to Arthur Mitzman, 'Otto Gross: Anarchism, Expressionism and Psychoanalysis', *New German Critique*, no. 10, Winter (1977), pp 77-104.
26 Jennifer Michaels, *Anarchy and Eros: Otto Gross's Impact on German Expressionist Writers* (New York: Peter Lang, 1983), pp 19-20.
27 See Sam Whimster with Gottfried Heuer, 'Otto Gross and Else Jaffé and Max Weber,' *Theory Culture and Society*, Special Issue on Love and Eroticism, xv/3-4 (1998), pp 129-60.
28 Frieda Lawrence, *The Memoirs and Correspondence*, ed E.W. Tedlock (London: Heinemann, 1961), pp 86, 90-91.
29 Frank, *Heart on the Left*, p 45.
30 Franz Jung, *Der Weg Nach Unten*, pp 89 *et seq*.
31 Ibid.
32 Mühsam, *Unpolitische Erinnerungen*, p 52.
33 Fritz, *Die erotische Rebellion*, 80, p 28, quoting Baldur Olden.
34 Franziska zu Reventlow, *Tagebuch* (5 June 1898; München-Wien: Langen Müller, 1971), p 85.
35 Fritz, *Die erotische Rebellion*, p 88.
36 Watson, *Strange Bedfellows*, p 137.
37 Dodge-Luhan, *Intimate Memories*, p 572.
38 Watson, *Strange Bedfellows*, p 145.
39 Dell, *Homecoming*, pp 272, 287.
40 Ibid., p 283.
41 Trimberger, 'Feminism, Men and Modern Love', in Snitow, p 184.
42 For a discussion of Princess Diana as the contemporary equivalent of a fallen woman see Elizabeth Wilson, 'The Unbearable lightness of Diana', *New Left Review*, no. 226, November/December 1997.

A TASTE FOR THE INFINITE

Man's vices, however horrific, contain proof (even if only in their infinite exten-sibility!) of his taste for the infinite; only – it is a taste which often takes the wrong path.

Charles Baudelaire: Les Paradis Artificiels

Erotic experience was only one of several routes to the altered state to which the bohemian aspired. The stereotype of the bohemians as jolly fornicators, roisterers and barflies is superficial because it completely ignores the significance of Excess. If Bohemia was a journey as well as a destination, it was a journey in the dark to a land of danger as well as pleasure. It promised a path along the edge of a precipice, and it was impossible to know in advance whether that path led to revelation or madness, triumph or oblivion. The point of Excess was ultimately not self-gratifica-tion, but self-discovery, or sometimes self-destruction, as Baudelaire expressed it, 'a taste for the infinite.' The deadly sin of Bohemia was not Lust or Gluttony, but Hubris – the pride of Daedalus, who courted death by daring to fly.

The association of intoxication and extreme states with creativity had ancient roots. According to classical Greek legend, the beautiful but effemi-nate god of wine, Dionysus, son of Zeus and Semele, was driven mad by Hera, Queen of Heaven, in her jealousy at her husband's infidelity. Her curse caused Dionysus to wander over the earth, but as he travelled through the Middle East and Asia he introduced the cultivation of the vine, which was associated with the early development of civilization. Returning to Greece, he attracted female followers – bacchantes – and when Pentheus, King of Thebes tried to prevent the local devotees from worshipping the god and indulging in their bacchic frenzy, they tore him

to pieces. This representation of the madness of excess was closely connected to the production of art, since Greek drama grew out of the dithyrambic choruses recited at Dionysiac festivals.

In modern times the self-destruction of the bohemian through excess partly reversed the story of Pentheus, since now repressive society destroyed the dionysiac artist who nevertheless triumphed in achieving martyrdom. Oscar Wilde's fate has been retrospectively interpreted in this way. Modigliani, too, was portrayed after death as the victim of society's failure to recognize his genius. More recently rock stars such as Janis Joplin, Jimi Hendrix and Curt Cobain were posthumously mourned as victims of a culture that destroys its artists. In these legends excess becomes the occupational risk of genius and the price of fame.

The genius needed – craved – heightened experience. Modigliani believed that the artist is created 'for intense life and joy. We ... have rights that others have not, because we have different needs that place us above ... their moral code. Your real duty is to save your dream ... You must hold sacred ... all that which may exalt and excite your intelligence. Seek to provoke and multiply all such stimulating forces which alone can drive the intelligence to its utmost creative power.'[1]

The association of genius with excess provided for the play of the interminable ambivalence with which the bohemian was surrounded. Once the idea of artist as rebel, indulging in every kind of forbidden pleasure, had been established, it became not only a potential role for every artist, it became a role for those who would never succeed as artists. It became an aspiration for those whose talent did not match their aspirations, who wanted to *be* bohemian rather than create works of art, who wanted in some way to stamp their individuality on an indifferent society. Excess was the enactment of genius unrecognized, but equally of lack of genius, or of sheer eccentricity.

The Communard bohemian, Jules Vallès, had a name for these awkward individuals: 'the Refractory Ones.' They had 'sworn to be free' and 'instead of accepting the place in life to which they were destined, wanted to make a place for themselves by dint of their own efforts alone, whether by audacity or talent.' They therefore deliberately went against the grain. They 'cut across the fields instead of keeping to the main road,' and made their way along the gutters of Paris instead of sticking to the pavement. Vallès included among the refractory ones:

> the professor who has sold his gown, the officer who has exchanged his tunic ... the lawyer who has become an actor, the priest who takes up journalism ... all those who have a mission to complete, a sacred trust to carry out, a flag to defend ... all those who have no roots in life, no profession, no standing, no skill ... whose only baggage ... is the obsession they make of art, literature, astronomy, magnetism, chiromancy ... or who dream of founding a school or a religion.[2]

Jerrold Siegel cites Murger's emphasis on work and abstinence as hallmarks of the bohemian way of life. He argues that Bohemia was to some extent a 'parody' of bourgeois society, a kind of mirror image. The bohemian, he suggests, was preoccupied with uncertainties similar to those that plagued the bourgeois, and acted out tensions and conflicts that were central to bourgeois society, 'testing and probing' its boundaries, but above all he was ultimately as dedicated as any capitalist to the imperatives of the work ethic.[3] Murger's insistence that he and his friends were 'water drinkers' was partly a reaction to the stereotype of the café idler and imbiber, and his version of the legend treated poverty and the bohemian way of life as unwelcome necessities rather than a chosen alternative.

To equate bourgeois values with the work ethic is itself one-sided. The relationship between bourgeois and bohemian was symbiotic, as much because they shared an addiction to risk-taking, as because of a shared work ethic. Bourgeois capitalism, after all, was founded on risk. Industrial capitalism practised cut-throat competition and was – and is – plagued by cyclic instabilities of boom and recession. The captain of industry was often an adventurer who took considerable risks and on occasion sailed close to the wind. Scientists, too, staked their reputations on the exploration of new realms – Sigmund Freud, for example, outwardly bourgeois, referred to himself as a 'conquistador,' an intellectual conqueror and hero. Yet although this was a high-risk society, the surface of bourgeois life operated as a wholesale denial of this, above all in personal terms. Everything about it was designed to create the impression of stability and calm, the bourgeois family and domestic environment in particular. Many nineteenth-century novelists explored the illusory nature of this surface calm.

Artists and bohemians therefore addressed many of the problems that lay beneath the surface of bourgeois society when they confronted the emotional and subjective implications of risk and danger. They journeyed into the subjective and unstable world of feeling and experience, so that they not only offended the puritanical proprieties of bourgeois society, but, even more disturbingly, demolished the myth of life as safe and secure with their explorations of tragic passion, insanity and squalor. To recuperate them too far, as Siegel does, for the work ethic, almost wilfully underplays the huge differences between a respectable and a deviant way of life, especially for women. It trivializes the violence of the protest made by many bohemians against the amoral, profit-driven social order in which they were forced to live. It leaves out the 'refractory ones' whose lives rather than their work were their main creations; and it obliterates the importance of extreme experiences for those who were bent on creating works of art from the raw material of their own lives.

That is not to say that excessive indulgence in drink and drugs was necessarily deliberately undertaken as part of a search for this material. In the nineteenth-century Bohemia of the cafés and cabarets alcohol was almost an occupational hazard, and bohemian men drank heavily more or less as a

matter of course. Maxime du Camp recalled that Baudelaire got through two bottles of red wine in an hour on the occasion of their first meeting;[4] at Rosalie's café, where Nina Hamnett met Modigliani, red wine cost just five centimes a bottle and a glass of champagne could be had for a few sous. Drink was a cheap solution to life's difficulties, and was, unsurprisingly, a way of life, especially for men – Nina Hamnett drank to excess and Nancy Cunard was famous for her drunken binges and the aggression that emerged on such occasions, but many bohemian women avoided drink altogether. Sylvia Beach, Natalie Clifford Barney and Bryher (Winifred Ellerman) were teetotallers in the 1920s, and despised the macho drinking of Ernest Hemingway and his crowd. On one occasion Bryher looked round at her drunken male companions and realized to her horror that 'it was a vicarage garden party in reverse. These rebels were no more free of the conventions ... than a group of old ladies.'[5] It was positively *conventional* for bohemians to get drunk.

Another explanation for excessive indulgence in drink and drugs was the commonsensical belief that it was a kind of rest cure. Drink, suggested Nicolette Devas, writing of Augustus John, provided a period of oblivion and a respite from creative endeavour. It 'blunts the edges of sharp reactions ... you sail through the day in a delicious blur, while the unconscious gets on with the business of renewing lost energy.' Sex, she felt, could have a similar effect.[6] Marianne Faithfull made a different, but related point: 'You turn to alcohol, to drugs to help you get through. It's a form of self-medication, an act of self-preservation.'[7]

The double and contradictory properties ascribed to drugs – it was claimed both that they diminished experience by blunting the feelings, and that they heightened experience opening the mind to intense sensations – had long fascinated creative individuals. Thomas de Quincey had written of the compelling promise of opium and the suffering his addiction to it caused him in *Confessions of an English Opium Eater*, published in 1821. This formed the basis for Baudelaire's *Les Paradis Artificiels*, which repeated and amplified de Quincey's ambiguous message. Writing of the terrible morning after the god-like mood of the previous evening, Baudelaire proclaimed: 'Man is forbidden, on pain of degeneration and intellectual death, to disturb the primordial conditions of his existence and to rupture the equilibrium established between his faculties and the circumstances in which he is destined to exist, in a word, to meddle with his destiny in order to substitute for it a new kind of fatality.'[8]

Yet to 'disturb the primordial conditions of existence' was exactly what many artists wished to do, and Baudelaire's discussion glamorized the experience of drug taking while purporting to warn against it:

> Remember Melmoth. His atrocious suffering had its roots in the discrepancy between his marvellous gifts, acquired instantaneously through a pact with Satan, and the milieu in which, as a creature of God, he was condemned to live ... it was easy to understand the rapport that exists

between the satanic creations of the poets and those creatures who have dedicated themselves to drugs ... Each one of us that refuses to accept the conditions of his life sells his soul ... man wanted to be God, and as an inevitable result he was cast down lower than his real human nature.[9]

It was precisely the lure of such suffering that drew the fatal men and women of Bohemia as moths to a flame.

The dangers of opium addiction were understood in the nineteenth century, but its use was legal and it could easily be purchased in various forms, such as laudanum, a tincture, which was widely used by respectable middle-class women and professional men. Samuel Taylor Coleridge became an addict, and wrote his unfinished poem, 'Kubla Khan', under its influence.[10] Wilkie Collins described its dire effects in *The Moonstone*, but his addiction was perceived not as deviant, rather as the result of overwork or medical treatment gone wrong. It was only towards the turn of the century that drugs began to be associated in the West with moral deviancy and criminality. Typical users – and pushers – were now perceived as working men, non-white races, especially the Chinese, and women such as actresses and society celebrities, who were represented as sexually wayward and whose lives were interpreted as a challenge to patriarchal authority. In this way drug use developed a new set of meanings, and the moral panic surrounding their use depicted them as the inevitable road to degradation and an early death.[11]

At all times, however, drugs were associated with altered mental and emotional states, and with madness. Although often used as a form of self-medication, the cure could be worse than the disease, intensifying, for example, the depression it was intended to alleviate. The 'fierce chemistry' and 'insufferable splendour' of de Quincey's opiate-induced dreams:

> were accompanied by deep-seated anxiety and gloomy melancholy ... I seemed every night to descend, not metaphorically but literally to descend, into chasms and sunless abysses, depths below depths, from which it seemed hopeless that I could ever reascend. Nor did I, by waking, feel that I *had* reascended ... the state of gloom which attended these gorgeous spectacles, amounting at last to utter darkness, as of some suicidal despondency, cannot be approached by words.[12]

Drugs and madness were therefore closely allied, but although both could destroy, they could also redeem the artist; they drove you mad, yet cured you; they were a form of escapism, yet brought you face to face with sublime truths.

Otto Gross was an example of the drug-driven bohemian whose life was both more exalted and more degraded than that of ordinary men. He and his fellow Nietzscheans blurred the distinction between madman and seer. Nietzsche himself had gone mad, and Gross was the hero of a youth movement for whose adherents madness was a privileged condition and the

psychiatric asylum an instrument of patriarchal state oppression (a view revived in the 1960s by radical psychiatrists such as R.D. Laing and David Cooper).

In the Bohemias of *fin de siècle* Munich and Berlin mental instability seemed especially prevalent, due, perhaps, to the intolerable contradiction between the patriarchal authoritarianism of Wilhelmine society and the intensity of radical ideas, as the works of Ibsen, Nietzsche and Freud captivated a generation of dissident intellectuals and artists. It has even been alleged that Freud's theory of the unconscious was born of Viennese bohemian café life, although Freud himself was no great lover of cafés.[13] Certainly Ernest Jones, Freud's earliest British disciple, first witnessed a psychoanalytic session in a Munich café:

> Otto Gross was my first instructor in the technique of psychoanalysis. It was in many ways an unorthodox demonstration. The analytic treatments were all carried out at a table in the Café Passage, where Gross spent most of the twenty four hours – the café had no closing time. But such penetrative power of divining the inner thoughts of others I was never to see again, nor is it a matter that lends itself to description ... Shortly afterwards Gross was removed to Jung's Bürgholzli asylum.[14]

Franz Werfel later described a similar occasion in his autobiographical novel, *Barbara oder die Frömmigkeit*. In this account, 'Gebhardt,' based on Gross, sits between two women, and analyses both. One of them uses cocaine frequently and mouths psychoanalytic concepts without understanding them. Later a third woman joins the analytic session. (Werfel wrote this account in the late 1920s, when he had long since – under Alma Mahler's influence – rejected the Bohemia of his youth. Also, since Werfel met Gross only in Prague during the First World War, he may have known of the café scene only from hearsay. In any case, like so many bohemian legends, it may well have been highly embellished or even apocryphal.)[15]

During the Weimar Republic years, the conflict in Germany between traditional morality and radical ideas of every kind, between rural conservatism and the astonishing modernity of the metropolis, became intolerable. The dancer, Anita Berber, personified these extremes, as she performed on a knife edge between insanity and experimental art on the one hand and glamorous celebrity on the other, fuelled by drugs and presenting herself as the epitome of Weimar decadence. She had spent her childhood in Munich and brought the Schwabing spirit into post-war Berlin, first as a 'naked dancer' in cabaret, then as a successful singer and film star, appearing in *Dr Mabuse* and in *Anders Als die Andern*, an early film about homosexuality. Notorious for her exploits in Berlin's lesbian and gay subculture, she, like Marlene Dietrich, sometimes wore men's clothes. In spite of this she was also married three times and with her second husband, Sebastien Droste, she formed a controversial dance partnership, with performances entitled 'Suicide', 'Morphine',

Figure 31 Charlotte Berend-Corinth's portfolio of artistic erotic images of Anita Berber, 1919.

'Night of the Borgias', and 'House of the Mad'. Her Dionysian dances anticipated the way in which performance seemed increasingly not only to blur the distinction between life and art, but to be reaching for an intensity of experience that came close to charismatic religious frenzy.

Klaus Mann felt that she was the absolute symbol of the Weimar spirit of intoxication, and wrote that 'scandal was her daily bread'. On one occasion she appeared in the dining room of Berlin's best hotel, the Adlon. Her flaming red hair contrasted starkly with her greenish white face; her fur coat was buttoned to the chin; she wore high-heeled gold shoes, but – unbelievably shocking at that time – no stockings. Calling loudly for three bottles of Veuve Clicquot, she removed her coat. A gasp went round the room, for she was stark naked.[16]

She represented simultaneously a Berlin night world of clubs and cabaret, inextricably associated with prostitution and with a female sexuality liberated from patriarchal control, and the expressionist world of avant-garde ideas and erotic ideals, yet presented them to a mass cultural audience. Caricatured in the popular press, which also disseminated her fashionable publicity stills, she was also portrayed by Charlotte Berend-Corinth in a series of erotic lithographs for a limited audience 'accustomed to fine art but aware of the popular construction of stars'.[17]

Otto Dix painted her in a garnet red dress which, despite its high neck and long sleeves, clung to her body, revealing every line. In photographs her face looks innocent and blank, but Dix's misogyny transforms her into a malevolent vamp with black eye make-up and tiny, lasciviously pursed lips. That was how Weimar wanted to see her, before growing tired of her as she went spectacularly to the bad, a slave to cocaine, and dead before she was thirty from galloping tuberculosis:

> The last time I saw her was in front of Alfred Flechtheim's house during *Fasching*. He was giving a private masked party at his place, for company that was certainly a little too sophisticated for Anita, and she was not let in. She stood in the street and yelled so you could hear her all over Tiergarten ... We didn't hear any more of her for a while after that. Then the rumour started ... that she was fatally ill in the south. The south was Baghdad and she was penniless. We got a collection together to bring her back, and so it was that she returned to Berlin to die.[18]

Cultural contradictions were particularly stark in Weimar Germany, but existed everywhere. The life of the French theatrical innovator, Antonin Artaud, was, like Berber's, and in the same period, a chronic struggle with mental breakdown and drug addiction, which began in adolescence when he was introduced to opium by a psychiatrist in the sanatorium where he was taking a 'rest cure'. At the age of twenty-three he arrived in Paris. At first, penniless, he drifted between cheap hotels, but his beauty, ambition and talent soon secured him an appearance as Tiresias in Cocteau's version of *Antigone*, an important production directed by Charles Dullin, with sets by Picasso, costumes by Chanel and music by Arthur Honegger. He played Marat in Abel Gance's film, *Napoleon*, appeared in Dreyer's film of *Joan of Arc*, and in several films produced at the Berlin UFA studios, but his main interest was live theatre. Throughout the 1920s (when he was associated with the Surrealists for a time) he was developing radical, anti-naturalistic theories of performance, and in 1932 completed the first draft of his manifesto for what he now termed the 'Theatre of Cruelty.' His attempts to realize his ideas culminated in an experimental production of Shelley's *The Cenci*.

In the mid-1930s, exhaustion after a period of gruelling travel in Mexico tipped him into delusion and in 1937 he was detained at the Sainte-Anne psychiatric clinic outside Paris, where Jacques Lacan was in charge. Lacan,

however, displayed little interest in his unusual patient, and for the next nine years Artaud was shunted from one hospital to another. No clear diagnosis of his condition was ever made, but he was subjected to 51 ECT (electro-convulsive therapy) shock treatments, administered without anaesthetic. When finally released, he was already suffering from an undiagnosed cancer, but he continued to perform until his death in 1948.[19]

Carl Solomon formed a direct link between Artaud and the American Beats, for in 1946 he walked by chance into a Paris art gallery where a performance by Artaud was in progress. Reading from his own text on Van Gogh, Artaud declared that 'a lunatic is a man who prefers to become what is socially understood as mad rather than forfeit a certain superior idea of human honour'.[20] On returning to New York, Solomon enrolled as a student at Brooklyn College, and there committed a 'gratuitous act' inspired by Artaud: he stole a peanut butter sandwich from the cafeteria and then informed the security guard. The nightmarish consequence of this trivial misdemeanour mirrored Artaud's years in the asylum, for Solomon was detained at the Columbia Psychiatric Institute, and was there subjected to another experimental but popular treatment of the period, insulin coma. The comas produced convulsions and amnesia, but instead of recognizing the cause of these symptoms in the treatment, psychiatrists diagnosed them as further evidence of deep-seated psychosis and Solomon was made to undergo fifty further comas.

In the Institute he met another patient, Allen Ginsberg. Ginsberg's mother had become schizophrenic, and he himself had experienced visions and hallucinations, but he was undergoing psychiatric treatment as part of a deal to avoid a prison sentence after he had inadvertently become involved in receiving stolen goods from Herbert Huncke. Ginsberg was impressed by the way in which, he felt, Solomon appeared to have embraced the madness that had been thrust upon him, boasted of absurdist acts and spouted surrealist epigrams.[21]

Solomon recovered, and as a publisher's editor was responsible for the appearance in print of William Burroughs' *Junkie*, but turned down Jack Kerouac's *On The Road*. Later he suffered a further breakdown and was detained in the huge Pilgrim State Hospital, Long Island, where Ginsberg's mother was also permanently locked up. The famous first line of Ginsberg's poem, *Howl* – 'I saw the best minds of my generation destroyed by madness' – alluded to both these figures.

Burroughs, Ginsberg and Kerouac, the Beat 'group of libertines,' had first met in 1943, brought together by a fourth, Lucien Carr, a student at Columbia. Carr, too, had a psychiatric history, but his friends saw him as a Rimbaud figure, a genius manqué. 'Carr and his scarred ego,' wrote Ginsberg in his diary. 'He had to be a genius or nothing, and since he couldn't be creative, he turned to bohemianism, eccentricity, social versatility, conquests.'[22]

But Carr had unfortunately made one conquest too many: David Kammerer, an older man who had been following him obsessively since they

had first met as scout and scout master in St Louis. For some time Carr
tolerated and played up to Kammerer's obsession, but one night when drunk
he stabbed him to death on Riverside Drive. Because he was so young, and
because his victim had made unwelcome homosexual advances to him, Carr
did a mere two years in a reformatory. Yet when he came out of prison he
was changed. He was no longer Rimbaud; he went straight, got a job, got
married, described himself as 'petit bourgeois'.

The choice between madness and conformity seemed that stark in cold war
America, where the definition of normality had become extraordinarily
narrow. When the writer Seymour Krim had a breakdown in the 1950s, his
psychiatrist described Greenwich Village as a 'psychotic city', and when Krim
brought another psychiatrist to the Village café, the San Remo, she said it
reminded her of the admissions ward at Bellevue mental hospital.[23] That
only made madness seem more meaningful as a way of blasting through the
conformity, as Kerouac asserted when he wrote: 'The only people for me are
the mad ones, the ones who are mad to live, mad to talk, mad to be saved,
desirous of everything at the same time, the ones ... who burn, burn, burn,
like fabulous yellow roman candles exploding like spiders across the sky.'[24]

William Burroughs was equally drawn to the 'lower depths' of New York.
He hung about Times Square in the belief that there he would 'surely find
some hidden rock bottom truth in that treacherous, all night world of
pushers and addicts, thieves and whores, that you couldn't get by reading
Dostoevsky or Céline – it had to be experienced directly'.[25] In the 1940s the
district was 'was picturesque without being sleazy. Instead of porn movie
houses, it had art houses that showed French films such as *Pépé le Moko* and
Le Jour Se Lève'.[26] Nevertheless he found there the demi-monde of pimps and
hustlers he was looking for, and they provided the raw material for *Junkie*.

For many years, Burroughs lived a life of resolute marginality. He was a
remittance man, with an allowance from his family, which enabled him to
avoid regular work. This was a lifeline, for, as he said to Ginsberg, 'a regular
job drains one's very lifeblood ... It's supposed to. They want everything
you've got.' Instead he became a petty criminal, a patient in Bellevue, a
heroin addict. Later he travelled to Mexico, to Quito, to Ecuador and
Paraguay in search of the magical drug, Yagé. Dogged by depression and
addiction he spent his time in dismal suburbs, on a rundown farm in a
Texas valley backwater, in a seedy Left Bank Paris hotel, and in Tangier, the
ultimate Bohemia 'at the end of the world'.

There was no certainty that addiction was the most effective route to
heightened consciousness, a 'royal road to the unconscious' equal to dreams.
Burroughs certainly believed his drug addiction was negative. In 1950, for
example, he wrote to Kerouac: 'When I am on the junk I don't get around
much. I miss experience because I spend too much time in the house. There
is more to miss in Mexico than in the States because here no limits are
imposed on experience. I am aware of the waste involved in not getting
around so I am kicking the habit.'[27] 'Nothing ever happens in the junk

world,' he wrote, but 'it was more accurate to say that only one thing ever happened. Junkies lived in a universe endlessly imploding upon a single event: the fix. Junk time was thus cyclical time, and cyclical time is by definition ritual time.'[28] But the ritual reproduced only itself, not art.

Yet ritual might become an end in itself. Ritual, madness and art might, furthermore, be closely allied to mystical states. Accordingly, mysticism was a recurring theme in Bohemia. Individual bohemians could be found to represent every variety of religious belief, from Baudelaire's negative catholicism to the nihilistic atheism of Francis Bacon. Bohemians, however, seemed more susceptible than most to the persistent attraction of the occult, cult religions and 'alternative' belief systems.

Kandinsky, for example, along with many others in the early twentieth century, became involved in Theosophy. Georgette Leblanc and Margaret Anderson were among the followers of the mystic Gurdjieff, who set up a centre for his movement outside Paris in the 1920s. (Like numerous later 'tele-evangelists' he was afterwards accused of financial malpractices.) Philip Heseltine was by no means the only London bohemian to become involved with the 'black magician' Aleister Crowley in the 1920s. Jack Kerouac, a roman catholic, and the Jewish Allen Ginsberg, became interested in Buddhism (and were nicknamed 'the Suzuki rhythm boys' by James Baldwin). Neal and Carolyn Cassady became devotees of an evangelist, Edgar Cayce, who preached reincarnation – they even named their dog Cayce. The hippie underground of the 1960s was awash with 'alternative' forms of belief, among the more superficial symptoms of which were the fashion for Tarot cards, the I Ching and horoscopes.

The early sixties was the time when 'the literary identification with the opium-eaters of the past was just beginning in New York as hipsters began to fit the black men's code to the facts of Baudelaire and Rimbaud'.[29] In January 1961, Dr Timothy Leary of Harvard University, who was experimenting with LSD, wrote to Burroughs at the suggestion of Allen Ginsberg. This was the moment at which drugs began to filter into mainstream culture. 'The mutation from Beat to hippie meant a switch from grass to acid, from literature to music, from a small group of writers and artists and jazz musicians to a mass youth movement ... the Beat mission of expanding consciousness mutated into ecological and anti-war consciousness. The questioning of authority, the drugs, the experimental lifestyle, the leaning towards Eastern philosophy, all were a carryover from the Beats.'[30]

In the 1960s the British radical psychiatrists R.D. Laing and David Cooper argued passionately at first for a view of insanity as meaningful, later as prophetic and utopian. Instead of dismissing schizophrenic ramblings as gibberish, Laing listened to the stories patients told him and realized that they were telling truths about their experience, sometimes in obscure, but sometimes in poetical language. Later he felt, for a time at least, that they were speaking a truth for the whole insane world of the hydrogen bomb.

This contributed to a vision of life that circulated in the late 1960s,

whereby art, madness and politics fused into a total experience. In 1967 the psychiatrists organized the Dialectics of Liberation conference in London, the central topic of which was 'the demystification of violence.' Allen Ginsberg was one of the prominent participants, but his chanting of a mantra was out of step with the general atmosphere, for by this time the visionary approach of Laing was being superseded by a harder-edged politics. At the conference the contributions of Marxists such as Ernest Mandel and Herbert Marcuse, and activists such as Stokeley Carmichael of the Black Power movement[31] seemed more relevant than Ginsberg's mysticism. The subjective quest for extreme states was turning outwards, once more towards politics.

Notes

1 Rose, *Modigliani*, p 36, quoting Amedeo Modigliani, letter to Oscar Ghiglia.
2 Jules Vallès, 'Les Réfractaires', *Oeuvres Complètes*, vol 2 (orig publ 1857; Paris: Livre Club Didiot, 1969), pp 148-9.
3 Siegel, *Bohemian Paris*, pp 11-12.
4 Du Camp, *Literary Recollections*, vol 2, p 85.
5 Quoted in Andrea Weiss, *Paris was a Woman*, p 19.
6 Devas, *Two Flamboyant Fathers*, p 96.
7 Faithfull, *Faithfull*, p 221.
8 Charles Baudelaire, 'Le Pôeme du Haschisch', *Les Paradis Artificiels* (Paris: Livre de Poche, 1972), p 115.
9 Ibid.
10 See Richard Holmes, *Coleridge: Early Visions* (Harmondsworth: Penguin, 1989).
11 Marek Kohn, *Dope Girls: The Birth of the British Drug Underground* (London: Lawrence and Wishart, 1992), p 2.
12 Thomas de Quincey, *Confessions of an English Opium Eater* (orig publ 1821; Harmondsworth: Penguin, 1971), p 103.
13 Steve Bradshaw, *Café Society: Bohemian Life from Swift to Bob Dylan* (London: Weidenfeld and Nicolson, 1978), p 114.
14 Jones, *Free Associations*, pp 173-4.
15 Michaels, *Anarchy and Eros*, pp 145, 148.
16 Lothar Fischer, *Tanz zwischen Rausch und Tod: Anita Berber: 1918-1928 in Berlin* (Berlin: Haude und Spenersche, 1988), *passim*.
17 Marsha Meskinnon, *We Weren't Modern Enough: Women Artists and the Limits of German Modernism* (London: I.B.Tauris, 1999), p 55.
18 Anton Gill, *A Dance Between Flames: Berlin Between the Wars* (London: John Murray, 1993), p 109, quoting PEM (Paul Erich Marcus), *Heimweh nach dem Kurfürstendamm* (Lothar Blanvalet Verlag, Berlin, 1952), pp 115-16.
19 See Stephen Barber, *Antonin Artaud: Bombs and Blows* (London: Faber and Faber, 1993), *passim*.
20 Morgan, *Literary Outlaw*, p 199.
21 Ibid., p 165.
22 Ibid., pp 102-3, quoting Allen Ginsberg, *Journal*.
23 Wakefield, *New York in the Fifties*, p 138.
24 Jack Kerouac, *On The Road* (orig publ 1957; Harmondsworth: Penguin, 1996), p 7.

25 Johnson, *Minor Characters*, p 4.
26 Morgan, *Literary Outlaw*, p 117.
27 Oliver Harris (ed), *The Letters of William Burroughs, 1945-1959* (London: Picador, 1994), p 71.
28 Maynard, *Venice West*, p 95.
29 James Campbell, *Paris Interzone* (London: Secker and Warburg, 1994), p 99.
30 Morgan, *Literary Outlaw*, p 365.
31 Cf Robert Hewison, *Too Much: Art and Society in the Sixties, 1960-1975* (London: Methuen, 1986), pp 134-8.

CHAPTER 13

THE POLITICS OF EXCESS

To make literature with a gun in my hand had been for a time my dream. To be something like a robber baron of the pen.
　　　　　Richard Huelsenbeck: En Avant Dada: A History of Dadaism

Bohemian politics represented an attempt to reconcile two incompatible views. On the one hand there was the view that the highest purpose of the arts and of artists was to reveal a vision of a better world and that this purpose was ultimately political. On the other, there was the view that the purpose of politics was to create a world of freedom for the arts, since it was art that gave meaning to life. The danger of the former view – that art is necessarily political – was that, taken to an extreme, the arts became the supreme ideological weapon in the service of politics, completely subordinated to the state, whereas the danger of the opposing view was that art became a depoliticized realm remote from 'real life'. The doctrine of 'art for art's sake' is commonly interpreted as just such a retreat from politics into an ivory tower. However, Gautier, who argued for art as the supreme value in his preface to *Mademoiselle de Maupin*, did not look at it in this way, while Théophile Dondey, a fellow member of *les Jeunes France*, wrote that:

> Those who think that we lived in a certain detachment from the popular cause are completely mistaken. For the most part we were republicans ... When we wrote of the need to distance ourselves from republican fanaticism we certainly did not mean from republicanism altogether, but from conspiracies, riots and assassinations, from violence of all kinds. We dreamed of the reign of Art, it is true. It seemed to us that one day Religion must be ... replaced by the Aesthetic. But we desired more than that ... Amongst our number were adherents of St Simonianism and Fourierism ... and we were dedicated to social revolution.[1]

The attempt to marry art and politics was a perennial balancing act not easy to sustain, for while many bohemians and artists were political activists, by no means all political activists were bohemians. On the contrary, many were suspicious of avant-garde art and believed that bohemian lifestyles alienated the masses. During their years of exile, for example, Lenin and his wife, Nadezdha Krupskaya, sometimes lived in bohemian districts, which provided them with a certain amount of camouflage, but on the whole they avoided social contact with bohemian neighbours, whose way of life they distrusted. Only in London did their wandering life, including spells in prison, seem 'bohemian' to British trades unionists, but while Krupskaya sneered at the 'petty bourgeois mentality' of the English organized working class, she disliked the outrageous Schwabing bohemians even more. In Munich, where they edited the first issues of the Bolshevik paper, *Iskra*, she waspishly described how one of their comrades lived in a 'nihilist fashion – dressed carelessly, smoked endlessly, and an extraordinary disorder reigned in her room. She never allowed anybody else to tidy it up.'[2]

Krupskaya was also startled when Axelrod, an *Iskra* comrade, complained that 'under the new state of society [i.e. socialism] there won't be any fights at all – only deadly boredom'. This single sentence encapsulates everything that separated the bohemian from the revolutionary perspective. The bohemians thrilled both to the immediate process and to the utopian future. The 'politicos', on the other hand, occupied the middle ground between these two extremes, where they were engaged in a struggle to win power. For the bohemian utopian revolutionaries, by contrast, to win power was a form of failure. As in the world of the arts, so in the world of politics: to succeed was to fail; the fulfilment of the dream was always a disappointment and a betrayal.

On the other hand, the outrage perpetrated by the flamboyant bohemians provoked a more gratifyingly immediate reaction from 'straight society.' During the First World War the quiet university town of Zurich was stuffed both with arms dealers and black market operators profiting from the war, and with pacifists and radicals in flight from it. Lenin and Krupskaya turned up there as well, and rented an apartment in the same street as the Dada group's Café Voltaire, which opened in 1916. (Today a plaque marks the Lenin residence, while there is none for the Dada group.) 'The short sighted citizens of Zurich had no complaints again Lenin, because he was inconspicuously dressed. Dada, on the other hand, really got under their skin.'[3] While the Dada group performances courted outrage with their nonsense poems and 'chants nègres,' Lenin consulted with trades union leaders and his wife visited local schools. Later, former Dadaists speculated whether Lenin had ever set foot in the Café Voltaire, and by 1972 Richard Huelsenbeck had persuaded himself that he had indeed seen the great Bolshevik there.

Yet it seems unlikely that the 'chants nègres' and nonsense poems would have greatly appealed to Lenin. He firmly believed in the arts as powerful

tools of political education rather than as modes of individualistic self-expression. On one occasion he suggested to Maxim Gorky: 'You should write a novel for workers on how the predatory capitalists have despoiled the earth and wasted all its oil, iron timber and coal. That would be a very useful book.' Such a model fails to recognize that indirect messages often have more powerful effects – because they appeal to feeling – than those that are directly didactic and rational. It also implies a settled perspective on the world, whereas art in general and Dada in particular questions the whole basis of civilization.

Yet Lenin was aware of the power of art. He was so moved by classical music that he ceased listening to it on the grounds that it made the listener too soft and vulnerable. That he was also aware of the different and off-centre perspective of art seems implied in an earlier conversation with Gorky, on the occasion of their visit to a London music hall. There Lenin identified 'eccentrism' as a feature of theatre art, and commented: 'There is a certain satirical and sceptical attitude to the conventional [in this type of theatre art], an urge to turn it inside out, to distort it slightly, in order to show the illogic of the usual. Intricate but interesting.'[4]

The 'illogic of the usual' was, like the 'marvellous in the banal', a concept that went to the heart of the bohemian sensibility. Those bohemians, at least, who believed that politics should serve art (by the abolition of censorship, by providing artists with an income, by valuing them at their true worth) were on the whole more interested in exploring the 'illogic of the usual' – the strangeness of everyday life – than in producing representations of capitalist rapacity.

The majority of bohemians nevertheless subjectively sympathized with the underdog, the marginalized and the outcast: Baudelaire's rag-pickers, Marx's 'lumpenproletariat', Carco's pimps and prostitutes. As Stephen Spender wrote: 'I pitied the unemployed, deplored social injustices, wished for peace, and held socialist views. These views were emotional.'[5] Bohemia flourished throughout the whole of two centuries when the political hopes of socialists, radicals and even liberals were repeatedly disappointed. Every generation lived through a period of revolutionary hope for the transformation of society and after the defeat of those hopes had to find a way of living with the disappointment. 'That need has created a political and cultural space that has often been occupied by Bohemia.'[6]

One reaction was to retreat from politics. In 1838 Delphine de Girardin commented on the way in which the best-known writers and artists were free to spend their time at balls and dances because they had taken up a stance of 'internal migration' (her phrase).[7] They had turned their back on politics, a strategy similar to the 'internal exile' of East European dissidents after 1945. Again, during the repressive years of the Second Empire, disaffected bohemians filled the Paris cafés, often under surveillance, sometimes persecuted by the police. Shown a list of proscribed writers, the bohemian republican Pierre Dupont responded: 'Well then, I will be proscribed from within. I will no

longer work at anything except my art. I shall write verse ... to pass the time, to wait.'[8]

There was also the familiar movement from left to right. Baudelaire later reinterpreted his violent actions in 1848 as the pure negativity of revolt, the love of evil. Murger was never left-wing – on the contrary at one time he was employed as the secretary of a Tsarist spy, to whom he acted as an informer. Some former republicans, such as Arsène Houssaye, made the most of the corruption of the Second Empire, and even Gustave Courbet, an intransigent revolutionary, appears to have made an accommodation of sorts with the regime. Jules Vallès, faithful to the Commune, was forced to flee to London after its defeat, but George Sand deplored the excesses of the Communards (as did Gautier), although the savage way they were slaughtered after their defeat caused her much hand wringing.

In his discussion of Courbet, art historian T.J. Clark attempts to resolve the ambiguity of the bohemians' relationship to politics by dividing the revolutionary sheep from the avant-garde goats. He argues that Gautier and others who believed in 'art for art's sake' made an accommodation with the market. Their Bohemia was simply the exuberance of bourgeois youth, in contrast to the 'real' Bohemia that evolved. This pertained less to the Latin Quarter than to the 'dangerous classes', 'a world of grinding poverty and of absolute refusal of bourgeois society rather than the sowing of flippant wild oats'.[9] Yet rather than being radically distinct, the two Bohemias were closely intertwined, indistinguishable even. In any case, the hedonism of successive generations of aesthetes seems often to have been closer to a gesture of despair than to careless enjoyment, or alternatively expressive of an idealism that had soured into cynicism in the face of hopes so often betrayed.

Yet in each generation the hopes arose anew. Before the First World War, all the Greenwich Village bohemians read Marx, 'and all the radicals had a touch of the bohemian: it seemed that both types were fighting in the same cause'. After the Russian Revolution, however, the two sides were split, for the politicos suffered increasing police harrassment, while the aesthetic bohemians could 'continue to exist safely'.[10] In 1913, when he became editor of *The Masses*, Max Eastman had declared that it was a revolutionary, not a reformist journal. In 1934 he responded to Communist Party attacks on the 'mere bohemianism' of the Village by stating that his ideal and that of his comrades was similar to that of the nineteenth-century utopian socialists. Like the utopians, they had wanted to create a prefigurative socialist society as an enclave within still-existing capitalism, while working for its extension to all. 'The wish to live a free and real life, and to cherish and communicate its qualities in works of art, deserves the respect of every revolutionist.'[11] Yet however grudging and puritanical the carping of orthodox Marxists, the uncomfortable truth was that the 'free and real life' was open largely to those who benefited, at least to some extent, from their privileged class position within capitalist society.

The individualism of the bohemian 'genius' rebelled against any tightly organized militant party or grouping, and it was therefore not surprising if anarchism was the doctrine that most appealed to the bohemians. This was a particularly powerful force in Germany before the First World War. For anarchists, personal behaviour was potentially a form of revolution in itself. They also believed in the revolutionary credentials of the lumpen portion of society. In 1909 Erich Mühsam formed an Action Group in an attempt to bring vagabonds, unemployed youth and prostitutes of both sexes into political activity. His efforts met with little success. When the execution of an anarchist in Spain led to international outrage, demonstrations in Munich included the detonation of a bomb near the town hall. Accused of having caused the explosion, Mühsam was indicted along with other members of his group. Their trial degenerated into farce when prostitutes admitted that their main purpose in attending Action Group meetings had been to tout for trade, while others claimed to have participated because of the free beer and to have been too drunk to understand what was going on.[12] Franz Jung later claimed that when a woman anarchist tried to entertain the group with revolutionary French songs she had the clothes torn off her back by the disgusted objects of Mühsam's revolutionary intentions;[13] however, since Jung arrived in Munich two years after these events occurred, his version may have been one of the many apocryphal bohemian legends that circulated at every period.

With the outbreak of war, 'Bohemia liquidated itself', wrote Jung. A surprising number of German bohemians enlisted, carried away at first by the general atmosphere of patriotism. Most soon thought better of it (and Fanny Reventlow staked out a pacifist position from the beginning). Jung, the cartoonist George Grosz, and the writer Oskar Maria Graf joined up, deserted, were recaptured, escaped again. Graf was repeatedly arrested for refusing to obey orders, and when examined by a doctor, shrieked abuse at him for passing conscripts fit to be killed as cannon fodder. The result of this outburst was that he was diagnosed as insane, a fate – preferable to court martial and execution – that befell several of the German bohemians.

In 1918 Mühsam's friend Frank Wedekind died. For Mühsam this marked the end of the old Schwabing spirit and inaugurated a grimmer struggle. In the chaotic and volatile situation after Germany's defeat, there were insurrections, violent uprisings violently crushed, hunger and desperation. In Munich the revolution passed through several stages. A provisional social democratic government was set up, but came under continual pressure from the ultraradicals, such as Mühsam, to move further to the left. An Artists' Council was formed, and there was a Council of Brain Workers, which discussed 'educative propaganda in the press, school reforms and the right of intellectuals to take part in decisions relating to other cultural questions'.[14] There were chaotic meetings at which no one could agree, and Ernst Toller, who, with Mühsam and the anarchist Gustave Landauer, led the short-lived *Räterreblik*, afterwards described how they had been besieged by cranks advocating every form of utopian lifestyle from dress reform to Esperanto.[15]

Despite the weakness of the social democratic government during the Weimar period and their reservations about the German Communist Party (KPD), several of the Munich bohemians dedicated themselves to the Communist cause in the twenties. Even Mühsam joined the KPD, although only for a few months. Herwath Walden, editor of the expressionist journal *Der Sturm*, became a communist and eventually moved to the Soviet Union, where he disappeared without trace. Jung, too, joined the KPD but soon defected to a breakaway group, the Communist Workers Party, the KAPD. Sent with a fellow comrade as a delegation to the Comintern to explain the KAPD position, he and his friend stowed away on a ship. Once in open waters they hijacked the vessel and forced it to sail to Murmansk in the USSR, where they tried to present it to the Soviet government. Although Lenin himself received them, the Communist International refused to accept the KAPD programme. Instead, Lenin read to them from his polemic against deviationism, *Left Wing Communism: An Infantile Disorder*.[16]

It was predictable that Schwabing should have nurtured anarchists, pacifists, left-wingers and rampant individualists who were Bolshevik only in the sense of being 'bolshie'. Perhaps more surprising was the extent to which it nourished extreme right-wing views. At the turn of the century, a Nietzschean group formed as disciples of the poet Stefan George. These Nietzscheans, Ludwig Klages, Karl Wolfskehl (himself Jewish) and Alfred Schuler, held utopian views about cultural regeneration. Schuler, an archaeological historian, believed that the 'life fire' had burned most strongly in 'das Volk' in heathen times, becoming ever weaker until in the present day only a few individuals retained any trace of it. The Germans were the foremost bearers of this 'life fire', followed by the ancient Greeks and Romans, but the Jewish race was excluded because it had promoted Father Right (patriarchy) and had thereby fallen prey to damnation. However, Christians such as Martin Luther were equally to be condemned as 'Jewish' or 'Molotisisch' on account of their patriarchal beliefs. ('I never realised Luther was a Jew!' cried Frau Wolfskehl in amazement.)

Yet the three Nietzscheans believed there was still hope for the renewal of modern society, since they themselves were now the bearers of the 'life fire'; they were special individuals who were 'cosmic' or 'Enorm.' Klages in particular hoped that the 'life fire' would be rekindled and transmitted to the next generation via the agency of aristocratic women – specifically his lover, Fanny Reventlow – who were free from petty bourgeois morality.

Schuler, then in his forties, was still living with his mother. Roderich Huch became a disciple of the Enorms at the age of 18, and later mockingly described how Schuler:

> simply did not recognize himself as an archaeological scholar of the nineteenth century, but as an ancient Roman – it was uncanny, the way he'd stare in front of him, seeing right through us, and speak of Rome as if he'd just come from the Forum.

I once asked Klages how Schuler could be so cosmic when ancient
Rome, after all, had been a patriarchal society, but he told me that the
Roman period inhabited by Schuler was prehistorical – that is, it was
Etruscan.[17]

Huch was sceptical about Schuler's theories, but Klages insisted that every-
thing about Schuler was cosmic, even his plan – fortunately not carried out
– to visit the mentally ill Nietzsche and free him from his derangement
through the performance of Greek Korybantic dances. 'I realized then,'
concluded Huch, 'that Klages lacked a sense of humour when it came to his
blessed theories,' and thereafter he and his friends mockingly referred to
Klages as 'Theodor Theory'.

Like 'Rodi' Huch, Fanny Reventlow was unable to take the beliefs of the
Klages group seriously. The two of them caricatured the Enorms in the
Schwabinger Beobachter, a locally produced newsheet, in spoof articles such as
'How can I become Enorm?' and a parody of Klages as a Jew. The quarrel
following this precipitated Fanny's break with her lover, Klages, although she
was more passionately attached to him than to any of her other men and
after this incident her letters expressed her growing alienation from and
disgust with the group.

The theatre director, Georg Fuchs, was nevertheless the only individual
from the Schwabing heyday to become an out and out Nazi. Like Klages and
Stefan George he believed that capitalism was inherently decadent, but that a
new form of racial art could lead to national renewal and purification. In the
early 1900s he became involved with the Munich *Kunstlertheater*, attempting
unsuccessfully to produce grandiose allegorical works. In this he was inspired
by Nietzsche, who had argued in *The Birth of Tragedy* that theatre was to
become a pagan experience, inducing in its audience a mystical state of intox-
ication that would rescue them from the disintegrating influences of the
industrial urbanized world.[18]

Nietzsche, the bible of left-wing radicals before the First World War, was
reinterpreted during the unstable Weimar years, and was now associated with
the 'revolution from the right'. The phrase 'conservative revolution' became
popular, and ultimately lent fascism a degree of intellectual respectability.

In the early years of Weimar a number of 'barefoot prophets' founded
sects or gathered informal groups around themselves and wandered through
the countryside. These fragmented, utopian movements inherited some of the
preoccupations of pre-war Ascona, embracing vegetarianism, religion, reform
dress, erotic liberation and the body beautiful to varying degrees and in
varying combinations. They turned away from urban life, searching for
physical and spiritual health in the countryside and physical pursuits. Most
were too radical for the established bourgeois political parties and the
catholic church, but for the workers' parties and the communists they were
not radical enough, and were held guilty of estranging their youthful
followers from class struggle. The nationalistic extreme right, on the other

hand, saw them as 'dangerous Bolshevists.' In fact, their ambivalent ideals, especially in relation to the body beautiful (and Aryan), made it possible for many who walked, stripped and sunbathed with them later to acquiesce in, and in many cases, actively support the Nazi vision.[19]

There was, after all, a strongly aesthetic dimension to Nazism, and a surprisingly large number of its leading figures had literary or artistic aspirations. Hitler's ambition to become an architect is well known. Goebbels was a novelist and poet, Baldur von Shirach was a poet, and 'the proportion of frustrated aesthetes among the founders of the Nazi Party in the 1920s was ... stunningly high.'[20] It was for this reason that a leading Munich journalist referred to the Nazi party as 'armed Bohemia.'

Because Klages was an anti-Semite who idealized race and paganism, both Georg Lukàcs and Thomas Mann accused him of being sympathetic to or even partly responsible for Nazism. Yet his relationship to Nazism was ambiguous. He remained in Germany throughout the Third Reich and did not dissociate himself from National Socialism, but his rejection of the 'will to power' distanced him from direct political participation or even open endorsement of the Nazis. The Nazis in their turn distrusted his emphasis on the supreme value of the erotic.[21]

The Nazis were well aware of the power of art, actively encouraged the art they felt reflected and supported the might of the Third Reich, and attacked modernism and radical art.[22] Their 'Degenerate Art' exhibition in 1937 vilified non-realist art, and compared paintings by artists such as Picasso to the physiognomy of the mentally ill and retarded. The film director, Leni Riefenstahl, celebrated the regime cinematically in *Triumph of the Will*, her record of the Nuremberg Rally, and her film of the 1936 Olympic Games, *Olympiad*. Local pageants and bombastic displays glorified the state and the Aryan military hero, while proscribed artists went into exile, lay low, were imprisoned or liquidated. As is well known, Soviet leaders were equally or even more prescriptive in their attitude towards art, and by the 1930s the doctrine of socialist realism had triumphed over the experimentation of the previous decade.

The assumption that art and literature are powerful weapons to be used directly in promoting political views, whether these be from the right or the left, continued to influence both major power blocks after 1945. The CIA actively promoted experimental music and art in their belief that these exemplified Western freedom and individualism. This had the bizarre result that a painter like Jackson Pollock, a communist sympathizer who had been associated with Diego Rivera, became a symbol of American freedom, although both his work and his life flouted everything that most Americans held sacred.[23]

Jackson Pollock's life contained all the ingredients of bohemian excess: mental disturbance, sexual confusion, radicalism, womanizing and drunkenness – he died when the car he was driving, while drunk, went off the road. His abstract-expressionist paintings were interpreted as expressions of man's alienation in a soulless modern world – and alienation was seen as the inescapable

'human condition,' having nothing to do with politics. This was in accordance with Marcuse's criticism of the way in which art in the West was perceived as an autonomous realm. While, therefore, in Nazi Germany and the USSR under Stalin there had been no space for freedom of expression, in the West there was infinite space. This, however, was on condition either that that freedom was depoliticized (although, of course, it was precisely this that *was* the politics of the CIA) or, if political, marginalized.

A third situation developed in Eastern Europe after 1945. In Czechoslovakia, for example, art was central throughout the communist period. 'Artists and poets invented the enthusiastic new language and images of the "builders of socialism" in the 1950s. They also laid the groundwork for the Prague Spring [of 1968]. After that was crushed they maintained the unofficial alternative culture through the 1970s and 1980s, leading eventually to the events of 1989 and the collapse of the communist regime.'

It was difficult to be an artist during the years of Eastern European 'actually existing socialism'. 'Your work was supervised constantly, and judged according to ideological criteria. However, the "socialist" state still claimed actively to support art, and in some cases it provided a certain amount of security.' 'Unofficial' artists found a limited audience through clandestine channels, the only way of avoiding the heavy-handed and often puritanical censorship, but in doing so risked the sack and were liable to be banned completely from all state channels of publication and production. On the other hand, even then there was both a 'semi-official' underground, and a second, completely 'unofficial' underground. The first was less political; in the late seventies and early eighties its art was a kind of neo-expressionism that was popular and attractive and for which there were recognized, albeit non-state outlets. The second group, far more confrontational, engaged in highly ideological performance art: 'someone, somewhere would strip and perform naked, which was terribly inflammatory to totalitarian prudery.'[24]

During this period the pre-war café tradition persisted in Prague, ending only with the emigration of the 1980s, after Charter 77. The café was a relatively safe meeting place, and a place from which to make telephone calls, since the public phone was less likely to be tapped than a line in a private house. As in nineteenth-century France, cafés were also economically cheap to maintain since both rents and wages were very low.

Czech dissidents built on a form of surrealism, Poetism, the central idea of which was that the artist is a free person. The satirical cabaret movement – tolerated throughout most of the communist period – was closely related to Poetism. There was also jazz. This was an important common language uniting bohemians and dissidents across the 'iron curtain', a source of inspiration in the efforts of artists in every medium to make connections and forge a new multimedia art. In Eastern Europe, Poland was especially famous for its jazz. After the Prague Spring of 1968, and its defeat, jazz bands also became an extremely important aspect of a popular, semi-legal,

oppositional culture in Czechoslovakia. In the early seventies there were many bands, often formed by instrumentalists who were 'straight' professional musicians by day. They usually played to small audiences in private apartments or on rented steamboats, and one important aspect of the music was that it was an art that crossed class boundaries.[25]

The peculiarity of a dissident artist's life in communist Czechoslovakia was that s/he was in a sense freed within an economic system that absolutely didn't work. While a dissident plumber would have difficulty getting a job, the artist could freelance. The photographer Pavel Büchler was able to support himself and even contribute to the underground theatre movement by designing a single record sleeve every month. He also had a job as a caretaker, which, contrary to Western assumptions, was a good situation since it involved hardly any work, and employers were usually extremely deferential.

In communist Czechoslovakia, then, there was a situation – which varied according to the mood of the government – in which semi-tolerated or underground forms of dissidence took an aesthetic form because of the difficulties of open political debate. In the film industry, for example, it was easier to make feature than documentary films – but fiction could carry as potent a message. In the absence of democracy, literature, film and music carried the weight of political aspirations.[26]

After 1989 political censorship ended, but was insidiously replaced by a new form of censorship: that of money. Art became much less important:

> Today people don't read much. Only a few years ago we used to copy books on typewriters ... there was such a hunger for culture, which simply doesn't exist any more. Art used to awaken hopes in us; it gave us human dignity, was like part of our identity. Today people travel, do business, open shops, and so on, but under totalitarianism the same people attempted to write poetry, copied poetry by underground writers.[27]

In exploring this paradox, Czech artists voiced anxieties startlingly similar to those expressed by the French artists of the 1830s: 'now you will be commercially successful only if you do something easily comprehensible and acceptable – decorative pictures that can be hung on walls, not performances. And so [many] ... still feel like an opposition, even though the situation isn't as clear cut as it used to be.'[28]

This feeling was familiar to Western radicals too. The student movements of the 1960s and 1970s revived many of the ideas and artistic practices developed by earlier artistic communities – the German Greens, for example, even reclaimed those aspects of the philosophy of Ludwig Klages that emphasized reverence for nature and the Earth.[29] There was a renewal of interest in past Bohemias. Writing at the high point of student rebellion, Helmut Kreuzer made a link between the Beats, the hippies, Dutch 'Provos,' Russian 'stilyagi' and other youth movements of his time, and the classic Bohemias of Munich and Paris, while for Joanna Richardson:

Figure 32 The 'Events' in Paris in the summer of 1968: students rioting: the last manifesta-
tion of bohemian anarchist politics? Courtesy Hulton Getty

> The hippies ... recall the Bousingos of the 1830s. The takers of LSD
> descend perhaps from the hashish-eaters of the 1840s. The modern student
> demonstrations sometimes recall the battle of Hernani and the wilder
> excesses of the *Jeunes France*. The behaviour is similar for the background is
> much the same.[30]

The impulse behind these movements, she suggested, is transhistorical: a lack
of purpose, no 'vast crusade' or spiritual direction, and the permanent need
of the young to rebel against authority. This rather negative and belittling
assessment focused on the lifestyle rather than the creative aspect of Bohemia
(to the extent that the two could or should be separated). She may partly
have been reacting to the way in which mass culture was adopting Bohemia
as its own. It was becoming a mass media event, rather than a private way of
life, and thereby, possibly, being destroyed.

Notes

1 Philothée O'Neddy (Théophile Dondey), *Lettre Inédite sur le Groupe Littéraire
 Romantique dit des Bousingos* (Paris: Rouquette, 1875), p 14.

2 Nadezdha Krupskaya, *Memories of Lenin*, trans Martin Lawrence (London: Panther, 1970), p 53.

3 Richard Huelsenbeck, 'Die Dadaistische Bewegung', in Raabe (ed), *The Era of German Expressionism*, p 352 (Appendix), orig publ in *Die Neue Rundschau*, xxxi, 1920.

4 Both Lenin quotes are from Victor Shklovsky, *Mayakovsky and his Circle*, trans and ed Lily Feiler (London: Pluto Press, 1970), p 117.

5 Spender, *World Within World*, p 134.

6 Siegel, *Bohemian Paris*, pp 60–61.

7 De Girardin, *Oeuvres Complètes* (1860), tome iv, 'Lettre 4', 15 March 1838, p 249.

8 Quoted in Philibert Audebrand, *Derniers Jours de la Bohême: Souvenirs de la Vie Littéraire* (Paris: Calmann Levy, 1905), p 208.

9 T.J. Clark, *Image of the People: Gustave Courbet and the 1848 Revolution* (London: Thames and Hudson, 1973), p 33.

10 Cowley, *Exile's Return*, p 66.

11 Quoted in Fishbein, *Rebels in Bohemia*, p 62–63.

12 Jelavich, *Munich and Theatrical Modernism*, p 278.

13 Franz Jung, *Der Weg nach Unten*, p 76.

14 Oskar Maria Graf, *Prisoners All*, trans Margaret Green (New York: Alfred Knopf, 1928), p 156.

15 Stephen Lamb, 'Intellectuals and the Challenge of Power: The Case of the Munich "Räterrepublik"', in Phelan, Anthony, ed., *The Weimar Dilemma: Intellectuals in the Weimar Republic*, Manchester: Manchester University Press, 1985, pp 132–161.

16 Jung, *Der Weg nach Unten*, *passim*.

17 Roderich Huch, 'Alfred Schuler, Ludwig Klages und Stefan George: Erinnerungen an Krise und Krisen der Jahrhundertwende in Munich-Schwabing', in *Castrum Peregrini*, CX (Amsterdam: Castrum Peregrini Press, 1973), pp 26 *et seq.*

18 See Jelavich (1986), *Munich and Theatrical Modernism*.

19 See Ulrich Linse, *Barfüssige Propheten: Erlöser der Zwanziger Jahre* (Berlin: Siedler, 1983).

20 Peter Viereck, *Metapolitics: From the Romantics to Hitler* (New York: Alfred Knopf, 1941), p 154.

21 Richard Hinton Thomas, 'Nietzsche in Weimar Germany – and the Case of Ludwig Klages', in Phelan, Anthony, ed., *The Weimar Dilemma*, pp 71–91.

22 See D. Ades *et al.* (eds), *Art and Power Europe Under the Dictators, 1930-1945* (London: Hayward Gallery, 1995); Ascherson, Neal, 'Modernism and the Nazis', in Paul Büchler and Nikos Papastergiadis (eds), *Random Access 1* (London: Rivers Oram Press, 1993); and Peter Jelavich, *Berlin Cabaret* (Cambridge, Ma: Harvard University Press, 1993).

23 See Peter Wollen, 'The Triumph of American Painting: "A Rotten Rebel from Russia"', in Peter Wollen, *Raiding the Icebox: Reflections on Twentieth Century Culture* (London: Verso, 1993), pp 72–119; and Frances Stonor Saunders, *Who Paid the Piper? The CIA and the Cultural Cold War* (London: Granta Books, 1999).

24 Eva Hauser, 'The Velvet Revolution and Iron Necessity', in Carol Becker, ed., *The Subversive Imagination*, New York: 1994, pp 78, 79.

25 According to Pavel Büchler, the West misunderstood Czech dissidence as a movement consisting entirely of middle-class intellectuals. Even Charter 77 included many manual workers. Interview with Pavel Büchler, March 1994.

26 Interview with Pavel Büchler.
27 Eva Hauser, The Velvet Revolution', p 82, quoting Vlasta Čihaková-Noshin.
28 Ibid.
29 Green, *Mountain of Truth*.
30 Joanna Richardson (1969), *The Bohemians*, p 7.

CHAPTER 14

BOHEMIA FOR THE MASSES

Life is so boring there is nothing to do except spend all our wages on the latest skirt or shirt. Brothers and Sisters, what are your real desires?
 Angry Brigade: Communiqué 8 (The bombing of Biba)

According to Malcolm Cowley the commercialization of Bohemia was apparent in Greenwich Village soon after 1918. Cowley maintained that bohemian lifestyles were essential to the way in which more and more aspects of life were marketed. Business, forced to create new markets once the pioneering phase of American expansion had ended, seized upon a bohemian ethic of hedonism, hostile to puritanism, and used its ideas to encourage consumerism all over the United States. It was not that Greenwich Village had *caused* the consumer ethic or the moral revolution, but its ideas shaped the form these took, and Cowley was being only partly ironical when he suggested that the bohemian ideals of self-expressionism and paganism:

> encouraged a demand for ... modern furniture, beach pyjamas, cosmetics [and] coloured bathrooms with toilet paper to match. *Living for the moment* meant buying an automobile, radio or house, using it now and paying for it later. *Female equality* was capable of doubling the consumption of products – cigarettes for example – that had formerly been used by men alone.[1]

Across the whole continent women who had never set foot in Greenwich Village bobbed their hair, smoked in the street, met to gossip in black and orange tea rooms and gave parties at which their guests drank cocktails.

The bohemian rituals, fashions and counter-customs commercialized for mass consumption included or, rather, relied on a pre-existing environment

acclimatized to diluted Freudian theories. Psychoanalysis had been filtered through Bohemia and now influenced almost the whole of society, popularizing the view that self-fulfilment was essential to mental health.

A second expansion of bohemian ideas and ways of life came about in the 1960s when international youth movements provided further mass markets for consumer culture. By the late 1950s the music and fashion industries had discovered the teenage consumer. This inaugurated a period in which rock'n'roll was linked to the glamour of the designer. Both Mary Quant and the Beatles came out of the English art schools and were influenced by the Mods of the early sixties. The Rolling Stones went to the fashionable designer Ossie Clark and to the hippie emporium Granny Takes a Trip for their clothes. In the seventies Malcolm McLaren brought the two markets together in the explosive moment of Punk.[2] These cultural innovators acknowledged the inspiration of the avant-garde. Their influence came from an ability to marry elements of avant-garde culture to the mass youth market.

The sociologist Bernice Martin drew the conclusion that romanticism, Bohemia and the avant-garde were 'self defeating' since every attempt to push forward the boundaries of art was swallowed up in mass consumption:

> however hard the radicals tried to eliminate the distinction between life and art, their very success ... ensured that their various efforts have become styles, forms and fashions ready for imitation, marketing and consumption ... the contemporary culture market muddles together elite and vulgar, yesterday's shock and today's joke in one gloriously trivial *bricolage*. Style is everything and everything can become a style.[3]

Or, as Malcolm Bradbury put it, 'there are bohemians on every street corner, self parodists in every boutique, neo-artists in every discotheque'.[4]

By the 1980s Fredric Jameson felt that there had been 'a prodigious expansion of culture throughout the social realm, to the point at which everything in our social life ... can be said to have become "cultural" in some original and as yet untheorized sense'.[5] It was largely consumer culture that had created this 'aestheticized' world. Ironically, therefore, the 'reign of art', for which the nineteenth-century bohemians hoped, had by the end of the twentieth century come to pass for the very mass audience the avant-garde despised. The aesthetic pioneers pushed forward the boundaries of taste with sometimes brutal determination, only to find themselves eagerly followed by a mass audience. Every time they ratcheted up the level of shock in a spiral of transgression their imitators were close on their heels.

From Murger's sentimental tales onwards, Bohemia became the material for popular journalism, best-selling novels, illustrated magazines, salon paintings and films. In the mutual attraction/repulsion of bohemian and bourgeois, mass culture acted as go-between, presenting tales of bohemian life to give the bourgeois public a vicarious thrill. The Victorian novelist, Ouida,[6] for example, placed the outcast artist at the centre of several of her hugely

Figure 33 The Patisserie Valerie in 1999, showing Toulouse-Lautrecian murals. Author's photograph

popular best sellers. Both bohemian artists and genuine gypsies were popular subjects for salon painters.[7]

In 1896 George du Maurier's *Trilby*, and Puccini's opera *La Bohème*, further popularized a picturesque version of bohemian life. Du Maurier borrowed extensively from Murger, but transformed his bohemians into decent Anglo-Saxons on temporary leave from the professional middle class, their

dilettantism far removed from Murger's desperate poverty; while, unlike Murger's heroine, Mimi, victim of poverty and disease, Trilby was destroyed by the sinister 'oriental,' Svengali, a racial caricature of Jewish greed, so that this was a paranoid version of Bohemia pandering to the prejudices of its imperialist audience.

Art, politics and popular culture came together more radically in the cabaret movement that swept Europe at the *fin de siècle*. In 1878 a group of Parisian poets formed the Club des Hydropathes (water haters). The group met for the first time in October 1878 at the Café de la Rive Gauche. It included Émile Goudeau, Jean Richepin, Maurice McNab and Maurice Rollinat – a number of whose poems were set to music for the popular Pigalle star, Yvette Guilbert. It was dissolved in 1881, but Goudeau now joined forces with a café proprietor, Rodolphe Salis, to open the *Chat Noir* in Montmartre. Salis intended his new café to be a rendezvous for artists, but it became more than that. At the *Chat Noir* bohemian café life was cross-ferti-lized with the working-class culture of the Montmartre music halls, brothels and bars – a coarse but vivid demi-monde peopled with dancers and pimps, singers and managers. The melancholy themes of poverty, prostitution and the underworld, favoured by Richepin and his contemporaries, were repro-duced in *chanson réaliste*, the popular musical form of the vaudeville. Henri de Toulouse-Lautrec's posters further contributed to the transformation of the *Moulin Rouge* performers into icons of glamour and defiance. The cabaret singer Aristide Bruant, in black cloak lined with scarlet and broad-brimmed hat, the singer La Gouloue,[8] with her gingery topknot of hair and her lesbian minders, and the feline Yvette Guilbert leering round the corner of the stage curtain, were rediscovered in the 1950s. Then they signified Bohemia to post-war generations who pinned them to college, bed-sitting room and café walls.[9] By 1960 Jean Renoir's *French Can Can* and John Huston's *Moulin Rouge* (based on a popular novel of the same name by Pierre Lamure) had brought the life of Toulouse Lautrec and the *fin de siècle* scene of Pigalle/ Montmartre to the screen.

Underlying cabaret was the Wagnerian concept of the total artwork. This aimed to break down the barriers between artistic media, and, 'by turning to folk and popular culture for inspiration, by merging "high" and "low" art, by narrowing – or eliminating – the distance between spectator and performer,' signalled the disdain of its interpreters for conventional, academic art.[10] It 'testified to a new kind of symbiosis between la Bohème and the bourgeoisie, and to the existence of a broad public seeking a taste of Bohemia.'[11] Yet it also had radical implications, as a form of 'metropolitan montage,' the origins of which could be traced back to Baudelaire's prose poems of Paris life, and which prefigured the collage and photomontage of the 1920s.[12]

After 1918 the popularity of the bohemian as a subject for popular works continued and even increased. Margaret Kennedy's 1924 *The Constant Nymph*, a tale of adulterous love and tuberculosis among musicians, sold a million

copies, its central male characters based on Augustus John and possibly the painter Henry Lamb and/or the composer Rutland Boughton. The following year Michael Arlen's best seller, *The Green Hat*, was one of several novels to fictionalize aspects of the life of Nancy Cunard. In the 1930s Joyce Cary's *The Horse's Mouth* maintained the tradition with its portrait of a painter of genius reminiscent, again, of Augustus John or Stanley Spencer.

The Green Hat was made into the Greta Garbo vehicle, *A Woman of Affairs*; and after 1945 films even more than novels disseminated popular versions of Bohemia: from *Song without End*, a sentimental bio-pic of Liszt, starring Dirk Bogarde, to Marcel Carné's *Les Enfants du Paradis*; from *Funny Face*, starring Audrey Hepburn, to Claude Chabrol's *Les Cousins*; from Vincente Minelli's life of Van Gogh, *Lust for Life* (a title that condenses the bohemian stereo-type), to the 1960s decadence of Nicholas Roeg's *Performance*; from *The Bad Lord Byron* ('George – these bills! We must *do* something ... Oh, don't drink now, you should be writing,' woodenly intones Rank starlet Sonia Holmes to Denis Price), to Derek Jarman's *Caravaggio* and his bleak celebration of punk, *Jubilee*. The French *Nouvelle Vague* provided bohemian anti-heroes for the Sixties in Jean-Luc Godard's *A Bout de Souffle* and François Truffaut's *Jules et Jim*. By the 1980s *Gothic*, Ken Russell's ludicrously self-parodic account of Byron and Shelley's exploits in Switzerland, *Desperately Seeking Susan*, Cronen-berg's *The Naked Lunch*, the lurid punk biography, *Sid and Nancy*, and the British cult success, *Withnail and I* recycled the glamour and despair of Bohemia once again. In the 1990s Mary Harron's *I Shot Andy Warhol*, Julian Schnabel's *Basquiat*, and John Maybury's portrait of Francis Bacon, *Love is the Devil*, were reinventing the Beats, the Sixties, the Punks, the Lower East Side and Fitzrovia for a new generation. As the millennium approached, films of the lives of Georgia O'Keefe, Robert Mapplethorpe, Jackson Pollock and Diane Arbus were in production; and this is without even mentioning a whole industry of Bloomsbury films, books and television serials.

Cinematic representations of Bohemia ranged from the dreadful to the sublime, but most portrayed the bohemian/artist as doomed genius: Basquiat, exploited and destroyed by the art market, or Francis Bacon, the homosexual incapable of love, creating works of genius while tortured by life's meaning-lessness. Alternatively Bohemia was depicted as the haunt of pretentious failure as in Chabrol's witty *Les Cousins*, or of post-adolescent drunken squalor and untogetherness in *Withnail and I*.

Les Enfants du Paradis transcended these alternatives. Made partly clandesti-nely, as the Nazi occupation of France was ending, it depicted the 1830s as a relatively happy and carefree time, contrasted with the darkening years of the Second Empire, drawing an implicit parallel between past and present, the 1830s referring obliquely to the 1930s of the Popular Front, the Napoleon III period suggesting the Occupation. In this way the film indirectly addressed the political dimension of Bohemia. It was original and unusual, indeed unique, in deconstructing the figure of the bohemian, for aspects of the myth were divided among the three main male characters. Debureau, the

great mime, represented the genius of art and enthralment to his passion for his Muse; Frédérique Le Maitre, the romantic actor, represented the dedication of bohemian life and art to pleasure and performance; and Lacenaire, the thwarted playwright, dandy and criminal who commits a murder – the gratuitous act of the failed genius – represented the underworld aspect of *la Bohème*. Marcel Carné thus created a portrait of the bohemian demi-monde of nineteenth-century Paris, which recognizes that the bohemian was never a single entity. His portrayal of women in Bohemia was more traditional, for he included no female genius, no George Sand or Marie d'Agoult. The female characters come from the world of the theatre: Debureau's wife, the *grisette* betrayed and Garance the eternal Muse, who plays out with Frédérique and Debureau the eternal *Commedia dell'Arte* triangle of Columbine, Harlequin and Pierrot. Garance also possibly represents both Art itself and the artist's perennial desire for the impossible love that is simultaneously the perfect work of art – again, the traditional role of woman as representative of abstract ideals.

The popular press was no less important than the movies in promoting a stereotype of bohemian life throughout the twentieth century. In 1920s Britain, for example, there was the sensational reportage of the proceedings when Aleister Crowley sued Nina Hamnett for libel after the publication of her memoirs. Crowley was suspected of involvement in black magic, deviant sexual behaviour, experiments with drugs and even poisoning, while the excesses of Nina Hamnett and other colourful characters such as 'Tiger Woman' Betty May, habituée of the Café Royal and the Fitzroy Tavern, equally thrilled suburbia; for by this time it was the 'suburban' rather than the more political 'bourgeois' that functioned as Bohemia's 'other.'

The young migrated to Chelsea studios, still furnished in *Ballets Russes* style, where they smoked, drank cocktails and experimented with drugs and bisexuality. 'Not artists at all, but Arty People,' sneered the *Daily Dispatch*, 'they just talk about drawing and painting and their studios are only used for dressing up for parties and dances.' 'These people,' echoed Robert Graves, 'pretended to paint but had little or nothing to show for their pretensions, and their chief influence on art was to make the rents of studios rise so high that real artists could no longer afford them.'[13] Meanwhile Tom Driberg, gossip columnist, unashamed homosexual and later Labour MP, reproduced the antics of his upper-class friends for his 'William Hickey' column in the *Daily Express* (antics also fictionalized in Evelyn Waugh's novel, *Vile Bodies*), and well-connected bohemians and aesthetes such as Brian Howard, Harold Acton and the three Sitwell siblings, Edith, Osbert and Sacheverell, were featured both in the popular press and in major novels: Acton and/or Howard in Waugh's *Brideshead Revisited*; and numerous composers, writers, painters, communists, fellow travellers and general hangers-on in Anthony Powell's novel sequence, *Dance to the Music of Time*. Both of these enjoyed a further lease of life when they were televised, *Brideshead* to great acclaim in the 1980s, the Powell sequence less successfully a decade later.

As bohemian countercultural and political movements were recast as youth movements after the Second World War, many commentators predicted the end of Bohemia. In Britain the arrival of the fully fledged welfare state was a threat:

Bohemianism is obviously finished. There may be some isolated cases – the odd chap in the attic – but on the whole much of the struggle has been removed from the artistic career. Nobody in his sane mind and with a reasonably balanced budget would fling himself into a total *décadence* or *Sturm und Drang* ... So long as an artist or a poet produces something that can conceivably pass as a work of art, his bare living will be assured by official grants ... [from the] Arts Council ... In a panic not to miss out on a latent genius, this well-meaning institution ensures a steady level of mediocrity.[14]

Cyril Connolly echoed the view that artists and intellectuals had become 'hard working officials ... in fact culture diffusionists, selling culture for a living',[15] and the newly established Arts Council was blamed for bureaucratizing Bohemia:

There was a perceptible change in the relation of the artist to society. Bohemianism, like Bloomsbury, was dead ... Painters, like writers, could no longer afford *la vie bohème*. Artists ... became bourgeois ... Since art and literature had the, at least nominal, support of the State their practitioners were forced into the role of civil servants.[16]

Yet in the 1950s Bohemia continued to flourish in Fitzrovia (a new name for Soho), and the excesses of Dylan Thomas, Julian Maclaren-Ross and later the 'Chelsea Set' provided the popular press with yet more bohemian copy.

In France and the United States bohemians were given new names and were reclassified as youth movements: Existentialism and the Beats. Jack Kerouac's *On The Road* became the bible of the first post-war generation, and Lawrence Lipton's best seller, *The Holy Barbarians*, published in 1960, made a major contribution to the transformation of the Beats into a mass media phenomenon. A Beat himself, hack writer and obscure novelist, Lipton had in the 1920s been associated with the Wobblies in Chicago, as had the poet Kenneth Rexroth. By the early fifties both had migrated to the West Coast, where they collaborated to write the *Escalator Manifesto* and Lipton began to organize 'at homes' in his house at Venice West. What began as an avant-garde and semi-underground movement soon became a cliché and media stereotype, as beatnik characters appeared in soap operas and comic strips; Stuart Perkoff appeared on a game show with Groucho Marx, and Lipton himself was invited to play the role of beatnik in a coffee bar scene in a low budget horror movie.[17]

Stuart Perkoff described how 'one morning we who lived in Venice woke up and walked out onto the Promenade and we saw hundreds of people who looked just like us'[18] – 'ravers' or tourists equally distanced from full time

Рисунок Л. САМОЯЛОВА.

— Кого как, а меня устранвают папашины средства.

Figure 34 Satirical take on Russian 'Stilyagi,' from *Krokodil*, February, 1961. They were usually portrayed as middle class layabouts. Newspaper headline: 'Inculcate our youth with hard working habits by all possible means.' Youth: 'I don't know about other people, but papa's means [ie wealth] suit me.'

artists and from the vulnerable who had found refuge in the obscurity of Bohemia undiscovered. Thus Venice West inadvertently promoted 'a new branch of popular culture dedicated to the rejection of popular culture'.[19]

The Russian suffix 'nik' came into use after the first space satellite, the Soviet Sputnik, was launched in 1957, testifying to the paradoxical influence of Soviet culture on the West during the cold war. Meanwhile even in the USSR youth was touched by mass cultural bohemianism. A Russian astrophysicist attributed the simultaneous appearance of the Beats in the West and the *Stilyagi* and the Soviet New Wave in the East, to the influence of the sun and the cosmos (hardly a Marxist explanation), but it was surely more likely – although the political conditions seemed so different – that both movements arose for similar social reasons. 'I think it was first of all a democratization, an appeal to the street, to the lower parts, against conservatism, against hierarchy, both there and here,' wrote one Russian writer.[20]

Andrei Bitov believed that the *Stilyagi* had appeared in Moscow and Leningrad before the death of Stalin in 1953, but Vassily Aksyonov described how the *Stilyagi* emerged in the aftermath of his demise:

Confusion arose among Communists – as though they didn't know how they could live without Stalin. Thanks to that confusion, our generation appeared ... we lived absolutely like Beatniks, with all the elements of

beatnik life which they had in San Francisco. We went around in torn clothes, listened to jazz, we lived in a commune, we painted abstract pictures ... we drank, danced the boogie woogie ... It was a totally new time, literally.[21]

The *stilyagi* way of life was a youth movement and a form of mass 'aesthetic dissidence'. It involved the organization of enormous weekend dances, satirical student shows, art exhibitions, literary groups and clubs. During the cultural 'thaw' officialdom tolerated spontaneous New Wave poetry readings at universities and factories. By the early 1960s these had expanded to become open events with huge audiences in vast arenas. Long-hidden Picassos reappeared on the walls of the Hermitage, Western theatre groups began to visit, and young people stood in queues literally for a week to get tickets for *Porgy and Bess*: 'It was an endless line of young people; camp fires burned and everyone had a terrific time.'[22] Another important event was the 1957 Moscow Youth Festival, when for the first time Soviet youth met young men and women from the West.

The West was soon to experience the rise of the international counterculture of the 1960s. This combined avant-garde Happenings with rock music, confrontational theatre with nudity and demotic language, and radical politics with cartoon graphics in its 'underground' press. The Happening, influenced by Artaud, Dada and abstract-expressionism, had emerged in New York in the late fifties, initiated by visual artists. It was an 'art of finds ... an extension of the Duchamp "readymades"' that soon became performance art. It was a visceral and immediate irruption into life, for instead of taking place in a separate, designated space, it just happened – in the street, anywhere. It increasingly involved members of the public and ventured ever closer to the cutting edge of the 'real'.

One of the most extreme examples was the Vienna Aktion Group. Its feminist member, Valie Export, risked electrocution;[23] another member, Hermann Nitsch, gave performances in which one performer pulled a lamb's entrails through his flies while simulated blood was poured over the carcase.[24] Gunter Brus swallowed urine, and the sado-masochistic violence of a fourth member of the group, Rudolf Schwarzogler, involved self-mutilation, which eventually led to his death.[25]

When the Abreaktionspiel visited London, the event was organized by Gustave Metzger, who had developed a technique for spraying acid on nylon, to create a work of art that disappeared while you looked at it. Metzger's name for this was auto-destructive art – he aimed to create work that could not be exploited by the commercial dictates of capitalism, because it destroyed itself. 'We want monuments to Hiroshima,' he proclaimed, 'where the material is squirming, writhing, where heat-bursts puncture the material ... Autodestructive monuments contain the brutality, the over-extended power, the nausea and unpredictability of our social systems.'[26] This might have seemed hardly the stuff to ignite a mass audience; but Metzger taught

Figure 35 'Boho chic' in the high street, autumn 1999. Author's photograph

Pete Townsend at art school, and when Townsend became lead singer of the
rock band The Who, autodestruct was incorporated into the band's act as
they smashed guitars and broke up amplifying equipment on stage.

 Music, in fact, was central to the dissemination of the bohemian avant-garde
into mass culture. The record sleeve of the Beatles' 1967 album, *Sergeant
Pepper's Lonely Hearts Club Band*, designed by pop artist Peter Blake, juxtaposed
hallucinogenic images with portraits of famous past and contemporary

bohemians such as Burroughs and Edgar Allan Poe. The tracks collaged sound to produce a work that transcended the distinction between 'pop' and 'art'. Other musicians followed; George Melly suggested, for example, that Procul Harum's 1967 hit, 'A Whiter Shade of Pale,' had 'all the dangerous and seductive charm of Baudelaire's *Artificial Paradise*.'[27]

In the mid-1970s, the Punks, like *les Jeunes France* of 1830, found their dystopian nihilism massively promoted in the popular press and on television. True, the publicity was usually hostile, but it served all the more successfully to promote the idea of Punk as the latest youth rebellion. Punk was a 'carnival of the oppressed' by 'teenagers [who] changed their lives in pop acts of transformation, using bizarre dress codes, cartoon pseudonyms and amphetamines.'[28] On speed, swearing, spitting and puking, they borrowed from Rimbaud, Mao and the Situationists, but also from pornography, cartoon culture and the tabloids. Punk was 'a portent with its polysemy of elements drawn from the history of youth culture, sexual fetish wear, urban decay and extremist politics,' and it 'spoke of many things: urban primitivism; cheap, second-hand clothes; the fractured nature of perception in an accelerating, media-saturated society; the wish to offer up the body as a jumble of meanings.'[29]

Yet on both sides of the Atlantic, Punk, this howl of rage, was assimilated with surprising ease into the Reagan–Thatcher years of greed and brutal politics; bohemian cultural nihilism could be adapted without too much difficulty to express the moral nihilism of capitalist economics. Derek Jarman's *Jubilee* was an avant-garde homage to Punk at its most intransigent and destructive; but *Desperately Seeking Susan* less than ten years later marketed a sweetly humorous version stripped of fear.

Thus a breathless flood of cultural material celebrated, romanticized and sensationalized bohemian lives. This bohemianization of mass culture has had a double and contradictory effect: on culture itself; and on moral codes and social behaviour. The hippies of the 1960s, the Punks of the 1970s, 1980s New Romantics, fetish dressers and Queer Culture, were bohemians by another name. They provided a focus for dissidence and rebellion, yet were more rapidly marketed than ever.

An historical retro-Bohemia could also now be recycled. Films such as *Henry and June*, a dire portrayal of Henry Miller's love affair with Anais Nin, and *Quartet*, which brought Jean Rhys's novel about her relationship with Ford Madox Ford and his wife, Stella Bowen, to the screen, gave rise to a revival of 'bohemian' fashions in the 1980s and luxurious retro chic in crushed velvet, beads and satin reappeared again in the nineties. In 1996 *Elle* predicted 'the new bohemian' for Autumn. 'Colour and texture are key and the trick is not to clash but gracefully to collide ... Interpretations range from 70s hippie to 90s Portobello Market.' In 1998 fashion again revisited hippie chic for 'bohos with credit cards,' while the London *Evening Standard* ran a feature on the shops from which to collect retro costumes costing up to £15,000 a piece. Fashions that had begun by combining poverty with

originality received their apotheosis at the London shop, Voyage, which became for a time a membership organization so exclusive it was rumoured that Madonna had been refused an entry card. Yet boho chic could also be found in every high street chain-store. Even eco-warrior style could be mass-marketed. The appearance of a British 'crustie' with dried vomit all over his jumper might still have power to inspire dread in Middle England, but New Age travellers, with their *bricolage* of blonde dreadlocks, handknit jumpers, combat trousers and hippie accoutrements, influenced fashionistas. In 1997 when the road protester Daniel 'Swampy' Hooper seemed poised to become the hero of mainstream society, a Sunday broadsheet, tongue only partly in cheek, promised: 'You too can look like Swampy ... without preventing a single bypass' and discussed ways of achieving the look, which was 'anything but accidental':

> A seasoned protester says: 'There is a strong sense of belonging in these communities and I suppose clothes are a tribal thing for protesters.' The Swampy style demands dreadlocked hair, piercings in the most imaginative places (tongue, nose, chin, lips and eyebrows are popular), multi-layers of clashing knit jumpers and combat pants tucked into black wellies or boots.
> Consult the fashion guidebook for the current year and you will find that all these elements are 'in' this season. Everyone ... has been pierced. Combat pants are favoured by street labels.[30]

Just as important, however, was the abandonment of many of the sartorial regulations that once rigidly defined correct dress for the bourgeoisie. Careless, casual dress was no longer a bohemian uniform. The very concept of 'correct dress' was disappearing (at least up to a point).[31]

Popular fiction, too, adopted bohemian attitudes. Julian Stallabrass, for example, suggests that the hip urban sleaze and dystopian mood of the cyberpunk novels published in imitation of William Gibson's 'cult classic', *Neuromancer*, recuperated bohemian rebellion and reduced it to technicist fatalism,[32] presenting their audience with an 'ersatz Bohemia and its chainstore alienation'. In a typical scenario:

> a self-destructive but sensitive young protagonist, [pursued] through wasted urban landscapes/elite luxury enclaves/eccentric space stations full of grotesque haircuts/clothes/self mutilations/rock music/sexual hobbies/designer drugs/telectronic gadgets ... ultimately hooks up with [rebels] ... who offer the alternative not of community/socialism/traditional values/transcendental vision, but of supreme life-affirming *hipness*, going with the flow.[33]

In life as in cyberspace, drugs, once used to explore unusual, even dangerous states of mind as new material to be converted into art, were widely used 'for recreational purposes'. Equally, the bohemian belief (derived from popular

psychoanalysis) that the truth of one's being resides in erotic fulfilment was now taken for granted. Even homosexual relations were increasingly perceived as a lifestyle choice rather than a transgressive destiny, while fetishistic 'perversions' have become a major source for mainstream fashions.[34]

Advertisers followed the trend, selling bohemian attitudes as well as styles. Their market research showed that young people 'dare to be different'. They were in favour of androgyny, rejected fixed gender roles and had moved away from 'attachment to authority, puritanical codes, security and parochialism ... "deviance" had become for many young people a distinctive style with which to navigate a world without reliable landmarks'. It seemed unclear whether this was simply a manifestation of *fin de siècle* decadence, or whether youth en masse really welcomed 'the end of the tyranny of conformity'.[35] Either way, mundane products such as lager and jeans could be marketed with S/M (sado-masochism), transvestite and other images of hip, 'transgressive' urban chic.

Celebrity was an ingredient of the cocktail. This too went back to the 1960s, when Andy Warhol and his Factory provided the conduit between extreme bohemian outrage and 'radical chic'. Thus it came about that where once the term 'bohemian' had suggested the fanatical dedication to art and authenticity of the artist who turned his back on worldly compromise, now it was used to describe glamorous personalities just outside the mainstream of Hollywood or the rock industry. Once it had referred to an artistic underworld, now it attached itself to offbeat stars. Actor Daniel Day Lewis had a 'bohemian' pad. Freddie Mercury and Queen were 'the last of the bohemians' – and had a major hit with 'Bohemian Rhapsody'. The life of Patti Smith, announced *The Guardian*, had 'all the tragedy and romance that marks out a bohemian legend.'[36] Film director Jim Jarmusch was 'bohemian' because he was 'hip', because he was 'languid' instead of being a 'hyper-ventilating careerist', because he didn't want to make films that said nothing, and because, with his prematurely white hair, he dressed in black 'to emphasize his connection to black-and-white, hipster cinema'; but – and this is crucial – he *was* still authentic, for 'my hair is not dyed, it's a genetic thing'.[37]

These 'personalities', however, were not positioned as the Other or opposite of the 'bourgeois'. How could they be – for the uptight, authoritarian, conformist 'bourgeois' has disappeared along with his opposite number. The bohemian personalities of the 1990s were merely glamorized by their halo of slightly offbeat success; they were simply cooler, hipper versions of an ideal to which millions aspired.

In the Notting Hill of the 1960s and 1970s artists such as David Hockney and dress designer Ossie Clark had neighboured with Afro-Caribbean revolutionaries, next door to squats stuffed with radical transvestites, while local Situationists had covered the walls of the railway cuttings with anarchist calls to take up arms against the society of the spectacle and the oppressive consumerism of everyday life. It had featured in the Nicholas Roeg film *Performance*, starring Mick Jagger, James Fox and Anita Pallenberg, a psychedelic

dream which juxtaposed the aestheticism of the hippie 'underground' to the criminal underworld; and hippies and politicos had floated among the tourists between the richly hung market stalls of the Portobello Road.

By 1998 the peeling stucco had been repainted in dazzling white and cream, many of the squats had been sold to the gentrifying classes, and the district had become the most fashionable in London for wealthy metropolitan media glitterati.[38] It had also been made into a film, *Notting Hill*, a soft-centred romance set in a pseudo-Bohemia of ineffectual British eccentrics. The controversial British politician Peter Mandelson – the 'prince of darkness' and 'master of spin', accused by some of air-brushing socialism out of the Labour party and laundering its philosophy to suit the middle classes – briefly lived in the area, as if by moving there he 'showed what a bohemian radical soul he was, a natural social rebel ... not a boring old leftie who can't have a good time.'[39] Mandelson's position of power meant that the hostesses, media moguls and members of café society who were his off-duty friends, could never be, as he may have believed, a kind of anti-Establishment. What is significant is that he might have thought they were, that he might have believed himself to be a member of some latterday *bohème d'orée*. The application of the adjective 'bohemian' to a career politician who aspired to social glamour shows how far the myth has travelled.

Trends such as these elicited further requiems for Bohemia, with the difference that now mass culture rather than the welfare state was blamed for its demise. Art critic Tim Hilton, for example, asked: 'Can there be such a thing as a postmodernist Bohemia?' Without hesitation he answered himself in the negative: 'Of course not! ... Bohemia has now almost disappeared, pretty much unmourned and without an obituary ... where are the young bohemians? ... All swept up in a youth culture that doesn't differentiate between art and entertainment.'[40]

Yet while a bohemian myth was glamorized for mass consumption, mass audiences increasingly hungered for high art. Mass culture is a wall-to-wall experience. The world is drenched in its aesthetic on a daily basis. Yet the spectacle, sound and sensation are not, in fact, confined to 'the popular'. Mass culture is not just about soap opera and the tabloids, it is not just pop music and football, but goes beyond these to popularize the historical avant-garde. Reproductions of the Impressionists decorate millions of sitting-room walls, calendars, birthday cards and biscuit tins. Every event has its sound-track – Vivaldi's *Four Seasons* in the health-food store, Mozart in the bookshop, a *Lakmé* aria to advertise British Airways and Elgar's cello concerto or Bellini's 'Casta Diva' to promote the latest car. Visual images bombard us, ads are based on Caravaggio or Magritte, we gorge ourselves on stories, excitements, dance, drama, global gossip, blood and eroticism. This vast cultural explosion *includes* 'high' cultural forms often denounced as elitist, the most obvious example being Puccini's 'Nessun Dorma', which, as the signature tune for the 1990 football World Cup, went to the top of the charts. Audiences for opera have expanded in recent years, while in 1998

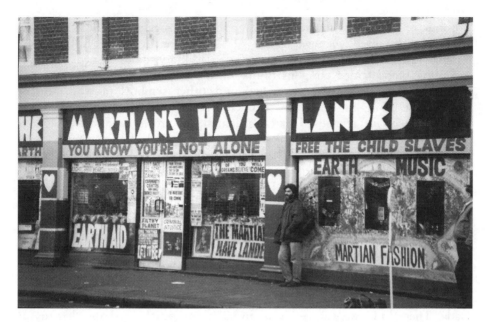

Figure 36 New age 'Bohemians.' In 1995 an alternative religious group, the Church of All Worlds, occupied an empty shop in Camden Town, London, publicizing their mixture of New Age Christian, science fiction, artistic and environmentalist concerns and selling secondhand goods. They were eventually evicted by the local authority for nonpayment of business rates. Author's photograph

publishers reported that 'the growth in popularity of more highbrow [books] … has been fed by the rise of reading groups, where people gather to discuss the books they have read in the previous week.' Publishers had known for a long time ' "that reading groups were popular, but they've grown … We've had to become aware of their importance".'[41]

Even the most challenging avant-garde art was becoming a metropolitan mass pursuit. New clubs in London, for example, combined experimental art, socializing, performance and the popular. At the Plunge Club artists suspended themselves from the ceiling, a twelve-foot fertility goddess loomed over druids and sequinned dancers, and six hundred guests danced to tribal rhythms.[42] The Oval theatre in South London organized a series of 'flâneur' events. Poet Sarah-Jane Lovett hosted monthly bohemian evenings at the Groucho Club and at Jibby Beane's Arts Club anyone could turn up for music, poetry and fashion shows. Thirty years after the International Poetry Festival he had masterminded in 1965, Mike Horowitz organized a Poetry Olympics, and, as one journalist breathlessly reported, 'spoken-word events, salons, art installations and galleries are again becoming the most happening hangouts'. Neo-beats, performance artists, poetry readings and galleries appeared all over London and the home counties; high culture was becoming 'the leisure activity of choice' for the under thirty-five-year-olds.[43]

Some of the most confrontational political struggles of the 1980s and 1990s also involved avant-garde art. At Greenham Common in 1983 the feminist protesters encamped outside the military base created artworks including bloodstained tampons (punk musician Sid Vicious had worn one in his buttonhole some years earlier) and other symbols of womanliness, which were hung on the wire perimeter fence. New Age movements in Thatcher's Britain revitalized extra-Parliamentary protest and direct action, indeed they created a whole alternative culture with its own crafts and aesthetic, sharing a way of life that, with its festivals and markets, offered a carnivalesque, anti-authoritarian and self-sustaining alternative with a strongly aesthetic dimension.[44] In Leyton, East London, campaigners against the extension of a motorway married art and protest as they attempted to protect streets from demolition. Murals, roadside sculptures and the recreation and reconstruction of interiors of houses that had been knocked down, decorated with Walt Whitman poems, a pastiche of a Matisse painting, 'Dancers', and shrines constructed from objects retrieved from the demolition, all became part of the protest.[45]

In a discussion of 'Slacker art' critic Jan Bankovsky drew on its links with Dada. These links were traceable in installations which used the detritus of daily life in 'apparently random accretions of found objects, trashy knick-knacks and personal souvenirs', so that 'from its cracks bleeds a crazy texture of bohemian intensities'.'46 Richard Linklater, whose film *Slackers* explored the bohemian lives of students who stayed on in Austin, Texas, after graduation, suggested: 'there are affinities with earlier kinds of bohemians; a desire to be individual, to question the grinding down effect society has on its inhabitants, to formulate your own code of decency and spending time.'[47]

It was therefore not simply that the lifestyle trappings of Bohemia crossed into mass culture. In a reciprocal move, the bohemian challenges to convention transformed deep-seated attitudes. In Germany, once bars and cafés were allowed to stay open into the small hours, a new ambience was created which displaced the old, university-based forms of student bohemian life in favour of customs more suited to the present. The world of serious education and serious careers was becoming meaningless, some felt, now that employment no longer seemed permanent or secure. The bohemian bar provided an alternative for a hand-to-mouth generation, a Teutonic equivalent of America's 'Generation X'.[48]

This is inevitably no more than a sketch of the massive expansion of the cultural sphere in the past forty years. In the 1980s the term postmodernism[49] came into widespread use, partly as an attempt to account for this expansion. Like the idea of Bohemia itself, postmodernism was an umbrella concept. Many of the phenomena once labelled bohemian now came to be perceived as postmodern, artistic experiments that mingle high and low forms, for example. Postmodern, too, it is argued, is the disintegration of monolithic classes into fragmented tribes with a diversity of moral views and cultural tastes, postmodern the belief that the centre will not hold, since

there is no longer a dominant ideology (other than the global market, which orchestrates the diversity).

Whereas 'bohemian' was a descriptive term, however, postmodernism has made large theoretical claims and aimed to provide a set of explanations for the bewildering nature of a cultural and moral world dominated by mass media. Some commentators have greeted the new postmodern world they have discovered with euphoria, but many have explored it in terms reminiscent of the nostalgia and pessimism of previous generations of dissident bohemians. Both Bohemia and postmodernism have made much of the decay of political consciousness, the expansion of the aesthetic into all areas of life and a moral approach that rejects absolutes in favour of relative values. Theories of postmodernity may therefore shed light on the dissemination of bohemian ways throughout mass culture, and the possible results of this.

Notes

1 Cowley, *Exile's Return*, p 62.
2 Mulvagh, *Vivienne Westwood: An Unfashionable Life*, p 88.
3 Bernice Martin, *The Sociology of Contemporary Cultural Change* (Oxford: Blackwell, 1981), p 236.
4 Ibid., quoting Malcolm Bradbury, 'A Dog Engulfed in Sand II: Abstraction and Irony', *Encounter*, lii/1 (January 1979), pp 39–40.
5 Fredric Jameson, 'Postmodernism or the Cultural Logic of Late Capialism', *New Left Review*, 146 (July/August 1984), p 87.
6 My thanks to Tony Halliday for pointing this out. See, for example, Ouida, *Folle-Farine* (London: Chapman and Hall, 1871). This novel is dedicated to Ingres and the epigraph is from a poem by Baudelaire.
7 Marilyn Brown, *Gypsies and Other Bohemians*, who charts how the popularity of these subjects fluctuated from year to year.
8 La Goulue later fell on hard times. Shortly before the First World War Modigliani discovered her at a street fair, where she stood, hugely fat, in a cage with mangy wild animals (see Rose, *Modigliani*, p 193); and she was still there in the 1930s when Pavel Tchelitchew and Charles Henri Ford encountered her: 'a huge woman weighing possibly 300 pounds and clothed in a loose wrapper sits placidly in a rocking chair fanning herself. In the background, like some incongruous butler, stands an old man, toothless, but with the famous Mephistopheles chin ... Valentin-le-Désossé, her old dancing partner.' (Parker Tyler, *The Divine Comedy of Pavel Tchelitchew* [London: Weidenfeld and Nicolson, 1967], p 321.)
9 For example, there are pastiche Toulouse Lautrec murals in the well-known bohemian Soho café, the Patisserie Valerie.
10 Harold B.Segel, *Turn-Of-The-Century Cabaret: Paris, Barcelona, Berlin, Munich, Vienna, Cracow, Moscow, St Petersburg, Zurich* (New York: Columbia University Press, 1987), p xvii.
11 Siegel, *Bohemian Paris*, p 230.
12 Jelavich, *Berlin Cabaret*, p 20.
13 Graves and Hodge, *The Long Weekend*, p 120.

14 Guy Deghy and Keith Waterhouse, *Café Royal: Ninety Years of Bohemia* (London: Hutchinson, 1955), p 193.
15 Clive Fisher, *Cyril Connolly: A Nostalgic Life* (London: Macmillan, 1995), p 277.
16 Alan Ross, 'Introduction', in Maclaren-Ross, *Memoirs of the Forties*, no page nos.
17 Maynard, *Venice West, passim.*
18 Ibid., p 112.
19 Ibid., p 113
20 Inger Thorup and Per Dalgard (eds), *The Beat Generation and the Russian New Wave* (Ann Arbor: Ardis, 1990), p 41.
21 Ibid., pp 81, 59.
22 Ibid., p 58.
23 Rosa Lee Goldberg, *Performance Art: From Futurism to the Present* (London: Thames and Hudson, 1979), p 164.
24 Hewison, *Too Much: Art and Society in the Sixties*, p 118, quoting *New Society*, 27 July 1967.
25 Goldberg, *Performance Art.*
26 Quoted in Hewison, *Too Much: Art and Society in the Sixties.*
27 George Melly, *Revolt into Style: The Pop Arts in Britain* (Harmondsworth: Penguin, 1970), p 110.
28 Savage, *England's Dreaming*, p 192.
29 Ibid., p 230.
30 James Sherwood, 'You too can look like Swampy', *Independent on Sunday*, 'Real Life' section p.8, 23 March, 1997.
31 However, there is a counter-move towards more rigidly enforced dress codes in some places of employment, for example in offices where employees are forbidden to wear jeans. Uniforms are ubiquitous in large retail concerns; by contrast some employers insist that their workers 'dress down' on Fridays. Also, although women lawyers and stockbrokers are now permitted to wear trousers, it was not until January 2000 that a British woman won her discrimination case against her employers, the Professional Golf Association, after being sent home for wearing trousers; and in 1999 a British schoolgirl took her mixed-sex school to the Equal Opportunities Commission because girls at the school were forbidden to wear trousers. (The school eventually backed down.)
32 Julian Stallabrass, *Gargantua: Manufactured Mass Culture* (London: Verso, 1996), p 43.
33 Istvan Csicery-Ronay Jr, 'Cyberpunk and Neuromanticism', in Larry McCaffery (ed), *Storming the Reality Studio: A Casebook of Cyberpunk and Postmodern Fiction* (Durham, NC: Duke University Press, 1991), p 184.
34 See Valerie Steele, *Fetish: Fashion Sex and Power* (New York: Oxford University Press, 1996).
35 Mark Simpson, 'Deviance Sells', *The Guardian*, London, 11 November 1994, pp 14–15.
36 Michael Bracewell, 'Woman as Warrior', *Guardian Weekend*, London, 22 June 1996, p 13.
37 Jonathan Romney, 'Wandering Star', *The Guardian*, London, 27 June 1996, p 10.
38 Although a good deal of social housing still remains.
39 Colin Hughes, 'Naivety of a Machiavelli', *The Observer*, London, Sunday 27 December 1998, p 8.
40 Tim Hilton, 'The Death of Bohemia', *The Guardian*, London, 20 March 1991, p 17.

41 Martin Bright and Sarah Ryde, 'Books boom as shoppers turn over a new leaf,' *Observer*, London, News Section, 13 December 1998, p 11. In Britain the radio station Classic FM was also thought to have increased the popularity of classical music, although this argument was countered by the suggestion that this station, playing extracts from the best-known classics, worked against Radio 3, which played whole, and less known works – in other words that the increased popularity of familiar musical classics might actually be a form of 'dumbing down'. Some musicians have also argued that the mass production of musical classics on CDs has a similar effect, making lesser-known or difficult works even harder to get hold of.

42 Judith Palmer, 'Taking the Plunge', *Independent*, London, 12 April 1995, p 15.

43 Oliver Bennett, 'Welcome to the Culture Club', *Independent on Sunday*, London, 7 July 1996, p 4.

44 Kevin Hetherington, 'Stonehenge and its Festival: Spaces of Consumption', in Shields, Rob, ed, *Lifestyle Shopping: The Subject of Consumption*, London: Routledge, (1992).

45 Murray Armstrong, 'The Art House Effect,' *Guardian Weekend*, London, 25 June 1994, pp 28-32, 52.

46 Jan Bankovsky, 'Slacker Art', *Art Forum*, xxx/3, November 1991, p 98.

47 Simon Reynolds, 'The Slacker's Life of Apathy', *The Guardian*, London, 19 March 1992, p 26.

48 Diedrich Diederichsen, 'Gefühlte Paprika – die politische Subjectivität der Boheme', *Texte und Kunst*, 11, September 1993, pp 65-9. Thanks to Beatrice Behlen for drawing my attention to this article.

49 Along with 'postmodernity'. Just as 'modernity' refers to the industrial period in general and includes all aspects of the economic, the social and the political, while 'modernism' refers to the cultural moment of modernity, so postmodernity is a wider term than postmodernism, but both are fairly loosely used to refer to numerous aspects of the postmodern. See Terry Eagleton, *The Illusions of Postmodernism* (Oxford: Blackwell, 1996).

CHAPTER 15

POSTMODERN BOHEMIA(N)S

The air is so full of phantoms, mirages of a glorious cultural future breaking upon us overnight in spite of all.
 Walter Benjamin: Imperial Panorama: A Tour of the German Inflation

Bohemia first emerged as a counter-space in opposition to the repressive authority of bourgeois society. It was particularly significant in states such as nineteenth-century France and Germany where parliamentary democracy was not fully established, but had resonance throughout the Western world as an alternative way of life. Indeed it was more than that. It was an alternative world. It presented itself both as the absolute opposite of bourgeois society, a site of political dissidence challenging the oppressive powers of the state, and as a stronghold of artistic values against the philistine. It was the 'Other' of bourgeois society, that is to say it expressed everything that the bourgeois order buried and suppressed. In that sense it was an image of utopia.

As Other to bourgeois society Bohemia incorporated elements of carnival, reintroducing the low, the sexually excessive, disorder, and defiance of authority and power. The traditional carnival was both a subversion and an acknowledgement of the social order that class society embodied,[1] and to some extent a *licensed* deviation from normal regulation. Yet even then it was transgressive, because although it acknowledged opposites, it simultaneously confounded them, and thus became a different kind of reality. Eric Mühsam implied the carnival aspect of Bohemia when he described the Berlin Café des Westens as a 'meeting place of free spirits', in which the bohemians came together in an atmosphere in which work *became* play. The participants transformed discussion into a display of mental acrobatics, so that 'thought became elastic and ideas could be kneaded and shaped at will'.[2] In Bohemia as in carnival, the customary divisions of bourgeois society were overturned.

The art of the avant-garde bohemians reflected this. Surrealism and Expressionism, for example, 'took over in a displaced form much of the inversion, grotesque body symbolism, festive ambivalence and transgression which had once been the provenance of carnival'.[3] In their lifestyles as well as their art the bohemians both brought together the 'high' and the 'low', and amalgamated two aspects of life excluded or marginalized by bourgeois ideology: the bodily 'low' on the one hand and the spiritual aspects of art which were to give meaning to life in a secularized world.

The bohemians of the nineteenth and early twentieth centuries – les Jeunes France, the dissidents of the Second Empire and the Nietzscheans of Wilhelmine Germany – were living through what is loosely known as modernity: the vast upheavals of the period when the West industrialized. They were responding to a new world, a bizarre, marvellous and terrifying urban society. They were pitted against societies in which authority and social rules were directly expressed and rigidly enforced. The bohemian 'myth' corresponded to this period in the development of industrial capitalism.

Experimental art – Modernism – developed as a response to this world and an attempt to apprehend and understand it. Modernism and the avant-garde were closely connected to Bohemia, although not coextensive with it. Artistic daring and experiment – which overflowed into artists' lives – flourished, it has been suggested, because three factors coincided at this time. These three factors were: that the ruling class retained some of its aristocratic aspects; that the political situation was unstable, therefore still promising the possibility of radical change; and that technologies still had enormous novelty value. Modernism was able to exploit the contradictions of this fairly prolonged period when inventions, politics and rulers were out of step with one another.[4]

Modernists, the avant-garde and the bohemians all in different ways exploited the situation. Artists transformed art by marrying it to new technology. Sometimes they did this by inventing new forms, such as film and photomontage; sometimes by representing the new technologies visually and aurally in their art and music, or by writing in such a way as to capture the bewildering kaleidoscope of the modern metropolis, its speed, fragmentation and anomie.

Politically bohemians tended to be drawn to utopian systems and extreme oppositionalism. Their goal was total social transformation rather than incremental political change. Consequently their revolutionary challenge to social privilege, conformity and conservatism was symbolic,[5] hence their use of outrage and confrontational lifestyles as weapons.

After the Second World War the situation stabilized. Solidly based capitalist democracies were installed in the West, while revolutionary hopes were crushed by the distortions of Stalinism in the East. The rigidity of the cold war period deprived modernism of its vitality. In the 1960s, however, the political glaciers began to thaw, and the further social and economic changes of the 1970s and 1980s meant that postmodernism could emerge.[6]

The cultural changes brought together under the rubric of postmodernism have been analysed both from conservative and from radical perspectives. In her critique of the youth movements of the sixties, Bernice Martin argued that their influence led not only to an aesthetic, but also to a moral transformation. The assimilation of countercultural romantic values of feeling, infinity and ambiguity into mainstream culture had, she felt, changed Western society profoundly for the worse by promoting narcissism and self-indulgence.

From a different political position, Perry Anderson drew rather similar conclusions. Capitalism, an intrinsically amoral system, initially derived its moral authority from pre-bourgeois values, drawing on religion or on aristocratic conceptions of mutual responsibility across classes. By the 1970s this 'classic' bourgeoisie had become virtually extinct. Multinational companies that transcended national boundaries and the rootlessness of financial markets had undermined the ways in which the social classes had traditionally composed and expressed themselves.

There no longer existed a clearly defined bourgeoisie that aspired to aristocratic ways of life, rather the opposite was occurring: the *encanaillement*, as Anderson disdainfully termed it, of the dominant classes. As inequalities of wealth intensified, members of the new class of the 'super rich' that emerged were more likely to 'go slumming, adopt the manners of boxers, the accents of the ghettoes, and the vulgarity of Hollywood and Disney'.[7] Yet while they indulged plutocratic tastes for private jets and diamond necklaces worth $39 million, these jostled on their shopping lists with Jackson Pollock canvases and Gucci jeans customized to look like genuine torn hippie items. In other words the new plutocracy has taken over both classically 'bohemian' tastes and that taste for the popular which was also partly bohemian.

At the same time, suggested Anderson, the conventional art establishment and the canons of bourgeois academic good taste in art and literature disappeared, so that the conservative aesthetic against which the bohemian and/or the avant-garde rebelled no longer existed. The market and the spectacle of consumer society had become all-inclusive. Anderson welcomed this 'plebeianization' insofar as it referred to greater literacy, less deference and a decline in the importance of inherited wealth and rank, but argued that it had also resulted in the suppression of cultural opposition. For when celebrity replaces both aristocracy on the one hand and fame based on talent on the other, and when mass culture triumphs over high art, the possibility of cultural revolt is extinguished, since 'any category of the Other in the collective imaginary' has disappeared.[8] Socially meanwhile, observed Bernice Martin, 'authority is seldom able to legitimate itself with the old vocabulary of authority *per se*, but only by means of a populist and anti-hierarchical rhetoric'.[9]

In contrast to this pessimistic analysis, however, others argued that postmodernity/postmodernism undermined the 'grand narratives' of the white Western Enlightenment – by which they meant those theories, especially Marxism, that had claimed to explain all aspects of experience. This was to

be welcomed in that it weakened traditional hierarchies and allowed the Others of history – women, minorities, non-whites – whose voices had until now been suppressed, to make an appearance on the world stage, to be culturally and, it was argued, politically recognized.

In particular it was argued that postmodernism broke down the traditional distinction between high art and mass culture. It was not that mass culture had triumphed over high art, but rather that the boundaries between them had collapsed. This meant that the tastes of the majority could be brought in from the cold, and it made possible a move away from what was judged to be the elitism of Marxists such as Theodor Adorno and Max Horkheimer.

Adorno had argued that experimental art could play a subversive role, that the avant-garde escaped dominant ideology and formed the basis for resistance. Mass culture on the other hand was a new opium of the people, which stifled dissent and served the needs of capitalist imperialism. But from the 1960s and 1970s onwards, cultural theorists disagreed. They maintained that hostility to mass culture and an obsession with its insidious ideological domination had blinded left-wing elitists both to the pleasure it provided and to its relevance to people's lives, and had implied contempt for the very 'masses' with whom they were supposed to be politically aligned.[10]

These more optimistic theorists emphasized the creativity with which contemporary audiences use and subvert mass culture. Some went so far as to argue that 'popular culture is always a culture of conflict, it always involves the struggle to make social meanings that are in the interests of the subordinate and that are not those preferred by the dominant ideology.' According to this view popular culture is inherently subversive, while Adorno and Horkheimer 'have no room in their scenario for resistant or evasive practices'.[11]

This line of reasoning was equally reductive, and merely inverted Adorno's analysis, reducing 'high culture' to *nothing but* elitism. The 'deep, complexly crafted texts [of high art] … narrow down their audiences and social meanings', whereas popular culture is to be admired precisely because it is 'tasteless and vulgar, for taste is social control and class interest masquerading as a naturally finer sensibility'.[12]

Adorno had believed that 'the masses' had had the wool pulled over their eyes by Hollywood and Tin Pan Alley, and had thus succumbed to 'false consciousness.' The cultural populists explicitly rejected the whole idea of false consciousness as authoritarian, yet they themselves were effectively just as elitist as Adorno. In the first place their argument implied that the majority really is too stupid to understand the 'complexly crafted texts' of high culture. Secondly they blithely resurrected 'false consciousness' when they accused an assumed elite of pretentious snobbery, asserting that while preferences for high art might 'masquerade' as aesthetic discrimination or genuine choice, they were in fact dictated by 'class interest'.[13] This argument also seems at odds with the assertion that the boundary between high and mass culture has collapsed.

Yet cultural populism originated in an attempt to extend the parameters of what was considered aesthetically and artistically important. The radical cultural theorists of the 1970s rejected the masculine and 'white Western' bias of the established artistic and literary canons in order to legitimate working-class, 'people's,' women's and black alternative art as well as mass culture. In so doing they appeared ironically to echo the preferences of an earlier bohemian avant-garde. John Fiske, for example, has argued that popular culture 'minimizes the difference between text and life.' As 'a process- and practice-based culture' the popular breaks down 'the distinction between the aesthetic and the everyday,' whereas 'bourgeois, highbrow' culture, which is text- or performance-based, reinforces the divide between art and life.[14] In this respect, cultural populism echoed the bohemian enthusiasm for the popular, the avant-garde desire to collapse art into life, and the longing for carnival.

The carnival of the bohemian avant-garde, however, was conceived as part of a wholesale challenge to the status quo. It was predicated on the belief that there existed a possible alternative, no matter how that was envisioned. Today, on the other hand, the most serious defect of cultural populism is not its refusal to deny that the enjoyment of high culture could ever be authentic. It is that however passionately theorists emphasize the radical potential of mass culture they invariably describe a world in which the form taken by dissent is that of internal exile rather than open opposition. Michel de Certeau, for example, influentially argued that the oppressed have always resisted, have 'poached' on the domains of the powerful and reworked the dominant culture for their own ends.[15] He described this, however, as a new form of internal migration by peoples who had been thoroughly colonized. 'Resistance' and 'transgression' have replaced 'revolution' and 'transformation' in a world turned inside out rather than upside down. This is a world in which the insignia of dissent are flaunted openly, and challenging attitudes in personal and everyday life question bourgeois traditions that are in any case dying. Yet it is also a world in which the impersonal power structures of the global economy are never challenged. Instead they are either viewed fatal-istically or positively welcomed.

Such a position views the triumph of hedonism too complacently, and seems blind to the way in which 'personal choice' in private life is coupled with a growing democratic deficit. For there is a real danger that when liberal, personal freedoms are taken for granted, yet when the civil and poli-tical rights with which they once went hand in hand start to crumble away, they become vulnerable to assault from other, more militant belief systems. Religious fundamentalisms, for example, offer moral and cultural certainties that radically challenge the 'anything goes' of a mass culture of consumerism and celebrity. They appear particularly attractive to groups, such as young people in developing countries, that have been excluded by poverty from the ever-receding nirvana of infinitely expanding desires.

Panglossian cultural theorists,[16] therefore, in exaggerating the subversive

potential of mass culture, abrogate intellectual responsibility. In the first place they take little account of the way in which mass culture may be becoming a global dominant, thus crushing non-Western cultural systems. Secondly, their argument fails to recognize that to reduce protest *to* mass culture represents a grotesque narrowing of the parameters of permitted contestation in a political climate in which civil rights are neglected and in which disillusionment with defective forms of democracy has led to widespread apathy.

The *'encanaillement'* – the loss of deference and increase in familiarity which some equate with rudeness – the loss of *overt* respect for authority, arguably encouraged by mass culture, and deplored by Bernice Martin, is in any case a fairly superficial phenomenon. That today we reserve our adulation for footballers and super models rather than dukes and duchesses may make us feel more democratic, but in fact the talents or beauty we worship are also partly inherited and bear a similar relationship to glamour and gossip. To address your boss – or the President of the United States of America – by his Christian name may seem democratic, but underneath this cheery egalitarianism old forms of submission and obsequiousness retain and strengthen their hold. In fact the surface of first-name familiarity and the pretence that we can each choose our destiny masks grotesque and intensifying social and economic inequalities. If any social phenomenon justifies the label of false consciousness, it is surely this.

Nor are the artistic and literary talents by which the bohemians set such store much more evenly rewarded than they were in the 1830s. British writers of the 1940s who feared that the welfare state would bureaucratize the arts did not, apparently, anticipate the accompanying expansion of academic teaching, publishing and the media throughout the earlier post-war period. These opportunities created greater financial security for artists, writers and professionals in arts-related spheres. But with the oil crisis, 'stagflation', recession, short-term contracts and deteriorating conditions in the 1970s and 1980s, the casualization of cultural and intellectual work began to re-appear. As early as 1982 new graduates were emerging 'into an unwelcoming world, feeling very separate from the traditional university elites', and it seemed possible that 'the rapid expansion of higher education, followed by recession, contraction and graduate unemployment, provided the classic conditions for intellectual revolt'.[17]

Many intellectuals and professionals in the media and cultural industries have been subjected to the 'rigours of the market', as workers' rights everywhere have been whittled away in the interests of deregulation and flexibility. Changes in the music industry, the media and publishing have caused insecurity and alarm. For example: 'in the wake of the [publishing] industry's perennial mergers, shakedowns and rationalizations, the number of relatively well-known (and occasionally extremely well-known) writers who now have difficulty in finding someone to publish them increases year by year.' 'Short-termism infects modern publishing' – new writers and some big names are paid grossly inflated advances, while older 'talented but small-selling authors'

are let go.[18] Classical conductors and instrumentalists, too, viewed the commercialization of their music with alarm, as, they alleged, popular compilations of 'the classics' replaced whole performances and the recording of lesser-known works.

It is possible that the return of a nineteenth-century-style 'lumpen intelligentsia' in a time of democratic decay may recreate the preconditions in which traditional bohemian countercultures could re-emerge. But when, rifling through the rails of second-hand cultural identities, we find the bohemian role still hanging at the back of the wardrobe, we may feel that this old-fashioned frock is now too quaint to wear. Although it still has a certain musty charm it must be relegated – as has for so long been predicted – to the museum of ideas to which all good cultural phenomena go when they die. Despite the cycle of eternal recurrence – which is as characteristic of the socio-economic and political realms as of fashion – it seems unlikely that the bohemian frock will do. Protest would have to take a different form in a cultural landscape that has certainly shifted, so that there is no longer either a single continuum, or two hostile camps of high and low, but rather a 'multidimensional' social and cultural space.[19] Art, too, has fundamentally changed.

Some postmodern theorists have argued that social cohesion has fragmented, and that individuals now adhere to fluctuating, fluid social 'tribes', in which the search for identity (dissident or otherwise) is a search for belonging, a question less of 'resistance through rituals'[20] than of 'conformity through rituals'.[21] Refusals may take a passive rather than an active form, of flight and concealment rather than confrontation.[22]

This too, though, is surprisingly consistent with the lives of those bohemians who were perennial marginals, exiles, whose strategy was escape rather than battle. One such was a certain Dr Walter Serner, who appears fleetingly in the annals of the German Bohemia. During the First World War he helped comrades avoid the draft, and later himself fled to Switzerland 'on the very day the police waited for him with a warrant at the Café des Westens'. There he became part of the Dada movement.

After the end of the war he continually wandered from one city to another:

> Rome, or Genoa, Naples, Frankfurt, Vienna ... his life was just like his stories in which somebody is always arriving and going away again and doing the strangest things in between. He was always open to the infinite possibilities of existence. Sometimes we would roam from dusk till dawn through the harbour area [of some city] and squat in crude music-halls ... it was the right background for his brilliantly spontaneous *aperçues*. I last heard of him in 1927 ... That he should disappear without trace is characteristic of him.[23]

In was in the Soviet Union that Serner disappeared, perhaps in search of the bohemian's always elusive utopia.

This final fragment of a bohemian life illustrates the way in which bohemians tried to hold incompatibilities together, tried to avoid choosing between the life of politics and the life of art, tried always to have both. It is representative, too, of the bohemian love of out-of-the-way experiences and places, uncolonized by theory and system, the search for that which is excluded.

The multi-dimensional postmodern space with its shifting tribal groupings unexpectedly resembles Bohemia, insofar as it refers to similar confusions of art and lifestyle, identity and culture, *bricolage* and avant-gardism, kitsch and intransigence – or intransigent kitsch. There is also a convergence between the strangely euphoric melancholy of the postmodernists who simultaneously celebrate consumer culture and mourn the death of protest, and the requiem of those who lament the death of Bohemia.

Bohemian protest in the form of 'the shock of the new' long ago lost its power to shock. It is this that may have caused us to miss or forget the way in which, as forbidden areas of personal experience have become more acceptable, whole areas of the political have been withdrawn from circulation and put on the Index of Censorship, at best marginalized, at worst completely forgotten. As aesthetic rebellion has flooded Western society it would appear to have drowned political radicalism altogether. We live in a baroque epoch of aesthetic excess and political suffocation – or rather, vacuum.

This does not mean that the desire to change society has disappeared, as some commentators have implied. It does not follow that youth culture is concerned only with 'distinction,' with an empty kind of coolness and hip, devoid of political aspirations.[24] Nor need it necessarily lead to the despairing negation of T.J. Clark's cry: 'If I cannot have the proletariat as my chosen people any longer, at least capitalism remains my Satan.'[25] Groups and individuals in the West (let alone in the rest of the world – which is another story) struggle to protest and strive to find effective ways in which to force change. Gustave Metzger, for example, still believes that art can change the way in which its audiences see and understand the world.

As the millennium approached new forms of protest did seem to be emerging – for example in Seattle in the autumn of 1999 against the World Trade Organization. Although these protests were in some respects incoherent and inconclusive, they signalled the emergence of new forms of political organization, since they were orchestrated internationally by Internet and email.

On the other hand the protests took the rather traditional and rather bohemian (and certainly anarchist) form of spectacular demonstration, with performance and theatre playing a role. In this context the myth of Bohemia is neither part of a dead past, nor does it gesture towards a future utopia. The bohemian impulse will find new expressions and new forms, for it is not, after all, the case that postmodernism inaugurates an 'end of history' in which there is no 'other' and nothing is excluded. It is rather, as Terry Eagleton suggests, a transitional period, one in which we do not as yet recognize the sources from which a future history will arise. While future dissidents,

therefore, may not be known as bohemians, it is most unlikely that the desire to create a different and more authentic life will ever disappear.

Finally, the generations of bohemians acted out a struggle between two different and incompatible conceptions of art and its relation to political change. There was the 'conflict' view, which understands culture primarily 'as a medium through which power is exercised and/or as the field of symbolic struggles,' and there was an 'existentialist' view, which 'sees culture primarily as satisfying a universal human need for meaning.'[26] The work of Pierre Bourdieu articulates the first view, and an interpretation of bohemian behaviour based on his work would emphasize the search for distinction and the pursuit of an ultimately economic self-interest.[27] And certainly, as I have argued, Bohemia arose in response to economic change. A more Nietzschean approach, articulated in *The Birth of Tragedy*, would acknowledge the inevitability of 'destruction, absurdity, horror, misfortune' in human life, but would state that art permitted us to see these features of existence 'as *aesthetically* meaningful and justified.' By admitting humankind's 'existential predicament [and by the adoption of] an aesthetic (dis)position towards life, art makes life possible and worth living.'[28] The ambiguity of Bohemia, and the ambivalence with which it has *always* been viewed, arises in part because it constituted a battlefield upon which these two contrasting understandings of culture perennially but inconclusively struggled. The 'existential' view could lead to the elevation of art into a religion (art for art's sake). A utopian politics, on the other hand, tended to belittle art and taste (reducing it to the search for 'distinction'). It could not accept the inevitability of suffering, nor the incomplete nature of human life. It was this incompleteness that Walter Benjamin expressed when he wrote: 'what one has lived is at best comparable to a beautiful statue which has had all its limbs knocked off in transit, and now yields nothing but the precious block out of which the image of one's future must be hewn.'[29]

The peculiarity of the bohemian was in holding these incompatibilities in tension. The bohemian impulse (in theory if not always in practice) transcended both the vulgarity of cultural populism and the elitism of 'difficult' art. Benjamin's beautiful image reaches the heart of this impulse and its implications: that it is out of the inevitability of imperfection and suffering that we must create an inspiration to encompass both tragedy and hope. The heroism of the bohemians was in their steadfast loyalty to that ideal. The 'impossibility' of their identity resulted from the utopianism of that desire.

Notes

1 Peter Stallybrass and Allon White, *The Politics and Poetics of Transgression* (London: Methuen, 1986), p 26.
2 Mühsam, *Unpolitische Erinnerungen*, p 57.
3 Stallybrass and White, *Politics and Poetics of Transgression*, p 189.
4 Perry Anderson, *The Origins of Postmodernism* (London: Verso, 1998).

5 See Kreuzer, *Die Boheme: Beitrage zu ihrer Beschreibung.*

6 Anderson, *The Origins of Postmodernism.*

7 Ibid.

8 Ibid., p 111.

9 Martin, *The Sociology of Contemporary Cultural Change*, p 23.

10 John Fiske, *Reading the Popular* (London: Routledge, 1989), p 183.

11 Ibid., pp 6–7.

12 Ibid. Jim McGuigan and others have also criticized this work on the grounds that it merely mirrors the ideology of 'consumer sovereignty' and the belief that the market satisfactorily fulfils all needs, even cultural (and spiritual) ones. See Jim McGuigan, 'Cultural Populism Revisited,' in Marjorie Ferguson and Peter Golding (eds), *Cultural Studies in Question* (London: Sage, 1997), p 141.

13 But see also Pierre Bourdieu, *Distinction: A Social Critique of the Judgment of Taste*, 1986 trans Richard Nice; and Howard Becker (London: Routledge, 1986). See also Howard Becker, *Art Worlds* (Berkeley: University of California Press, 1982) for an alternative sociological view.

14 Fiske, *Reading the Popular*, p 6.

15 Michel de Certeau, 'Walking in the City', in Michel de Certeau, *The Practice of Everyday Life* (Berkeley: University of California Press, 1984).

16 For a critique of these 'cultural revisionists' from a different perspective see James Curran, 'Rethinking Mass Communications', in James Curran *et al.* (eds), *Cultural Studies and Communications* (London: Edward Arnold, 1996), pp 119–65.

17 Robert Hewison, *Too Much: Art and Society in the Sixties*, p 284, quoting Anthony Sampson, *The Changing Anatomy of Britain* (London: Hodder and Stoughton, 1982).

18 D.J. Taylor, 'Rewriting the Rules', London, *The Guardian*, G2, 14 July 1999, p 16. Some of these, however, says Taylor, are publishing themselves; 'cyberspace is revolutionizing the way in which [authors] can bring themselves to market,' and just possibly this may backfire on the big firms.

19 Sarah Thornton, *Club Cultures: Music Media and Subcultural Capital* (Cambridge: Polity Press, 1995), p 163.

20 This was the title of an important analysis of youth cultures from the influential Birmingham Centre for Contemporary Cultural Studies, Stuart Hall and Tony Jefferson (eds), *Resistance Through Rituals: Youth Subcultures in Postwar Britain* (London: 1976).

21 Michel Maffesoli, *The Time of the Tribes* (London: Sage, 1996).

22 Caroline Evans, 'Dreams That Only Money Can Buy ... Or The Shy Tribe in Flight from Discourse', *Fashion Theory*, i/2 (June 1997), pp 169–88.

23 Christian Schad, 'Zurich/Geneva: Dada,' in Raabe (ed), *The Era of German Expressionism*, p 169.

24 See Thornton, *Club Cultures.*

25 T.J. Clark, *Farewell to an Idea: Episodes from a History of Modernism* (New Haven: Yale University Press, 1999), p 8.

26 T.J. Berard, 'Dada between Nietzsche's *Birth of Tragedy* and Bourdieu's *Distinction: Existenz* and Conflict in Cultural Analysis,' *Theory Culture and Society*, xvi/1 (February 1999), p 141.

27 Ibid., p 145.

28 Ibid., p 146.

29 Benjamin, *One Way Street*, p 76.

BIBLIOGRAPHY

ADES, Dawn *et al.*, *Art and Power: Europe Under the Dictators, 1930-1945* (London: Hayward Gallery, 1995).

AGOULT, Marie d,' *Mémoires 1833-1854* (Paris: Calmann Levy, 1927).

ALDINGTON, Richard, *Life for Life's Sake* (New York: Viking, 1941).

ALLEN, Roy F., *Literary Life in German Expressionism and the Berlin Circles* (Epping, Essex: Bonher Publishing Co., 1983).

ALMERAS, Henri d,' 'La Littérature au Café Sous le Second Empire, *Les Oeuvres Libres*, CXXXV (Paris: Fayard, 1933).

ANDERSON, Margaret, *My Thirty Years War: An Autobiography* (New York: Knopf, 1930).

ANDERSON, Perry, *The Origins of Postmodernism* (London: Verso, 1998).

ANDREWS, Keith, *The Nazarenes: A Brotherhood of German Painters in Rome* (Oxford: Clarendon Press, 1964).

ANON., *L'Artiste*, 5 September 1832.

ARAGON, Louis, *Paris Peasant* (London: Picador, 1980).

ARCHER-STRAW, Petrine, 'Negrophilia: Paris in the 1920s: A Study of the Artistic Interest in and Appropriation of Negro Cultural Forms in Paris during the Period,' unpublished Ph.D dissertation, Courtauld Institute of Art, University of London, 1994.

ARNOLD, Matthew, *Culture and Anarchy* (London: John Murray, 1867).

ASCHERSON, Neal, 'Modernism and the Nazis,' in Paul BÜCHLER and Nikos PAPASTERGIADIS (eds).

ASH, Juliet and WILSON, Elizabeth (eds), *Chic Thrills: A Fashion Reader* (Berkeley: University of California Press, 1993).

AUDEBRAND, Philibert, *Derniers Jours de la Bohême: Souvenirs de la Vie Littér-re* (Paris: Calmann Levy, 1905).

BAB, Julius, 'Der Berliner Boheme,' in OSTWALD, Hans, (ed), *Dunkle Winkel in Berlin, Großstadt Dokumente*, Band 1, Berlin/Leipsig: Verlag von Harman Seemann Nachfolger, 1905.

BAINES, Sally, *Greenwich Village 1963: Avant Garde Performance and the Efferves-cent Body* (Durham, NC: Duke University Press, 1993).

BAKER, Michael, *Our Three Selves: A Life of Radclyffe Hall* (*London: Gay Men's Press, 1985*).

BALDICK, Robert, *The First Bohemian: The Life of Henry Murger* (London: Hamish Hamilton, 1961).

BALZAC, Honoré de, *Illusions Perdues* (Paris: Livre de Poche, 1983 [1837–43]).

—————————— *Lost Illusions* (Harmondsworth: Penguin, 1983).

—————————— *La Cousine Bette* (Paris: Livre de Poche, 1973 [1846]).

—————————— *Le Père Goriot* (Harmondsworth: Penguin, 1951 [1834]).

BALL, Hugo, *Flight Out of Time: A Dada Diary* (New York: Viking, 1974).

BANDY, W.T. et PICHOIS, Claude, *Baudelaire devant ses Contemporaines* (Monaco: Éditions du Rocher, 1957).

BANKOVSKY, Jan, 'Slacker Art,' *Art Forum*, xxx/3, *November 1991*.

BANVILLE, Théodore de, *Petits études: Mes Souvenirs* (Paris: Charpentier, 1882).

BARAKA, Amiri, *The Autobiography of Le Roi Jones* (New York: Freundlich Books, 1984).

BARTHES, Roland, *Mythologies* (New York: Hill and Wang, 1957).

BATTERSBY, Christine, *Gender and Genius: Towards a Feminist Aesthetics* (London: The Women's Press, 1989).

BAUDELAIRE, Charles, *Écrits sur l'Art*, 2 (Paris: Livre de Poche, 1971).

—————————, *Les Paradis Artificiels* (Paris: Livre de Poche, 1972).

—————————, *Selected Writings on Art and Literature*, trans P.E. Charvet (Harmondsworth: Penguin, 1972).

—————————, *Fusées: Mon Coeur Mis à Nu: La Belgique Déshabillée* (Paris: Gallimard, 1975).

BEARD, Rick, and BERLOWITZ, Leslie Cohen (eds), *Greenwich Village: Culture and Counterculture* (New Brunswick: Rutgers University Press, 1993).

BEATON, Cecil, *The Glass of Fashion* (New York: Doubleday, 1954).

BEAUMONT, Anthony (ed), *Alma Mahler-Werfel: Diaries 1898-1902* (London: Faber and Faber, 1998).

BEAUVOIR, Simone de, *Force of Circumstance* (Harmondsworth: Penguin 1963).

BECKER, Carol, (ed), *The Subversive Imagination*, New York: Routledge, 1994.

BECKER, Howard, *Art Worlds* (Berkeley: University of California Press, 1982).

BECQ, Annie, 'Expositions, Peintres et Critiques: Ver L'Image Moderne de l'Artiste,' *Dix-Huitième Siècle*, xiv (1982), pp. 131-49.

—————————— 'Artistes et Marché,' in S.C. BONNET (ed), *La Carmagnole des Muses: l'Homme de Lettres et l'Article dans la Révolution* (Paris: 1988), pp. 81-95.

BELL, Daniel, *The Cultural Contradictions of Capitalism* (London: Heinemann, 1979).

BÉNICHOU, Paul, *L'École du Désenchantement: Saint Beuve, Nodier, Musset, Nerval, Gautier* (Paris: Gallimard, 1992).

BENJAMIN, Walter, 'A Berlin Chronicle,' in Walter BENJAMIN, *One Way Street*, London: Verso, 1979.

—————————, 'Central Park,' *New German Critique*, trans Lloyd Spencer, 34 (Winter 1985).

BENSON, T., *Raoul Haussmann and Berlin Dada* (Ann Arbor. University of Michigan Research Press, 1987).

BILLY, André, *La Présidente et ses Amis* (Paris: Flammarion, 1945).

BIRKENBACH, Sabine Werner, 'Emmy Hennings: A Woman Writer of Prison Literature,' in SMITH (ed).

BLASS, Ernst, 'The Old Café des Westens,' in RAABE (ed).

BLESSINGTON, Lady, *Conversations of Lord Byron with the Countess of Blessington* (London: Bentley, 1834).

BOKRIS, Steven, *Warhol* (Harmondsworth: Penguin, 1989).

BOURDIEU, Pierre, *The Field of Cultural Production*, trans Claude Verlie (Oxford: Polity Press, 1993).

BOWEN, Stella, *Drawn From Life* (London: Virago, 1984 [1941]).

BRADE, Johanna, *Suzanne Valadon: vom Modell in Montmartre zur Malerin der klassische Moderne* (Stuttgart: Beber Verlag, 1994).

BRADSHAW, Steve, *Café Society: Bohemian Life from Swift to Bob Dylan* (London: Weidenfeld and Nicolson, 1978).

BRASSAÏ, *Picasso and Co.* (London: Thames and Hudson, 1937).

BREWER, John, *The Pleasures of the Imagination: English Culture in the Eighteenth Century* (London: HarperCollins, 1997).

BRINNIN, John, *Dylan Thomas in America* (London: J.M. Dent, 1956).

BROWN, Marilyn, *Gypsies and Other Bohemians: The Myth of the Artist in Nineteenth Century France* (Ann Arbor: University of Michigan Research Press, 1985).

BUCK-MORSS, Susan, 'The Flâneur, the Sandwichman and the Whore: the Politics of Loitering,' *New German Critique*, 39 (Fall 1986).

BÜCHLER, Pavel and PAPASTERGIADIS, Nikos (eds), *Random Access 1* (London: Rivers Oram Press, 1993).

BÜRGER, Peter, *Theory of the Avant Garde*, trans Michael Shaw (Manchester: Manchester University Press, 1984).

BURLEIGH, Michael and WIPPERMAN, Wolfgang, *The Racial State: Germany 1933-1945* (Cambridge: Cambridge University Press, 1991).

CAMPBELL, Colin, *The Romantic Ethic and the Spirit of Modern Consumerism* (Oxford: Blackwell, 1987).

CAMPBELL, James, *Paris Interzone* (London: Secker and Warburg, 1994).

——————, *This is the Beat Generation* (London: Secker and Warburg, 1999).

CARCO, Francis, *From Montmartre to the Latin Quarter: The Last Bohemia*, trans Madeleine Boyd (London: Grant Richards and Humphrey Toulmin, 1929).

CASSADY, Carolyn, *Off the Road: My Years with Cassady, Kerouac and Ginsberg* (London: Black Spring, 1984).

CERTEAU, Michel de, *The Practice of Everyday Life* (Berkeley: University of California Press, 1984).

CHAMPFLEURY, *Les Excentriques* (Paris: Michel Levy, 1855).

CHARTERS, Jimmy, *This Must Be The Place: Memoirs of Montparnasse* (London: Herbert Joseph, 1934).

CHAUNCEY, George, *Gay New York: Gender, Urban Culture and the Making of the Gay Male World, 1890-1940* (New York: Basic Books, 1994).

CHEVALIER, Louis, *Labouring Classes and Dangerous Classes in Paris During the First Half of the Nineteenth Century*, trans Frank Jellinek (London: Routledge and Kegan Paul, 1973).

CHISHOLM, Anne, *Nancy Cunard* (Harmondsworth: Penguin, 1981).

CITRON, Pierre, *La Poésie de Paris dans la Littérature Française de Rousseau à Baudelaire* (Paris: Gallimard, 1963).

CLARK, T.J., *Image of the People: Gustave Courbet and the 1848 Revolution* (London: Thames and Hudson, 1973).

——————, *Farewell to an Idea: Episodes from a History of Modernism* (New Haven: Yale University Press, 1999).

COOK, Blanche Weisen, 'The Radical Women of Greenwich Village: From Crystal Eastman to Eleanor Roosevelt,' in BEARD and BERLOWITZ (eds).

COSGROVE, Stuart, 'The Zoot Suit and Style Warfare,' *History Workshop Journal*, 18 (Autumn 1984).

COWLEY, Malcolm, *Exile's Return: A Literary Odyssey of the 1920s* (London: The Bodley Head, revised edition, 1964).

CRÉPET, Eugène et CRÉPET, Jacques, *Charles Baudelaire: Étude Biographique, suivie des Baudelairiana d'Asselineau* (Paris: Vannier, 1906).

CROMPTON, Louis, *Byron and Greek Love: Homophobia in Nineteenth Century England* (London: Faber and Faber, 1985).

CSICERY-RONAY Jr, Istvan, 'Cyberpunk and Neuromanticism,' in McCAFFERY (ed).

D'ANGLEMONT, Alexandre Privat, *Paris Inconnu* (Paris: Adolphe Delahaye, 1861).

DAVID, Hugh, *The Fitzrovians: A Portrait of Bohemian Society, 1900-1955* (London: Michael Joseph, 1988).

DEGHY, Guy and WATERHOUSE, Keith, *Café Royal: Ninety Years of Bohemia* (London: Hutchinson, 1955).

DELÉCLUZE, M.E.J., *Louis David: Son École et son Temps* (Paris: Didier, 1855).

DE LEUUW, Ronald (ed), *The Letters of Vincent Van Gogh* (Harmondsworth: Penguin, 1996).

DELL, Floyd, *Love in Greenwich Village* (London: Cassell, 1927).

——————, *Homecoming* (New York: Farrar and Rinehart, 1933).

DE QUINCEY, Thomas, *Confessions of an English Opium Eater* (Harmondsworth: Penguin, 1973 [1821]).

DELVAU, Alphonse, *Les Dessous de Paris* (Paris: Poulet Malarus et de Brosse, 1861).

—————— *Histoire Anecdotique des Cafés et Cabarets de Paris*, Paris: Poulet Malarus et Delabrosse, 1862.

DEVAS, Nicolette, *Two Flamboyant Fathers* (London: Collins, 1966).

DIEDERICHSEN, Diedrich, 'Gefühlte Paprika – die politische Subjectivität der Boheme,' *Texte und Kunst*, 11 (September 1993).

DODGE-LUHAN, Mabel, *Intimate Memories:* vol 1, *Background*, vol 2 *European Experiences*, vol 3, *Movers and Shakers*, vol 4, *Edge of Taos Desert* (London: Martin Secker, 1933-1937).

DORGELÈS, Roland, *Bouquet de Bohème*, Paris: Albin Michel, 1945.

DOUGLAS, Ann, *Terrible Honesty: Mongrel Manhattan in the 1920s* (London: Picador, 1996).

DOUGLAS, Charles (pseudonym of Douglas GOLDRING), *Artist Quarter: Reminiscences of Montmartre and Montparnasse in the First Two Decades of the Twentieth Century* (London: Faber and Faber, 1941).

DRABBLE, Margaret, *Angus Wilson: A Biography* (London: Secker and Warburg, 1995).

DU CAMP, Maxime, *Literary Recollections* (London: Remington and Co., 1893).

DUPÊCHEZ, Charles, *Marie d'Agoult* (Paris: Librairie Académique Perrin, 1989).

EAGLETON, Terry, *The Illusions of Postmodernism* (Oxford: Blackwell, 1996).

EHRENBERG, Ilya, *People and Life: Memoirs of 1891-1917*, trans Anna Bostok and Yvonne Kapp (London: MacGibbon and Kee, 1961).

ERENBERG, Lewis, 'Greenwich Village Nightlife, 1910-1950,' in BEARD and BERLOWITZ (eds).

EVANS, Caroline, 'Dreams That Only Money Can Buy ... Or The Shy Tribe in Flight from Discourse,' *Fashion Theory*, i/2 (June 1997).

FAITHFULL, Marianne, *Faithfull* (Harmondsworth: Penguin, 1995).

FARSON, Daniel, *The Gilded Gutter Life of Francis Bacon* (London: Vintage, 1993).

FERGUSON, Marjorie and GOLDING, Peter (eds), *Cultural Studies in Question* (London: Sage, 1997).

FERRIS, Paul, *Caitlin: The Life of Caitlin Thomas* (London: Pimlico, 1993).

FISCHER, Lothar, *Tanz zwischen Rausch und Tod: Anita Berber: 1918-1928 in Berlin* (Berlin: Haude und Spenersche, 1988).

FISHBEIN, Leslie, *Rebels in Bohemia: The Radicals of The Masses, 1911-1917* (Chapel Hill: University of Carolina Press, 1982).

FISHER, Clive, *Cyril Connolly: A Nostalgic Life* (London: Macmillan, 1995).

FISKE, John, *Reading the Popular* (London: Routledge, 1989).

FOSTER, Alicia, 'Dressing for Art's Sake: Gwen John, the *Bon Marché* and the Spectacle of the Woman Artist in Paris,' in HAYE and WILSON (eds).

FRAYLING, Christopher, *The Vampire: From Byron to Bram Stoker* (London: Faber and Faber, 1992).

FRANK, Leonhard, *Heart on the Left*, trans Cyrus Brooks (London: Arthur Barker, 1954).

FRITZ, Helmut, *Die erotische Rebellion: das Leben der Franziska Gräfin zu Reventlow* (Frankfurt: Fischer Verlag, 1980).

GARB, Tamar, *Sisters of the Brush: Women's Artistic Culture in Late Nineteenth-Century Paris* (New Haven: Yale University Press, 1993).

GAUTIER, Judith, *Le Collier des Jours: Souvenirs de ma Vie* (Paris: Juven, 1907).

——————, *Le Collier des Jours: Souvenirs de ma Vie – le Second Rang du Collier* (Paris: Juven, 1910).

GAUTIER, Théophile, *Mademoiselle de Maupin* (Paris: Garnier-Flammarion, [1835] 1966).

——————, *Histoire de l'Art Dramatique en France depuis Vingt-cinq Ans*, Series 2 (Paris: Hetzel, 1858-9).

———————, *Histoire du Romantisme* (Paris: Charpentier, 1874).

GILL, Anton, *A Dance Between Flames: Berlin Between the Wars* (London: John Murray, 1993).

GIRARDIN, Delphine de, *Geuvres Complète*, Tome 4 (Paris: Plon, 1860).

GIROUD, Françoise, *Alma Mahler ou l'Art d'Être Aimée* (Paris: Laffont, 1988).

GOLDBERG, Rosa Lee, *Performance Art: From Futurism to the Present* (London: Thames and Hudson, 1979).

GOLDRING, Douglas, *The 1920s: A General Survey and Some Personal Memories* (London: Nicolson & Watson, 1945).

GONCOURT, Edmond et GONCOURT, Jules, *Journal des Goncourts: Mémoires de la Vie Littéraires*, 1e et 2me vols., (Paris: Charpentier, 1887).

GRAF, Oskar Maria, *Prisoners All*, trans Margaret Green (New York: Alfred Knopf, 1928).

GRANA, César, *Modernity and Its Discontents: French Society and the French Man of Letters in the Nineteenth Century* (New York: Harper Row, 1967).

GRAVES, Robert and HODGE, Alan, *The Long Weekend: The Living Story of the Twenties and Thirties* (Harmondsworth: Penguin, 1971 [1940]).

GRAY, Francine du Plessix, *Rage and Fire: A Life of Louise Colet – Pioneer Feminist, Literary Star, Flaubert's Muse* (London: Hamish Hamilton, 1994).

GREEN, Martin, *Mountain of Truth: The Counter Culture Begins: Ascona 1900-1920* (Harvard, Ma: University Press of New England, 1986).

GREEN, Martin and SWAN, John, *The Triumph of Pierrot: The* Commedia dell'Arte *and the Modern Imagination* (New York: Macmillan, 1986).

HALDANE, Charlotte, *The Galley Slaves of Love: The Story of Marie d'Agoult and Franz Liszt* (London: Harvill Press, 1957).

HARRIS, Oliver (ed), *The Letters of William Burroughs, 1945-1959* (London: Picador, 1994).

HAUSER, Eva, 'The Velvet Revolution and Iron Necessity,' in BECKER, Carol, (ed), New York: Routledge, 1994, pp 77–94.

HAYE, Amy de la and WILSON, Elizabeth (eds), *Defining Dress* (Manchester: Manchester University Press, 1999).

HAMNETT, Nina, *Laughing Torso* (London: Virago, 1984 [1932]).

HAPGOOD, Hutchins, *A Victorian in the Modern World* (Seattle: University of Washington Press, 1972 [1939]).

HEBDIGE, Dick, *Subculture: The Meaning of Style* (London: Methuen, 1979).

HENDIN, Josephine Gattuso, 'Italian Neighbours,' in BEARD and BERLOWITZ (eds).

HETHERINGTON, Kevin, 'Stonehenge and its Festival: Spaces of Consumption', in Shields, (ed), pp. 83–98 (1992).

HEWISON, Robert, *Too Much: Art and Society in the Sixties, 1960-1975* (London: Methuen, 1986).

HOLROYD, Michael, *Augustus John: A Biography* (Harmondsworth: Penguin, 1976).

———————, *Augustus John: The New Biography* (London: Chatto and Windus, 1996).

HOOKER, Denise, *Nina Hamnett: Queen of Bohemia* (London: Constable, 1986).

HOUSSAYE, Arsène, *Les Confessions: Souvenirs d'un Demi Siècle* (Paris: Dentu, 1885).

HUCH, Roderich, 'Alfred Schuler, Ludwig Klages und Stefan George: Erinnerungen an Krise und Krisen der Jahrhundertwende in Munich-Schwabing,' *Castrum Peregrini*, CX (Amsterdam: Castrum Peregrini Press, 1973).

HUDDLESTONE, Sisley, *Paris Salons, Cafés and Studios: Being Social Artistic and Literary Memories* (New York: Blue Ribbon Books, 1928).

HUELSENBECK, Richard, 'Die Dadaistische Bewegung,' in RAABE (ed).

HUXLEY, Juliet, *Leaves of the Tulip Tree* (London: John Murray, 1986).

ISHERWOOD, Christopher, *Christopher and His Kind, 1929-1939* (London: Methuen, 1977).

JACKSON, Stanley, *An Indiscreet Guide to Soho* (London: Muse Arts, 1946).

JACOBY, Russell, *The Last Intellectuals: American Culture in the Age of Academe* (New York: Basic Books, 1987).

JAMESON, Fredric, 'Postmodernism or The Cultural Logic of Late Capitalism,' *New Left Review*, 146 (July/August 1984).

JELAVICH, Peter, *Munich and Theatrical Modernism: Politics, Playwriting and Performance, 1890-1914* (Cambridge Ma: Harvard University Press, 1985).

——————, *Berlin Cabaret* (Cambridge, Ma: Harvard University Press, 1993).

JOHNSON, Joyce, *Minor Characters* (London: Harvill Press, 1984).

JONES, Ernest, *Free Associations* (London: Hogarth Press, 1958).

JONES, Hettie, *How I Became Hettie Jones* (New York: Penguin, 1984).

JUNG, Claire, 'Memories of Georg Heym and his Friends,' in RAABE (ed).

JUNG, Franz, *Der Weg nach Unten: Aufzeichnungen aus einer Grossen Zeit* (Berlin: Hermann Luchterland Verlag, 1961).

KEROUAC, Jack, *On the Road* (Harmondsworth: Penguin, 1996 [1957]).

KESSLER, Harry, *The Diaries of a Cosmopolitan: Count Harry Kessler, 1918-1937* (London: Weidenfeld and Nicolson, 1971).

KING, Viva, *The Weeping and the Laughter* (London: Macdonald and Jane's, 1976).

KLEEMAN, Elisabeth, *Zwischen symbolischer Rebellion und politischer Revolution* (Frankfurt: Peter Lang, 1985).

KLÜVER, Billy and MARTIN, Julie, *Kiki's Paris: Artists and Lovers 1900-1930* (New York: Abrams Inc., 1989).

KNEPLER, Henry (ed), *Man About Paris: The Confessions of Arsène Houssaye* (London: Victor Gollancz, 1972).

KNIEBLER, Yvonne et al., *De la Pucelle à la Midinette: Les Jeunes Filles de l'Age Classique à nos Jours* (Paris: Temps Actuel, 1983).

KNIGHT, Arthur and KNIGHT, Kit (eds), *Kerouac and the Beats: A Primary Source Book* (New York: Paragon House, 1988).

KOCH, Stephen, *Stargazer* (New York: Praeger, 1973).

KOHN, Marek, *Dope Girls: The Birth of the British Drug Underground* (London: Lawrence and Wishart, 1992).

KOPS, Bernard, *The World is a Wedding* (London: MacGibbon and Kee, 1963).

KRACAUER, Siegfried, *Offenbach and the Paris of his Time*, trans Gwenda David and Eric Mosbacher (London: Constable, 1937).

KREUZER, Helmut, *Die Boheme: Beitrage zu ihrer Beschreibung* (Stuttgart: J.B. Metzlersche Verlagsbuchhandlung, 1968).

KRUPSKAYA, Nadezdha, *Memories of Lenin*, trans Martin Lawrence (London: Panther, 1970).

LAMB, Stephen, 'Intellectuals and the Challenge of Power: The Case of the Munich "Räterrepublik",' in PHELAN, (ed).

LAWRENCE, Frieda, *The Memoirs and Correspondence*, ed E.W. TEDLOCK (London: Heinemann, 1961).

LEBLANC, Georgette, *Maeterlinck and I*, trans Janet Flanner (London: Methuen, 1932).

LEVIN, Harry, *The Gates of Horn: A Study of Five French Realists* (New York: Oxford University Press, 1963).

LEVITINE, George, *The Dawn of Bohemianism: The Barbu Rebellion and Primitivism in Neo-Classical France* (Philadelphia: Penn State University Press, 1978).

LINSE, Ulrich, *Barfüssige Propheten: Erlöser der zwanziger Jahre* (Berlin: Siedler, 1983).

LUCK, Kate, 'Trouble in Eden, Trouble with Eve: Women, Trousers and Utopian Socialism in Nineteenth Century America,' in Juliet ASH and Elizabeth WILSON (eds).

McCAFFERY, Larry (ed), *Storming the Reality Studio: A Casebook of Cyberpunk and Postmodern Fiction* (Durham NC: Duke University Press, 1991).

McGUIGAN, Jim, 'Cultural Populism Revisited,' in Marjory FERGUSON and Peter GOLDING (eds).

MacINNES, Colin, *Absolute Beginners* (London: MacGibbon and Kee, 1959).

MACLAREN-ROSS, Julian, *Memoirs of the Forties* (Harmondsworth: Penguin, 1984 [1965]).

MAFFESOLI, Michel, *The Time of the Tribes* (London: Sage, 1996).

MAHLER-WERFEL, Alma, *And The Bridge is Love* (London: Hutchinson, 1958).

MAILER, Norman, *Advertisements for Myself* (London: Panther, 1968).

MAILLARD, Firmin, *Les Dernières Bohèmes: Henri Murger et son Temps* (Paris: Librairie Sartorius, 1874).

——————, *La Cité des Intellectuels: Scènes Cruelles et Plaisantes de la Vie Littéraire des Gens de Lettres au XIX Siècle* (Paris: D'Aragon, 1905).

MANN, Klaus, *The Turning Point* (London: Oswald Wolff, 1984).

MANN, Thomas, *Stories of Three Decades* (London: Secker and Warburg, 1946).

——————, *Selected Stories* (Harmondsworth: Penguin, 1988).

MARTIN, Bernice, *The Sociology of Contemporary Cultural Change* (Oxford: Blackwell, 1981).

MARX, Karl, '*Les Conspirateurs* by A Chenu, *La Naissance de la République* by Lucien de la Hodde,' in Karl MARX and Frederick ENGELS, *Collected Works*, vol 10 (1849–51) (London: Lawrence and Wishart, 1978).

MARX, Karl and ENGELS, Frederick, *Selected Works* (London: Lawrence and Wishart, 1970).

MASPERO, François, *Roissy Express*, trans Paul Jones (London: Verso, 1994).

MAYNARD, John Arthur, *Venice West: The Beat Generation in Southern California* (New Brunswick NJ: Rutgers University Press, 1991).

MEHRING, Walter, *The Lost Library: The Autobiography of a Culture*, trans Richard and Clara Winston (London: Secker and Warburg, 1951).

MELLY, George, *Revolt into Style: The Pop Arts in Britain* (Harmondsworth: Penguin, 1970).

MESKINNON, Marsha, *We Weren't Modern Enough: Women Artists and the Limits of German Modernism* (London: I.B.Tauris, 1999).

MICHAELS, Jennifer, *Anarchy and Eros: Otto Gross's Impact on German Expressionist Writers* (NewYork: Peter Lang, 1983).

MITZMAN, Arthur, 'Otto Gross: Anarchism, Expressionism and Psychoanalysis,' *New German Critique*, no. 10, Winter (1977).

MORAES, Henrietta, *Henrietta* (London: Hamish Hamilton, 1993).

MORGAN, Ted, *Literary Outlaw: The Life and Times of William S. Burroughs* (New York: Henry Holt, 1986).

MORRISROE, Patricia, *Mapplethorpe: A Biography* (London: Macmillan, 1995).

MÜHSAM, Erich, *Unpolitische Erinnerungen* (Berlin: Verlag Volk und Welt, 1958).

MULVAGH, Jane, *Vivienne Westwood: An Unfashionable Life* (London: HarperCollins, 1999).

MURGER, Henry, *Scènes de la Bohème* (Paris: Michel Levy, 1851).

——————, *Les Buveurs d'Eau* (Paris: Michel Levy, 1853).

NEWMAN, Ernest, *The Man Liszt* (London: Cassell, 1934).

NEWTON, Stella Mary, *Health, Art and Reason: Dress Reformers of the Nineteenth Century* (London: John Murray, 1974).

NICHOLL, Charles, *Somebody Else: Arthur Rimbaud in Africa* (London: Jonathan Cape, 1997).

NODIER, Charles, 'Les Barbus du Présent et les Barbus de 1800,' *Le Temps*, 5 October 1832, in M.E.J. DELÉCLUZE.

NUTTALL, Jeff, *Bomb Culture* (London: Paladin, 1970).

OLIVIER, Fernande, *Picasso and his Friends*, trans Jane Miller (London: Heinemann, 1964).

O'NEDDY, Philothée (DONDEY, Théophile), *Lettre Inédite sur le Groupe Littérre Romantique dit des Bousingos* (Paris: Rouquette, 1875).

PEM (Paul Erich Marcus), *Heimweh nach dem Kurfürstendamm: Aus Berlin's glanzvollsten Tagen und Nächten* (Berlin: Lothar Blanvalet Verlag, 1952).

PERRY, Gillian, *Women Artists and the Parisian Avant Garde* (Manchester: Manchester University Press, 1995).

PHELAN, Anthony (ed), *The Weimar Dilemma: Intellectuals in the Weimar Republic*, Manchester: Manchester University press, 1985.

PICHOIS, Claude and ZIEGLER, Jean, *Baudelaire*, trans Graham Robb (London: Vintage, 1991).

POLHEMUS, Ted, *Street Style* (London: Thames and Hudson, 1994).

PYAT, Félix, 'Les Artistes,' *Le Nouveau Tableau de Paris*, iv (1834).

RAABE, Paul (ed), *The Era of German Expressionism*, trans J.M. Ritchie (London: Calder and Boyars, 1974).

RANSOME, Arthur, *Bohemia in London* (Oxford: Oxford University Press, 1984 [1907]).

REVENTLOW, Franciska zu, *Tagebuch* (München-Wien: Langen-Müller, 1971[1898]).

RICHARDSON, Joanna, *Théophile Gautier: His Life and Times* (London: Max Reinhardt, 1958).

——————, *The Bohemians: La Vie de Bohème in Paris, 1830-1914* (London: Macmillan, 1969).

RICHARDSON, John, *A Life of Picasso, Volume I: 1881-1906* (London: Jonathan Cape, 1991).

——————, *A Life of Picasso, Volume II: 1907-1917* (London: Jonathan Cape, 1996).

ROSE, June, *Modigliani: The Pure Bohemian* (London: Constable, 1990).

RYKWERT, Joseph, 'The Constitution of Bohemia,' *Res* xxxi (Spring 1997).

SADLEIR, Michael, *Blessington D'Orsay: A Masquerade* (London: Constable, 1947).

SAID, Edward, *Orientalism* (Harmondsworth: Penguin, 1985).

SAINT CHÉRON, 'De la Poésie et des Beaux Arts dans Notre Époque,' *L'Artiste: Journal de la Littérature et des Beaux Arts*, 1re Série, iv (1832).

ST JOHN, Christopher (Christabel Marshall), *Hungerheart: The Story of a Soul* (London: Methuen, 1915).

SALMON, André, *La Vie Passionnée de Modigliani* (Paris: Intercontinentale du Livre, 1957).

SAND, George, *Lélia* (Paris: Henri Dupuy, 1833).

SARTRE, Jean-Paul, *Baudelaire* (Paris: Gallimard, 1963).

SAUNDERS, Frances Stonor, *Who Paid the Piper? The CIA and the Cultural Cold War* (London: Granta Books, 1999).

SAVAGE, Jon, *England's Dreaming: Sex Pistols and Punk Rock* (London: Faber and Faber, 1991).

SCHAD, Christian, 'Zurich/Geneva: Dada, in RAABE (ed).

SCHAMBER, Ellie, *The Artist as Politician: The Relationship Between the Art and the Politics of the French Romantics* (Lanham, MD: University Press of America, 1984).

SCHEBERA, Jürgen, *Damals im Romanischen Café: Künstler und ihre Lokale im Berlin der zwanzige Jahre* (Braunschweig: Westerman, 1988).

SHKLOVSKY, Victor, *Mayakovsky and his Circle*, trans and ed Lily Feiler (London: Pluto Press, 1970).

SCHMIDT, Paul, 'Visions of Violence: Rimbaud and Verlaine,' in George STAMBOULIAN and Elaine MARKS (eds).

SCHORSKE, Carl E., *Fin de Siècle Vienna: Politics and Culture* (London: Weidenfeld and Nicolson, 1961).

SEGEL, Harold B., *Turn of the Century Cabaret* (New York: Columbia University Press, 1987).

SENNETT, Richard, *The Fall of Public Man* (Cambridge: Cambridge University Press, 1974).

SERT, Misia, *Two or Three Muses* (London: Museum Press, 1953).

SEYMOUR, Miranda, *Ottoline Morell: Life on the Grand Scale* (London: Hodder and Stoughton, 1992).

SHATTUCK, Roger, *The Banquet Years: The Origins of the Avant Garde in France, 1885 to World War One* (New York: Viking, 1968).

SHEPPARD, Richard (ed), *New Studies in Dada: Essays and Documents* (Hutton, Duffield, Yorkshire: Hutton Press, 1981).

SHIELDS, Rob, (ed), *Lifestyle Shopping: The Subject of Consumption*, (London: Routledge, 1992).

SIEGEL, Jerrold, *Bohemian Paris: Culture, Politics and the Boundaries of Bourgeois Life, 1830-1890* (New York: Viking, 1986).

SKELTON, Barbara, *Tears Before Bedtime* and *Weep No More* (London: Pimlico, 1993).

SMITH, Barry, *Peter Warlock: The Life of Philip Heseltine* (Oxford: Oxford University Press, 1994).

SMITH, Brian Keith (ed), *German Women Writers, 1900-1933* (Lampeter: Edwin Mallen Press, 1993).

SMITH, Neil, 'New City, New frontier: The Lower East Side as Wild Wild West,' in Michael SORKIN (ed).

SNITOW, Ann, STANSELL, Christine and THOMPSON, Sharon (eds), *Desire: The Politics of Sexuality* (London: Virago, 1984).

SORKIN, Michael (ed), *Variations on a Theme Park: The New American City and the End of Public Space* (New York: Noonday Press, 1992).

SPENDER, Stephen, *World Within World* (London: Hamish Hamilton, 1951).

STALLABRASS, Julian, *Gargantua: Manufactured Mass Culture* (London: Verso, 1996).

STAMBOULIAN, George and MARKS, Elaine (eds), *Homosexualities and French Literature: Cultural Contexts/Critical Texts* (Ithaca NY: Cornell University Press, 1979).

STALLYBRASS, Peter and WHITE, Allon, *The Politics and Poetics of Transgression* (London: Methuen, 1986).

STANFORD, Derek, *Inside the Forties: Literary Memoirs 1937-1957* (London: Sidgwick and Jackson, 1977).

STARKIE, Enid, *Arthur Rimbaud in Abyssinia* (Oxford: Clarendon Press, 1937).

——————, *Petrus Borel the Lycanthrope: His Life and Times* (London: Faber and Faber, 1954).

STARR, Kevin, *Americans and the Californian Dream, 1850-1915* (New York: Oxford University Press, 1973).

——————, *Inventing the Dream: California Through the Progressive Era* (New York: Oxford University Press, 1985).

STEELE, Valerie, *Fetish: Fashion Sex and Power* (New York: Oxford University Press, 1996).

STEELE, Valerie, *Paris Fashion: A Cultural History*, New York: Oxford University Press, 1988.

STEIN, Gertrude, *The Autobiography of Alice B. Toklas* (New York: Vintage Books, 1933).

STEINMETZ, Jean-Luc, *Arthur Rimbaud: Une Question de Présence* (Paris: Tallandier, 1991).

THACKERAY, William Makepeace, *The Paris Sketchbook* (*Collected Works*, vol 5) (London: Smith Elder and Co., 1898).

THIRION, André, *Revolutionaries without Revolution*, trans Joachim Neugroschel (London: Cassell, 1975).

THOMAS, Alison, *Portraits of Women: Gwen John and her Forgotten Contemporaries* (Oxford: Polity Press, 1994).

THOMAS, Caitlin, *Leftover Life to Kill* (London: Ace Books, 1959).

THOMAS, Richard Hinton, 'Nietzsche in Weimar Germany – and the Case of Ludwig Klages,' in PHELAN, ed, pp 71-91.

THORNTON, Sarah, *Club Cultures: Music Media and Subcultural Capital* (Cambridge: Polity Press, 1995).

THORUP, Inge and DALGARD, Per (eds), *The Beat Generation and the Russian New Wave* (Ann Arbor: Ardis, 1990).

TILLEY, Sue, *Leigh Bowery: The Life and Times of an Icon* (London: Hodder & Stoughton, 1997).

TRELAWNEY, Edward John, *Records of Shelley, Byron and the Author* (Harmondsworth: Penguin, 1973 [1858]).

TRESSIDER, Megan, 'The *Awfully Funny Life of Beryl*,' *Guardian*, London, 8 April

TRIMBERGER, Ellen Kay, 'Feminism Men and Modern Love: Greenwich Village, 1900-1925,' in SNITOW *et al.*

TYTELL, John, *The Living Theatre: Art, Exile and Outrage* (London: Methuen, 1997).

VALLÈS, Jules, 'Les Réfractaires,' *Oeuvres Complètes*, vol 2 (Paris: Livre Club Didiot, 1975 [1857]).

VIERECK, Peter, *Metapolitics: From the Romantics to Hitler* (New York: Alfred Knopf, 1941).

VINCENDEAU, Jeannette, 'The *Mise en Scène* of Suffering: French *Chanteuses Réalistes*,' *New Formations*, 3 (Winter 1987).

VOROBËV, Marevna, *Life in Two Worlds* (London and New York: Abelard Schulman, 1962).

WAKEFIELD, Dan, *New York in the Fifties* (New York: Houghton Miflin, 1992).

WARHOL, Andy and HACKETT, Pat, *Popism: The Warhol Sixties* (London: Pimlico, 1996).

WATSON, Steven, *Strange Bedfellows: The First American Avant Garde* (New York: Abbeville Press, 1994).

WEBSTER, Paul and POWELL, Nicholas, *Saint Germain des Prés* (London: Constable, 1984).

WEDEKIND, Frank, *Diary of an Erotic Life*, (ed) Gerhard Hay, trans W.E.Yuill (Oxford: Blackwell, 1990).

WEISS, Andrea, *Paris was a Woman* (London: Pandora, 1996).

WEISS, Peg, *Kandinsky in Munich: The Formative Jugendstil Years* (Princeton NJ: Princeton University Press, 1979).

WHIMSTER, Sam with HEUER, Gottfried, 'Otto Gross and Else Jaffé and Max Weber,' *Theory Culture and Society*, xv/3-4, Special Issue on Love and Eroticism (August–November 1998).

WILLIAMS, Raymond, 'The Bloomsbury Fraction,' in Raymond WILLIAMS, *Problems in Materialism and Culture* (London: Verso, 1980).

WILSON, Elizabeth, 'The Unbearable lightness of Diana', *New Left Review* no. 226, November/December, 1997 pp 136–145.

WINEGARTEN, Renée, *The Double Life of George Sand: Woman and Writer: A Critical Biography* (New York: Basic Books, 1978).

WISHART, Michael, *High Diver: An Autobiography* (London: Quartet Books, 1978).

WITTKOWER, Rudolf and WITTKOWER, Margot, *Born Under Saturn: The Character and Conduct of Artists: A Documented History from Antiquity to the French Revolution* (London: Weidenfeld and Nicolson, 1963).

WOLLEN, Peter, 'The Triumph of American Painting: "A Rotten Rebel from Russia",' in Peter WOLLEN, *Raiding the Icebox: Reflections on Twentieth Century Culture* (London: Verso, 1993).

ZUKIN, Sharon, *Loft Living* (London: Radius, 1982).

ZWEIG, Stefan, *The World of Yesterday* (London: Cassell, 1943).

INDEX